Original Dutch edition
Lorenzo & Giovanna. Schoonheid en noodlot in Florence
© 2009 Primavera Pers, Leiden

Revised English edition
edited by Monica Fintoni and Andrea Paoletti
© 2010 Mandragora. All rights reserved.

The translation of this book was funded by
the Netherlands Organization for Scientific Research (NWO).

Mandragora s.r.l.
Piazza del Duomo 9, 50122 Florence
www.mandragora.it

Editing, design and typesetting
Monica Fintoni, Andrea Paoletti, Michèle Fantoli,
Bianca Belardinelli, Paola Vannucchi

Printed in Italy by Alpilito, Florence
Bound by Legatoria Giagnoni, Calenzano

ISBN 978-88-7461-128-7

9 8 7 6 5 4 3 2 1

Gert Jan van der Sman

Lorenzo and Giovanna
Timeless Art and Fleeting Lives in Renaissance Florence

English translation by DIANE WEBB

Mandragora

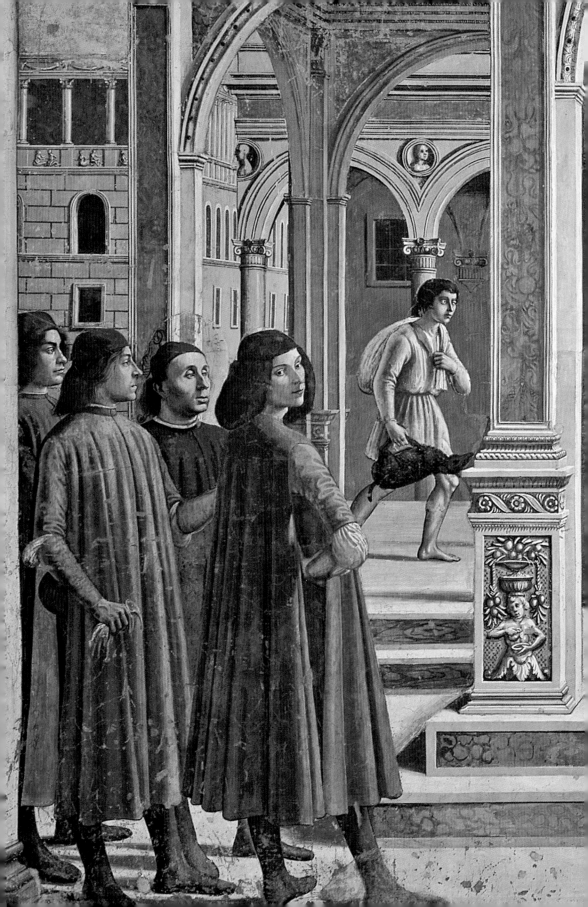

Preface

Where art and history meet, a story emerges. All too often that story is a patchy one, because time has removed every trace of an art work's origins, or left us with only snippets of information that cannot be pieced together into a cohesive whole. This is the case with Da Vinci's *Mona Lisa*, whose origins are still the subject of lively debate. Fortunately, there are also works of art which have left such clear historical traces that they function as an important source of information on the people they portray. Domenico Ghirlandaio's *Portrait of Giovanna degli Albizzi* is a case in point, for no Renaissance portrait of a woman is better documented.

The painting was given pride of place in the living quarters of Giovanna's husband, the wealthy banker's son Lorenzo Tornabuoni, whose initial—a stylized L—is visible on the shoulder of Giovanna's precious brocade gown. As an artistic creation of sparkling beauty, the portrait transcends time. As a historical document, it alludes to a defining moment in the sitter's life, for the book of hours on the right was given to Giovanna by her father upon her marriage.

In exploring the history of this painting, I was soon drawn into a web of events, rituals and relationships, all of which are rooted in the troubled history of Florence in the last decades of the fifteenth century. Against this backdrop, the lives of Giovanna and Lorenzo unfold on centre stage, the history of two young people for whom high ideals and a yearning for beauty were just as important as the dramatic events in their own lives and the political turbulence of their era.[1]

Lorenzo and Giovanna became acquainted in 1486 when their betrothal was officially announced. Both were members of distinguished Florentine families that could vie with each other in wealth and power; both were in the limelight from their earliest years. Lorenzo was the vastly talented cousin of Lorenzo de' Medici, the most powerful man in the city. Giovanna was one of the prettiest daughters of the wealthy patrician Maso degli Albizzi. Their wedding was such a lavish affair that it was still being written about a century later. Because of Lorenzo and Giovanna's prominent position in Florentine society, their lives

are fairly well documented, for more than twenty works of art—each wrapped up in its own historical context—can be connected with one or both of them. Such a wealth of visual documentation is extraordinary, even in the history of Florentine art.[2]

Remarkably, though, the story of Lorenzo and Giovanna has never been recounted in detail. Florentine history itself is to blame for this, for its vagaries caused their generation to fall into relative obscurity. Lorenzo Tornabuoni belonged, after all, to the same generation as the reviled Piero de' Medici, the son of Lorenzo the Magnificent. A good deal of the information available on Lorenzo is to be found in a scholarly treatise on his father, the respected paterfamilias Giovanni Tornabuoni. A capable businessman and ambitious patron of the arts, Giovanni had considerably enhanced the family's fame and prestige, and his son naturally followed in his footsteps.[3]

The search for new information on the life of Lorenzo Tornabuoni led me to many archives and libraries. The most interesting find came about as a result of both luck and perseverance. A friend and colleague who knew about my research discovered among the papers of a deceased codicologist a note concerning the whereabouts of a unique manuscript. It proved to contain a detailed description of Lorenzo and Giovanna's sumptuous wedding, which was attended by the crème de la crème of Florentine society.

Generally speaking, little first-hand information on the early years of Florentine women is available. My only hope was that Giovanna's father had kept detailed notes of his household affairs and that these notes had not been lost. Once again, the relevant sources were found in a private archive preserved by a noble Florentine family whose ancestors had ties to the Albizzi. All in all, the source material on Lorenzo and Giovanna could hardly be more varied—contemporary chronicles, account books, notarial acts, estate inventories, archival documents of secular and ecclesiastical bodies, private correspondence and literary texts. This information has been handled in accordance with the principles of narrative historiography. I have also made extensive use of visual sources, namely frescoes, paintings and sculptures, many of which are to be found in churches and public collections. These works —by famous and lesser known artists alike—treat such profound subjects as love, fidelity, death and the hope of eternal life. Their wealth of iconographic detail allows us to penetrate the complex world of intellectual, artistic and religious sensibility.

This book, which brings together both written and visual sources, addresses one main question: how were these works of art bound up with the lives of Lorenzo and Giovanna. From the very beginning of my research, it was this intermingling of life and art that intrigued me the most. Art historians often approach this question only in terms of function and use, pushing existential motives to the background. The question became more pressing as more information became available and I was confronted with apparent contradictions, for Lorenzo Tornabuoni and others of his generation had no qualms about combining highly principled intellectual endeavours and unparalleled aesthetic refinement with blatant self-glorification and, when deemed necessary, political ruthlessness. Everything, it seems, was professed with the same passion and sense of purpose. The multifaceted nature of Florentine Renaissance culture is thus revealed: business, politics, humanism, religion and art were constantly interacting and were of equal importance. In unravelling the threads of this intricate story, my aim has been to stick as closely as possible to the sources, both written and visual. The form that best suited my purpose proved to be that of a continuous narrative.

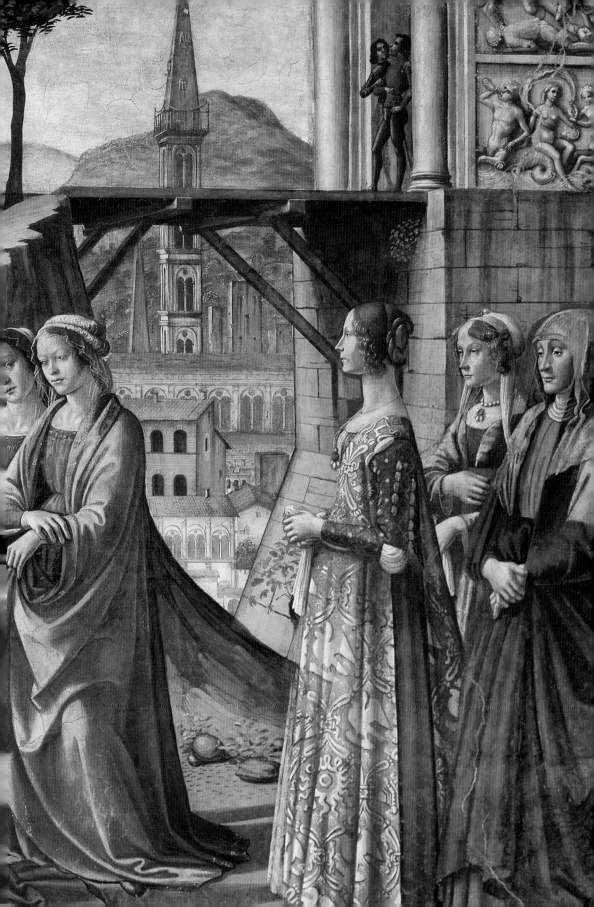

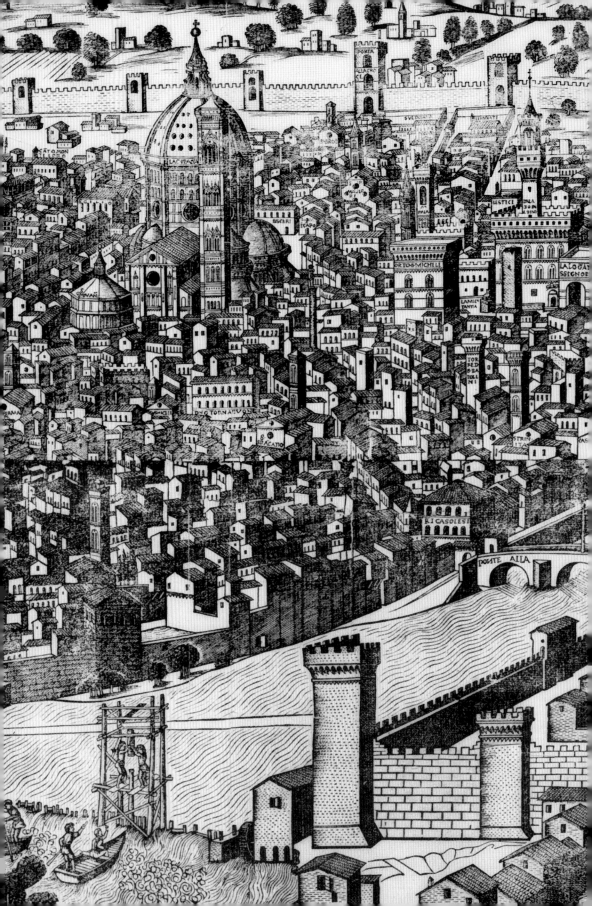

CHAPTER I

Two households

Shakespeare's *Romeo and Juliet*, the most famous love story in Western literature, opens with the words "Two households, both alike in dignity", but this line could equally be applied to the story of Lorenzo Tornabuoni and Giovanna degli Albizzi: both came from distinguished families, and their privileged position allowed them to witness—and play a part in—the glory of the Florentine Renaissance.

Lorenzo's family had long been active in Florentine trade and politics. His ancestors belonged to the powerful Tornaquinci clan, which had settled in the White Lion district of the quarter of Santa Maria Novella. They owned several buildings near Porta San Pancrazio, and the tower surmounting their main residence, next to a loggia at the corner of present-day Via Tornabuoni and Via Strozzi, testified to their status in late medieval Florence. The Tornaquinci owed their wealth and pre-eminence to a long-standing imperial privilege that gave them exclusive building and fishing rights on a section of the north bank of the river Arno. This put them in a position to control commercial and industrial activities in a fast-expanding area just outside the walls—no small advantage in a city that in its heyday numbered at least 90,000 and perhaps as many as 120,000 inhabitants. The growth of the wool trade, which had developed in the area around the monastery of Ognissanti at the instigation of the Friars Minor of the Humiliati order, had caused a sharp increase in both the city's wealth and the Tornaquinci's personal fortune. Large quantities of English wool were imported and processed by the best Florentine craftsmen, but before the wool could be spun into yarn and woven into worsted, it had to be washed in the Arno, which enabled the Tornaquinci to exploit their imperial privilege to the full.[4]

As was the case with other noble families, the Tornaquinci were targeted by legislation barring the *magnati* or *grandi*—the citizens of high economic and social standing—from holding the highest offices, and subsequently availed themselves of the provisions that allowed aristocrats to regain 'popular' status by founding a new family. Various branches thus split off from the main line: the Popoleschi (1364), the Cardinali (1371), the Iacopi (1379), the Giachinotti (1380) and the Marabottini (1386). On 19 November 1393, Simone di Tieri

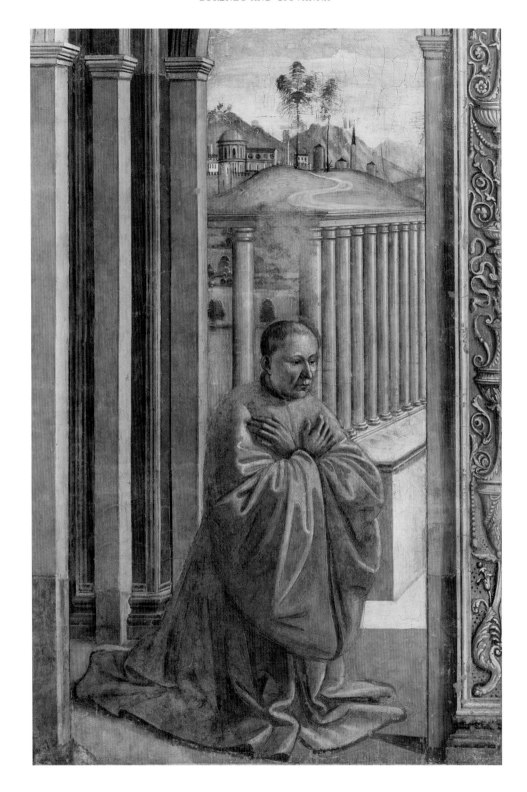

di Ruggero Tornaquinci chose the surname of Tornabuoni. It had the right ring to it, and its advantages were twofold: keeping the first part of the name preserved some of its ancient glory; at the same time, the new name formed a good-luck wish (*buono* is the Italian for 'good'). Simone's decision to change his family name came at a delicate moment. In the fierce political struggle between the Alberti and Albizzi clans, he chose to side with Maso degli Albizzi, who as Gonfalonier of Justice (the highest official in the Republic), was resolutely trying to establish an oligarchy by securing the allegiance of the old aristocratic families. This was the first time the Albizzi and Tornabuoni families crossed paths, and can thus be seen as the beginning of the long prelude to the magnificent marriage of Lorenzo and Giovanna.

The first Tornabuoni did not live to see his family at the height of their glory, for he died a few days after receiving official confirmation of his name change. Simone was buried on 3 December 1393 in Santa Maria Novella, the Dominican church with which the Tornaquinci had been closely connected since its foundation. His aspirations were fulfilled by his children and grandchildren, in particular Francesco, Simone's second son, who in 1427 was reckoned to be one of the four wealthiest citizens of Florence.

Francesco Tornabuoni was a true entrepreneur. His partnership with the wool merchant Francesco di Marco Datini, a native of nearby Prato, took him to the trading centres of northern Europe. From 1399 onwards, Francesco was a regular visitor to London and Bruges, where he supervised the purchase of wool and the shipment of fabric to Florence. In the course of his political career he held no fewer than ten offices and rose to the position of Gonfalonier of Justice. Francesco was married twice, in 1400 to Selvaggia degli Alessandri, who died barely five years later, and in 1411 to Nanna di Niccolò Guicciardini, who bore him eight children. The two youngest offspring, Lucrezia and Giovanni, were destined to bring the Tornabuoni family the most fame.

Born in 1427, Lucrezia married Piero de' Medici—the son of Cosimo the Elder, nicknamed 'the Gouty'—in 1444, and became known as one of the most cultured women of her day. When her husband died at a relatively young age, she was granted special privileges, which allowed her to participate in public life and demonstrate her wide-ranging talents. Her numerous letters reveal her political skill and business acumen, while her religious poems and sacred narratives betray her sensitive nature. She passed her literary talent on to her famous son, Lorenzo de' Medici, known as *il Magnifico*, 'the Magnificent'.[5]

Lucrezia had six brothers: Marabotto, Antonio, Niccolò, Filippo, Alfonso, Leonardo and Giovanni (fig. 4). Giovanni—the father of Lorenzo, on whom this history focuses—was the youngest and by far the most successful of the lot, and soon acquired a reputation as a capable and resolute businessman. In 1443, at the age of fifteen, he entered the employ of the Medici bank. His special responsibilities lay in Rome, where the Medici had set up a large branch linked to the financial business of the papacy. For many years Giovanni kept the ledger of the Rome branch under the supervision of the manager, Roberto Martelli, and the acting manager, Leonardo Vernacci. Communication between Giovanni and Vernacci was difficult, and the two men frequently complained about each other to Piero the Gouty. Vernacci pulled rank whenever he thought it necessary, but Giovanni held a valuable trump card—his family ties to the Medici—which he did not hesitate to produce at crucial times in his career. When, in 1464, Roberto Martelli died and it was time to name his successor, Giovanni made short work of Vernacci. In March 1465 he wrote to his broth-

er-in-law informing him that Vernacci was surreptitiously reading his correspondence, that their characters were incompatible, and that he would rather resign than continue to work under him. Not surprisingly, Vernacci was sent packing and Giovanni rose in the hierarchy. In October he styled himself "manager and partner of the branch of our business at the Roman Court".[6]

As head of the Rome branch of the Medici bank, Giovanni's sphere of responsibility encompassed not only money matters but also politics and culture. In his capacity as Depositary General of the Apostolic Chamber, he repeatedly attempted to influence the difficult relations between the Medici and Sixtus IV, the pope who would later be conspicuously involved in the Pazzi Conspiracy (1478). Giovanni also played an important role in bringing about the marriage of Lorenzo de' Medici and Clarice Orsini, who descended from a prominent Roman family. It had been Giovanni's idea to join the two in wedlock; he not only conducted the negotiations but also witnessed the signing of the preliminary marriage contract in November 1468.

In the meantime Giovanni Tornabuoni himself had married, having taken Francesca Pitti as his wife. Their marriage was intended primarily to heal political wounds: in August 1466, shortly before the wedding, Francesca's father Luca had been caught conspiring against Piero the Gouty. To preserve the political stability of the Florentine Republic, however, both parties pressed for reconciliation. Luca Pitti briefly entertained hopes of marrying his daughter to Piero's son Lorenzo, but when Giovanni was put forward as a candidate, Luca was also satisfied. All the evidence indicates that the two had a solid marriage. On 10 August 1468, Francesca gave birth to their first child, Lorenzo, the protagonist of this book. He was named after his older cousin, Lorenzo de' Medici, to confirm the uncommonly strong ties between the Tornabuoni and the Medici, that most powerful of all Florentine families. A second child, a girl named Ludovica, was born in 1476. She was presumably named after Louis (Ludovico) IX of France (1214–70), the patron saint of the French royal family, whom the Tornabuoni held in high esteem. Lorenzo also had an illegitimate half-brother named Antonio, who had probably been born in Rome before Giovanni's marriage to Francesca Pitti.[7]

Giovanni and his family spent at least as much time in Rome as they did in Florence. In Rome they lived in the Ponte district, named after Ponte Sant'Angelo, the bridge leading from the city centre to Castel Sant'Angelo. It was the neighbourhood where the Rome branch of the Medici bank was located and where most of the Florentines lived. Lesser-known bankers and merchants of Florentine descent were also active in the city, though mostly on a much smaller scale. The Tornabuoni's exact address is not known, but they certainly moved house at least once, for in July 1472 Francesca wrote to Clarice Orsini to tell her that they had just moved and she now had "a beautiful and very pleasant room". There can be little doubt that the Tornabuoni were much more a part of the community than the Florentines who lived in Rome for only a short time. Giovanni maintained ties at every possible level in and outside the Roman Curia. In 1478 he joined the Confraternity of Santo Spirito in Sassia, which answered directly to Sixtus IV and had its seat a short distance from St Peter's in the hospital of the same name, rebuilt by the pope after a fire had destroyed it a few years earlier. Giovanni's membership in this confraternity, which promoted special works of devotion and charity, assured him of indulgences and led to the expansion of what was already a wide-ranging network of social and business relations.[8]

Giovanni Tornabuoni was involved in nearly all the great cultural developments taking place in Rome and Florence. In Rome, he shared in the excitement felt by humanists and artists when new ruins and manuscripts were discovered. He surrounded himself with scholars of considerable stature, including Matteo Palmieri and Francesco Gaddi. The latter, a keen bibliophile and manuscript collector, was the original owner of Giuliano da Sangallo's famous architectural sketchbook, later known as the Barberini Codex. A pioneer in the study of classical architecture, Sangallo was one of the first to use a straight edge, compass and quadrant to take precise measurements and analyze the proportions of classical architecture. Giovanni himself also tracked down manuscripts on occasion and managed to acquire several books from the Byzantine humanist John Argyropoulos—probably Latin translations of the works of Aristotle—for Lorenzo de' Medici. He must also have played a significant role in securing highly sought-after ornamental gems and classical sculpture for the prestigious collection that Lorenzo had started to amass as early as 1471, when the young Medici was part of the Florentine delegation that travelled to Rome for the coronation of Pope Sixtus IV.[9]

Since 1469, the year of Piero de' Medici's death, his son Lorenzo had been destined to become the most powerful man in Florence. The twenty-year-old banker's son obviously had leadership potential and soon lived up to expectations. Lorenzo's political acumen could vie with that of his grandfather Cosimo, and this made him an authoritative party in discussions with other Italian rulers. Even more remarkable was the skill with which he manoeuvred within the Florentine government, gradually bending it to his will by installing electoral commissions and magistracies composed almost entirely of his supporters. This meant that, behind the façade of republican governmental bodies, the political scene was dominated by a strong de facto ruler. Lorenzo de' Medici distinguished himself not only as a firm and capable leader, but also as an enthusiastic patron of the arts and sciences, which made him one of the key figures of the Florentine Renaissance.[10]

Lorenzo's lofty epithet—the Magnificent—was due to more than just his penchant for pomp and splendour. In fact, *magnifico* was an epithet reserved for a small group of high-ranking patricians, among whom were Giovanni Tornabuoni and his son. By contrast, the fact that such illustrious patrons of the arts as Francesco Sassetti and Filippo Strozzi could not claim this title testifies to the exceptionally high regard in which the Tornabuoni were held and the aristocratic image they sought to project.[11]

Giovanni's interest in ancient Rome helped to shape the first large-scale project he envisioned for his native city: the construction of a majestic palace. The plan took shape during the 1460s and 1470s, after Giovanni had purchased from various relatives and members of his clan several properties adjacent to his own. These buildings were then transformed into a *palatium* with a splendid inner courtyard. The construction of this palace was the first concrete proof of Giovanni's ambition to become a patron of the arts and to enhance his reputation and that of his family in perpetuity through honourable expenditure.

In early 1477 Giovanni's beloved wife became pregnant for the third time. The pregnancy ended tragically on 23 September, when Francesca and her baby both died in childbed. This was a fate shared by many women: limited knowledge of obstetrics meant a high mortality rate during childbirth, even in the most prosperous homes. Giovanni, who was extremely upset by his wife's death, revealed the depths of his grief in a letter he sent to his nephew Lorenzo de' Medici:

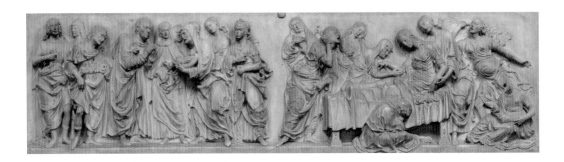

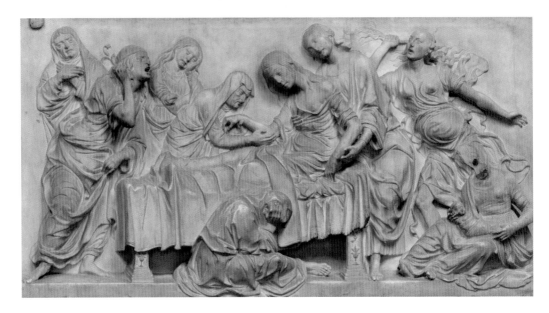

1. [p. 4] Domenico Ghirlandaio and assistants, *Expulsion of Joachim from the Temple*, detail (→ 74).

2. [p. 7] Domenico Ghirlandaio and assistants, *Visitation*, detail (→ 63).

3. [p. 8] Lucantonio degli Uberti (attributed), after an engraving by Francesco Rosselli,
View of Florence (*Pianta della Catena*), detail.
Berlin, Staatliche Museen, Kupferstichkabinett.

4. [p. 10] Domenico Ghirlandaio and assistants, *Portrait of Giovanni Tornabuoni*.
Florence, Santa Maria Novella, main chapel.

5–6. Workshop of Andrea del Verrocchio, *The Death of Francesca Pitti*: the relief and a detail.
Florence, Bargello.

7. Sixteenth-century artist, *Tomb of Francesca Pitti*.
Berlin, Staatliche Museen, Kupferstichkabinett.

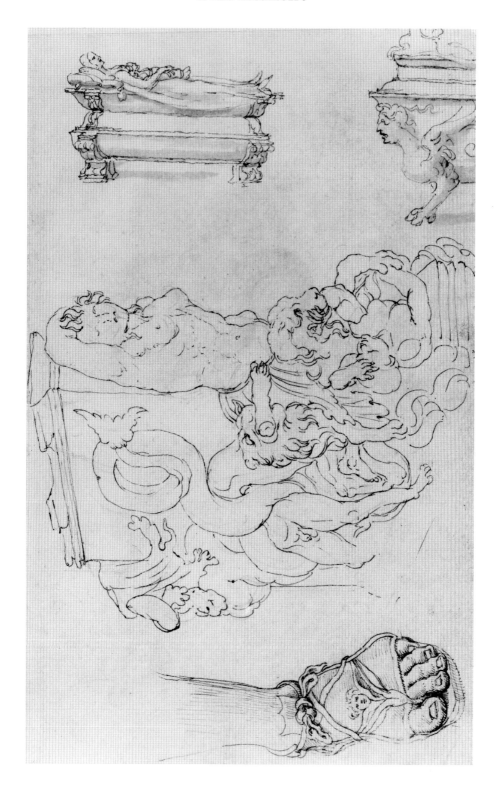

Dearest Lorenzo, I am so downcast by pain and grief, owing to the most bitter and unexpected accident that has befallen my beloved wife, that I scarcely know where I am. As you no doubt heard yesterday, it was God's will to take her from this life, at the twenty-second hour, in childbed, and, having cut her open, we took the child from her body—dead, to my double grief. I am absolutely certain that, with your usual mercy, you commiserate with me wholeheartedly and forgive me for not writing at length …[12]

Here the perils of childbirth first found poignant expression in a work of art. A sculptured relief from the workshop of Andrea del Verrocchio, the teacher of Leonardo da Vinci, portrays the drama of the moment (figs. 5–6). The right-hand side of the marble relief shows Francesca in her childbed, surrounded by eight women, one of whom holds the stillborn infant. Francesca—her breast half-bared, her eyes closed, her left arm hanging limply at her side—has just breathed her last. Two women support her, to prevent her lifeless body from collapsing. A cruel stroke of fate has turned the childbed into a deathbed. Francesca's demise is greeted with dismay. The compassion of the onlookers is expressed in a remarkable variety of grieving poses: one cries out in loud lament, another weeps softly. The figure in the foreground—the very picture of despair—has closed herself off from the world and sits hunched up beneath her heavy cloak. In the right-hand corner we see the dead baby. If it had lived, the wet nurse would have bared her breast, as is customary in this type of depiction. In the scene on the left-hand side of the relief, three servants convey the lifeless infant to Giovanni under the watchful eye of a physician. Upon seeing the child and hearing the bad tidings, Giovanni wrings his hands in despair, his features distorted by helplessness and grief. The sculptor portrayed this range of emotions admirably, his use of classical formulas lending the work a suitably noble and dignified tone.[13]

It is almost certain that this relief, now at the Bargello in Florence, was originally part of the funerary monument built in Santa Maria Sopra Minerva, the Dominican church of the Florentine community in Rome. Giovanni Tornabuoni had his own chapel or altar—off the aisle to the right of the nave—where his wife was buried with great ceremony in a monumental tomb that unfortunately no longer exists. The exact details of the tomb are largely a mystery, though a rough pen-and-ink sketch formerly attributed to the sixteenth-century Dutch painter Maarten van Heemskerck shows the sarcophagus with the likeness of Francesca (fig. 7). The tomb is remarkable, for resting on Francesca's breast is the stillborn child, which she lovingly protects. The child's salvation is therefore tied to that of its mother.[14]

At the time of his mother's death, Lorenzo was just nine years old and his sister not yet two. After his wife died, Giovanni personally cared for his children. He saw no reason to remarry, for in Florence, at least, he could ask the advice of his sister Lucrezia. Giovanni also made sure that Lorenzo in particular was given an excellent education. The son of a banker, he naturally received tuition in arithmetic from an early age. Money matters were part of everyday life. One of the rooms in the Palazzo Tornabuoni even contained a walnut table specially designed for counting money. Lorenzo gained a deeper understanding of the subject by studying mathematical treatises. A handwritten tract on arithmetic dedicated to him and now in Florence's Biblioteca Nazionale (fig. 8) celebrates the excellence of the "magnificent Lorenzo" and emphasizes the practical value of arithmetic, which, "in so far as it relates to commerce, surpasses all other disciplines in usefulness".

8. *Compendio di arithmetica*, opening folio:
Giovanni di Bernardo Banchegli's dedication to Lorenzo Tornabuoni.
Florence, Biblioteca Nazionale Centrale.

Lorenzo's education, moreover, complied in all respects with the humanist ideal. Since every cultivated Florentine was a potential rhetorician, and rhetoric was an indispensable weapon in the political struggle, much value was placed on the study of languages. Renaissance scholars went a step further: the study of the humanities was the only true path to intellectual, moral and social improvement. Indeed, it was customary in the higher circles to place a young man in the care of a grammarian. Lorenzo's first teacher was probably Martino della Commedia, no doubt a less inspiring figure than the tutor he later shared with Piero di Lorenzo de' Medici, the famous poet and classical scholar Politian (Angelo Poliziano), a true man of letters, whose liberal views did not always find favour with the more conservative members of the ruling elite.[15]

Politian opened up the world of ancient Greek literature to Lorenzo Tornabuoni. After the Council of Florence in 1439, which had been called to restore union between Eastern Christendom and the Church of Rome, the study of Greek had become de rigueur among the Florentine cultural elite. A few Byzantine scholars, who had followed Emperor John VIII Palaeologus to Italy, settled down for a longer stay in the city or visited frequently. Lorenzo de' Medici and the literati in his circle were particularly overcome by the Greek spirit and became intoxicated by the writings of Plato and the Neoplatonists and by Greek epic poetry. It is therefore only natural that at a young age Lorenzo Tornabuoni asked his cousin to lend him Greek manuscripts. Among those he borrowed in 1482 were two luxurious codices of the *Iliad* and the *Odyssey*. This reading matter was not wasted on the boy, whose knowledge of Greek was so remarkable that in 1485 Politian dedicated to him a didactic poem titled *Ambra*, which contained a eulogy of Homer and an idyllic celebration of the Medici estate in Poggio a Caiano. Just how thoroughly Lorenzo devoured Greek epic literature is also apparent from a number of commissions for works of art.[16]

Lorenzo Tornabuoni was immortalized at the age of fourteen by the celebrated Florentine painter Domenico Ghirlandaio, who portrayed him in the midst of contemporaries in *The Calling of Peter and Andrew*, a monumental fresco in the Sistine Chapel (fig. 9). Elegantly attired in the latest fashion, Lorenzo appears in a relaxed but self-assured pose, looking confidently at the viewer, his right hand nonchalantly hooked over his belt and his left arm akimbo. He is, in fact, portrayed here as the young man—more of a courtier than the average son of a Florentine patrician—with whom we shall soon become acquainted. Standing diagonally behind Lorenzo is his father Giovanni, in profile, clearly recognizable by the striking resemblance he bears to his donor portrait in Santa Maria Novella in Florence (fig. 4).

The people surrounding Giovanni and Lorenzo Tornabuoni presumably belonged to the Florentine community in Rome. Although the commission was intended primarily to underline the power of Pope Sixtus IV, this fresco bears the stamp of Florence. Indeed, the frescoes on the long walls of the Sistine Chapel are sometimes thought to have been a diplomatic gesture on the part of Lorenzo de' Medici towards the pope. The painting campaign was carried out in 1481–2, when passions had cooled somewhat after the bloody events of the Pazzi Conspiracy. With the exception of Perugino and Luca Signorelli, all the painters invited to take part—Cosimo Rosselli, Domenico Ghirlandaio, Sandro Botticelli, Bartolomeo della Gatta and Biagio d'Antonio—belonged to the Florentine school, which stole the show at the papal court. It is quite possible that Giovanni Tornabuoni was involved in the commission, since he was a key figure in Florentine-Roman diplomacy.[17]

Not only was Lorenzo Tornabuoni tutored at home, but from the age of sixteen or seventeen he was enrolled at the University of Florence, the Studio Fiorentino, where he expanded his knowledge of the classics and made contacts that would stand him in good stead in his later career. He also attended lectures in Pisa, where he met learned men such as Bernardo Accolti, who would later write a poem about Lorenzo's lot in life.[18]

By degrees Lorenzo was initiated into the world of business. He took his first important steps in banking and commerce in 1490 under his father's supervision. In Florence, a young man was under paternal authority until his twenty-fourth birthday, and sometimes even longer. This led to tension in some families. The fourteenth-century poet and storyteller Franco Sacchetti indiscreetly remarked in one of his novellas that five out of six sons were so eager to be financially independent that they longed for the premature death of their fathers. There were always ambitious young men who felt thwarted by the conservative Florentine system. Within the formidably rich Tornabuoni family, however, there seems to have been no such conflict between father and son. Both benefited by preserving the vast fortune that the family had amassed over the course of many decades. The paterfamilias, with all his experience and social clout, was the obvious person to administer the property for as long as possible. Archival documents reveal that Lorenzo's *emancipazione* took place in 1496, but even though he had officially come of age, it was still too early for him to embark on a political career, for the law forbade Florentines from holding office before the age of thirty. Exceptions were extremely rare (and were granted to a few Medici).[19]

The relationship between father and son was determined to a large degree by Francesca's early death and Giovanni's decision not to remarry, which meant that he and Lorenzo relied heavily on one another. It is hardly surprising that Lorenzo, while still young, made funds available for masses to be said in memory of his late mother, thereby continuing a custom begun by his father. That Giovanni placed great trust in his son is also apparent from a close reading of the will he made in 1490, in which Lorenzo is named as the person responsible for finishing the decoration of the family chapel in Santa Maria Novella. In other areas, too, Giovanni and Lorenzo were of like mind: family pride was of great importance, and they both sought to distinguish themselves by flaunting their wealth and exquisite taste. Even so, their characters were not similar in all respects. Until his death, Giovanni continued to be a shrewd businessman, who always put the management of money and property first. In banking and financial matters, he was conscientious to the point of obsession, which is why, for decades, the Medici could depend on him utterly. Yet colleagues such as Tommaso Portinari sensed in Giovanni insufficient flexibility, and today he is sometimes looked upon as a man without vision. In 1481, for instance, he agreed to allow the pope to pay off part of his debt to the Medici bank in the form of large stocks of alum, but because the alum trade was controlled completely by the Genoese, it proved very difficult to sell.

Giovanni was so wrapped up in the bank's business that he had little opportunity to distinguish himself in politics, and for many years followed the political debate in Florence only from a distance. It was not until the early 1480s that he was chosen, on the basis of his respectable position in society, to serve as Gonfalonier of Justice of the Florentine Republic. Medici supporters no doubt saw him as a Nestor—a wise and clever man willing to serve the general interests of the oligarchy. Considering his solid record of service, Giovanni had neither the need nor the inclination to seek the limelight.

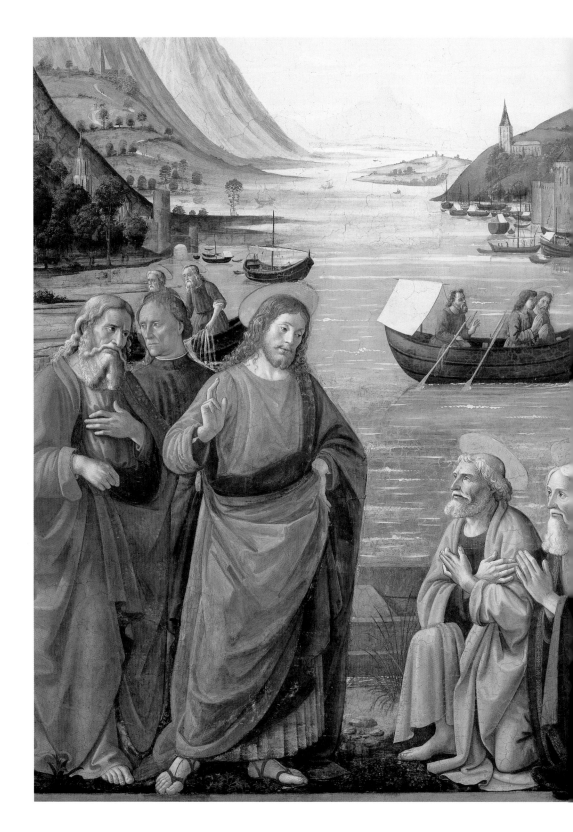

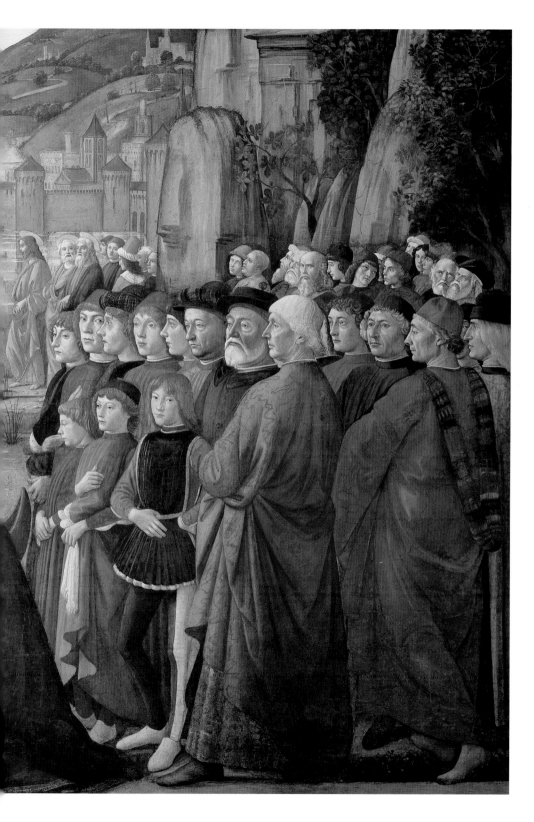

By contrast, Lorenzo is portrayed in the sources as a striking figure, a "noble and gracious youth more beloved by all the people than anyone his age". More extravagant and glamorous than his father, he also had a greater need to accomplish extraordinary deeds and was more likely to take risks in the pursuit of his ambitions.[20]

In 1486 an event took place that gave Giovanni great satisfaction and put his family in the public eye, namely the marriage of his beloved son. The alliance of one of the most promising young Florentine aristocrats and the daughter of Maso degli Albizzi was of great consequence for many reasons, one of which was the continuation of the male line. More importantly, however, the marriage had profound political significance.

In the early fifteenth century, the Albizzi were the only family whose power and influence rivalled that of the Medici. For decades the Albizzi had occupied key positions in government and played a decisive role in establishing the oligarchy. Maso (1343–1417) in particular had shown himself to be a clever and occasionally ruthless politician, who kept the lower classes out of power and adroitly disarmed his political opponents. In the late 1420s and early 1430s, Maso's son Rinaldo became one of the great rivals of Cosimo the Elder, then the manager of the fast-growing Medici bank. The scion of an ancient family, Rinaldo had an initial advantage over the newcomer Cosimo, a 'mere' banker; Rinaldo, after all, could boast a knightly title. But in the long run the rise of the Medici—supported in part by the populace—proved unstoppable, and in 1433 Rinaldo could think of no alternative but to stalemate his political opponent on false pretences. Accused of conspiring to oust the incumbent government, Cosimo was imprisoned and sentenced to death; however, he managed to have the sentence commuted to exile and left the city for the Veneto. Rinaldo, who had greatly underestimated the popularity of the Medici, lost the ensuing power struggle. Cosimo returned to Florence in 1434, whereupon Rinaldo was arrested and forced into exile. When he enlisted the help of the Visconti family—rulers of Milan and arch-rivals of the Florentine Republic—Rinaldo sealed his own fate: his property was confiscated and he was condemned to death as a rebel.[21]

The life of his younger brother Luca di Maso degli Albizzi—the grandfather of Lorenzo Tornabuoni's bride—took a very different course. Long before 1434, Luca had distanced himself from Rinaldo and sided with Cosimo de' Medici. It has been suggested that Luca was no more than an opportunist, a deft dissembler who had turned against his brother to further his own career. Yet it is difficult to deny that relations between Luca and Rinaldo had been strained for years. As far as we know, from 1426 to 1433 they exchanged letters only once. After allying himself with the Medici, Luca became less involved in domestic politics and immersed himself in foreign affairs. It was as a diplomat, travelling throughout Europe, that he rendered his greatest services to the Republic. From 1429 he distinguished himself as Captain of the Florentine Galleys, in which capacity he called at many ports in Spain and Portugal, also visiting southern England and Flanders. Luca married twice. His first wife, whom he married in 1410, was Lisabetta di Niccolò de' Bardi. Lisabetta died in 1425, and the following year Luca married Aurelia di Nicola di Vieri de' Medici, who belonged to a collateral branch of the Medici family. Even before Luca assumed the post of Captain of the Florentine Galleys, two children had been born to the couple. It is the firstborn, Maso di Luca degli Albizzi (1427–91), who deserves our special attention, for it was his second wife who gave birth to Lorenzo's bride, Giovanna.[22]

We are exceptionally well informed about the life of Giovanna's father. The private archives of a noble Florentine family contain documents drawn up by Maso himself: a diary and two detailed account books, which together comprise many hundreds of pages. These previously unstudied documents are a gold mine of information. The account books shed light on the mentality of a Florentine patrician who kept systematic and extremely detailed records of all income and expenditure connected with his numerous properties. The so-called *Libri debitori e creditori* ('Books of Debtors and Creditors') illuminate the material side of life from every angle, providing insight into such things as the intense traffic—in both money and goods—occasioned by marriages. The *Ricordi* ('Memoirs'), by contrast, constitute a valuable piece of life writing, in which events great and small were carefully recorded. Here Maso recounts in more personal terms the first years of his life as an adult. He regularly discusses family relations, especially when prompted to do so by marriage or death, thus giving us a glimpse of his private life.[23]

In 1451 Maso married Albiera di Orlando de' Medici, a member of a lesser-known but nonetheless influential branch of the Medici family. The high point of their marriage was the birth of a son, Luca, on the morning of Tuesday, 16 April 1454. It was inevitable that the first male heir would be named after Maso's father. As was customary, the child was baptized in the Baptistery on the square in front of the Cathedral. When Albiera was delivered of another child the following year, on 1 May 1455, her condition was critical. Seriously weakened and forced to keep to her bed, she died twenty-five days later—another striking example of the travails of childbirth. Maso reveals more of the circumstances than most diarists. The day Albiera died, a wake was held which was attended by the friars of Santa Croce, about twenty-five priests and a goodly number of citizens. Three days later the funeral was celebrated with great ceremony, and the next day masses were said in the church of San Pier Maggiore. Piero, the newborn child, remained sickly. "God saw fit to take him from us on 1 March 1455 [Florentine style, i.e. 1456]", Maso wrote in his diary: "He lived for exactly ten months, which he spent in poor health". Maso's first son, Luca, was destined to live longer. His name occurs repeatedly in Maso's tax statements. For decades Luca lived under his father's roof, the palace in Borgo degli Albizzi, just outside the old city gate and a stone's throw from the Piazza di San Pier Maggiore. A predella panel by Domenico Veneziano (fig. 10) gives an impression of the original architecture in this area: the subject of the work is *A Miracle of St Zenobius*, which according to legend took place in Borgo degli Albizzi.[24]

In the context of this story, Maso di Luca's second marriage is of more importance, and his diary reports in detail how this union came about:

> I record that today, 11 October 1455, in the name of God, as the widower of my wife, Albiera, at the request and according to the wishes of Cosimo de' Medici, and upon the advice of my first father-in-law Orlando de' Medici, Luca Pitti, and other blood relations and friends, in the house of the above-mentioned Cosimo I have agreed to take Caterina, daughter of Tommaso di Lorenzo Soderini, as my wife …

Thus, before remarrying, Maso asked the father of his late wife and a select company of dignitaries for their advice. All of them thought Caterina, the young daughter of Tommaso di Lorenzo Soderini and Dianora Tornabuoni (Giovanni and Lucrezia's sister), a suitable spouse for Maso. The marriage contract was signed in Cosimo de' Medici's magnifi-

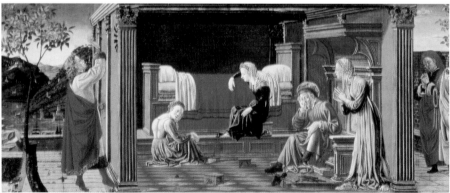

9. [pp. 20–1] Domenico Ghirlandaio, *The Calling of Peter and Andrew*.
Vatican City, Vatican Museums, Sistine Chapel, north wall.

10. Domenico Veneziano, *A Miracle of St Zenobius*.
Cambridge, Fitzwilliam Museum.

11. Giovanni di Francesco, *St Nicholas Provides Dowries for Three Impoverished Maidens*.
Florence, Casa Buonarroti.

cent palace. Luca Pitti, whose name is linked with an equally impressive and famous *palaz-zo*, was among those present. Just over three months later, when all the preparations had been made, Caterina Soderini was led to her husband's house "with no ostentation whatsoever", out of respect for Albiera.[25]

No fewer than twelve daughters were born in succession to Maso and Caterina—the chance of this happening is approximately one in four thousand. Of these twelve girls, three died in infancy.[26]

It was no small feat for Maso to find suitable husbands for all his growing daughters. To marry well, the girls would need adequate dowries, and Maso would need help from his friends and relations. He had considerable personal wealth, however, and had invested wisely. A panel attributed to the Florentine painter Giovanni di Francesco illustrates that 'time is of the essence' in finding partners for one's daughters and putting aside money for their marriages. This depiction of an episode from the life of St Nicholas of Bari shows the saint rushing to the aid of an impoverished nobleman (fig. 11). Lacking the money for dowries, the poor man and his three charming daughters have given up hope. The atmosphere is one of gloom and despair, for bankruptcy looms, and the maidens have no choice but to become prostitutes. Thanks to St Nicholas, however, the girls are spared this dreadful fate. The saint comes to their rescue by throwing three purses of gold through the window.[27]

Giovanna's father was fortunate in having sufficient funds to provide his daughters with dowries. Untroubled by financial worries, Maso and Caterina were primarily concerned with the physical and spiritual well-being of their offspring. Their views on this subject are apparent from a work of art commissioned during the first years of their marriage. It was customary for Florentine couples to have special household items made to mark the birth of a child. Maso and Caterina adhered to this tradition and commissioned a so-called *desco da parto*, a wooden tray used in the childbirth ritual. The octagonal panel is decorated on both sides with scenes depicting two important aspects of human existence. One side displays a naked putto merrily playing the bagpipes; radiating high spirits, he alludes to fertility—a highly appropriate theme in this context (fig. 12). The other side, by contrast, portrays the Last Judgement (fig. 13). Christ and Mary, surrounded by angels and saints, are enthroned in heaven. Down on earth, the sinners are separated from God's elect, and the damned are pushed into the jaws of Hell.[28]

Florentine baptisms took place in the Baptistery of San Giovanni where, looking up into the massive dome, the assembled citizens would see the glitter of medieval mosaics representing scenes from the Last Judgement and be reminded that life is fragile and birth is necessarily mirrored by death. However, the image of Christ sitting in judgement was not displayed in churches and private homes to instil fear alone: Christ's coming at the end of time indicates the fulfilment of His doctrine of salvation. On the *desco da parto* painted for Maso and Caterina, the angels carry the instruments of the Passion, the symbols of redemption. Moreover, in the midst of the heavenly host, Mary and John the Baptist figure prominently as loving intercessors. The contrast between the putto's *joie de vivre* and the *memento mori* of the Last Judgement reflects the mixed feelings of joy and apprehension attendant upon delivery and birth. Ten of Maso and Caterina's twelve daughters were born in Florence and baptized in San Giovanni. Only Albiera, the eldest daughter, and possibly Bartolomea I were born on the family's country estate in Nipozzano. In 1457 a plague epidemic had forced the family to flee the city, and Albiera was therefore baptized privately, "at the

fonts of Ghiacceto". The baptism was witnessed by the local priest of the church of San Niccolò and a number of godparents, including one of Maso's tenant farmers.[29]

Albiera's beauty was praised by several worthy poets, all of whom moved in the circle of Lorenzo the Magnificent. Albiera was engaged to Sigismondo della Stufa, a faithful follower of the Medici, and was on the point of marrying him when she fell ill and died. This tragedy occasioned the writing of a number of tributes to her memory, which were collected in a volume. The young Politian contributed the most impressive poem, a long elegy in Latin titled *Epicedion in Albieram*; others were composed by the philosopher Marsilio Ficino, the chancellor Bartolomeo Scala, and such humanists as Ugolino Verino, Bartolomeo della Fonte, Naldo Naldi, Alessandro Braccesi and the Byzantine Andronicus Callistus.

Giovanna, the protagonist of this story, had much in common with Albiera. Born on 18 December 1468, she was the eighth daughter of Maso and Caterina. The baptismal registers of the Cathedral record the time of her birth as "sixteen hours"; her baptism took place the following day. As Giovanna grew older, her beauty became increasingly apparent. Comparison with Albiera, who had died in 1473, was inevitable.[30]

Politian's elegy on the death of Albiera contains a beautiful passage, in which he praises the charms of Maso's eldest daughter:

> How often she untied her profuse hair and let it hang freely,
> She then resembled Diana, the terror of fearful beasts.
> Or when again she gathered it into a golden knot,
> She was like Venus adorning herself with her comb.[31]

This literary ode is comparable to the image on the reverse of one of Giovanna's portrait medals, for although Albiera was often lauded by poets, Giovanna was immortalized with equal frequency in the visual arts. Giovanna's bronze medal displays Venus in the guise of Diana (figs. 14–5). The accompanying verse was borrowed from Virgil: "virginis os habitumque gerens, et virginis arma", 'a maiden's face and mien, and a maiden's arms' (*Aen.* I. 315). In accordance with the text of the *Aeneid*, two goddesses have become one: Venus, goddess of love, and Diana, goddess of the hunt and emblem of chastity. Both ideals of beauty were united in Giovanna, as they had been in Albiera. Furthermore, the dynamism of the depiction evokes the atmosphere of Virgil's poetry: "For from her shoulders in huntress fashion she had slung the ready bow and had given her hair to the winds to scatter; her knee bare, and her flowing robes gathered in a knot" (*Aen.* I. 318–20). A world of literary associations thus lies beneath the image on Giovanna's portrait medal.[32]

Albiera and Giovanna had a similar upbringing. In their early years they were placed in the care of Annalena Malatesta, the founder of a convent situated in the Oltrarno district, on the south bank of the river. Annalena had been married for years to one of the most formidable army commanders of the time, Baldaccio di Anghiari. He served many lords and masters, including the Florentine Republic, but in 1441 a dispute with the Gonfalonier of Justice Bartolomeo Orlandini, whom he accused of cowardice, cost him his life. The chroniclers report that Baldaccio was first thrown out of a window of the Palazzo della Signoria and then beheaded in the most gruesome manner. When Annalena's son Galeotto died a short while later, she decided to sell all the property she had inherited and use the money to found a convent. Many girls of standing ended up there, for convents were becoming in-

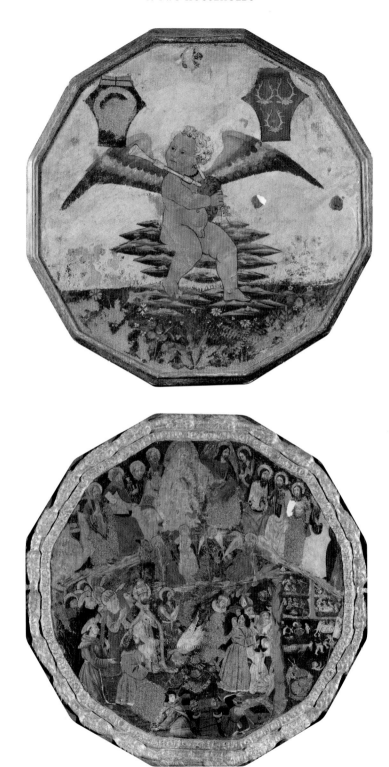

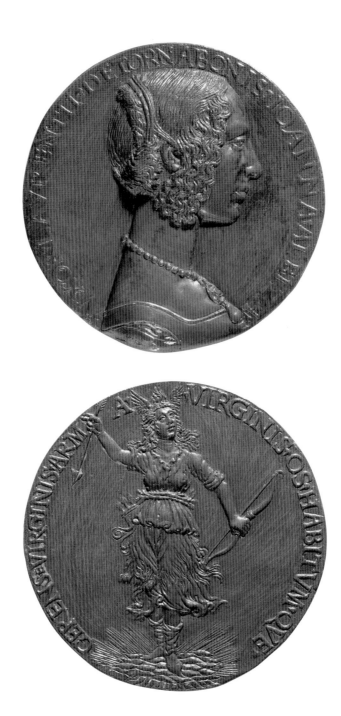

12–3. [p. 27] Florentine school, *desco da parto*:
Last Judgement (obverse); *Putto Playing the Bagpipes* (reverse).
Florence, Museo Horne.

14–5. Niccolò Fiorentino (attributed), portrait medal of Giovanna degli Albizzi:
Portrait of Giovanna degli Albizzi (obverse); *Venus with Bow and Arrows* (reverse).
Florence, Bargello.

creasingly popular as educational institutions for the daughters of the urban patriciate. A municipal ordinance of 1456 shows just how fashionable Annalena's convent had become. The ordinance prohibited innkeepers and publicans from setting up business in the vicinity of the convent, since the women within its walls needed peace and quiet in order to acquire intellectual skills, good manners and a pious demeanour. Ruffians and brutes were meant to keep their distance from maidens of good birth. During the period of her tutelage, Albiera formed strong ties to Annalena. When Albiera died and her fiancé, Sigismondo della Stufa, was overwhelmed with poetic condolences, he did a touching thing: he had the poems bound and presented the volume to Annalena. In the dedication he expressed the hope that she would take lasting comfort, as did he, from these exceptional verses.

Unfortunately, no such information is available with regard to Giovanna's schooling. Nor is it certain that Annalena's convent was as popular as an educational institution in the 1470s as it had been in previous decades. Even so, there is good reason to assume that Giovanna followed in the footsteps of her elder sister, since Annalena is named as one of the women who helped to make the items in Giovanna's trousseau.[33]

The fact that Maso degli Albizzi's marriage to Caterina Soderini produced only daughters did not stop him from ensuring that all of his offspring learned to read. Before they left the parental home, he gave each of his daughters a book of hours for their private devotions. It was customary for women of standing to own such a prayer book, which lent religious structure to daily life in the family circle. After all, a young mother was expected to be an anchor of peace and stability within the family. Maso shared an interest in literature—particularly the classics—with many educated Florentine patricians. His library contained a volume of Terence, Cicero's *De officiis*, Silius Italicus' *Punica* and a biography of Alexander the Great. Before the advent of printing, handwritten texts were regularly lent out and exchanged: for example, Maso once lent Annalena Malatesta a book "on the nature of animals". Maso's notes also contain evidence of his interest in the visual arts. An inventory drawn up on 22 November 1455 lists "a panel of Our Lady with the Christ Child in her arms, by the hand of Fra Filippo Lippi", the teacher of Botticelli.[34]

Maso was a typical exponent of his generation inasmuch as he combined business with politics. His social network was extensive. One of the people encountered early on in Maso's account books is Giovanni Tornabuoni. Even more interesting is the mention in the official documents of the Florentine Republic of a diplomatic mission to Rome undertaken at the end of 1480 by twelve prominent Florentines. Among them were such faithful followers of Lorenzo de' Medici as Luigi Guicciardini, Bongianni Gianfigliazzi, Guido Antonio Vespucci, Giovanni Tornabuoni and Maso degli Albizzi. Presumably such missions provided opportunities for them to lay the foundations for future marriages.[35]

It is altogether too romantic to imagine that the marriage of Lorenzo Tornabuoni and Giovanna degli Albizzi was the result of a meeting between two young people, both struck by Cupid's arrows. Love was not sufficient reason to marry. For the families involved, the socio-economic and political consequences of a marriage alliance were too great to allow the choice of partner to depend on personal feelings. Moreover, young people had few opportunities to meet in public. Nevertheless, there are indications that from the very beginning the bond between Lorenzo and Giovanna was a special one, and that the overriding importance of an alliance based on wealth and status did not prevent them from becoming an exceptionally close-knit couple.

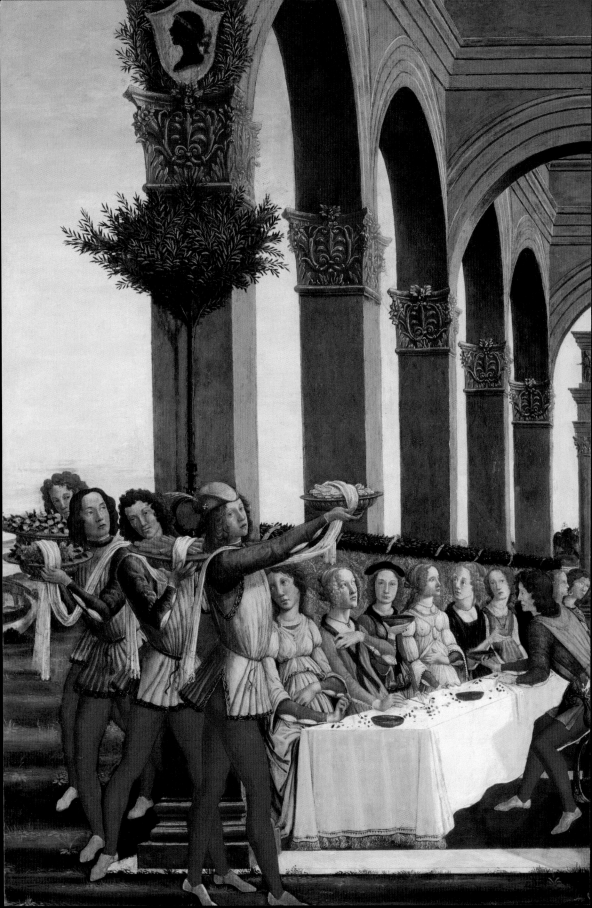

CHAPTER 2

The wedding

In Renaissance Florence, marriage was a public occasion marked by pomp and ritual, the culmination of a lengthy process involving numerous dealings and ceremonies, both legal and symbolic. First, the heads of the families entered into complex and sometimes protracted negotiations, eventually arriving at an agreement that was confirmed by a handshake. A notary then drew up a formal document—a precautionary measure that prevented either party from breaking the contract easily. Occasionally this was followed by a meeting, preferably in a public place, at which the bridegroom and the father of the bride formally approved the provisions of the marriage contract. After this ceremony, the groom sent his servants and attendants to the house of his bride, to present her with a box containing such objects as jewels and valuable textiles. Several months later the actual wedding took place: in the presence of a small group of witnesses, chosen from their respective circles of friends and relatives, the bride and groom were questioned by a notary, and solemn pledges were exchanged. The bride had necessarily become involved in the proceedings by this point, for just as in ancient Rome, a marriage could not be solemnized without the consent of the woman. The bride and groom exchanged rings—then, as now, a symbol of mutual affection—thus sealing the union. At last, after a few days or perhaps weeks, the union was made public when the bride was conducted to her husband's house. Among the well-to-do, this was the occasion for a festive procession through the centre of the city.[36]

The pre-nuptial negotiations were generally recorded in notarial documents, but no such records concerning Lorenzo and Giovanna have been found. There are, however, other contemporary sources that provide valuable information about the circumstances of their marriage. The previously mentioned account books of Maso degli Albizzi offer insight into the financial obligations he undertook as the father of the bride. The cost of Giovanna's marriage is documented down to the last detail, and it is these thorough financial records that paint such a vivid picture of the extensive wedding preparations. Of a completely different nature is our second source: the *Nuptiale carmen ad Laurentium Torna-bonium Iohannis filium iuvenem primarium* by Naldo Naldi, a humanist who taught at the

Florentine Studio. Naldo Naldi recounts the event in all its grandeur, describing its splendour and glory in elegant elegiac distichs. The poem was written in beautiful humanistic script on parchment—336 lines of verse spread over ten folios—for the purpose of presenting it to the married couple. Specialists recognize the calligraphy as the work of Alessandro da Verrazzano, a scribe whose noble birth put him on friendly terms with humanists and influential collectors. In this case, an anonymous miniaturist added sparse but fine illumination. The family arms of Lorenzo and Giovanna are displayed in all their colourfulness on the first page of the work (fig. 17).[37]

Florentine nuptial poems are rare. Naldi was one of the few humanists from Florence who regularly wrote epithalamia—songs or poems in praise of a bride and bridegroom. In 1487 he composed a poem, known to us through a printed edition of which only a handful of copies have survived, to mark the wedding in Bologna of Annibale Bentivoglio and Lucrezia d'Este, and in 1503 he wrote another nuptial poem, this time commissioned by Lorenzo di Filippo Strozzi, one of the Tornabuoni's neighbours; again the result was a luxury manuscript for private use. Significantly, two of the wealthiest families in Florence had turned to Naldi to give their marriages additional distinction.[38]

In the *Nuptiale carmen*, Naldo Naldi takes a great deal of poetic licence as he sings the praises of Lorenzo and Giovanna. The classical gods make an appearance at nearly every moment of glory, but it is this exalted tone that gives the work its added value. It is important, from a cultural-historical perspective, to examine the means and metaphors that Naldi used to emphasize that Lorenzo and Giovanna's wedding was an event of uncommon substance and style.

The preparations followed a set pattern, for it was not the first time that Maso had given away a daughter in marriage. To begin with, he had reserved a sum of money for Giovanna's marriage when she was barely three—on 8 October 1471, to be precise. Like most of his fellow townsmen, Maso had taken advantage of a regulation instituted by the city of Florence in the first half of the fifteenth century, which allowed every Florentine to deposit money at an extremely favourable rate of interest in the so-called Monte delle doti, a municipal savings bank. This was an excellent means of building up a dowry, for those who deposited money in time could accumulate interest at an annual rate of over ten per cent for a period of fifteen years. There was, however, a ceiling on a dowry's value at maturity. In 1472, for example, the maximum for legitimate daughters of Florentine citizens was 800 *fiorini larghi*. Maso degli Albizzi spent a total of 1,250 *fiorini larghi*—the equivalent of 1,500 ordinary florins, which was more than ten times the annual salary of a senior government official—on Giovanna's dowry. More than seventy-five per cent of that amount was paid out in funds coming directly or indirectly from the Monte delle doti. All other expenses involved 'gifts in kind'—the so-called *donora*—which, according to custom, the bride brought to her new home. We can see the precise amounts on a sheet of paper inserted in Maso's account book (fig. 18). Even though it is a summary statement, the calculations are accurate to the last *soldo*:

Lorenzo Tornabuoni is to receive as Giovanna's dowry	1,250 *fiorini larghi*
He received in April [14]86, earned through the Monte	141 *fiorini larghi* 8 *lire* 1 *soldo*
On 18 June 1488, earned through the Monte	652 *fiorini larghi* 18 *lire* 6 *soldi*

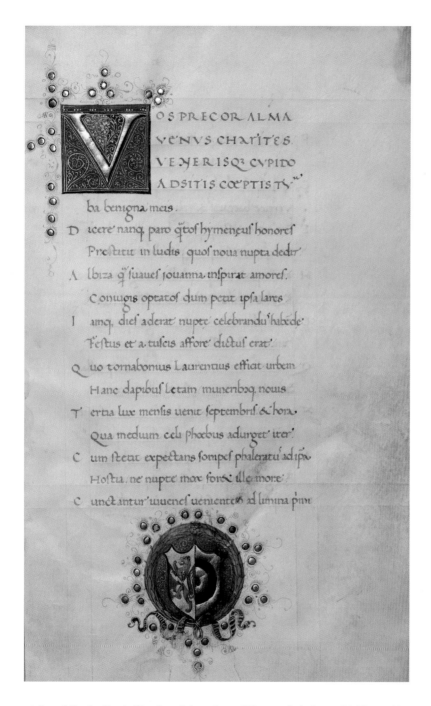

16. [p. 30] Sandro Botticelli and workshop, *Story of Nastagio degli Onesti. IV. The Wedding Banquet*, detail (→ 20).

17. Naldo Naldi, *Nuptiale carmen*, opening folio.
Private collection.

On the same day I transferred Ginevra's dowry, earned in August [14]85, to Lorenzo	149 *fiorini larghi*
Donora received [by Lorenzo], of which the value settled upon was 350 *fiorini di suggello in larghi*	291 *fiorini larghi* 13 *lire* 4 *soldi*
	1,234 *fiorini larghi* 19 *lire* 11 *soldi*

Still to be received 15 *fiorini larghi - soldi* 1 *denaro*[39]

Most of the objects making up the *donora* provided by Giovanna's father were items intended for personal use. Two months before the wedding, eighteen blouses were ordered, costing altogether 18 florins, as well as aprons, caps, stockings and handkerchiefs. Giovanna also took to her new home all kinds of luxury toilet articles: a mirror, a satin-covered hairbrush with a gold handle, hair ribbons, pins and brooches, handbags and two ivory combs. The mention of "a pinchbeck box for the midwife" contained the unspoken wish that Giovanna would soon need a woman to assist in the delivery of her child.[40]

The more costly items included an ivory box worth 2 florins and an elaborately wrought brass basin worth 3 *fiorini larghi*, to which the silversmith Francesco di Giovanni applied in silver and enamel the coats of arms of both families. Maso's account books record that Francesco received a separate payment for this object, which was not intended for Giovanna's personal use, but could serve as a showpiece when the young couple entertained. Guests washing their hands in the basin would be reminded of the strong ties between the Tornabuoni and Albizzi families. Another interesting item is the "little book of Our Lady with narrative illustrations, bound on boards with silver fittings". This book of hours had been bought for 20 florins and specially embellished for this occasion. Giovanna would cherish it for the remainder of her life.[41]

On the whole, Giovanna's *donora* included the customary items. A woman of the upper class was often provided by her father not only with toiletries and clothes but also with a basin and devotional items, such as a book of hours. At least as interesting as the *donora* themselves are the people involved in their production or procurement. Maso's account books name Florentines from all walks of life: not only aristocrats, but also clerics and, above all, many small tradesmen and artisans—generally known only by their Christian names—great numbers of whom lived in the city.

Filippo di Lutozzo Nasi, Giovanna's brother-in-law, acted as the go-between in many of these transactions. Filippo came from a family that had gained greatly in prestige in the course of the fifteenth century, which made him a suitable match for Giovanna's sister Bartolomea, her senior by two years. By finding appropriate marriage partners for his daughters, Maso created new—and mutually reinforcing—family ties. For example, Francesco di Lutozzo Nasi, an elder brother of Filippo, held an executive post at the Naples branch of the Medici bank and was the predecessor there of Lorenzo Tornabuoni.[42]

Giovanna's clothes were procured from a great variety of sources. Many articles were custom-made: dresses were ordered from the tailor Giovannone, shoes from Piero di Nando *chalzaiolo* and Iacopo *pianellaio*. Most common articles of clothing and accessories could be obtained from retail merchants such as "Tomaso di Pagholo, dealer", "Antonio di Tadeo, haberdasher" and "Piera, retailer". The finer embroidery work was commissioned

from the women at the convents of Le Murate and San Vincenzo, who derived part of their income from such traditional handiwork.[43]

Skilled artisans were called upon when silver and gold applications were required. Francesco di Giovanni not only embellished the couple's large brass basin but also gilded the binding of Giovanna's book of hours. Francesco had an excellent reputation in Florence: he and his associate Antonio di Salvi had produced one of the reliefs (a portrayal of *Herod's Banquet*) for the Baptistery silver altar of the Calimala—the guild of the wool merchants, the richest and most exclusive of the great Florentine guilds. Maso also contracted the services of the goldsmith Francesco Finiguerra, the brother of Maso Finiguerra, who is credited by some with the invention of niello, which led to the art of metal engraving. Francesco, by contrast, was less successful; in fact, the modest commission he received from Giovanna's father was a godsend. When asked in 1480 about his financial situation, he said that he scarcely earned enough to pay the rent on his workshop in Via Vacchereccia, between the Piazza dei Priori (present-day Piazza della Signoria) and Via Por Santa Maria. His working capital was completely depleted, and he had been forced more than once to take on odd jobs for fellow artisans.[44]

Finally, the account books show that on 4 July, probably upon the signing of the marriage contract, Maso paid the carpenter Betto for a wooden podium that was set up for a reception held in conjunction with a small procession. At the banquet laid on in the inner courtyard of his mansion, dry white wine was served, along with bread and wafers.[45]

For their part, the Tornabuoni did their best to keep up their end of the bargain. There are no written sources testifying to their initial efforts during the couple's engagement, but as luck would have it, an object that recently surfaced on the French art market tells part of the story. It is a round wooden box with an elegant decoration in gilt gesso—a so-called pastiglia casket—which bears the arms of the Tornabuoni and Albizzi families (fig. 19). It is almost certainly the box that contained the precious objects and symbolic gifts that Lorenzo gave Giovanna; indeed, it is likely to have held the costly pendant Giovanna wears in nearly every portrait. The Tornabuoni put the jewel at the new bride's disposal so that its brilliance would reflect well on her, for tradition demanded that a beautiful wife not be lacking in beautiful jewellery.

After the preparatory steps and ceremonies described above, the union was celebrated on a grand scale. The festivities began on 3 September 1486, as recorded on the opening folio of Naldi's nuptial poem. Half of Florence joined in, it seems, and there was nothing to prevent the enthusiastic celebration of the marriage. After a period of military unrest in the Florentine state, there was—at least for the time being—no threat of war.

From mid-1480 to August 1486, the Italian peninsula had witnessed almost continual military hostilities between two opposing factions: on one side the pope had forged an alliance with the Venetian Republic; on the other side were the Republic of Florence, the Duchy of Milan and the Kingdom of Naples. In 1485 the so-called Barons' Revolt—supported by Pope Innocent VIII—against Ferdinand of Aragon further strained relations between Naples and Rome, but a treaty signed on 11 August 1486 temporarily restored peace. All influential Florentines knew exactly what was taking place in the Italian peninsula, and Lorenzo de' Medici—as *primus inter pares*—was kept constantly informed of the latest developments. A letter sent by a Milanese envoy and another written by Lorenzo himself to Iacopo Guicciardini reveal that the Magnificent met with Ferdinand's son, Alfonso duke

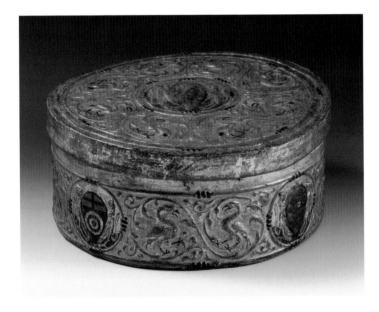

18. Maso degli Albizzi, *Libro debitori e creditori*, 1480–1511, loose note.
Pontassieve, Poggio a Remole, Archivio Frescobaldi.

19. Florentine production, casket with the arms of the Tornabuoni and Albizzi families.
Private collection.

of Calabria, on 2 September—the day before Lorenzo Tornabuoni's wedding—near Borgo San Sepolcro. The concerns of these rulers, however, as well as the implications and risks of a new political agreement, had little or no effect on the celebration of Lorenzo and Giovanna's marriage, for the wedding was very lavish indeed.[46]

The festivities began in the morning, with Giovanna as the focal point of the *ductio ad domum*, a ritual deeply rooted in Mediterranean culture, whereby the bride was led from her parents' house to that of her husband. A multitude looked on as the ceremonious leaving of the ancestral home unfolded. According to Naldo Naldi, the large crowd that had gathered in front of Maso's palace in Borgo degli Albizzi stood in awe of the seventeen-year-old Giovanna when she appeared on the threshold. Her gown was dazzlingly white, her hair carefully combed and adorned with costly pins. A group of cavalrymen on beautifully caparisoned horses were waiting for her. Two Florentine nobles—Luigi Guicciardini and Francesco Castellani—led Giovanna through the streets of the city. The former was probably Luigi di Piero, a nephew of Giovanni Tornabuoni's mother who had acquired a certain fame in public life and had been knighted in 1464. The elderly Francesco Castellani also prided himself on the dignity of knighthood. As a result of his father's untimely demise, Francesco had been decorated at the age of twelve, an honour that he continued to boast about until his death. The parade of escorts also included many young people. It was graced, moreover, by the presence of the Spanish ambassador, Don Íñigo López de Mendoza, count of Tendilla, one of the architects of the peace treaty, who was temporarily residing in Florence. Thus Giovanna's *ductio* was rather like a triumphal procession, comparable to the famous *ductio* of Clarice Orsini to the house of Lorenzo de' Medici.[47]

In Naldo Naldi's poem, the gods accompany Giovanna: while Cupid ensures the safe passage of the procession through the assembled crowd, Venus scatters roses from Mount Olympus, thus giving Giovanna a crimson bloom—a bloom, to quote Virgil, "as when one stains Indian ivory with crimson dye, or as when white lilies blush with many a blended rose". The euphoria of the moment could not have been more aptly expressed.[48]

The poet gives a colourful description of Giovanna's arrival at the imposing Palazzo Tornabuoni. To everyone's delight, an olive tree had been set up between the windows of the *piano nobile*. The joyousness evoked by the olive tree is described in the account of Clarice Orsini and Lorenzo de' Medici's wedding: when Clarice was approaching the Palazzo Medici, an olive tree was hoisted triumphantly up to the windows. In a painting portraying a *Wedding Banquet* (fig. 20) executed in the workshop of Sandro Botticelli after the master's design (the fourth in the famous series depicting the *Story of Nastagio degli Onesti*), the decoration features instead trees and garlands of laurel, a plant associated with victory but also with the person of Lorenzo de' Medici, whose portrait is clearly recognizable among the guests (he is the fourth from the right at the table of men). Lorenzo had acted, after all, as an intermediary in arranging the Pucci–Bini marriage, for which occasion the panel was produced. An evergreen tree, the olive is a symbol of life, abundance, peace and wisdom, but Naldo Naldi's text stresses its association with the goddess Athena. When Zeus promised to award Attica to whichever contestant produced the most useful gift for the land, Athena caused an olive tree to sprout and was declared the victor. The olive thus became a sacred tree, a symbol of the peace and plenty of the city-state, and of civic pride and prosperity in general. In this way Naldi pays homage to the city of Florence as the 'new Athens on the Arno'.[49]

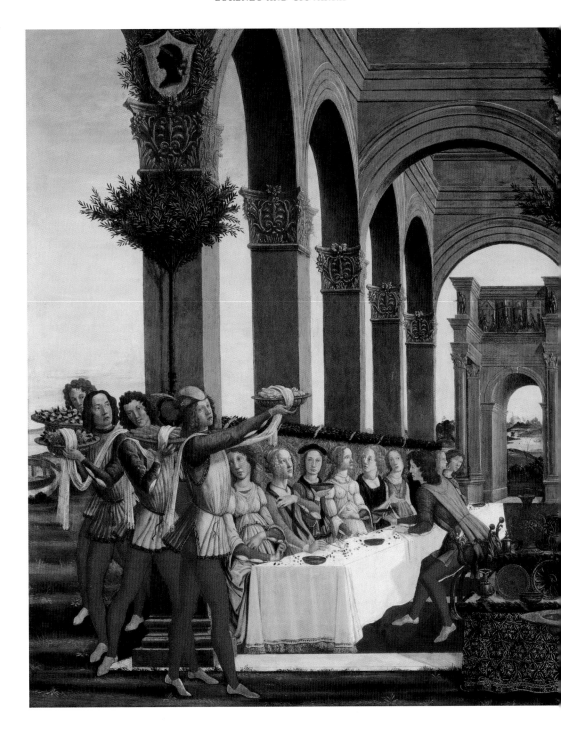

20. Sandro Botticelli and workshop, *Story of Nastagio degli Onesti. IV. The Wedding Banquet.*
Private collection.

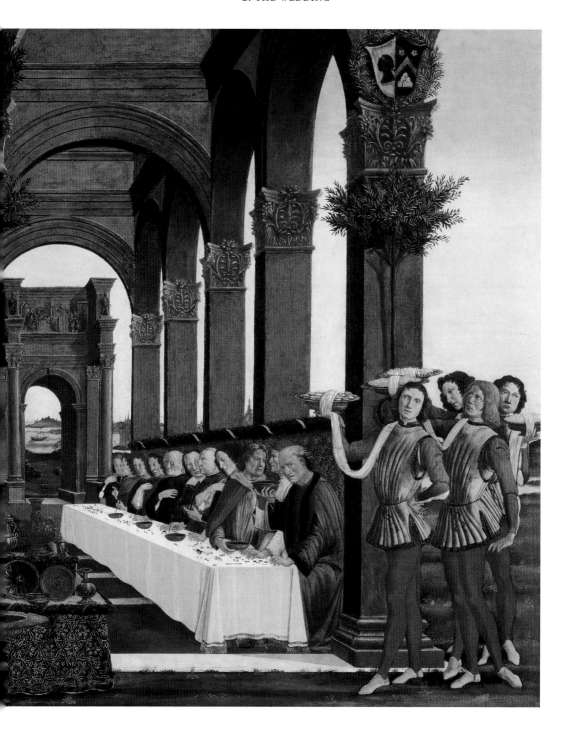

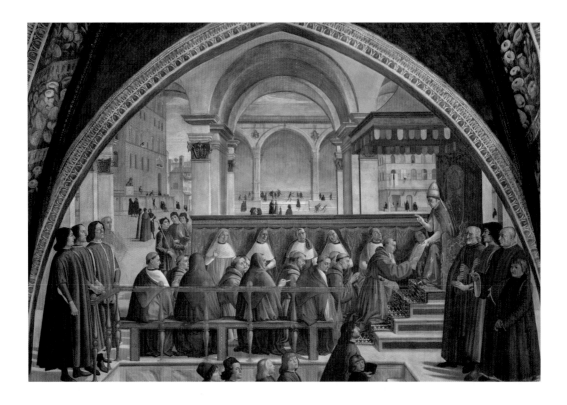

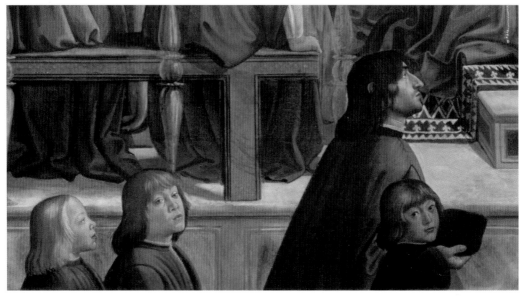

21–2. Domenico Ghirlandaio, *Confirmation of the Rule of St Francis*: the fresco and a detail. Florence, Santa Trinita, Sassetti Chapel.

A crowd had gathered to witness Giovanna's arrival at her new home. Giovanni Tornabuoni was standing at the main entrance, ready to embrace his young daughter-in-law and lead her inside. The Palazzo Tornabuoni looked more like a royal palace than a private residence. Naldi reports that numerous walls were decorated with colourful frescoes. The spacious hall had been filled for the occasion with exquisitely laid tables. The elite of the Florentine aristocracy attended the wedding banquet, at which the Spanish ambassador had the seat of honour. In providing a superabundance of food and drink, Giovanni apparently sought to compete with Lucullus, the famous Roman consul. According to Naldi, after the first course every guest was presented with a pinecone—a classical symbol of fertility —covered with gold leaf. When the banquet was nearing its end, the first toasts to future offspring were no doubt proposed. Naldi has Apollo, the god of poetry and music, remark flatteringly that Giovanna's first child could hardly surpass her in beauty.[50]

At the end of this first banquet, the festivities underwent a change of venue. A podium had been erected in the piazza in front of the church of San Michele Berteldi (now Piazza Antinori), next to the Palazzo Tornabuoni. In accordance with custom, it had been covered with sailcloth and hung with tapestries. An elaborate, 'staged' credenza, set with silver, was presumably placed at one side. Again, a banquet was laid on, intended mainly for young people of high birth, one of whom was the youthful Piero de' Medici, the son of Lorenzo Tornabuoni's first cousin once removed, who was to play a key role in Lorenzo's life.

Piero—born on 15 February 1472 and therefore nearly four years younger than the bridegroom—was the most privileged of all young Florentine patricians. As the son of Lorenzo de' Medici, he had received the best education imaginable. He began to write letters when he was barely six. In a missive of 21 September 1478, he informed his father: "I have already studied some verses by Virgil, and I know the first book of Theodore almost by heart. My teacher listens to me reciting my lessons daily". And a year later he wrote to his father in Latin: "Nos bene valemus. Vacamus litteris" ('We are well and spend our time studying literature'). He soon mastered Greek as well, for he could formulate his thoughts effortlessly in the style of Pindar. In a fresco in the Sassetti Chapel in the church of Santa Trinita in Florence, the young Piero is depicted standing behind his teacher, Politian (figs. 21–2). Owing to Politian's influence, Piero's collection of manuscripts came to consist almost entirely of Greek texts.

In the words of Naldo Naldi, Piero was a second Apollo: he equalled the sun in radiance and caused the stars to pale in comparison. Moreover, he was always trying to profit from "what the ancient Latin writers said, and what the kind Muse gave to the Greeks". Piero de' Medici and Lorenzo Tornabuoni did, in fact, have a great deal in common, and for a long time their lives ran nearly parallel. Their sympathy and solidarity ran deep, so deep that the disastrous turn taken by Piero's fortunes proved fatal to Lorenzo as well.[51]

On the day of her wedding, Giovanna wielded special authority as the bride. The podium in the Piazza San Michele was used mainly as a dance floor, and from her place on a beautifully painted bench Giovanna invited young men and women to dance as couples by turns. A dance was always an ideal opportunity for Florentine patricians to display their finery. Their costly, elegant attire features in the so-called Cassone Adimari, the most famous work by Masaccio's younger brother, Giovanni di Ser Giovanni called Scheggia (figs. 23–4). The ladies' richly ornamented dresses with trains are especially eye-catching, and illustrate the irrepressible desire of rich youth to flaunt their wealth and beauty.

Nevertheless, the festivities in the piazza were not an exclusively aristocratic affair, for the neighbourhood residents had also been invited. This gesture of goodwill towards the neighbours undoubtedly enhanced the Tornabuoni's standing and was certainly good for community relations, but the abundance of food made it difficult for the guests to control themselves. There were a number of scuffles, and according to one sixteenth-century man of letters, a silver dish was purloined during the revelries.[52]

At the end of the day—filled with so many moments of tribute, affection, hospitality and entertainment—Lorenzo and Giovanna made their way to the bedroom, where the marriage was to be sealed. The consummation of a marriage had legal status in Florence, since the Monte had decreed that a husband could not collect the dowry until he had fulfilled his conjugal duty. Naldo Naldi is obviously not alluding to this legal aspect when he describes the marital encounter, in purely poetic terms, as a heavenly embrace: as Giovanna enters the bridal chamber, Venus surrounds her with clouds, so that the sweet and sacred act of consummation is hidden from view.[53]

The following morning the couple visited the "pure temple of the gods", meaning either the church of San Michele or the Cathedral, after which the festivities were resumed. At the Palazzo Tornabuoni the tables were again lavishly laid, and the house was finally graced by the arrival of the most important guest of all: Lorenzo de' Medici, just back from his diplomatic mission. There was no one in Florence who inspired more respect; in the opinion of Naldo Naldi, Lorenzo could not be praised highly enough. Having compared Piero de' Medici with Apollo, Naldi now put his father on a par with Jupiter. The peace and prosperity of Florence was due to Lorenzo the Magnificent, who "rules over the Etruscans, preserves the walls of the fatherland and dispels enemy threats". His presence was reason enough for the Spanish ambassador to attend this banquet as well. According to the sources, the two men were on good terms, both having been involved in the negotiations that had put an end to earlier political conflicts. A personal meeting with Lorenzo would give the ambassador a chance to catch up on the latest political developments. For his part, Giovanni Tornabuoni seized this opportunity to report proudly on the progress of the nuptial celebration. As the host, he also saw to it that entertainments of every kind—music, dance and games—were provided in good measure.[54]

On the third and last day of the wedding, the winners of the jousting tournaments organized by Maso degli Albizzi were awarded their prizes. Mock battles took place by torchlight in the late evening hours; Giovanna was privileged, as queen of the tournament, to designate the winners. The entire three-day celebration was rounded off with a procession. In honour of her father and mother, Giovanna—accompanied by the youthful competitors—paid a visit to her parental home. Profiting from the jubilant atmosphere, the families of the bride and groom made the most of this opportunity to strengthen their ties with other influential families. There was every indication that this alliance between two powerful families would further enhance their status and influence. The high expectations of the couple's future role in society are evident in two exceptional commissions—carried out by the most famous artists in Florence—which bear witness to the Tornabuoni's role as distinguished patrons of the arts.

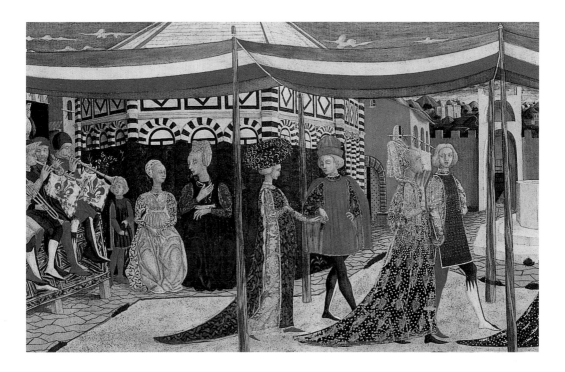

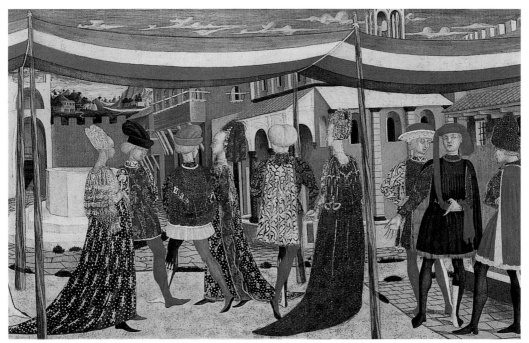

23–4. Scheggia, *Wedding Procession* (Cassone Adimari), details.
Florence, Accademia.

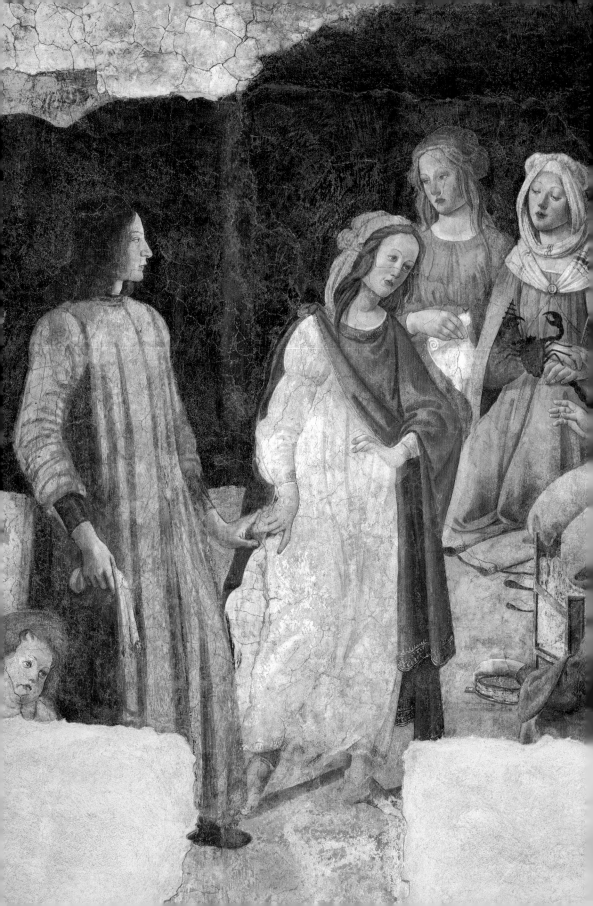

CHAPTER 3

Wisdom and beauty

The end of the wedding was the beginning of a new life for Lorenzo and Giovanna, who divided their time between the Palazzo Tornabuoni in the heart of Florence and the family's country villa at Chiasso Macerelli, situated in the hills north of the city. In the first year of their marriage, special works of art—indicative of the young couple's new status and hopes for the future—were commissioned to decorate their private apartments in both residences. In the Tornabuoni's villa, one of the most renowned artists of Florence painted a cycle of frescoes whose charm was completely in keeping with the villa's pleasant rural surroundings.

Like many well-to-do Florentines, the Tornabuoni family fled the oppressive heat of the city and took refuge in the countryside during the sultry summer months. Early sources, such as Leon Battista Alberti's treatise *On Architecture*, list the advantages of country houses above city residences, one being the owner's ability to supervise from his villa the tenant farmers who cultivate his land. Moreover, a stay in the country is invigorating, and those who are so inclined can devote themselves—in peace and tranquillity, far from the cares and anxieties of everyday life—to study and contemplation.[55]

The country estate of the Tornabuoni family conformed to the model of the *villa suburbana*. The villa lay no more than two miles outside the walls of the old city, not far from the medieval parish church of Santo Stefano in Pane. In the oldest bird's-eye view of the city of Florence—called *della Catena* ('of the Chain') after the chain that frames it—this church is clearly visible next to the long arterial road beginning at Porta a Faenza (fig. 26). The villa was therefore easily accessible, and perfect for taking short breaks from the stress of city life. The gently sloping hills to the north of Florence were considered a prime location. The Tornabuoni residence was a stone's throw from the villa where Cosimo the Elder, then Piero and finally Lorenzo de' Medici held a kind of literary court. Scholars and artists gathered there to exchange ideas, for even though the Renaissance villa was a place of seclusion and leisure, it was also a place for private gatherings and conversation. The Medici villa was located just above the Tornabuoni's in the area called Careggi, a name in

which the Medici's erudite friends promptly found an allusion to the Charites or Graces (*Charitum ager*, 'field of the Graces').[56]

To go from the Villa Tornabuoni to the Villa Medici, one walked uphill in a north-westerly direction along the river Terzolle. Another path following the Via Incontri in a north-easterly direction eventually brought one to Montughi, where another fifteenth-century patrician, Francesco Sassetti, owned a country estate so beautifully appointed that it was described as a palace. Like Giovanni Tornabuoni, Sassetti had great responsibilities as manager of the Lyons branch of the Medici bank. The Tornabuoni, the Medici and the Sassetti had more in common than status and profession: they shared a genuine love of country life. In 1488, when Francesco Sassetti was forced to spend a long time in Lyons, straightening out the bank's affairs, he wrote a letter to Giovanni Tornabuoni that clearly expresses his nostalgia for the Florentine countryside: "Think of me, when enjoying the solace of that splendid villa, above all at Africo in that wood of Francesco Nori, where there is said to be a fountain". Sassetti was referring to a country house on the other side of the city—across the Arno—in the parish of Santa Maria all'Antella. Clearly, even the thought of a country sojourn could give rise to feelings of happiness.[57]

Giovanni Tornabuoni had come into the possession of the country house at Chiasso Macerelli in 1469, before which time it had belonged to the Galliano family, who had just had the villa renovated in the modern style when the paterfamilias, Piero di Filippo, suddenly died. The villa comprised several structures of two or three storeys, which over the years had come to form a single building with two principal wings of living quarters lining the long sides of a rectangular courtyard (fig. 27). Piero's widow, Monna Ginevra, could not afford to maintain a large villa and was finally forced to sell it. The Tornabuoni—long bent on acquiring a large country house in such a choice location—jumped at the opportunity. When the purchase took place, the mediator was Piero the Gouty, father of Lorenzo the Magnificent.[58]

Giovanni Tornabuoni initially purchased the house on behalf of himself and three of his elder brothers, but the municipal property register of 1480–1 reveals that he soon became the sole owner of the villa. Giovanni immediately set about placing his personal stamp on the house: he began by having the family arms applied to the capitals of the columns surrounding the inner courtyard, and went on to furnish the whole estate, inside and out, according to his own taste. A 1498 inventory reveals the uses to which the villa was put; for one thing, Giovanni intended it as a place for his children, Lorenzo and Ludovica, each of whom had a spacious room with an antechamber on the top floor. According to custom, the servants were also part of the family; smaller rooms—some on the east mezzanine—were put at their disposal. Most of the activities took place on the ground floor, where many of the rooms gave on to the inner courtyard—featuring a splendid well—which was the true heart of the house. The vaulted storage rooms held the fruits of the farm labourers' work; the meals were prepared in the *cucina terrena*, or ground-floor kitchen. The inventory also lists a *camera del pane*, where bread was baked.[59]

In the months when the villa was fully occupied, visitors were constantly coming and going, and the gates frequently stood open to admit them. The villa had two large rooms where guests could make music and play games. The *sala terrena*, or ground-floor reception room, thus contained two chess sets and a lira da braccio. For Lorenzo's generation, games, conversation and literary entertainment were the principal pastimes of the aristoc-

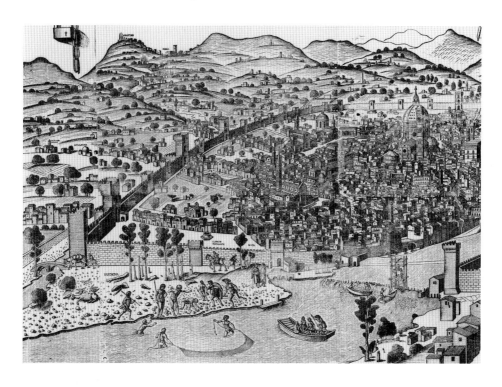

racy at their country retreats, but they also engaged in other forms of relaxation. The Villa Tornabuoni, for example, had a small study with a reference library containing approximately thirty volumes in both Latin and the vernacular. After all, as Cicero had said, what could be more pleasant than 'lettered leisure'? Mindful of such paragons of literary achievement, the Tornabuoni, too, tended to take advantage of the peace and quiet of the countryside for the purpose of study and meditation. Even so, the inventory contains an almost casual reference to an item that reveals the informal nature of country life: the straw hat that belonged to Giovanni's grandson Giovannino.[60]

Some time before the birth of Giovannino in 1487, one of the most celebrated of all Florentine painters—Sandro Filipepi, known as Botticelli—had been put to work at the villa. As early as the 1470s, Botticelli had become renowned for paintings distinguished by their gracefulness and tender melancholy. He excelled at the depiction of profane subjects: no other painter understood so well the enchanting power of the world of classical mythology. His most famous creation, the *Primavera*, has sometimes been characterized as a 'rustic song' of unsurpassed charm and refinement, a poem in the form of a painting. Botticelli gives the goddesses in particular a special grace, manifested in their poses and strengthened by the play of lines in the undulating draperies. Moreover, everything is meticulously drawn: faces, hands, gems, trees, even the flowers in the grass.[61]

While the *Primavera* (now in the Uffizi) is known from early descriptions, the commission carried out at the Tornabuoni villa long remained unknown. In September 1873, colourful frescoes were discovered—more or less accidentally—beneath a layer of whitewash in one of the rooms on the top floor. As soon as it was suspected that the frescoes were the work of Botticelli, the owner of the villa, Petronio Lemmi, called in several specialists, who confirmed the attribution. Lemmi then had the frescoes removed and sold them to the Louvre in Paris (figs. 30, 33).[62]

As the frescoes—one of which bore traces of the coat of arms of the Albizzi family—were being uncovered, two contemporary portraits emerged. These findings were followed almost immediately by the identification of the sitters as Lorenzo Tornabuoni and Giovanna degli Albizzi. The 1498 inventory confirms the identification. It states that Lorenzo had a private apartment on the top floor, which is precisely the part of the house that was decorated by Botticelli. This apartment consisted of the rooms described as 'Lorenzo's room upstairs' ("chamera di Lorenzo di sopra") and 'the new room upstairs' ("chamera nuova di sopra"). Both rooms were used primarily as bedrooms. Lorenzo's room contained two beds (a canopy bed and a *lettuccio*, or divan), a table, two chest-benches (*cassapanche*) and many household articles. The walls were decorated with a *Madonna and Child* and a painted cloth with a *Nativity*. Botticelli's frescoes were, in short, an essential part of the domestic decor, and as such, integrated into a setting far removed from the impersonality of a museum.[63]

Botticelli's frescoes originally filled almost the entire wall. The depictions were surrounded by a painted architectonic frame, which created the illusion of depth and the suggestion of space behind the openings of a loggia. The opposite wall was also covered (at least in part) with murals, of which only a single, seriously damaged fragment remains (fig. 29). Two life-size portraits, seen close up, appear against the backdrop of a luxuriant landscape. The man in the red cloak, whose face is obliterated, has been identified as Giovanni Tornabuoni. Standing beside him is his daughter Ludovica, at the age of about ten, judging from her height. The painting documents an informal, outdoor gathering at a simple tres-

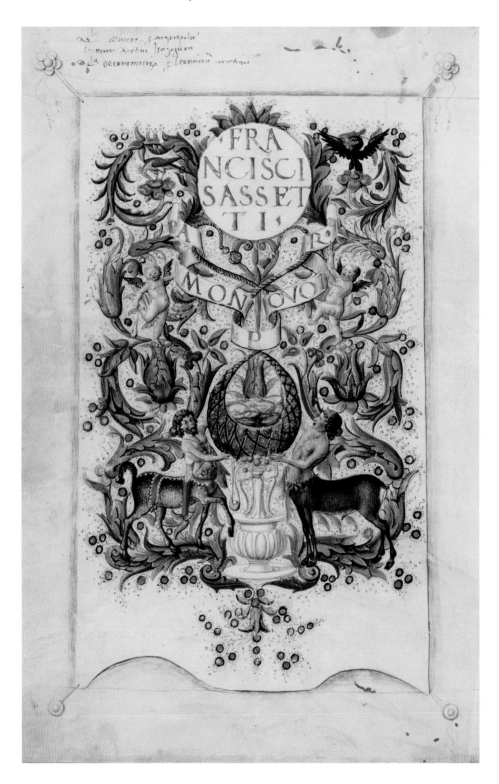

25. [p. 44] Sandro Botticelli, *Grammar Introduces Lorenzo Tornabuoni to Philosophy and the Liberal Arts*, detail (→ 30).

26. [p. 47] *Pianta della Catena*, detail with the Porta a Faenza (→ 3).

27. [p. 47] Villa Tornabuoni Lemmi, Florence.

28. [p. 49] Ex libris of Francesco Sassetti.
Florence, Biblioteca Medicea Laurenziana.

29. Sandro Botticelli (attributed), *Giovanni and Ludovica Tornabuoni*.
Florence, Villa Tornabuoni Lemmi.

tle table that stands amid flowers and shrubs. Boats ply the river winding through the hilly background.[64]

Botticelli thus allowed three worlds to merge—the world of the viewer, the world of the sitters, and the world of mythology and allegory—and in this blending of spheres Lorenzo and Giovanna have been cast in leading roles: Lorenzo is accompanied by personifications of the arts; Giovanna—standing in an enclosed garden, screened off at the back by trees and other greenery—faces Venus and her faithful companions. Little or nothing of the vegetation in the background can be discerned, but at the upper left a fountain in Renaissance style spouts refreshing water. Giovanna's clothing and jewellery typify her as Lorenzo's wife. The putti and family arms (now abraded) unite the pair both visually and iconographically, emphasizing the importance of matrimonial bonds.

There were good reasons for putting Lorenzo and Giovanna on a par with the liberal arts and the gods, for the frescoes provide insight into the newlyweds' sphere of personal fulfilment, and show that they had more to offer each other than mere material goods. The sitters' social background was naturally a consideration, but so were their ages. Giovanna married at seventeen, a common age for brides in those days, whereas Lorenzo, who was just eighteen, was more than ten years younger than the average bridegroom, since most Florentine men married between the ages of thirty and thirty-five.

Lorenzo received the intellectual education appropriate to his social standing, and his access to the rarest Greek manuscripts allowed him to develop into a young scholar. He had such a keen sense of the nuances of Latin and Greek that Politian considered him one of his best pupils. Giovanni was fully aware of his son's wide-ranging talents, and was immensely proud of him for having a thorough command of a language he himself had never mastered. In his nuptial poem, Naldo Naldi has Giovanni address the following words to his new daughter-in-law:

> You are fortunate to have a husband rich in virtue, thanks to which
> He has set out on the path of the Muses and strives for the stars.
> For he cultivates the exceptional arts of divine Pallas
> And everything taught by the oldest Latin writings.
> He has even dared to scoop the waters from Greek sources
> So that he may learn both these languages.[65]

A humanist education not only enhanced a young man's prestige, but also lent him the kind of authority that made him a suitable match for a woman of rank. A work of art commissioned to mark a marriage might therefore depict the arts of Pallas. Furthermore, Naldi's text suggests that the execution of the frescoes was done in consultation with Giovanni Tornabuoni, who had presumably commissioned them in the first place. But Botticelli would not be Botticelli if this complex allegory merely affirmed Lorenzo's excellence: the ingenious composition is also an incitement to inner contemplation.

In the middle of the composition, a young, comely woman takes Lorenzo by the hand. This variation on a classical pictorial formula—in the *Divine Comedy*, Dante is accompanied first by Virgil and later by Beatrice—is a motif often used to denote an adventurous journey through an imaginary world, as aptly illustrated by two monuments of early Italian book production: Federico Frezzi's *Quadriregio*, first published in Florence in 1508, and

the renowned *Hypnerotomachia Poliphili* (Venice, December 1499). In Botticelli's version, Lorenzo's guide is Grammar, the 'foundation, gate and source' of all the other liberal arts. Her prominent position is due to the special status of the humanities. Florentine patricians and Renaissance scholars shared an unshakeable faith in the power of language. For Lorenzo's tutor Politian, a thorough knowledge of grammar was a prerequisite to the knowledge of all things.[66]

In accordance with the precepts of a traditional education, the first three liberal arts—grammar, rhetoric and logic (or dialectics)—comprised the *trivium*, or language-oriented subjects, while arithmetic, geometry, astronomy and music made up the *quadrivium*, or mathematically oriented subjects. In Botticelli's fresco, six of the seven liberal arts are grouped in a semicircle. Each discipline has a clearly recognizable attribute. Rhetoric has a scorpion, which, according to a twelfth-century didactic poem, the *Anticlaudianus* by Alan of Lille, expresses the idea that eloquence is an effective means of combating heresy. In his rendering of this traditional pictorial motif, Botticelli was influenced by Andrea di Bonaiuto's frescoes in Santa Maria Novella's Spanish Chapel and by a number of illuminated manuscripts. Of the six female figures, Arithmetic is the most active—directing her gaze at Lorenzo and raising her right hand—and for good reason, since mathematical skills would stand a banker's son in good stead. That is also the tenor of the recommendations given in the above-mentioned treatise on arithmetic dedicated to Lorenzo (fig. 8), where the author states that, as the only science directly applicable to trade and commerce, arithmetic far surpasses all other disciplines in usefulness.[67]

Botticelli's fresco conveys a high moral ideal: it is no coincidence that *all* the liberal arts are present. In his *Convivio* ('Banquet')—a work held in high regard in fifteenth-century Florence—Dante pronounces the following judgement:

> We must therefore not give the name of philosopher to anyone who for the sake of pleasure is a friend of wisdom with respect to only one of its parts, as are many who take pleasure in listening to *canzoni* and in devoting their time to them, and who take pleasure in studying Rhetoric or Music but shun and abandon the other sciences, all of which are branches of wisdom.[68]

Those who truly love wisdom, therefore, will not neglect any form of science or source of knowledge. Lorenzo Tornabuoni is just such a 'lover of wisdom', and the woman facing him, who presides over the meeting of the seven liberal arts, is Philosophy herself, familiar as the chairwoman of similar gatherings in medieval allegorical representations. Botticelli typifies her in an original way, by giving her a relatively young appearance and the unusual attributes of a bow and a costly cloak.[69]

In the fifteenth century it was no longer unusual to give Philosophy attractive features. In his extremely popular treatise *De consolatione philosophiae*, Boethius (d. 524) described Philosophy as an old woman with threadbare clothing, but over the centuries she became younger and younger. In a Flemish manuscript of *De consolatione* dated 1485, Philosophy sits at the foot of the bed of the philosopher-poet: she is portrayed as a graceful girl in a richly embellished dress (fig. 32). In the Italian peninsula, Dante's *Convivio* may have influenced the figurative tradition, since the great Florentine poet describes Philosophy as a "a gentle lady ... most noble and beautiful". The personification of Philosophy in the Ca-

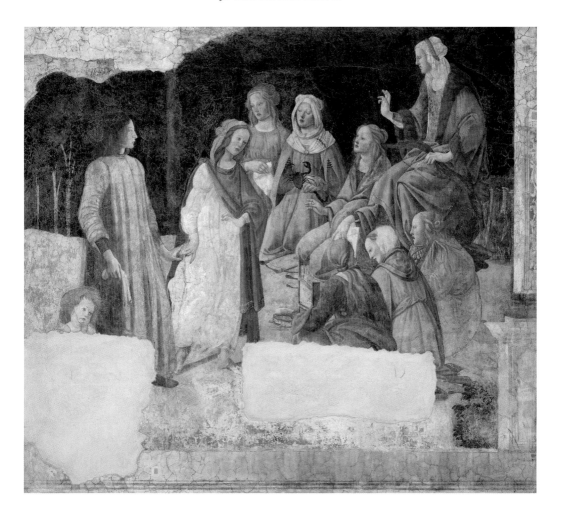

30. Sandro Botticelli, *Grammar Introduces Lorenzo Tornabuoni to Philosophy and the Liberal Arts*.
Paris, Louvre (formerly Florence, Villa Tornabuoni Lemmi).

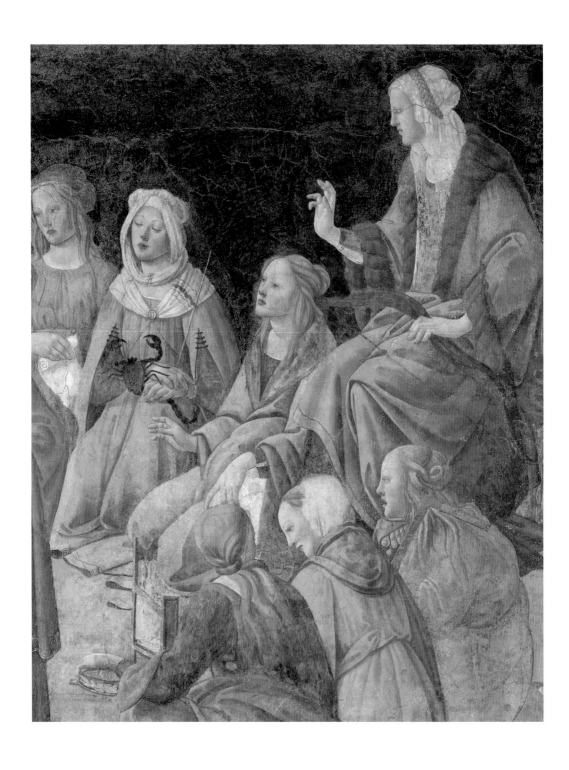

31. Sandro Botticelli, *Grammar Introduces Lorenzo Tornabuoni to Philosophy and the Liberal Arts*, detail (→ 30).

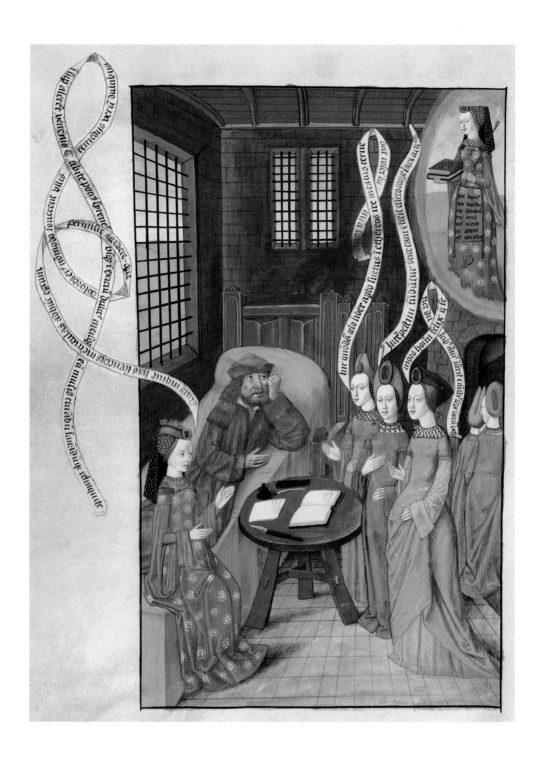

32. Fifteenth-century Flemish illuminator, *Philosophy Appears to Boethius*; *Philosophy Addresses the Arts*. Berlin, Staatsbibliothek.

rafa Chapel in Santa Maria Sopra Minerva in Rome thus has a rather youthful appearance. The work was painted by Filippino Lippi, a pupil and associate of Botticelli.[70]

The hunter's bow features prominently as an attribute in Botticelli's allegorical fresco. The motif seems to derive from fifteenth-century literary sources, in which it has positive connotations. Since the appearance of Nicholas of Cusa's treatise *De venatione sapientiae*, the 'hunt' for knowledge had been a well-known metaphor for the study of philosophy, and the comparison was fashionable among the Florentine humanists, who were familiar with his writings. Just as the hunter cannot do without his bow, the philosopher cannot do without logic: "Est enim, ut Aristoteles dicebat, *logice* exactissimum instrumentum ad venationem tam veri quam verisimilis" ('For logic is, as Aristotle said, a most exact instrument for pursuit of both the true and the truthlike'). The bow therefore stands for the power of the human intellect. Like the personifications of the liberal arts, Philosophy now possessed a suitable attribute.[71]

Even so, Lorenzo is not depicted here simply as a youthful pursuer of knowledge. Philosophical reflection alone does not necessarily make a noble spirit. In the eyes of many, the highest form of philosophy was neither logic nor metaphysics but ethics, since moral philosophy was everyone's concern and not solely the province of scholars. This concept is also expressed in Botticelli's fresco. The scene is set against the sober backdrop of a dense, dark wood, a wood associated with the opening lines of that most famous of Dante's works:

> When I had journeyed half of our life's way,
> I found myself within a shadowed forest,
> For I had lost the path that does not stray.

The literary topos of the dark wood is interwoven with the theme of human vulnerability, particularly in adolescence, a time of seeking and doubt. Botticelli's fresco shows that Lorenzo's humanistic schooling included his moral education. In this allegorical representation, love of virtue and love of wisdom are inextricably entwined.[72]

Using gold paint and the *a secco* technique, Botticelli applied bundles of flames to the heavy fur-lined cloak of Philosophy. The flames were intended primarily as a reference to Lorenzo himself, since his patron saint, the early martyr Lawrence, had been roasted alive. This emblem recurs in a number of works commissioned for and by Lorenzo, as though it were his personal insignia.

Lorenzo's generation developed a passion for devices and symbols, and possessed sufficient resourcefulness to apply them to a wide variety of situations—chivalric tournaments, poetry, the figurative arts. In this context the bundle-of-flames symbol seems to be connected with the way in which Dante describes in his *Convivio* the transcending beauty of Philosophy, using the following image: her beauty causes "little flames of fire" to rain down, animated by a lofty spirit that gives rise to 'good thoughts'. He then goes on to explain that the little flames symbolize the inspiring effect of Philosophy, who fills those who are receptive to it with love.[73]

Thus the imaginary meeting between Lorenzo and Philosophy takes on a deeper meaning. While Lorenzo focuses his attention on the liberal arts, the mother of all the arts and sciences addresses him personally, recognizing in him a 'lover of wisdom'. The scene exudes an intimate atmosphere that is intensified by the poses and gestures of the main figures. In

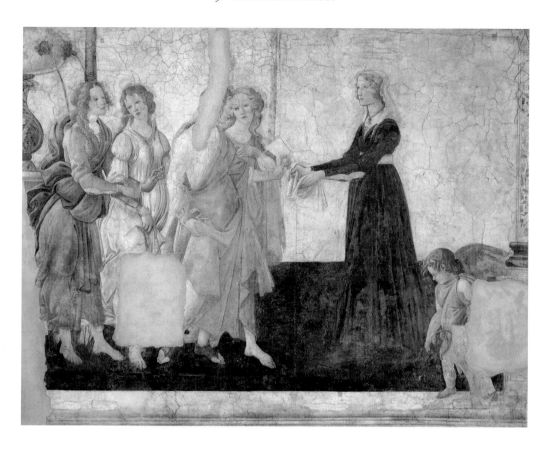

33. Sandro Botticelli, *Venus and the Three Graces Offer Flowers to Giovanna degli Albizzi.*
Paris, Louvre (formerly Florence, Villa Tornabuoni Lemmi).

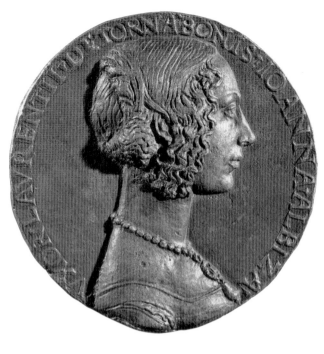

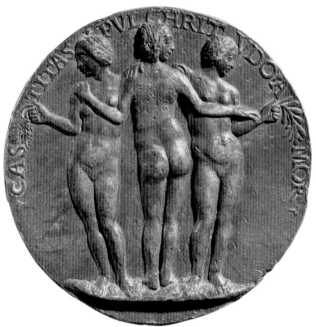

34–5. Niccolò Fiorentino (attributed), portrait medal of Giovanna degli Albizzi:
Portrait of Giovanna degli Albizzi (obverse); *The Three Graces* (reverse).
Florence, Bargello.

36. [p. 61] Sandro Botticelli, *Venus and the Three Graces Offer Flowers
to Giovanna degli Albizzi*, detail (→ 33).

the familiar surroundings of the villa at Chiasso Macerelli, the humanistically schooled Lorenzo is thus urged to persevere in his study of the liberal arts and to strive at all times for virtue and spiritual perfection. The image presents a unique combination of praise, moral instruction and philosophical reflection.[74]

In the fresco of Giovanna, attention is shifted from intellectual schooling and love of wisdom to the domain of love itself. The staging of the scene leaves no room for doubt: the fountain at the left evokes the theme of the Garden of Love, a popular subject in fourteenth- and fifteenth-century art, which was closely related to the ideal of courtly love. A Garden of Love has by definition a paradisiacal atmosphere, being an enclosed pleasure-ground rich in luxuriant plants and flowers, where courting couples can stroll down shady paths and sit together in pleasant seclusion. In Botticelli's enclosed garden, however, there are no courting couples, and the general mood is more solemn than light-hearted. The young, life-size Giovanna is portrayed as a newly married woman, wearing a plain red-brown *gamurra*, suitable for daily wear at home. This type of garment was usually part of a bride's trousseau; Giovanna had a number of *gamurre* in a variety of colours, but this one is particularly elegant, its neckline edged with costly pearls and revealing a portion of the richly embroidered blouse underneath. Nevertheless, the showiest item of dress is the necklace with a precious ruby pendant given to her by Lorenzo. This valuable piece of jewellery also appears on the bronze portrait medal made to mark their marriage, where Giovanna is described as *uxor Laurentii de Tornabonis* (fig. 34).[75]

Giovanna's counterparts—ideal figures exuding grace and charm—come from the realm of the gods. Venus, the goddess of love, wears a richly ornamented *himation* with the Tornabuoni emblem, a diamond. Next to Venus are the Three Graces, her handmaidens and constant companions, and even fairer than she. Their names—Aglaia, Euphrosyne and Thalia—were construed as Splendour, Gladness and Verdure. In Botticelli's depiction the Graces are extremely light-footed. The sense of movement is quickened by the rhythmic play of the draperies, which lends emphasis to the painter's convincing suggestion that life without the Graces would be drab indeed. The palette, too, heightens this effect. In his treatise on painting, Leon Battista Alberti wrote the following:

> I should like, as far as possible, all the genera [i.e. kinds] and species of colours to appear
> in painting with a certain grace and amenity. Such grace will be present when colours are
> placed next to others with particular care; for, if you are painting Diana leading her band,
> it is appropriate for this nymph to be given green clothes, the one next to her white, and
> the next red, and another yellow … This combining of colours will enhance the attrac-
> tiveness of the painting by its variety, and its beauty by its comparisons.[76]

Botticelli's composition focuses on a simple act: Venus hands Giovanna a gift, which she receives with suitable modesty. Unfortunately, the fresco is too badly damaged to say with certainty what the gift was. The layer of plaster, however, bears the incised contours of flowers. Venus almost certainly hands Giovanna three roses—the flower associated with the goddess. This solemn expression of kindness may be seen as a symbolic gesture. Venus undoubtedly acts in her capacity as goddess of beauty and sensual love, which naturally includes fertility. And although the continuation of the family was one of the most important aims of any marriage, there is more to Venus's generosity than this.

In Naldo Naldi's nuptial poem, too, the goddess of love appears as a giver. As soon as Giovanna enters the Palazzo Tornabuoni, Venus surprises her with the gift of the magic girdle, for those who wear it become irresistible. In Naldi's composition, however, Venus's gift is a 'chaste present', and throughout the poem the allusions to Giovanna's beauty and charm are kept in check by equal praise of her chastity and virtue. The moral dimension is emphasized in Botticelli's artistic creation by the presence of the Three Graces, who were in many respects exemplary. In his philosophical writings, Giovanni Pico della Mirandola characterized them as attendants of an 'ideal beauty' that transcends all sensual beauty. In one of his own verses, Lorenzo attributed the Three Graces with the formation of his wife's mind and character: Giovanna owed her outward beauty to Venus, but her inner beauty was due to the Graces.[77]

The reverse of one of the two bronze portrait medals of Giovanna allows us to be more precise (fig. 35), for this image was intended to accentuate her feminine excellence. Such medals were generally produced in limited numbers to present to friends and relations, who often found them to be a source of inspiration and contemplation. On Giovanna's medal the Three Graces are portrayed in the most classical pose—nude, two seen from the front, one from the back, together forming a circle. The image is accompanied by the telling inscription CASTITAS·PVLCHRITVDO·AMOR: Chastity, Beauty and Love, three inextricable concepts. According to the humanists, beauty without love is an abstract idea. Beauty is a delightful gift, but fragile and delicate, and of no value without chastity. Indeed, it is in beauty that the seemingly conflicting concepts of love and chastity come together. Clearly, the subject of Botticelli's fresco is not only sensual love and fertility, but also Giovanna's perfection. She has been chosen to receive the gift of Venus, because she possesses every quality necessary to give and receive love. Like Lorenzo, Giovanna is thus encouraged to cultivate all her noble moral traits. Thematically, the focus shifts, but there is no hierarchical distinction: the harmonization of love, beauty and chastity is no less important than the quest for knowledge.[78]

The fresco featuring Giovanna is characterized—to an even greater extent than the one focusing on Lorenzo—by a natural cohesion of content and form. Owing to Botticelli's artistic resourcefulness and refined palette, the mural is an enduring tribute to Giovanna's beauty and modesty. In his poem, Naldo Naldi is occasionally guilty of exaggerated displays of erudition; Botticelli's allegory, on the other hand, is sheer poetic vitality.[79]

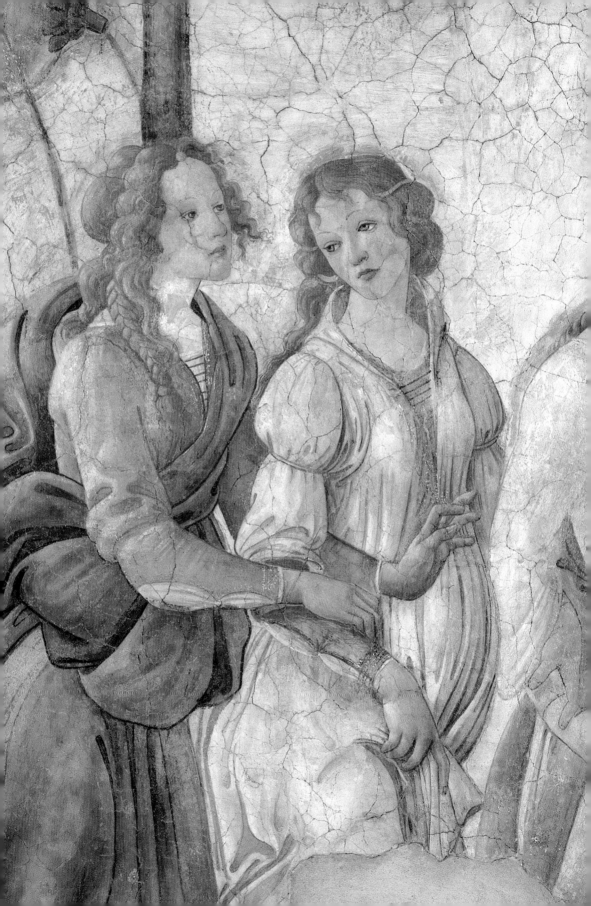

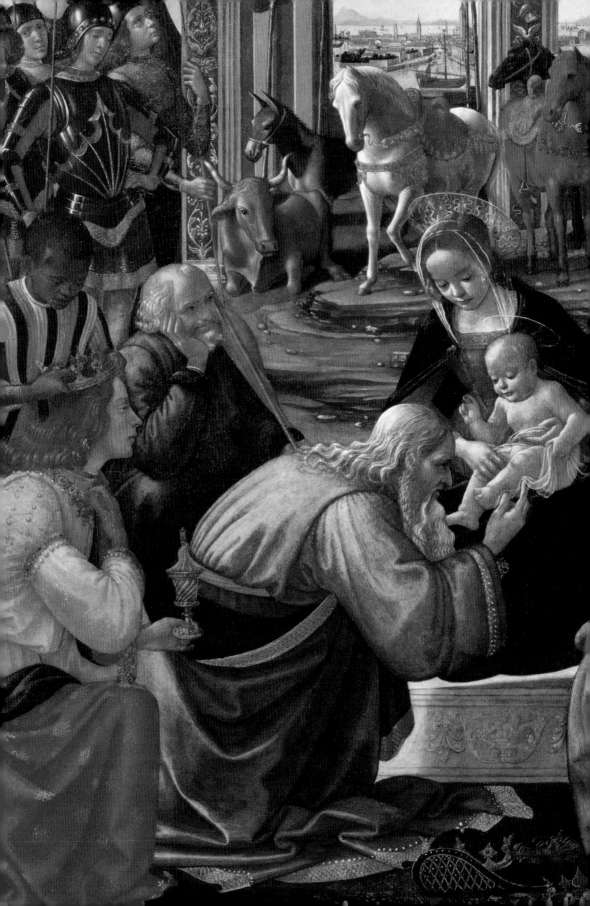

CHAPTER 4

Lorenzo's beautiful chamber

The second work of art commissioned to mark the marriage of Lorenzo and Giovanna leads us back to the heart of the city, to the Palazzo Tornabuoni. In the 1480s this palace was among the most impressive private dwellings in Florence, as evidenced by the view of the city known as *della Catena* (fig. 3). In this woodcut the Palazzo Tornabuoni is clearly recognizable, both because of its location—in the very centre of the city, in present-day Via Tornabuoni—and because of the inscription DN. G. TORNABVON[I], applied by the engraver in capital letters. In terms of size, the Palazzo Tornabuoni was just as imposing as the Palazzo Medici. Most of the construction was carried out between 1460 and 1480 at the behest of Giovanni Tornabuoni, whose aim it was to increase his standing in the city. After his father had allotted him the house previously owned by an uncle, Niccolò di Simone, Giovanni had gradually acquired the adjoining properties, including the former Tornaquinci tower. As early as 1470, the property register described Giovanni's residence as completely new. Seven years later he doubled his holdings by purchasing two more houses: one from Salvestro di Giovanni Popoleschi, the other from Giovanni di Francesco Tornaquinci, both of whom were part of the Tornaquinci clan. By 1480 Giovanni had a continuous row of houses at his disposal stretching the entire length of Via dei Belli Sporti (the upper segment of present-day Via Tornabuoni), from the intersection with Via della Vigna Nuova to the church of San Michele Berteldi (now Santi Michele e Gaetano). A monumental façade on the street side was designed to unify the whole.[80]

Giovanni entrusted the design of the façade to a pupil of Michelozzo. The architecture was austere, with neither rusticated decorations nor a heavy classical cornice. Even so, the façade met the classical criterion of *concinnitas*, that is, 'elegance through harmony'. The upper storeys featured two rows of arched windows, distributed across the front with a feeling for proportion and symmetry. The most reliable reproductions of the original Renaissance façade are provided by Stefano Bonsignori's bird's-eye view of Florence of 1584 (fig. 38) and a pen-and-ink drawing from the early nineteenth century (fig. 39). In Bonsignori's depiction, the *piano nobile* has nine windows. The main entrance—several metres high—

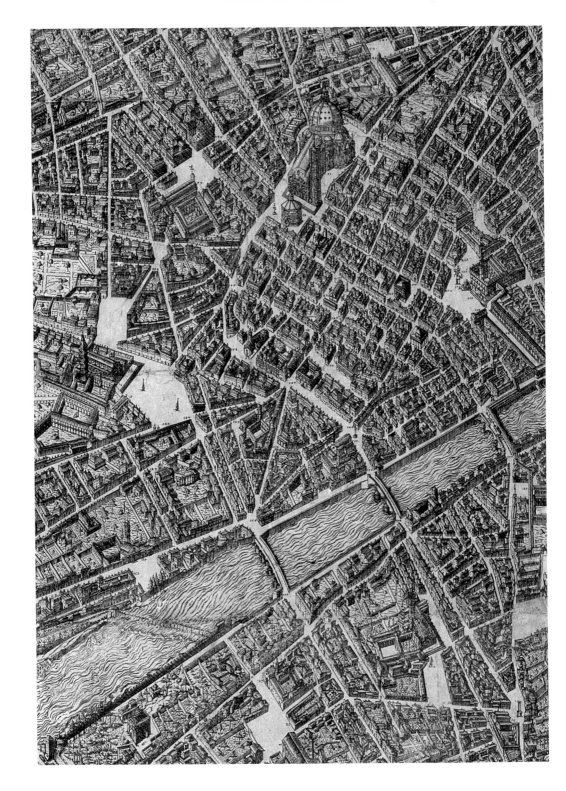

4. LORENZO'S BEAUTIFUL CHAMBER

renewal (fig. 40).[81]

In about 1480, after Giovanni Tornabuoni's plans had been realized, the palace was frequently used to receive dignitaries from other cities in the Italian peninsula. During the third quarter of the fifteenth century, more state visits were hosted at the Palazzo Tornabuoni than at the Palazzo Medici. In 1481 Costanzo Sforza, lord of Pesaro, was a guest of honour, and in 1482 Giovanni held ceremonious receptions for both the duke of Urbino and the cardinal of Mantua. After an official reception at the Palazzo della Signoria, the cardinal was taken to the Palazzo Tornabuoni, where unstinting hospitality was provided at the expense of the Florentine state. Similarly, Alfonso, duke of Calabria (1483) and Count Nicola Orsini (1485), both renowned military commanders, were housed at the Palazzo Tornabuoni during their state visits. The 1480s were thus the heyday of the Tornabuoni family in terms of public honour. Giovanni's fame continued to resound until late in the sixteenth century: "Two of the countless palaces that grace the city of Florence transcend all civic magnificence: the house of the Tornabuoni and the house of the Medici, the one built by Cosimo the Elder, *Pater Patriae*, and the other by Giovanni, head of that family".[82]

The interior of the palace was no less impressive than its exterior. According to the poet Naldo Naldi, a number of walls were decorated with gay, colourful frescoes. The numerous and often luxurious furnishings are best described in the inventory drawn up in 1498 by a public official who made a careful record of all the movable goods in the house. A wall painting by a pupil of Ghirlandaio in the Florentine oratory of the Buonomini di San Martino demonstrates the diligence with which such officials went about their work (fig. 41). Cupboards and chests were opened, so that each and every item could be listed. The clerk who recorded the inventory of the Palazzo Tornabuoni was led around by Giuliano di Filippo Tornabuoni, a cousin of Lorenzo who had made his career in the Church. During their tour of the palace, a wealth of information was recorded that sheds light on the Tornabuoni family's lifestyle.

The rooms on the ground floor served a wide variety of purposes. In addition to a number of high but poorly lit rooms that were used as storage space, the list included a reception room, an armoury and a stable, as well as bedrooms for the household servants. One of the most luxuriously furnished rooms was the "chamera terrena in sull'androne", a room that gave onto the corridor leading from the main entrance to the inner courtyard. This room contained a portrait of Giovanni's sister, Lucrezia, which demonstrates the extent to which her marriage to Piero de' Medici had raised the family's standing.[83]

Up to 1497, three generations of the male line of the Tornabuoni family—Giovanni, Lorenzo, Giovannino—occupied private suites on the upper floor. Each had an unusually large amount of space at his disposal. These private apartments were mainly situated at the front of the house. The servants' quarters, the kitchen and a room that housed the bread oven were at the back, to keep the sight and smell of the practical side of life separate from the formal elegance of the family's living quarters.

Giovanni, the paterfamilias, had three rooms, the largest of which served as his bedchamber, as well as a room where guests were received and the daily business of family life was conducted. He surrounded himself with holy images, not just the usual *Madonna and*

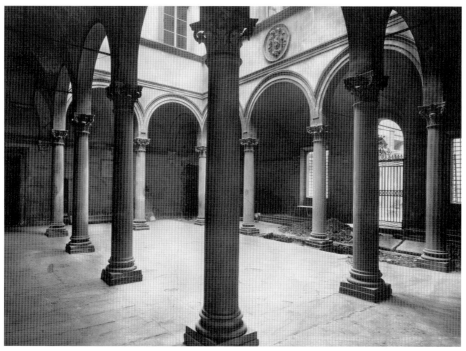

and a smaller one interrupt the unadorned wall stretching across the lower storey. Unfortunately, little was left of the original edifice after the drastic renovations carried out around 1880. Only the inner courtyard, situated behind the main entrance, was spared the rage of renewal (fig. 40).[81]

In about 1480, after Giovanni Tornabuoni's plans had been realized, the palace was frequently used to receive dignitaries from other cities in the Italian peninsula. During the third quarter of the fifteenth century, more state visits were hosted at the Palazzo Tornabuoni than at the Palazzo Medici. In 1481 Costanzo Sforza, lord of Pesaro, was a guest of honour, and in 1482 Giovanni held ceremonious receptions for both the duke of Urbino and the cardinal of Mantua. After an official reception at the Palazzo della Signoria, the cardinal was taken to the Palazzo Tornabuoni, where unstinting hospitality was provided at the expense of the Florentine state. Similarly, Alfonso, duke of Calabria (1483) and Count Nicola Orsini (1485), both renowned military commanders, were housed at the Palazzo Tornabuoni during their state visits. The 1480s were thus the heyday of the Tornabuoni family in terms of public honour. Giovanni's fame continued to resound until late in the sixteenth century: "Two of the countless palaces that grace the city of Florence transcend all civic magnificence: the house of the Tornabuoni and the house of the Medici, the one built by Cosimo the Elder, *Pater Patriae*, and the other by Giovanni, head of that family".[82]

The interior of the palace was no less impressive than its exterior. According to the poet Naldo Naldi, a number of walls were decorated with gay, colourful frescoes. The numerous and often luxurious furnishings are best described in the inventory drawn up in 1498 by a public official who made a careful record of all the movable goods in the house. A wall painting by a pupil of Ghirlandaio in the Florentine oratory of the Buonomini di San Martino demonstrates the diligence with which such officials went about their work (fig. 41). Cupboards and chests were opened, so that each and every item could be listed. The clerk who recorded the inventory of the Palazzo Tornabuoni was led around by Giuliano di Filippo Tornabuoni, a cousin of Lorenzo who had made his career in the Church. During their tour of the palace, a wealth of information was recorded that sheds light on the Tornabuoni family's lifestyle.

The rooms on the ground floor served a wide variety of purposes. In addition to a number of high but poorly lit rooms that were used as storage space, the list included a reception room, an armoury and a stable, as well as bedrooms for the household servants. One of the most luxuriously furnished rooms was the "chamera terrena in sull'androne", a room that gave onto the corridor leading from the main entrance to the inner courtyard. This room contained a portrait of Giovanni's sister, Lucrezia, which demonstrates the extent to which her marriage to Piero de' Medici had raised the family's standing.[83]

Up to 1497, three generations of the male line of the Tornabuoni family—Giovanni, Lorenzo, Giovannino—occupied private suites on the upper floor. Each had an unusually large amount of space at his disposal. These private apartments were mainly situated at the front of the house. The servants' quarters, the kitchen and a room that housed the bread oven were at the back, to keep the sight and smell of the practical side of life separate from the formal elegance of the family's living quarters.

Giovanni, the paterfamilias, had three rooms, the largest of which served as his bedchamber, as well as a room where guests were received and the daily business of family life was conducted. He surrounded himself with holy images, not just the usual *Madonna and*

37. [p. 62] Domenico Ghirlandaio, *Adoration of the Magi*,
detail (→ 53).

38. [p. 64] Stefano Bonsignori, *Nova pulcherrimae civitatis Florentiae
topographia accuratissime delineata*, detail.
Florence, Museo Storico Topografico "Firenze com'era".

39. [p. 65] Emilio Burci, *Via Tornabuoni with the Palazzo Tornabuoni,
later Corsi, before renovation.*
Florence, Gabinetto Disegni e Stampe degli Uffizi.

40. [p. 65] Florence, Palazzo Tornabuoni, courtyard.

41. Workshop of Domenico Ghirlandaio, *Inventorying Bequests.*
Florence, San Martino dei Buonomini.

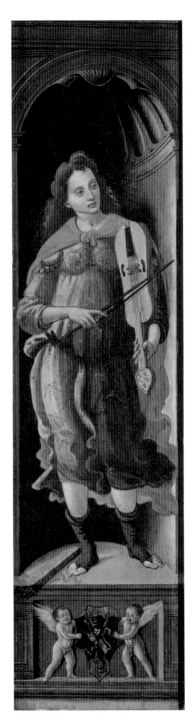

42–3. Bartolomeo di Giovanni, *Venus* and *Apollo*.
Private collection.

Child (a fixture of nearly every large Florentine living room or bedchamber), but also a *St Francis,* a *Mary Magdalene* and a *Salvator Mundi.* It is almost certain that the *Salvator Mundi* was a variant of the portraits of Christ painted north of the Alps by Jan van Eyck, Hans Memling and Dieric Bouts: a devotional picture that lent itself well to contemplation. Giovanni made regular use of an adjoining, intimate writing room, the contents of which included two large candles, his private papers, a small painted tabernacle and cabinets containing costly medals.[84]

The apartment of Giovanni's grandson Giovannino was furnished with comfort in mind. Both bed and bed linen were made of costly material. Copper and gilt bowls, as well as candlesticks, were on display. The extent to which Giovannino was cherished can be deduced from the fact that his baby cradle—made of walnut, with gold decorations—was stored elsewhere in the palace. Long after he had grown out of it, the family treasured it as a precious object of symbolic value.[85]

The most splendid rooms by far, however, were Lorenzo's. Even the official who drew up the inventory could not refrain from describing his main room as "beautiful". Praise of this kind is unusual in estate inventories, but Lorenzo's room was in fact a veritable showroom, filled with richly decorated objects and art works of magnificent colour and extremely fine detail, produced by a select group of painters. Miraculously, the works of art specially made for his room have all survived. Recent research has confirmed that the ensemble comprised a tondo by the hand of Domenico Ghirlandaio depicting the *Adoration of the Magi* (Uffizi, Florence), three panels depicting the *Story of Jason and Medea* (one in the Musée des Arts Décoratifs in Paris and two in a private collection), two oblong panels displaying episodes of the *Siege of Troy* (Fitzwilliam Museum, Cambridge) and two small, upright panels portraying *Venus* and *Apollo* (private collection). Together these paintings formed an impressive decorative ensemble.

Ghirlandaio's large tondo depicting "Our Lady and the Wise Men offering gifts to Christ" undoubtedly had pride of place, and its heavy gold frame lent it added distinction. The oblong panels with profane subjects were possibly part of a series of richly gilt *forzieri* (chests containing the trousseau) or else set into wood panelling. The panels depicting the *Story of Jason and Medea* functioned as *spalliere*—eye-catchers placed at shoulder height— and were presumably flanked by the small paintings of *Apollo* and *Venus.*

Both oblong paintings have a pleasing aspect. Apollo is portrayed in a rhythmically balanced pose as a handsome youth playing the lira da braccio (fig. 43). Venus, a Botticelli-like figure, holds a bunch of roses at her waist (fig. 42). In keeping with the subject matter of the frescoes from the Tornabuoni villa, Apollo, the god of lofty intellectual pursuits, is associated with Lorenzo, and Venus, the goddess of love, with Giovanna, since these small panels contain the arms of the Tornabuoni and the Albizzi. Moreover, Apollo's fluttering garment boasts the bundle-of-flames device. The two coats of arms remind us that Lorenzo's chamber contained the matrimonial bed and, more importantly, that it served as the symbolic and decorative centre of his new household. In short, Lorenzo's chamber was perfectly suited to receive—and impress—guests.[86]

With this ensemble of masterpieces, the Tornabuoni could vie with any Florentine family, including the Medici. In fifteenth-century Florence, the decoration of a chamber of this kind was a suitable opportunity for a young patrician to present himself as an art-loving Maecenas. Such was the pattern followed by the prominent citizens Marco di Parente

Parenti and Bernardo di Stoldo Rinieri. These two neighbours lived near the Cathedral: one was a silk merchant, the other a banker. Both Marco and Bernardo began to keep personal ledgers as soon as they entered into marriage agreements, and subsequently sought personal contact with carpenters and painters, entrusting them with the furnishing and decoration of their chambers. There is a good chance that Lorenzo, at the age of only eighteen, was personally involved in coordinating these various commissions. The paintings were completed in 1487, one year after Lorenzo and Giovanna's wedding, since that is the date recorded on the panel depicting Jason and the Argonauts, and on Ghirlandaio's *Adoration of the Magi*. Four painters participated in the decoration of Lorenzo's chamber: Domenico Ghirlandaio and three artists from his circle, namely Bartolomeo di Giovanni, Biagio d'Antonio (previously active in the Sistine Chapel) and the so-called Master of 1487, later identified as Pietro del Donzello. These four artists could be relied upon to provide paintings of high artistic quality and traditionally sound workmanship.[87]

Strict supervision was required to guarantee delivery within a year and to ensure that the various works of art formed a harmonious whole. Careful thought had to be given to the subjects depicted. Normally the prime considerations in the choice of subject matter were the status of the patron and the function of the room for which the work of art was intended. In this case the matter was more complicated, however, for the commission was seized upon as an opportunity to express opinions on a wide variety of subjects: Lorenzo's love for Giovanna, Giovanna's devotion to Lorenzo, the ideal of chivalry, the prominent position of the Tornabuoni and their ties to the Medici, and even the pursuit of moral perfection. All these themes were cleverly combined to produce a cohesive ensemble.

The resourcefulness with which the patron and his artists set to work is evidenced, above all, by the Argonautic cycle, a series of three panels that tell the story of Jason and Medea (figs. 45–7, 48–50). The choice of this theme from Greek mythology was right on target in every respect. The intrinsic power of the ancient story of Jason and Medea may be captured in two words: love and adventure. Literary tradition has it that the young prince travelled from Iolcus in Thessaly to the Colchian city of Aia on the east coast of the Black Sea, with the aim of capturing the golden fleece, which would restore to him the right to rule his country. In Colchis, Jason met with the resistance of King Aeëtes, but the king's daughter, Medea, fell in love with the beautiful Greek youth. Her skill in magic helped Jason to perform seemingly impossible feats. Their love grew stronger, and was sealed when Medea joined the Greeks and Jason solemnly swore to marry her. After securing the golden fleece, Jason and Medea returned together to Iolcus.

Famously recounted by Pindar (*Pythian* 4) in the fifth century BC and by Apollonius of Rhodes in Alexandrian times, the story of the two lovers was so poignant and engaging that it was passed down from generation to generation and connected time and again with love and courtship. Jason and Medea acquired a prominent place in late medieval court culture. The well-to-do often exchanged ivory marriage boxes featuring scenes from the lives of Jason and Medea. Jason was put on a par with the protagonists of the *chansons de gestes*, the Old French epic poems. After 1430, when Philip the Good chose Jason as the protector of the Order of the Golden Fleece—in a deliberate attempt to breathe new life into the chivalric tradition—the Greek hero came to be held in even higher regard. His popularity peaked in the fifteenth century, and the legend left its traces in Florence as well. Concrete proof of the tendency to romanticize the Argonautic legend is to be found in a

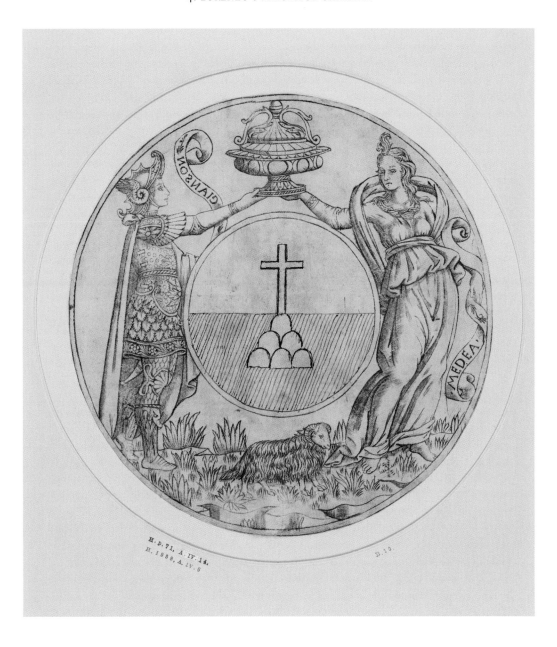

44. Baccio Baldini (attributed), *Jason and Medea*.
London, British Museum, Department of Prints and Drawings.

series of fifteenth-century copper engravings, the so-called 'Otto prints'. These engravings in the fine manner, attributed to the Florentine artist Baccio Baldini, put Jason and Medea on an equal footing with courtly lovers (fig. 44). The prints reflect the philosophy of the Florentine elite, in particular the sons and daughters of the wealthiest patricians, who could afford to amuse themselves with music, dance and courtly romance.[88]

Sometimes the emphasis is on fidelity in love and an inclination to self-sacrifice; at other times, attention is drawn to the dangers of coquetry. These prints, some of which were undoubtedly coloured, were used to decorate the lids of perfumed boxes, which young gallants presented to their mistresses. Such artefacts confirm that the subject of love was just as popular in Florence as it was at the courts of northern Europe. It is also known that the 'Otto prints' circulated in the Tornabuoni's milieu, since one of them refers to Lorenzo de' Medici and his youthful love, Lucrezia Donati, whom he admired so much that he held a tournament in her honour shortly before his marriage to Clarice.[89]

This brings us to the second aspect of the Jason legend, that of chivalry. Lorenzo Tornabuoni's knightly aspirations manifested themselves at such tournaments. The armoury displayed on the ground floor of the Palazzo Tornabuoni included all kinds of equipment used at lavishly organized mock battles and jousting tournaments. Those entering the armoury and its side rooms could feast their eyes on an impressive display of arms. Even the ostentatious horse trappings were a sight to behold: a breast-plate with bells, a saddle of black velvet with gilt fittings and a beautiful bridle with elaborate copper decorations. Clearly, Lorenzo's love of chivalry was not a bookish interest. He preferred the excitement of real-life combat to vicarious jousting in books.

In a letter written in mid-July 1493, Politian gives a brief account of an equestrian contest among young Florentine horsemen, at which the honour of victory was accorded to Lorenzo Tornabuoni and Piero de' Medici. Excelling at such events enhanced one's status: jousting was not just a social activity; there were also ethical and aesthetic aspects. The elite took just as much pride in their skill in arms as in their wealth and education.[90]

Still, the Jason legend was not chosen to decorate Lorenzo's room solely because of its amorous and knightly connotations. Of equal importance was the idea of the successful expedition. Jason actually succeeds in capturing the golden fleece, which is guarded by a dragon. The hero returns safely from Colchis to Greece with the treasure as well as a bride, which brings us full circle to the patron's surname, Tornabuoni. The fact that Jason's expedition took him across the sea to the Levant no doubt appealed to Giovanna's family, since her grandfather had long commanded the Florentine fleet and in 1404 had even undertaken a mission to the Holy Land. Flags and standards with the arms of both the Tornabuoni and the Albizzi embellished the Argo, the legendary ship depicted no fewer than five times in these three panels.

There is also the literary dimension of the story itself as told in the *Argonautica* of Apollonius of Rhodes, who in the third century BC related the story of Jason and Medea in great detail and with true feeling for nuance. We know that Lorenzo immersed himself in Greek literature. He cherished the Homeric poems, and most likely profited from the renewed interest in Apollonius, who in Hellenistic times had zealously carried on the epic tradition from his base in Alexandria. Various Florentine scholars, including Lorenzo's teacher Politian, studied the *Argonautica* in detail; Politian might well have become acquainted with the text during his own schooldays. Thanks to the keen interest shown in the original text,

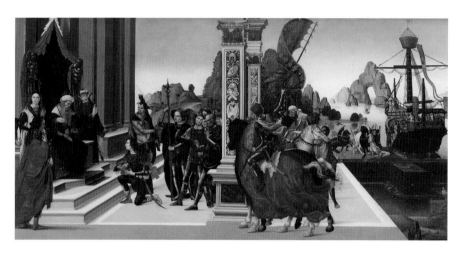

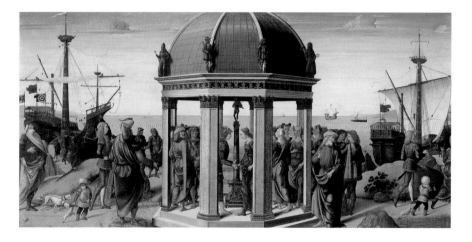

45–7. → 48–50.

the first printed edition of the poem was published in Florence in 1496. That project, supervised by Janus Lascaris, resulted in an incunabulum of exceptional typographic beauty.[91]

Chivalric romance, family pride and classicism thus formed the solid basis of one of the most fascinating portrayals of the Argonautic epos in the history of painting. Three talented artists were commissioned to depict the story. Even though they were given specific instructions—perhaps by Politian, acting as their scholarly consultant—they were also urged to make full use of their imagination.[92]

It is the painting by the lesser-known artist, Pietro del Donzello, that is the most virtuosic. Its depiction of the beginning of the story of Jason and the Argonauts draws us willy-nilly into the world of the ancient Greeks (fig. 48). Here we see Jason demanding redress from his half-uncle Pelias, who had previously ousted his father from power. Jason, who is told that he can regain the throne only if he manages to secure the golden fleece, is surrounded by a select group of helpers—heroes and demigods—among whom are Heracles and Zetes or Calais, one of the winged sons of the North Wind, Boreas. The exotic headgear of several figures reflects the contemporary fascination for all things oriental, freely expressed in a classical setting more reminiscent of the 'modern' Greek world than the ancient Roman one. The headdress of King Pelias, for example, is typically Byzantine.[93]

The spatial effect of this composition is highly original. In the foreground we see a terrace-like elevation, designed according to the rules of perspective. One level lower and extending across the entire breadth of the picture is a landscape painted with just as much love and attention to detail as the weaponry and attire of the heroes of antiquity. The ship Argo, ready to bring Jason and his companions to Colchis, is moored at the right. A swan swims in the far right foreground. Such details enliven the composition and hold the viewer in thrall.

The second panel—painted by Bartolomeo di Giovanni, an artist who assisted Domenico Ghirlandaio on numerous occasions—contains a succession of scenes in which Jason is portrayed no fewer than seven times, from the moment he sets foot in Colchis to his capture of the golden fleece (fig. 49). The easiest to recognize are Jason's labours, the difficult feats Aeëtes has ordered him to perform. First Jason manages to harness fire-breathing bulls to a plough and then succeeds in ploughing an untilled field. He subsequently sows dragons' teeth in the furrows and kills the armoured men that spring from them. Under the arch, one can see in the background how Jason manages to take the golden fleece from the unresisting dragon, whom Medea has lulled to sleep. This patchwork of episodes suggests that Bartolomeo di Giovanni had at his disposal not only Apollonius' text but also a visual model. In the late Middle Ages, parchment rolls with narrative drawings portraying the story of Jason and the Argonauts circulated throughout Europe. Unlike medieval draughtsmen and book illuminators, however, this Florentine painter succeeded in evoking both the style and the spirit of classical antiquity. The temples and buildings were inspired by ancient Roman examples. Moreover, on many points Bartolomeo di Giovanni followed the original text with amazing accuracy. This is quite an achievement, given the fact that there were no properly illustrated codices of the writings of Apollonius of Rhodes.[94]

Without doubt the most successful passage in Apollonius' text is the meeting of Jason and Medea, an intense moment depicted by Bartolomeo di Giovanni in the left background. Before Jason begins the tasks he has been ordered to perform, he pays Medea a visit. They meet near the temple of Hecate:

So they two stood face to face without a word, without a sound, like oaks or lofty pines, which stand quietly side by side on the mountains when the wind is still; then again, when stirred by the breath of the wind, they murmur ceaselessly; so they were destined to tell out all their tale, stirred by the breath of Love.

Jason, who realizes that Medea has been struck dumb by love, is the first to break the silence:

And Aeson's son saw that she had fallen into some heaven-sent calamity, and with soothing words thus addressed her.

Such moments are difficult to portray, especially in a small format, but Bartolomeo di Giovanni succeeded nonetheless in lending tenderness to the meeting of Jason and Medea. The young Greek warrior looks meaningfully at the elegantly dressed princess and rests his right hand delicately on her left arm.[95]

However, the most elaborate scene on the *cassone* panel is the banquet at the court of Medea's father, King Aeëtes. Here Bartolomeo di Giovanni wielded the brush with remarkable finesse: the colours are beautifully pure and the faces painted with painstaking attention to detail. The banquet is strictly a 'men only' affair. Jason himself is depicted in the foreground, listening to what Aeëtes has to say to him. Even though Medea, the king's daughter, is not one of the party, we associate the meal with a wedding banquet. Precious plates are displayed in an arched niche set up like a contemporary (that is, fifteenth-century) *credenza*, or sideboard. In accordance with Florentine custom, a group of musicians provide entertainment to accompany the meal. Curious youngsters lean out the palace windows to take in the scene below. The painter thus enhanced the relevance of the theme by linking the picture to the recently celebrated marriage of Lorenzo and Giovanna.

Medea's role as co-protagonist of the *Argonautica* is most clearly expressed in the third panel, painted by Biagio d'Antonio, which portrays *The Betrothal of Jason and Medea* (fig. 50). This might just as well be called the second panel, since in Apollonius' text the announcement of their betrothal precedes the capture of the golden fleece. After Medea flees her parental home to join Jason and his companions, Jason voices his intention to marry her. Their betrothal takes place beneath the roof of a small temple of Apollo. The structure —with a statuette of Apollo standing on a column in the middle—contrasts sharply with the expanse of light blue sea. At the very centre of this symmetric composition, Jason and Medea clasp hands, in keeping with the ancient Roman ritual known as *dextrarum iunctio*. A group of men and women witness the betrothal.[96]

Biagio d'Antonio, however, depicted the betrothal as more than just a ceremonial act. It also confirms Medea's unconditional devotion to her beloved, and is therefore a subtle allusion to Giovanna's fidelity, though not one to be taken too literally, since Medea's passion was so great that she was disloyal to her homeland. Truly, love conquers all. The handsome blond youth appearing on both left and right is Medea's stepbrother Apsyrtus, who serves to remind us that Jason's return voyage was anything but smooth. When King Aeëtes followed their ship, Medea kept her father at a distance by killing her step-brother and throwing his limbs into the sea one by one, thus deterring their pursuers, who were obliged to collect and bury the boy's mortal remains.

48. Pietro del Donzello (attributed), *Departure of the Argonauts from Iolcus*.
Mari-Cha Collection.

49. Bartolomeo di Giovanni, *Banquet of the Argonauts in Colchis*.
Mari-Cha Collection.

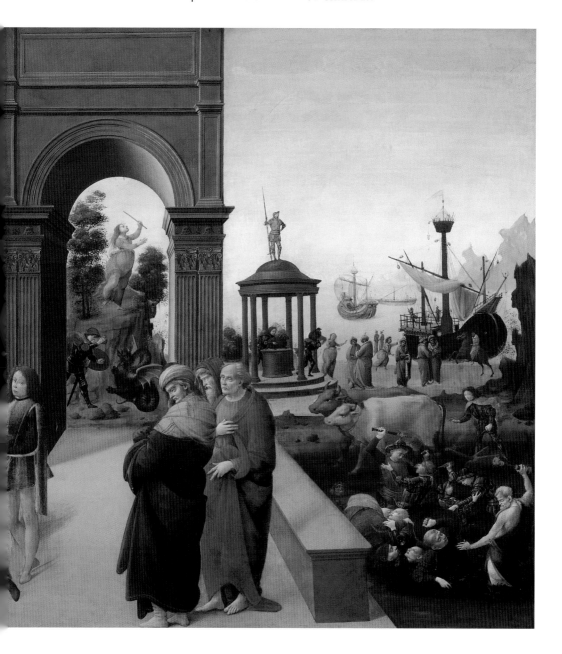

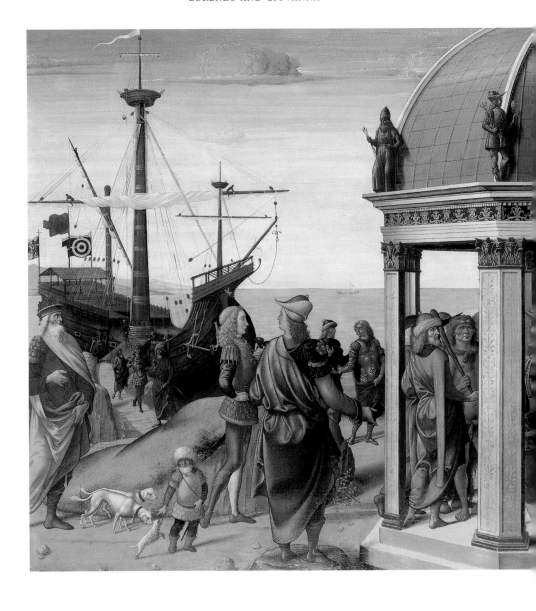

50. Biagio d'Antonio, *Betrothal of Jason and Medea*.
Paris, Musée des Arts Décoratifs.

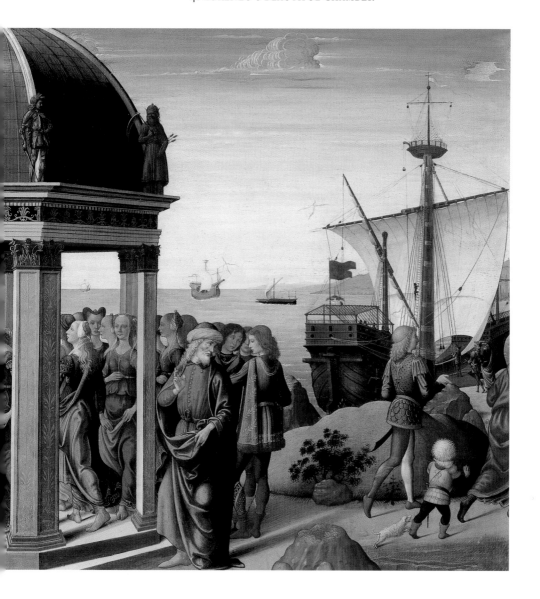

If we view the three panels as one continuous story, it becomes clear that the painters were applying a kind of censorship. The story of Jason and Medea unfolds like a film, but stops before the end. Those who know the sequel to the story are aware that the hero broke his promise: he later deserted Medea to marry Creusa (or Glauce), the daughter of King Creon. Medea used her magic to take revenge: she sent Jason's new bride a poisoned dress that caused immediate and agonizing death. Medea then murdered her own two children and fled to Athens. Depending on the source, Jason either killed himself or was struck dead by a falling beam on the rotten Argo.

To be sure, in Renaissance painting there are many instances of love stories that are broken off before the tale takes a tragic turn. The story of Dido and Aeneas sometimes ends in the cave where they first made love, before Aeneas' silent departure: this, for instance, is the final episode depicted on a set of two *cassone* panels attributed to the Florentine painter and illuminator Apollonio di Giovanni, who specialized in the decoration of marriage chests. Many fifteenth-century works of art commissioned to mark marriages made inventive use of classical sources to highlight the theme of 'happiness in love'.[97]

A second departure from the account of Apollonius of Rhodes is the presence of Heracles. Apollonius tells how Heracles stayed behind in Mysia to search for his friend Hylas, who had been seduced and dragged into a pool of water by nymphs. This happened before they reached Colchis. Still, in the paintings discussed here, Heracles remains Jason's faithful companion until the end of the expedition. This discrepancy between text and image can be explained by the fact that the Florentine humanists considered Heracles—or Hercules, as the Romans called him—a paragon of excellence. In the writings of Coluccio Salutati—the fourteenth-century humanist who served for decades as chancellor of the Florentine Republic—this Greek hero and demigod embodied the ideal of *virtus*, which is roughly translated as virtue, though it actually incorporates qualities such as wisdom, valour and strength (both physical and moral). It implies a determination to do one's utmost, which goes much further than simply confronting the inevitable. Even though the twelve labours of Heracles highlight his physical strength, the almost invincible demigod is described as a *vir sapiens*, who combats evil with 'the light of reason'. The combination of strength and intelligence was in keeping with a cultural ideal held in high regard by the Florentine elite. In an ode by Naldo Naldi to Lorenzo Tornabuoni's best friend, Piero de' Medici, we find the following remark: "No fame should be considered greater than this: / glory arising from both strength and genius".[98]

The Heracles myth was used to refer specifically to Lorenzo the Magnificent in two philosophical works by Cristoforo Landino, the *Disputationes Camaldulenses* and *De vera nobilitate*, written between the 1470s and the 1480s. Later on Politian made the same comparison. Marsilio Ficino had first referred to his colleague Politian as a Heracles, but the scholar strenuously denied the flattering parallel. Politian responded by writing an ode to Lorenzo de' Medici, in which he credited the leader of the Florentine Republic with the strength of Heracles. In the context of the art works commissioned to mark the marriage of Lorenzo and Giovanna, it was inevitable that Heracles would be associated with Lorenzo de' Medici, who had, after all, acted as a mediator in bringing about the marriage. In Biagio d'Antonio's painting, moreover, Heracles prominently witnesses the betrothal of Medea and Jason, and the flag flying from the ship, which is depicted twice, once bore the Medici arms. Finally, the statue of Apollo crowning the column in the middle of the tem-

ple is a reference to the bronze *David* by Donatello, then on display in the inner courtyard of the Palazzo Medici in Via Larga (fig. 83). Indeed, it is possible that the Palazzo Medici was the venue of the first negotiations concerning Lorenzo and Giovanna's marriage, just as it had been the scene of those preceding the marriage of Giovanna's parents. In any case, the image visualises the ties between the Medici and Tornabuoni families. The presence of Heracles has a double meaning: it is a concrete expression of Lorenzo Tornabuoni's loyalty to his cousin and a tribute to his political leadership.[99]

From Jason and Heracles it is only a short step to Achilles, the most outstanding example of Greek heroism. Two panels by Biagio d'Antonio, which are now in Cambridge but once belonged to Lorenzo Tornabuoni, depict the most famous episodes from the Trojan War (figs. 51–2), which raged outside the city walls for ten long years. The turning point in this war of attrition was Achilles' victory over Hector. The account of the fight between the two heroes is one of the highlights of Homer's *Iliad*. In the first Cambridge panel, Hector, the eldest son of King Priam of Troy, dons a dazzling outfit to face Achilles, who is filled with rage at Hector's slaughter of his beloved friend Patroclus. In a furious onslaught Achilles slits his enemy's throat. The tumult of battle—a jumble of warriors and horses—occupies centre stage in Biagio d'Antonio's painting. In this central representation, Hector still stands his ground, but on the right we see the fatal outcome of the fight. After killing Hector, Achilles ignobly defiles his body, tying it by the heels to his chariot and dragging it around as a trophy. Homer describes what happened when Achilles spurred his horse on: "A cloud of dust rose where Hector was dragged, his dark hair was falling about him, and all that head that was once so handsome was tumbled in the dust, since by this time Zeus had given him over to his enemies, to be defiled in the land of his fathers".[100]

This moment is simplified in Biagio d'Antonio's depiction: Hector's body is tied to Achilles' horse; traces of blood colour the dry earth. The artist's forms are too stylized to evoke the chill of Homer's poetry. True *terribilità* will not be encountered in the visual arts until Michelangelo. All the same, Biagio d'Antonio has given us an image in which the turmoil of battle is palpable, owing primarily to several borrowings from antique sculpture, one being a direct quotation of a relief on the Arch of Constantine.[101]

The decisive moment in the Trojan War—the capture of the city—is concisely portrayed by Biagio d'Antonio. No sooner have the Trojans begun to haul the wooden horse inside the city than Agamemnon's troops start to charge through the gates. The Greek soldiers have already begun to sack the city and set it on fire. In this way the painter combined two separate literary episodes to form a visual whole, but in doing so, he took a number of liberties. For example, among Agamemnon's retinue is a man on a horse whose trappings display the emblem of the Tornabuoni family. This is not to say that Lorenzo Tornabuoni was showing his colours, announcing, in effect, that he sided with the victorious Greeks. Homer's poem is, first and foremost, a story about the nature of war, the outcome of which was determined by the gods. Within this immutable framework, the losers always maintain their dignity. Beauty and glory are achieved only at the expense of tears and destruction.

Biagio d'Antonio's scenes from the *Iliad* clearly focus on the motif of battle. Moreover, the general tenor of Homer's poetry was so widely understood that the painter seized this opportunity to deal freely with the literary source. Here the city of Troy boasts buildings inspired by the architecture of ancient Rome and Renaissance Florence. The most easily

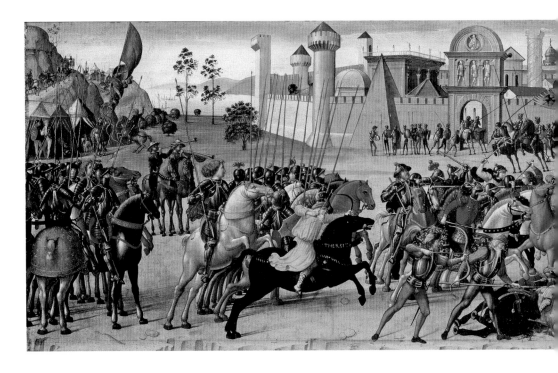

51–2. Biagio d'Antonio, *The Siege of Troy: The Death of Hector* and *The Wooden Horse*. Cambridge, Fitzwilliam Museum.

recognizable are the simplified versions of the Pantheon in Rome and the Duomo (Cathedral) in Florence, both with their characteristic domes. Therefore, even though the painting depicts the most tragic moment in the history of Troy—the total ruin of the city, King Priam and his people—there was no objection to an anachronistic reference to two cities of the future. This original note puts the scenes in a broader context. Troy is destroyed by flames, but the history of that pagan culture lives on. The only one who manages to flee the burning city is none other than Aeneas, the founder of the *gens Iulia* and thus the forefather of Roman civilization.[102]

First Troy, then Rome, now Florence: for many decades ancient Rome had been a shining example to the Florentine city-state. This had been the central theme of Leonardo Bruni's *Laudatio Florentinae urbis* ('Eulogy of Florence'). Bruni linked the city's outward beauty to its inner political structure and the "natural genius, prudence, politeness and magnificence" of its inhabitants—inhabitants who stemmed from the Romans, who "surpass by a long way all mortals in every sort of virtue". In Bruni's view, Florence had been founded in the latter years of the Roman Republic. After Bruni, the myth of Florence as the new Rome continued to haunt the Florentines. It was precisely in the 1480s, when the city was experiencing a new heyday, that the comparison with ancient Rome became topical. The decoration of the chapel in Santa Maria Novella, Giovanni Tornabuoni's largest commission, also touches upon this theme. The inscription speaks for itself: AN(no) MCCCCLXXXX QVO PVLCHERRIMA CIVITAS OPIBVS VICTORIIS ARTIBVS AEDIFICIISQVE NOBILIS COPIA SALVBRITATE PACE PERFRVEBATVR ('In the year 1490, when the most beautiful of cities, famed for its riches, victories, arts and buildings, enjoyed wealth, health and peace'). The fresco in which this inscription is incorporated, the *Annunciation to Zacharias*, is so rich in quotations from the architecture and sculpture of ancient Rome that no viewer could fail to see the link between Florence and the Eternal City.[103]

In Lorenzo's 'beautiful chamber' the admiration of classical civilization was thus visualized in a wide variety of ways without detracting from the purely literary qualities of the painters' sources. The cycle depicting the story of Jason and the golden fleece convincingly evokes the fairy-tale atmosphere of the Greek *Argonautica*, whereas the dramatic scenes of the Trojan War stress the Greek ideal of excellence. In addition, there are scores of visual references to ancient Rome. The ability to draw in this way upon the sources of classical culture testifies to the broad vision of the ancient world flourishing at this very time in Renaissance Florence.

But the history of humanity did not stop with the Greeks and Romans, as every fifteenth-century Florentine knew. After all, what moment in history had been of more far-reaching consequence than the coming of Christ? If there is one theme that aptly illustrates the transition from pagan to Christian culture it is the adoration of the Christ Child by the 'wise men from the East'. Italian painters were obsessed with this theme, which they welcomed as an opportunity to demonstrate their own inventiveness in depicting an imaginative setting, splendid clothing and a wealth of costly gifts. Yet even the most exuberant of artistic creations never ignored the promise of salvation. From the moment the pagan wise men, whom tradition had dubbed kings, paid tribute to Jesus, it was clear that the Saviour had come to save all mankind. Since antiquity, the Epiphany has exerted an enormous appeal as the embodiment of the idea that Christ was the first to unite humanity, abolishing all boundaries and bringing barbarians and Romans together in a single Church.

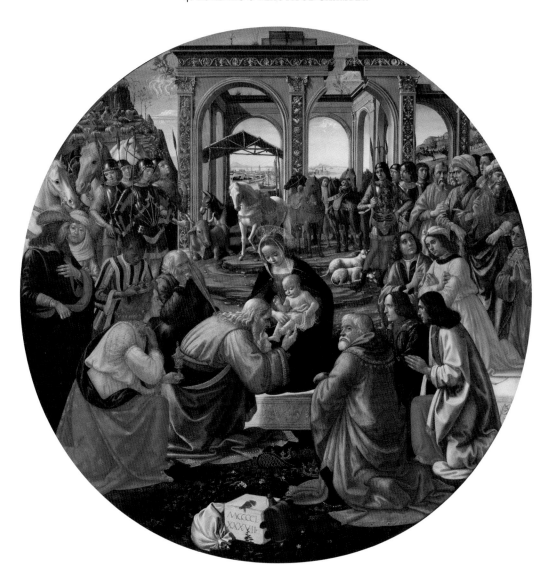

53. Domenico Ghirlandaio, *Adoration of the Magi.*
Florence, Uffizi.

Many fifteenth-century representations of the Adoration of the Magi refer to the transition from the pagan to the Christian era. So, too, Ghirlandaio's magnificent tondo, about five feet in diameter, which was the crowning glory of Lorenzo's chamber (fig. 51). According to a popular legend, Mary and Joseph had sought shelter near the ruins of King David's palace in Bethlehem. Here the ruins assume the form of a classical temple, thus referring to all ancient religions. Rising up in the midst of the debris is the simple stable in which Christ was born, symbolizing the dawning of the New Age. Mary and the Christ Child sit, moreover, on an ancient architectural fragment. Ghirlandaio took great trouble to give visual expression to the continuity between the old world and the new, and to ensure that the Christian representation formed a whole with the *cassone* panels and the *spalliere* featuring the heroes of antiquity. Ghirlandaio's composition is teeming with soldiers in armour; seldom are so many warriors seen in the retinue of the Three Wise Men; in addition, Ghirlandaio included numerous Orientals and at least two, but possibly three or four, lifelike portrayals of contemporary people. More than thirty figures have been deftly deployed in this circular composition, but the ingenious use of perspective and the wealth of colour prevent any sense of crowding.[104]

This bravura piece is therefore a deliberate display of Ghirlandaio's extraordinary artistic abilities, yet he, too, gives his undivided attention to the holy event. The Christ Child appears in the exact centre of the panel; the Three Kings are ready to shower him with gold, frankincense and myrrh. The eldest of the three bends over, seemingly in order to kiss Christ's feet—an expression of devotion often seen in such representations. In fifteenth-century Florence this ritual was performed on special occasions organized by a distinguished lay brotherhood, the Compagnia dei Magi. During the first decades of its existence, the brotherhood held splendid processions, of which Benozzo Gozzoli's frescoes in the chapel of the Palazzo Medici are an indirect reflection. In the late 1460s the brotherhood concentrated on organizing private gatherings devoted to spiritual exercise and mystical forms of devotion. A sermon delivered on Good Friday by Giorgio Antonio Vespucci contains an interesting variation on the theme of worshipping the feet of Christ. The members of the Compagnia dei Magi were urged to kiss the feet of Christ on a crucifix: "Let us go promptly to kiss his most holy feet". Thus inner experience and outward ritual were mutually reinforcing.[105]

In Ghirlandaio's painting, Caspar—the youngest of the Three Kings—is also strikingly portrayed. Wrapped in a richly ornamented cloak of bright red, he offers a golden receptacle to Christ, while a page removes his crown: this, too, is an expression of humble, unconditional devotion. The Epiphany provided suitable opportunities for highly placed and well-to-do individuals in particular to express their devoutness by having themselves portrayed as Wise Men, the paragons of Christian piety, and for that reason portraits of contemporary individuals were regularly included in scenes of the *Adoration*. A well-known example is a miniature from the Hours of Philip of Burgundy, in which Caspar wears fifteenth-century attire and displays the facial features of Philip himself. Ghirlandaio's *Adoration* contains a more subtle form of identification: Caspar's red cloak sports Lorenzo's personal emblem, namely the bundle of flames that likewise adorned the gown of Philosophy in the Botticelli fresco. The relationship between Caspar and Lorenzo is based on the principle of *imitatio*, the pagan king serving as an example to the Florentine youth. Together with Melchior and Balthasar, Caspar initiates the highest and purest form of wor-

ship—*adoratio*. Moreover, the philosopher-kings' devotion to Christ allows them to attain the purest spiritual understanding. The pursuit of moral perfection as a leitmotif in the life of young Lorenzo is thus given an added dimension.[106]

A number of factors ultimately combined to produce the magnificence of Lorenzo's chamber. The art works were commissioned during the so-called Laurentian Age, or time of Lorenzo de' Medici, when a specific, intensely experienced form of cultural optimism prevailed, traces of which can be found elsewhere in Florence as well. The Sassetti Chapel in the church of Santa Trinita—a stone's throw from the Palazzo Tornabuoni—is just such a place, an admirable example of the harmonious intermingling of ancient and Christian cultures. Completed between 1482 and 1485, its decoration was commissioned by a patron we have already encountered: Francesco Sassetti, whose background and interests were very similar to the Tornabuoni's. In the city of Lorenzo de' Medici, the myth of a Golden Age had again taken hold. In a famous *Eclogue* (4), Virgil had written that the return of the *aurea aetas* would be heralded by the birth of a child. From late antiquity this prophecy had been projected onto modern, Christian civilization, adding new connotations to the myth. The theme was of particular interest to the humanists, who devoted a great deal of intellectual energy to proving the cultural continuity between the ancient world and that of fifteenth-century Italy. In 1481, after the Florentines and the pope had settled a political dispute, the Dante scholar Cristoforo Landino expressed the hope that true Christian faith would inspire good governance and conduct in Florence, so that everyone could echo Virgil's words: "Now the Virgin returns, the reign of Saturn returns".

Nine years later, the conviction that the city on the Arno was in fact experiencing a Golden Age was aptly expressed in the previously quoted inscription in the Tornabuoni Chapel. Civic pride and cultural optimism went hand in hand. The active political propaganda surrounding the person of Lorenzo de' Medici caused the old myth to spread even faster. More and more citizens, including Giovanni and Lorenzo Tornabuoni, shared a faith in the power of their own culture. Classicism, simplicity of form, beauty, spiritual enlightenment and a blithe devotion to life itself: these are the values so compellingly evoked by the art in Lorenzo's beautiful chamber.[107]

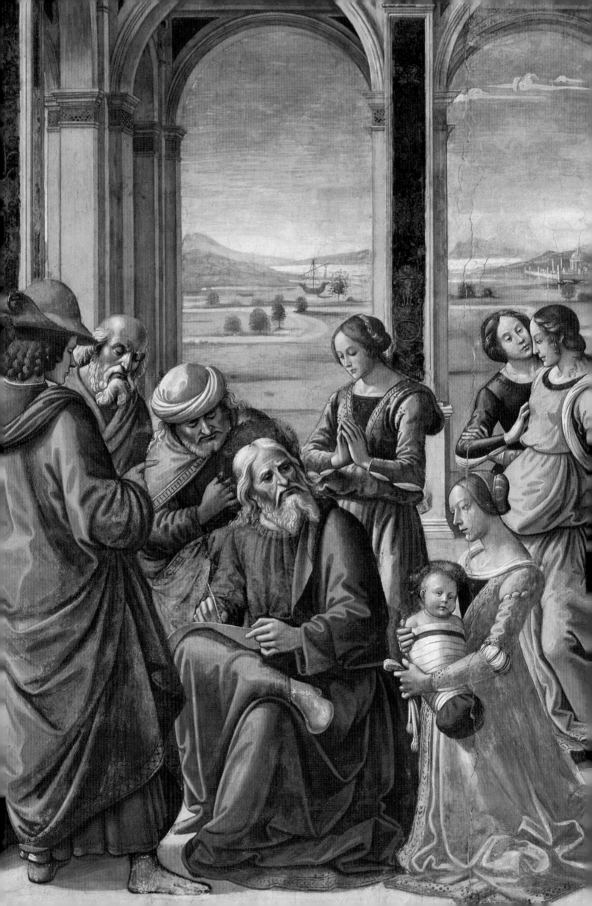

CHAPTER 5

The vicissitudes of fortune

During the first year of Lorenzo and Giovanna's marriage, numerous works of art were produced whose splendour testifies to remarkable optimism. The birth of a son was, of course, a momentous occasion. The hope that Giovanna would give the Tornabuoni family an heir had been voiced at the wedding. That wish was fulfilled on 11 October 1487, when eighteen-year-old Giovanna gave birth to a boy. Named after his grandfather, he was long called by his pet name, Giovannino.

Apart from extremely short entries in the so-called *Libri d'età* and the Baptistery registers, no records have survived to tell us about Giovannino's entrance into the world, but the lack of written sources is compensated for by the solid traces his birth left in the visual arts. This is hardly surprising, because the birth of Giovannino was of crucial importance to both Giovanni and Lorenzo. The continuation of the male line was perhaps the greatest concern of a family that had amassed a large fortune. When this son was born, the Tornabuoni were elated, and their feelings of pride and joy found expression in the monumental commission for which they will always be remembered: the magnificent main chapel in the church of Santa Maria Novella (fig. 55), the decoration of which was already well under way in late 1487.[108]

There is no doubt that the Tornabuoni Chapel is one of the most impressive artistic ensembles in the city of Florence. It features the famous frescoes by Domenico Ghirlandaio, which depict scenes from the life of the Virgin Mary and John the Baptist. To complement the murals, the decorative campaign provided for wooden choir stalls with intarsia panels after designs by Giuliano da Sangallo and three stained-glass windows, as well as a monumental altarpiece that was installed in the middle of the chapel, between the nave and the choir. The choir stalls and stained-glass windows are still *in situ*, and even though the original altarpiece was dismantled and replaced by an ostentatious marble altar, the overall effect is still magnificent.[109]

Exhaustive research has been carried out on the conception of the decorative programme. When the Palazzo Tornabuoni was more or less finished, Giovanni turned his at-

tention to the acquisition and stylish decoration of a family chapel in Santa Maria Novella. The late-medieval church with a Renaissance façade designed by Leon Battista Alberti was located in the White Lion district, at walking distance from the Palazzo Tornabuoni. To begin with, Giovanni had to obtain the rights of patronage to the entire chapel, which was no small matter, since over the years the friars had granted those rights to three different families: the Tornaquinci, the Sassetti and the Ricci. The latter family had long-standing burial rights they were loath to relinquish. Giovanni Tornabuoni was also afraid of competition from Francesco Sassetti—manager of the Lyons branch of the Medici bank—who insisted on retaining the right (granted him in 1470) to decorate the high altar. Giovanni Tornabuoni exerted what influence he could, but proceeded with caution. On more than one occasion, he generously donated such things as wax candles and liturgical vestments to the Dominican friars of the convent of Santa Maria Novella. He also became a member of the Compagnia dei Laudesi, the lay confraternity devoted to St Peter Martyr, whose headquarters were in an oratory next to the convent church. His strategy included stressing his descent from the Tornaquinci, who in the thirteenth century had contributed substantially to the convent's founding.[110]

In 1485 Giovanni took a decisive step towards achieving his goal: presenting himself as a patron of the arts, he entered into a written agreement with Domenico Ghirlandaio to paint the side walls and vault of the chapel. By asserting his "undisputed rights of patronage" to the *cappella maggiore*, he pre-empted the claims of other families. In the notarial act Giovanni is described as "a magnificent and generous citizen" who had set himself the goal of embellishing the chapel at his own expense, "to the praise, magnitude and honour of Almighty God and his glorious Mother, ever Virgin, and of St John, St Dominic and other saints as detailed below, and of the whole host of Heaven". Giovanni described his motives as "piety and love of God" and the exaltation of his house and family: aspirations, both spiritual and worldly, that were a profound part of his character and thus the source of deeply felt convictions. Domenico Ghirlandaio was given clear instructions as to which scenes to paint and where, and specific recommendations regarding the use of pigments. Remarkably, Giovanni asked the artist explicitly to paint not only figures but also "buildings, castles, cities, villas, mountains, hills, plains, rivers, rocks, garments, animals, birds and beasts". This exhortation to incorporate an abundance of motifs in the decoration of the chapel could be taken as an incitement to strive for the *varietas* advocated by Alberti in his *De pictura*. Giovanni was so well-informed about the visual arts that he instinctively knew how to stimulate Ghirlandaio's artistic imagination. The two men were, after all, no strangers to one another. The commission to decorate the Sistine Chapel had first brought them together, and they shared an admiration for the architecture and sculpture of ancient Rome. The result was a unique dialogue between artist and patron.[111]

This written agreement with Florence's most skilful fresco painter was undertaken to impress the friars, but was itself instrumental in securing the rights of patronage to the entire chapel. While Ghirlandaio was allowed to make a cautious beginning, Giovanni continued to press the friars to give his plans their formal approval. On 1 September 1486, two days before the wedding of Lorenzo and Giovanna, Giovanni made yet another generous donation in his capacity as *capitano* of the confraternity: he presented the convent with large wax candles weighing altogether 203 *libbre* (more than one hundred kilos). Finally, on 13 October 1486, the Dominicans of Santa Maria Novella granted Giovanni and his

54. [p. 90] Domenico Ghirlandaio and assistants, *The Naming of the Baptist*, detail (→ 57).

55. [p. 93] Florence, Santa Maria Novella, main chapel.

56. Domenico Ghirlandaio and assistants, *Adoration of the Magi*, detail.
Florence, Santa Maria Novella, main chapel.

57. [pp. 96–7] Domenico Ghirlandaio and assistants, *The Naming of the Baptist*.
Florence, Santa Maria Novella, main chapel.

consorteria the legal rights of patronage to the chapel. In the following years Giovanni also secured the rights to the chapel's stained-glass windows and high altar, to which separate rules and regulations applied.

Altogether it took over four years to execute the frescoes. Ghirlandaio began to paint the cross-vault of the chapel and one of the lunettes. He then turned to the left wall, where in 1487 and 1488 he painted six scenes from the life of the Virgin Mary, distributed over three registers. In one of the first scenes—in the fresco technique, one worked from top to bottom—we find concrete proof of this dating. The *Adoration of the Magi* features a giraffe in the background (fig. 56). This is the animal described as "very large, very beautiful and pleasing", which was presented by the sultan of Egypt's envoy to the Signoria, the governing body of Florence, on 18 November 1487. Since their arrival the previous week, the envoy and his delegation had caused quite a stir among the Florentines, for they had brought along not only the giraffe but also, as enthusiastically reported by the chronicler Luca Landucci, "a big lion, and goats and wethers, very strange". Regarding the giraffe, Landucci added: "What it looked like can be seen in various wall paintings in Florence". Finally, the right wall of the chapel was filled with scenes from the life of St John the Baptist, executed largely in 1489–90. The unveiling took place on 22 December 1490, which is the date legible on the last completed scene, the *Annunciation to Zacharias* (fig. 62).[112]

A certain amount of dynamism is always inherent in such extensive commissions, and in this case it was substantially heightened by the circumstances. Between 1 September 1486 —the date of the contract with Ghirlandaio—and December 1490, Giovanni had gradually succeeded in increasing his legal rights to the chapel. Equally important, however, is the fact that the commission was carried out in the crucial years in which Lorenzo and Giovanna married and Giovannino was born, which resulted in iconographic adjustments to the composition of the fresco cycle. It is likely that thematic modifications were discussed in advance with the erudite friars of Santa Maria Novella, who attached a great deal of importance to the theological consistency and profundity of the fresco cycle. The Dominicans were, after all, the traditional keepers of the most extensive theological systems, as formulated by such thinkers as Thomas Aquinas. Giovanni managed nonetheless to give distinct expression to his own preferences, for as soon as important changes took place in his own life, he did not hesitate to exert his influence as the patron. The birth of his grandson Giovannino was one such change. With true feeling for decorum, Giovanni found suitable ways of expressing his personal pride by having the painter introduce appropriate allusions. The references, which are subtly incorporated in the biblical story, do not detract from the general tenor of the cycle.[113]

The original contract stipulated that the third and fourth scenes on the right wall follow this sequence: "tertia, Nativitatis Santi Iohannis Batiste; quarta, Santi Iohannis euntis in desertum" ('third, the Nativity of St John the Baptist; fourth, St John in the Desert'). At the request of Giovanni Tornabuoni, however, an episode was inserted to allude to the birth of Giovannino: the *Naming of the Baptist* (fig. 57) took the place of *St John in the Desert*, which was moved to the back wall of the chapel. In the *Naming*, Ghirlandaio focused on the moment when Zacharias "asked for a writing table, and wrote, saying, His name is John. And they marvelled all" (Luke 1:63).[114]

There is lively interaction among the figures. Watching intently as a midwife tends the newborn child, Zacharias commits his words to paper. Curious onlookers take in the

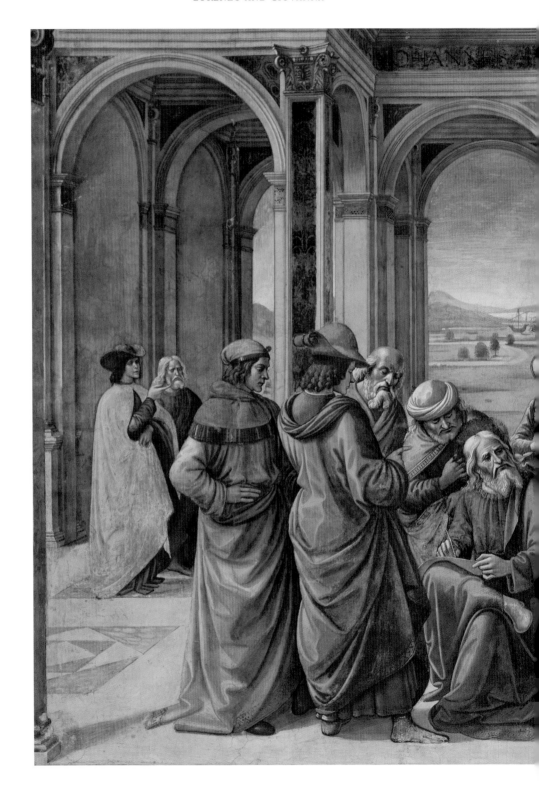

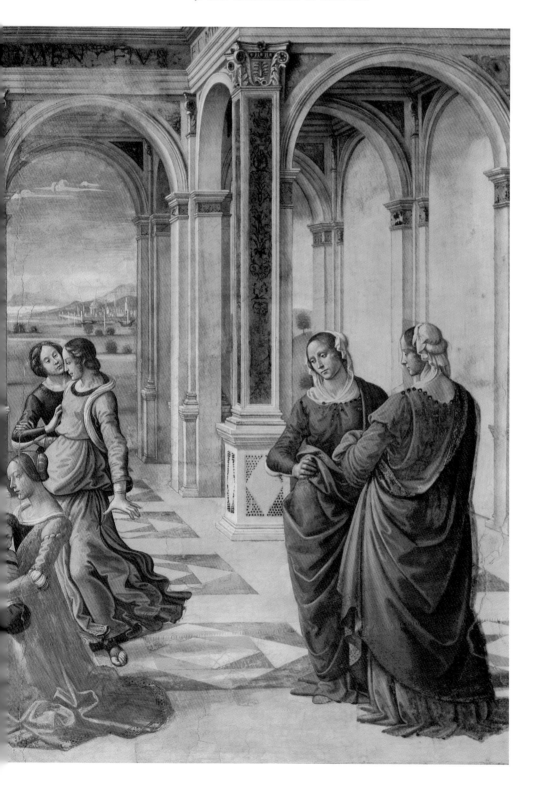

scene. They will presently be astonished to read the text, for the name John—meaning 'God is gracious'—implies that the child was given his name by divine intervention even before his birth. Ghirlandaio did not incorporate any contemporary portraits (at least not any recognizable ones) in this composition. The relation between past and present is only hinted at. The subject alone was sufficient for Giovanni to emphasize the special ties to his own name saint and that of his grandson. Moreover, the biblical scene evokes feelings of gratitude and joy. At the annunciation of the birth of John, Zacharias was told by the angel Gabriel that "thou shalt have joy and gladness; and many shall rejoice at his birth" (Luke 1:14). Zacharias was subsequently struck dumb, "until the day that these things shall be performed" (Luke 1:20), but after he had written the name John, he could speak again. He immediately broke into a song of praise, namely the famous *Benedictus*, the prophecy adopted by the Church as a hymn, which was especially popular among the Dominican friars.[115]

The adjacent representation, the *Nativity of St John the Baptist* (fig. 59), evokes the atmosphere of fifteenth-century Florence. The scene, which is situated in a contemporary interior, refers to an important ritual of Florentine social life: when an upper-class woman gave birth to a child, she was visited during her confinement by female friends and relatives who were received with all due respect and ceremony. The house and the room in which she had given birth were specially fitted out for the occasion. The congratulatory visit offered those invited the chance to wear the most beautiful clothes and the costliest jewellery. It was also customary to bring gifts to the young mother. The proprieties were strictly observed. Such visits could provide an occasion to strengthen political ties between prominent families; not infrequently, the husband supervised the proceedings. The well-to-do attached so much importance to the congratulatory visit that the ritual developed into an independent subject in profane painting in Tuscany. Masaccio was one of the most gifted practitioners of the genre (fig. 58). The power of this pictorial tradition allowed Ghirlandaio to blend the sacred and the profane in the *Nativity of St John the Baptist*.

Ghirlandaio's depiction, painted in warm hues, is at once intimate and solemn. Elizabeth sits upright in her wooden bed, which is placed on an elevation, according to Florentine custom. In the foreground, the infant John the Baptist is tended by two wet nurses, one of whom suckles him. On the right we see three visitors in fifteenth-century attire—three sophisticated ladies of various ages. The youngest woman in particular is sumptuously dressed. Ghirlandaio succeeded admirably in combining contemporary and biblical figures to form a harmonious and symmetrical composition. Entering the room at the far right is, surprisingly, a young woman with the grace of a classical goddess, dressed in a light blue gown. This figure prompted the following descriptive outpouring in a letter written by the cultural historian André Jolles—Johan Huizinga's friend—to his colleague Aby Warburg: "Behind them [the three visitors], close to the open door, there runs—no, that is not the word, there flies, or rather there hovers—the object of my dreams, which slowly assumes the proportions of a charming nightmare. A fantastic figure—should I call her a servant girl, or rather a classical nymph?—enters the room, bearing on her head a bowl of glorious citrus and tropical fruits, and wearing a billowing veil". Aby Warburg considered the classical nymph to be the perfect expression of a new, Dionysian outlook on life. One does not necessarily have to share this view to interpret the elegant figure balancing a platter of fruit on her head as a symbol of fertility, prosperity and abundance—symbolism that was highly appropriate to the birth of Lorenzo and Giovanna's first child.[116]

58. Masaccio, *Birth Scene*.
Berlin, Staatliche Museen, Gemäldegalerie.

59. [pp. 100–1] Domenico Ghirlandaio and assistants, *Nativity of St John the Baptist*.
Florence, Santa Maria Novella, main chapel.

60. [p. 105] Domenico Ghirlandaio, *Portrait of Giovanna degli Albizzi*.
Madrid, Museo Thyssen-Bornemisza.

Not long after the birth of Giovannino, Giovanna again became pregnant, but before she could be delivered of her second child, she fell ill and died in October 1488, at the age of nineteen. The family was grief-stricken, and there was widespread dismay among friends and relatives, including the numerous families with whom the Tornabuoni and the Albizzi maintained relations. Giovanni and Lorenzo saw to it that Giovanna was buried with due ceremony in Santa Maria Novella. She was given a last resting place near the chapel, the decoration of which was well advanced. Few were given such pride of place. A mass was also sung in her honour, during which an exceptionally large number of candles were lit.[117]

At least two poems were written to mark Giovanna's death. Politian, a friend of the family, expressed his sympathy in an epigram intended as an epitaph:

> By birth, beauty, child, wealth and husband
> I was fortunate, and also by talent, character and mind.
> But during the next birth and the next year of marriage
> Alas! with my offspring not yet born I perished.
> That I might die more sadly, treacherous Fate held out to me
> Many more favours than it actually bestowed.

As usual, Politian drew inspiration from the classical authors, who saw human mortality as the strongest manifestation of Fate. It is often assumed that Politian's poem was inscribed on Giovanna's tomb. This is uncertain, however, since her tombstone has not been preserved, nor is it mentioned in the oldest guide to Florentine tombs, Stefano Rosselli's *Sepoltuario Fiorentino* of 1657.

Lorenzo also wrote a poem in the form of an epitaph shortly after the death of his beloved wife. This rare expression of grief appears on the last page of the short but precious manuscript containing Naldo Naldi's nuptial poem. Lorenzo himself recorded the poem, for which he chose, like Politian, the form of the epigram:

> Epigram by Lorenzo Tornabuoni upon the death of his wife Giovanna.
> The Graces gave her wits and Venus beauty,
> The goddess Diana granted her a chaste heart:
> Here lies Giovanna, honour of the fatherland, descendant of the Albizzi,
> But married, while a young maid, to a Tornabuoni,
> Much loved by the people during her life,
> Now cherished by the highest God.[118]

Lorenzo's poem is permeated with the desire to commemorate Giovanna in as worthy a manner as possible. In comparison with Politian's epigram, Lorenzo places less emphasis on the cruelty of fate and more on Giovanna's supreme beauty and virtue, and also voices the conviction that God will have pity on the soul of his beloved wife.

The death of his wife, the mother of his only son, continued to occupy Lorenzo's mind. Precisely one year after Giovanna's death, he made a payment—which he later repeated—for candle wax and a sung mass. In 1489–90, Giovanna was prominently depicted in the mural of the *Visitation* in the family chapel in Santa Maria Novella, at the head of a group of female spectators (fig. 63). One of the underlying themes of this scene is the continued

alliance of husband and wife after death. Lorenzo also decided to commission a posthumous portrait of Giovanna, intended to hang permanently in the Palazzo Tornabuoni. It was not the first time that the death of a bride-to-be or wife prompted the commission of a piece of art. Indeed, the volume of poetry commemorating Giovanna's eldest sister, Albiera, mentions a marble bust made after her death. Lorenzo, however, preferred a painted likeness by the hand of Domenico Ghirlandaio (fig. 60).[119]

The 1498 inventory describes the painting as follows:

> In the *chamera del palcho d'oro* … a panel with a gold frame with the head and bust of Giovanna degli Albizzi.

The "chamera del palcho d'oro"—a room with a wooden ceiling featuring gilt decorations—was near Lorenzo's room and might originally have served as Giovanna's reception room. Happily, the portrait has survived the centuries and is in exceptionally good condition, its bright colours still showing to advantage. Even the most delicate brushstrokes are still visible.[120]

ARS VTINAM MORES | ANIMVMQVE EFFINGERE | POSSES PVLCHRIOR IN TER|RIS NVLLA TABELLA FORET | MCCCCLXXXVIII ('O Art, if you could portray character and mind, no painting on earth would be more beautiful, 1488'): thus reads the *cartellino* painted in the background. This touching utterance quotes the two closing lines—with the original *posset* changed to *posses*—of an epigram by the Latin poet Martial in which he describes a portrait of his friend Marcus Antonius Primus and ponders the question of what can and cannot be expressed by a work of art.[121]

This admittedly minor adjustment to Martial's verse gives the text far greater immediacy. The inscription addresses art itself, considerably heightening the paradox inherent in the closing lines. The viewer is reminded that Giovanna's admirable qualities, demonstrated during her lifetime, can scarcely be captured in a picture. At the same time, however, another message is conveyed: just look at what the art of painting can do! With this work Ghirlandaio was convinced that he had surpassed every portraitist of his time and had even outdone the poets who sang the praises of feminine beauty.

The portrait of Giovanna is indeed spellbinding. Particularly fascinating is its combination of two- and three-dimensionality. Giovanna's profile stands out clearly against the dark background, but inside its contours, the play of light and shadow is extremely subtle. The modelling of her face is breathtakingly confident. Small amounts of red paint sufficed to give Giovanna a soft bloom and to highlight her lips. Giovanna's golden hair, which was painted with the tip of the brush, is put up in such a way as to reveal her neck almost completely. The depiction of her costly clothing is also very refined, especially the rendering of the fabric's texture. Her gleaming dress of gold brocade displays at shoulder height her husband's initial and the diamond-shaped symbol of the Tornabuoni. Both her clothing and the costly pendant typify Giovanna as the "incomparable" wife of Lorenzo. A similar pendant—estimated to be worth between 100 and 120 florins—is described in Giovanni Tornabuoni's will of 26 March 1490 and in a receipt dated 25 February 1493 relating to the dowry of Giovanni's younger daughter Ludovica, who a few months earlier had married Alessandro di Francesco Nasi. In all likelihood this was the same pendant that Lorenzo had given Giovanna upon their betrothal in 1486. After Giovanna's death, it was no

doubt passed on to Ludovica, thus ensuring that this valuable piece of jewellery remained in the Tornabuoni family.[122]

Giovanna's face and bust are portrayed life-size, which lends the image a strikingly real appearance. At the same time, however, her portrait is highly stylized, as evidenced by the strict *mise en page* and her elongated neck. In his striving to make Giovanna's likeness as beautiful as possible, the painter did not overlook the ideal of beauty as described by classical and courtly poets: a straight and stately posture, white skin, blonde hair and thin lips were popular literary topoi.[123]

What Ghirlandaio envisaged was a combination of grace and captivating dignity. A female likeness *en profil* was associated with purity and distinction: purity by virtue of its similarity to the Christian donor portrait, distinction through its relation to Roman portrait medals. Furthermore, the painter surrounded Giovanna with a few, carefully chosen objects—objects which had actually belonged to her but also possessed symbolic value. On the plinth, at the height of Giovanna's bosom, lie a brooch (on the left) and a closed book (on the right). The brooch refers to the worldly side of Giovanna's existence. It was precisely this kind of jewellery—pendants, rings, pins—that women were given as counter-*donora* by their husbands. The volume on the right can only be the "little book of Our Lady"—used to fill the daily hours of prayer and meditation—which Giovanna brought along when she moved into the Palazzo Tornabuoni in September 1486. It was one of the costliest items her father gave her and among her most cherished possessions. Here it serves to keep the worldly and religious spheres in perfect balance.

In the small alcove a string of red coral beads hangs from a high wooden plinth. Even though Giovanna's trousseau included "a string of paternosters", it is not likely that Ghirlandaio painted a rosary, as is sometimes maintained. Rosaries were—already in those days—of a different composition, having ten small beads alternating with one large one, so that an Ave Maria could be said at each small bead and the Lord's Prayer at each large one. Moreover, Giovanna's paternosters were gilt and partly enamelled, so it is more likely that the coral beads depicted here served another purpose altogether, for this rare stone was said to be imbued with a magical effect, namely the ability to ward off evil. The string-of-coral motif also features on *deschi da parto*, or birth trays. Occasionally putti wear coral chains, and sometimes they are seen on newborn children—as in Masaccio's *Birth Scene* (fig. 58)—preserving such vulnerable beings from illness and death. In Giovanna's portrait, the string of coral must be viewed from a different perspective, since her earthly existence had already come to an end. This chain expresses not a wish, but a confirmation: during her lifetime, the virtuous Giovanna was untouched by evil. As in the work of the Flemish painters, the attributes are unobtrusive. They lie or hang motionless in the niche, and do not detract from the radiance of the woman to whom this portrait pays homage: 'O Art, if you could portray character and mind, no painting on earth would be more beautiful'.[124]

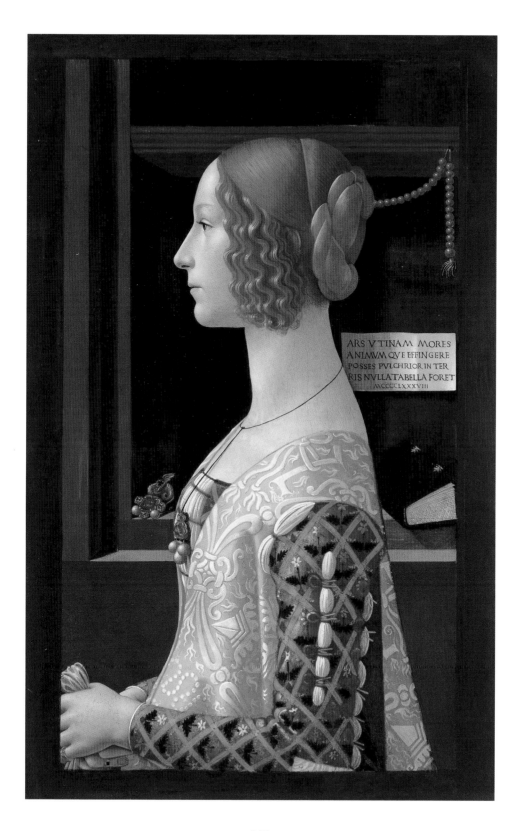

ARS VTINAM MORES
ANIMVM QVE EFFINGERE
POSSES PVLCHRIOR IN TER
RIS NVLLA TABELLA FORET
MCCCCLXXXVIII

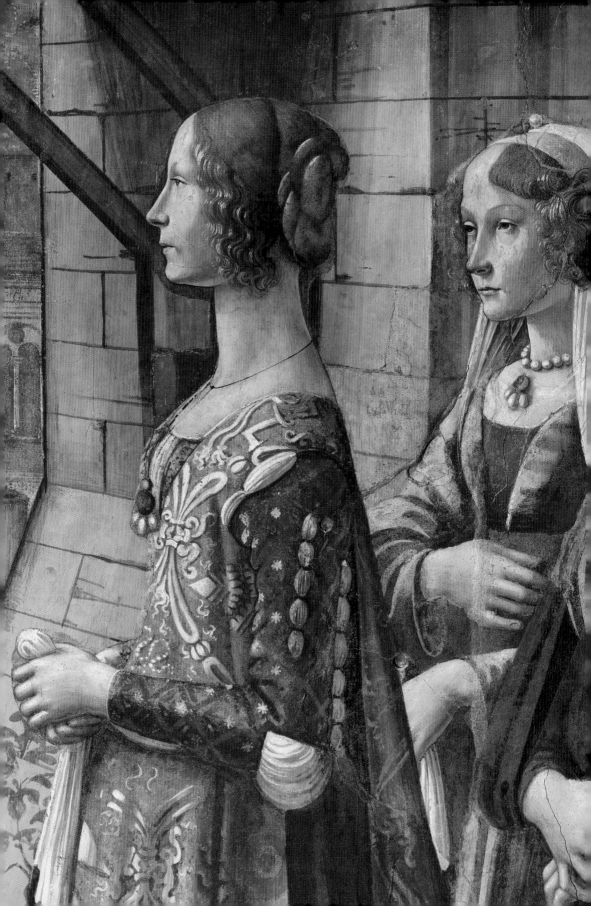

CHAPTER 6

The hope of eternal life

When Domenico Ghirlandaio accepted the commission to decorate the chapel in Santa Maria Novella, he took on an immense task—the decoration of more than three hundred square metres (the walls and the high cross-vault) with monumental yet detailed frescoes— which he was expected to complete in only a few years. He managed to do this by enlisting the help of assistants and pupils. Among Ghirlandaio's regular collaborators were his own brother David and Sebastiano Mainardi, but he also sought the cooperation of talented young artists who were still relatively unknown. In 1488 one of these was none other than Michelangelo Buonarroti, but he soon escaped the workshop. For an ambitious and temperamental artist like Michelangelo, Ghirlandaio's studio was, to be sure, an excellent school, but not a place to stay for any length of time.[125]

Ghirlandaio's workshop was particularly well organized and capable of handling large commissions; in Santa Maria Novella, however, the artist maintained strict supervision of the proceedings. As was customary in Florence, Ghirlandaio chose the most durable painting technique, *buon fresco*. Because the best effects could be achieved only by applying the paint to wet plaster, the fresco was applied a section at a time. It is known that the right wall of the Tornabuoni Chapel was decorated in 187 *giornate*, or days of work. These shifts coincided exactly with the contours of sections of the murals, so that the seams did not mar the paintings. To ensure that his assistants followed his ideas precisely, Ghirlandaio provided them with *cartoni*: large sheets of paper stuck together, which contained carefully worked-out compositional drawings in the same format as the paintings. By no means did he farm out all the brushwork, however. Ghirlandaio wanted to be certain that everyone entering the chapel would be amazed by the quality of the frescoes, which is why those on the lowest registers are the most refined in terms of finish, chiaroscuro and palette. Their unparalleled aesthetic quality is the result of the master's touch.[126]

On the lower register of the right wall we see on the right-hand side the *Annunciation to Zacharias*, which takes place in the temple to which he has brought an offering of incense (fig. 62). The temple, an ingenious edifice in classical style, is made of various types

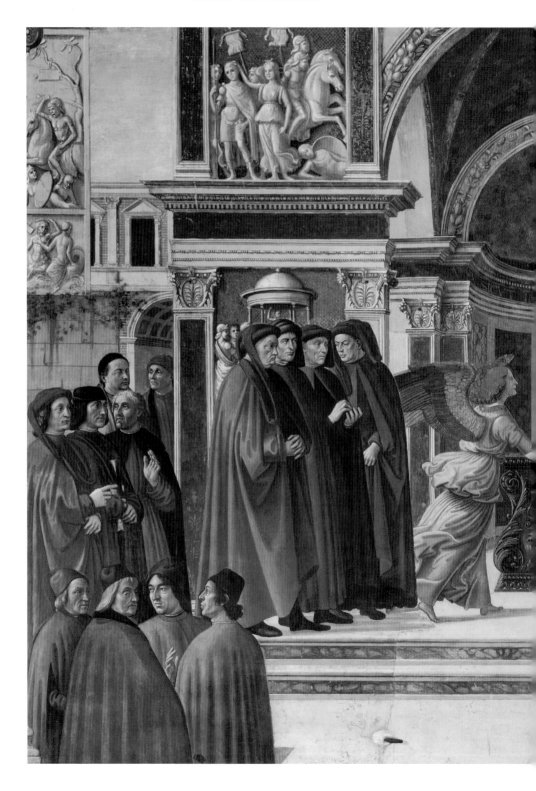

of marble. The reliefs were also inspired by Roman examples. While the multitude is pray-
ing outside, Zacharias is unexpectedly accosted by the angel Gabriel. The refined use of
colour and perspective draws the viewer's gaze into the picture by degrees. The heavenly
messenger is dazzling: when Gabriel, with his angelic countenance and colourful wings,
approaches the altar, Zacharias is startled. Turning around, he is overcome by fear. The
multitude consists of a select host of Florentine citizens. Here Ghirlandaio painted, very
precisely indeed, portraits of numerous members of the Tornabuoni family, as well as of
their clan: Girolamo Giachinotti, Pietro Popoleschi and Giovanni Tornaquinci. Grouped
together in the left foreground are four renowned writer-philosophers: Marsilio Ficino,
Cristoforo Landino, Politian and Gentile de' Becchi.[127]

The physical presence of so many well-to-do Florentines does not conflict with the sa-
cred nature of the depiction. On the contrary, those portrayed are directly involved in the
liturgical ritual taking place at the high altar of Santa Maria Novella. The passage from
Psalm 141 (140) inscribed in Roman capitals along the apse of the temple—"Dirigatur ora-
tio mea sicut incensum in conspectu tuo" ('Let my prayer be set forth before thee as in-
cense')—refers to the solemn act performed by Zacharias: it expresses the pious wish of
every Christian, but above all it refers to prayer and sacrifice at the altar. The Psalm was re-
cited or sung during the Offertory, when the bread and wine are presented to God. These
were the words uttered by the priest when incensing the altar and the congregation before
consecrating the elements in the Eucharist. In this way the Tornabuoni, as well as their kin
and kindred spirits, took part in the divine worship celebrated daily by the Dominican fri-
ars in the chapel.

The biblical scene of the *Visitation*, to the left of the *Annunciation to Zacharias*, also in-
cludes true-to-life portraits, though here they are less numerous (fig. 63). This time Gio-
vanna degli Albizzi figures prominently among the bystanders. According to the evange-
list Luke (1:39–45), after the angel Gabriel had departed, Mary "went into the hill country
with haste, into a city of Juda" to visit her cousin Elizabeth. Upon arrival, she greeted Eliz-
abeth, who was six months pregnant with John. "And it came to pass, that, when Elizabeth
heard the salutation of Mary, the babe leaped in her womb; and Elizabeth was filled with
the Holy Ghost". Elizabeth's subsequent laudation ("Blessed art thou among women")
prompted Mary's famous Magnificat. In the Christian tradition, the Visitation is crucial
for a number of reasons. When John moves in Elizabeth's womb, it is the first outward sign
that Mary is the Mother of Christ. The episode, which refers to the establishment of the
New Covenant, highlights the Virgin's role as intercessor for mankind.[128]

In his *Visitation* fresco, Domenico Ghirlandaio demonstrated his natural talent for com-
posing monumental figure paintings. Following the example of Giotto and Masaccio, he
distributed the figures evenly over the picture plane, and also paid considerable attention
to the fluid lines of the elegantly draped clothing. He differed from his predecessors most
clearly in his use of a bright palette and exquisite lighting effects: the entire scene is flood-
ed with light, causing the space to open up. It is generally known that Ghirlandaio was fa-
miliar with Flemish painting: here his interest is revealed not only in the atmospheric ef-
fect, but also in the detail of the figures leaning over a wall, known from the masterpieces
of Van Eyck and Van der Weyden. Within the monumental fresco, the blue and yellow-
gold mantles of Mary and Elizabeth immediately direct the viewer's attention to the cen-
tre of the scene: the posture and expressions of the two women convey the solemn yet in-

timate nature of their meeting. Their movements are less abrupt than in the only preserved preparatory drawing, a rapid pen sketch kept in the Gabinetto Disegni e Stampe degli Uffizi in Florence, and the positioning of the hands is different. In the work of Ghirlandaio, hands are nearly always a primary means of conveying expression. In this composition, in which all the main figures appear at the same height, the hands—which are indeed particularly noticeable—are very delicately rendered.[129]

Depictions of the *Visitation* rarely include portraits on the same scale as those of the two protagonists; here, however, we find three groups of full-length figures. At the far right, Giovanna appears in the company of two women, of whom the elder could be Lucrezia Tornabuoni. Giovanna, the most sumptuously dressed of the three, wears a magnificent, floor-length brocade gown decorated with heraldic motifs. We recognize the stylized L of Lorenzo and the diamond-shaped emblem of the Tornabuoni; the circle visible within the sun may be an allusion to the arms of the Albizzi family. Here, too, Giovanna wears a necklace with the costly jewel which she received on the occasion of her marriage. The women, silent witnesses to the holy event, stand at a respectful distance from Mary and Elizabeth. Even though Giovanna does not fold her hands in prayer (as is customary in donor portraits), she appears to be experiencing the mystery of the Visitation in heart and mind.

Giovanna is one of the key figures in the scene. In all likelihood it was decided early on to incorporate her into the decorative programme, since it would have been unthinkable *not* to include a portrait of Lorenzo's wife. Domenico Ghirlandaio probably made faithful portrait studies of Giovanna as a married woman, but she died before he began working on the lowest registers of the right wall. The meeting of Mary and Elizabeth was actually one of the last frescoes that Ghirlandaio tackled, and then only in the last stages, some time in 1489–90. Giovanna's premature death led to a reconsideration of her place in the whole. The timeless themes of pregnancy and fertility naturally make the *Visitation* a suitable scene in which to insert female portraits. Giovanna had given birth to a male heir—one named John, no less—but from the moment of her death and subsequent interment in Santa Maria Novella, the prime concern was the salvation of her soul. We know, in fact, that in 1491, exactly three years after Giovanna's death, Lorenzo Tornabuoni gave the church money "for the wax used in the chapel", thus ensuring that, at least in the chapel itself, sufficient candles would be lit during the masses said for his wife's soul.[130]

This concern for the fate of Giovanna's soul is expressed in a highly original way in the monumental fresco. According to Christian doctrine, the meeting of Mary and Elizabeth contains a promise, namely that of future redemption—the theme made explicit in the painting. At the far left are three female saints—Mary Magdalene, Mary of Cleophas and Mary Salome—the Three Marys who discovered Christ's empty grave after His resurrection. Luke (24:1–9) gives an evocative and poetic description of that moment: "Now upon the first day of the week, very early in the morning, they came unto the sepulchre, bringing the spices which they had prepared, and certain others with them". They were amazed to find that the stone had been rolled away from the sepulchre, and that Christ's body was no longer there. Perplexed, the women suddenly noticed two men "in shining garments" who told them that Christ's prophecy had been fulfilled: "He is not here, but is risen: remember how he spake unto you when he was yet in Galilee, saying, The Son of man must be delivered into the hands of sinful men, and be crucified, and the third day rise again". The women unexpectedly witnessed this central moment in Christian history.

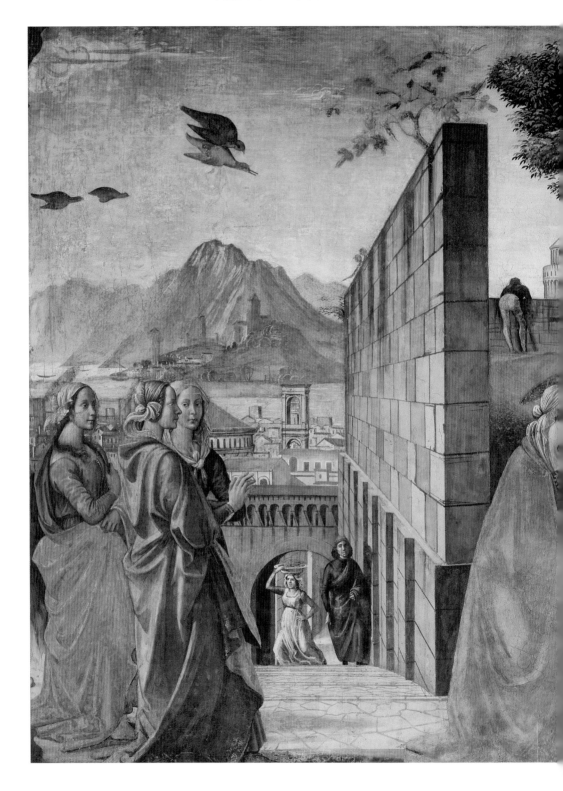

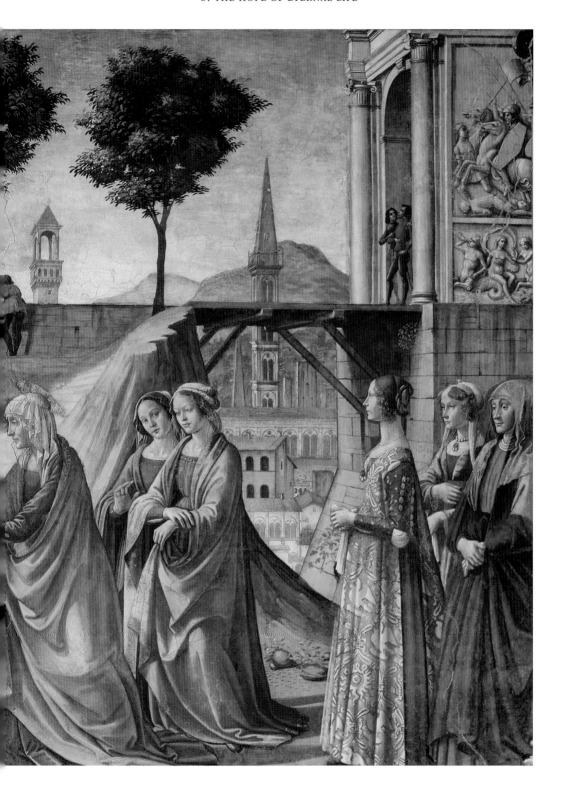

In this capacity the Three Marys are depicted not once but twice in the decorative ensemble of the Tornabuoni Chapel. They also figure on the back of the monumental, freestanding altarpiece, whose central panel features the *Resurrection of Christ* (fig. 64). The altarpiece in question was installed some time between January and April 1494 where the chapel meets the crossing of the church. As Christ rises triumphantly from his sarcophagus-shaped sepulchre, the frightened sentinels take flight. Filtered through classical models, the expression of pathos is thus incorporated in a traditional religious representation, the subject of which is the fulfilment of the prophecy of redemption. Viewers standing in the main chapel are compelled to take note of the Christological perspective of the Visitation scene. The first revelation of Christ heralded the advent of a new world, followed by the Nativity, Christ's Infancy, the Passion, and above all His death for man's sins and His Resurrection—signifying the vanquishing of death.[131]

The theme of the immortality of the soul was therefore of extreme importance in the decoration of the Tornabuoni Chapel. It is possible that the fig branch visible below Giovanna's hands was intended as a symbol of resurrection or revival. For Lorenzo's beloved wife, who had died much too young, there was hope of eternal salvation in heaven, and for Lorenzo, hope of reunion with Giovanna beyond the grave.[132]

The theme of the Visitation recurs in a painted altarpiece made to honour the memory of Giovanna (fig. 66). The painting was made in 1490–1 at the request of Lorenzo Tornabuoni. In the fifteenth and sixteenth centuries, it was highly unusual for a widower to commission a work of art to commemorate his deceased wife. Another rare example can be found in Naples, where the writer and humanist Giovanni Pontano had a splendid chapel built in the classical style, which he dedicated to the memory of his late spouse, Adriana Sassone. Its interior is decorated with inscriptions in classical Latin, including one—LAVRA BELLA—which refers to the pure, ideal love of Petrarch for Laura.[133]

Lorenzo's initiative was part of an ambitious campaign, launched around 1488, to renovate the church of Cestello (now Santa Maria Maddalena de' Pazzi). The church was located in the north-eastern part of the city in present-day Borgo Pinti, in the parish of San Pier Maggiore, not far from Borgo degli Albizzi, where Giovanna's parents lived. Although the Cistercians who lived in the monastery next to the church generally championed austerity, since they belonged to an order that embraced severe asceticism and prescribed daily manual labour and the observance of the rule of silence, they did not object to beautifying the church both inside and out with the financial aid of wealthy families. The vestibule was renovated under the supervision of Giuliano da Sangallo, an expert on Roman architecture and a protégé of Lorenzo the Magnificent. The interior was also adapted to suit contemporary tastes (fig. 65). The monks' decision to renovate the church created new opportunities in Florence to commission works of art that would distinguish patron and artist alike. Young, recently married patricians in particular seized this opportunity with alacrity. In most of the parish churches in Florence the rights of patronage to the chapels and altars were already taken, so the willingness of the Cistercians to make chapels available in Cestello was like manna from heaven. One of the first to take advantage of this new opportunity was Filippo Nasi, Giovanna's brother-in-law, who had often acted as a messenger between Giovanna and Lorenzo during their betrothal. Together with his brother Bernardo, he made funds available for the construction of the chapel in the left aisle closest to the high altar.[134]

61. [p. 106] Domenico Ghirlandaio and assistants, *Visitation*, detail with Giovanna degli Albizzi (→ 63).

62. [pp. 108–9] Domenico Ghirlandaio and assistants, *Annunciation to Zacharias*.
Florence, Santa Maria Novella, main chapel.

63. [pp. 112–3] Domenico Ghirlandaio and assistants, *Visitation*.
Florence, Santa Maria Novella, main chapel.

64. Domenico Ghirlandaio and workshop, *Resurrection of Christ*.
Berlin, Staatliche Museen, Gemäldegalerie.

65. Florence, Santa Maria Maddalena de' Pazzi (formerly church of Cestello),
Tornabuoni Chapel.

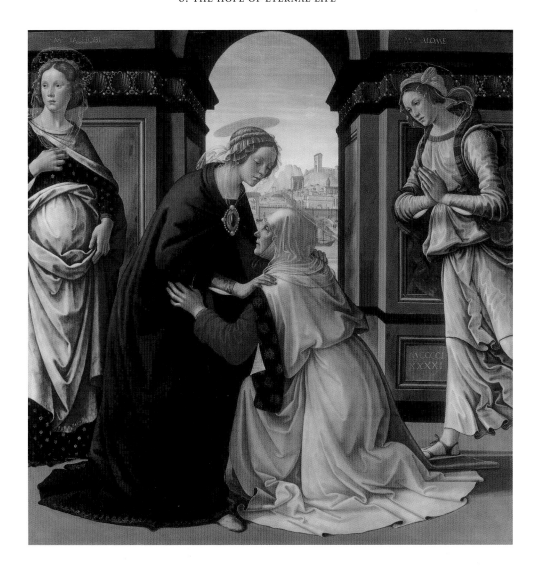

66. Domenico Ghirlandaio, *Visitation with Mary of Cleophas and Mary Salome.*
Paris, Louvre.

67. [p. 119] Girolamo Savonarola, *Tractato del sacramento et de mysterii della messa et regola utile*, title page.

Lorenzo began to focus his attention on the adjoining space. On 8 August 1490, he ordered stonecutters and masons to begin the renovation work. It was not long before the commencement of weekly memorial masses—to last for one hundred years—"particularly and especially for the soul of the wife of the above-mentioned Lorenzo Tornabuoni, that is, for Giovanna, the young daughter of Maso degli Albizzi". Altogether, about five thousand eight hundred masses were said for Giovanna's soul. The elaborate stonework was finally finished in March 1491, and on 28 June 1491 the altar was dedicated to "the Visitation of Mary, Virgin and Mother of God". The consecration was conducted by Benedetto Pagagnotti, bishop of Vaison, who assisted the archbishop of Florence in the performance of his duties. The Tornabuoni and Albizzi arms were carved into the magnificently sculptured capitals on the exterior of the chapel (fig. 65).[135]

The next important moment was the installation of an altarpiece and the accompanying decoration. The monk Antonio di Domenico Brilli, one of the monastery residents, kept a 'Book of Benefactors' in which he recorded the following information:

> On 21 July 1491 the above-mentioned Lorenzo sent to his chapel in Cestello a beautifully painted panel of the Visitation, worth eighty ducats, by the hand of Domenico Ghirlandaio; and on the same day he sent, to decorate said chapel, a predella and benches with backs, as well as two large white candlesticks and two of wrought iron, intended to hold candles at the altar; and on the same day also a stained-glass window featuring the figure of St Lawrence, produced by Sandro *bidello* at the Studio. And he sent on the above-mentioned day a chasuble of white damask, a dalmatic and a small tunic and a *paliotto* and a beautiful cope of damask. Blessed be the Lord, and may He adequately compensate him for his efforts.[136]

Besides Ghirlandaio's famous painting, now in the Louvre, the chapel's furnishings therefore included such objects as candlesticks, a *paliotto* (or altar frontal—the decorated cloth or panel adorning the front of an altar, many examples of which are still to be seen in the church of Santo Spirito in Florence) and various liturgical vestments, as well as a stained-glass window with a depiction of Lorenzo's patron saint, St Lawrence, made by Alessandro di Giovanni Agolanti (fig. 65). Sandro's nickname, *bidello*, referred to his other job—a porter at the university—but his true talent was in the field of stained glass. The Tornabuoni enlisted Sandro's services no fewer than three times: in the magnificent church of Santa Maria delle Carceri in Prato, in the church of Cestello and in Santa Maria Novella. The colourful window featuring St Lawrence, which is still in place, is best viewed in the morning. At the bottom, two angels hold a shield on which the arms of Lorenzo and Giovanna are combined, as they are on the opening folio of Naldo Naldi's nuptial poem (fig. 19).[137]

Rarely is so much information available on the original design of a chapel housing a particular work of art. Everything, including Ghirlandaio's monumental masterpiece, was conceived to heighten the hallowed atmosphere of divine worship. Of central importance was the mass said by the priests each week to honour Giovanna's memory, as requested by Lorenzo. This practice can be seen in a Savonarola incunabulum, which contains a woodcut of a priest standing before a Renaissance altar, presiding over a celebration of the Eucharist (fig. 67). The small chapel is filled with the assembled faithful, who observe with rapt attention the elevation of the Host.

Tractato del sacramento & de mysterii della messa
& regola utile cōposta da frate hieronymo da Ferrara.

The commemorative masses for Giovanna must have been attended with some regularity by Lorenzo, who distinguished himself as the patron of the chapel and a benefactor of the monastery. We may assume that the young widower contributed substantially to the discussions determining the dedication of the altar and the subject depicted on the altarpiece. As mentioned earlier, in the Visitation the themes of pregnancy, the first recognition of Christ and the hope of eternal salvation could be combined in a single representation.[138]

Ghirlandaio took this opportunity to render the New Testament subject with a fresh intimacy. Despite the splendour of the colours, the beauty of the painting lies in its portrayal of human interaction. Elizabeth, though the older of the two, kneels before the youthful Virgin and places her hand on Mary's abdomen. Mary responds to this expression of charity and humbleness by resting her hands tenderly and protectively on Elizabeth's shoulders. The contrast between Elizabeth's sharp features and Mary's flawless and delicately painted countenance is indeed striking, and serves to illustrate the transition from the Old Law to the New Law.

The composition focuses attention on the Virgin Mary, whose humility is visible in her serene expression. In the opinion of the Cistercian mystic Bernard of Clairvaux, a driving force in the late-medieval Marian cult, the virtue of *humilitas* was the greatest confirmation of Mary's status as the most blessed among women. Here, moreover, Mary is pointedly portrayed as the bright star of the sea and the shining or blessed gate of heaven. These epithets, known from ancient Marian hymns, are subtly incorporated in the background of the painting. The sea is glimpsed through the classical arch, which frames a view of a prosperous port, while the gate's splendour is affirmed by the precious stones and shells applied to its cornice. Like the Visitation fresco in Santa Maria Novella, this altarpiece can be seen as an ode to Mary's role as intercessor.[139]

In everyday religious practice much importance was placed on this intercessory role. Nearly all believers pinned their hopes on Mary's intercession to save their souls. During her daily prayers, Giovanna often had the opportunity to ponder Mary's divine motherhood, since her book of hours included a collection of prayers to the Virgin. Of course no two fifteenth-century books of hours were identical, because the prayers they contained were usually a matter of personal preference. Even the books of hours that Lorenzo the Magnificent commissioned for his daughters differ from each other: only one, for instance, contains the *Alma Redemptoris Mater* and the *Ave Regina coelorum*.[140]

Outside Italy, too, books of hours varied in their composition. The most popular Marian prayers were the *O intemerata* and the *Obsecro te*. Both prayers are laudatory and supplicatory, praising Mary in poetic terms and fervently entreating her to be a powerful protectress and merciful mediatrix. This is expressed by the following passage from *O intemerata*: "Incline, Mother of mercy, your ears of piety to my unworthy supplications, and be loving to me, a most wretched sinner, and be my helper in all things". The tone of the *Obsecro te* is similarly beseeching:

> Come and hasten to my aid and counsel, in all my prayers and requests, in all my difficulties and needs, and in all those things that I will do, that I will say, that I will think, in every day, night, hour and moment of my life. And secure for me, your servant, from your beloved Son the fullness of all mercy and consolation … all joy and gladness, and an abundance of everything good for the spirit and the body …[141]

The compelling cadence of these prayers rouses the emotions even more strongly. The most urgent request of all is made in the closing lines of the *Obsecro te*:

> And at the end of my life show me your face, and reveal to me the day and hour of my death. Please hear and receive this humble prayer and grant me eternal life. Listen and hear me, Mary, sweetest virgin, Mother of God and of mercy. Amen.

Devotional texts of this kind clarify the meaning of Ghirlandaio's *Visitation*.

Even though the altarpiece was destined for a position of special liturgical significance, its emphasis on the role of the Virgin Mary, as well as its intimacy and effectiveness in portraying human emotions, brought it close to the spirit of private devotion. Lorenzo Tornabuoni's commission gave rise to a beautiful panel that was not only suited to the decoration of an altar, but could also be an object of pious contemplation. As such, it was an appropriate tribute to his deceased wife. Furthermore, Domenico Ghirlandaio's talent as a painter ensured the happy union of thematic profundity and aesthetic refinement.

Special mention must be made of Mary Salome, the figure on the right, one of the most beautiful of Ghirlandaio's late creations. Standing out radiantly against the background, she is portrayed with extreme grace. Her face and hands express a state of spiritual contemplation, as though she sees what the future holds in store. She links the beholder and the Visitation, thus intensifying in a masterly way the viewer's relationship to the scene depicted.

Refinement in things spiritual and a deep concern for personal salvation: these two aspects of the private lives and realms of thought of Lorenzo and Giovanna come to the fore in the religious art they commissioned. The fragility of life undoubtedly contributed to an obsession with the soul, but it is not as though Lorenzo Tornabuoni took refuge in mystical devotion. On the contrary, in the 1490s he proved to be one of the most important and intrepid players in the political arena, and this caused his life to take a dramatic turn.

CHAPTER 7
Years of turmoil

Ghirlandaio's altarpiece for the church of Cestello originated at a time of great prosperity for the city of Florence—in the words of the inscription in the Tornabuoni Chapel, "the most beautiful of cities, famed for its riches, victories, arts and buildings".

As the strong leader of a city no longer plagued by the threat of war, Lorenzo de' Medici was optimistic about the future, and he sought to convey this optimism to his fellow citizens. In 1490 he had seven floats made for the carnival parade. Featuring representations of the planets, the floats attracted a great deal of attention as they were pulled through the city. Instrumental music and singing added lustre to the event, which was celebrated in unprecedentedly grand style. For this occasion the Magnificent himself wrote the lyrics to the *Canzona de' sette pianeti* ('Song of the Seven Planets') and perhaps also the most famous of his festive songs, an ode to youth and happiness beginning with the following verses:

> How delightful is sweet youth,
> Which passes quickly, yea forsooth …

Young lovers were expressly urged to be receptive to Love:

> Lads and lasses, hearts in thrall,
> Long live Bacchus, long live Love!
> Sing and dance now, one and all!
> Let sweet love your hearts inflame!
> Away with weariness and pain!

The refrain, which is repeated eight times, aptly expresses the Dionysian attitude to life:

> If so inclined, be glad and sing,
> For who knows what tomorrow will bring.[142]

The following year Lorenzo again held a parade, which took place on the feast of St John (24 June), the patron saint of Florence. On this ecclesiastical holiday, Lorenzo organized a pagan procession with a strong element of propaganda. The subject he chose to portray was the 'triumph' of Lucius Aemilius Paullus—the Roman consul and general celebrated by Plutarch—who had scored glorious victories in the Third Macedonian War. What made a comparison between Paullus and Lorenzo de' Medici so attractive was the profit gained from the Roman commander's military prowess. Tribaldo de' Rossi, a contemporary of the Magnificent, claimed that Lucius Aemilius Paullus had obtained so much war booty for Rome that "no taxes had to be levied for forty or fifty years". Moreover, Paullus' keen awareness of Roman traditions was coupled with a great love of Greek culture. He consciously entrusted his sons' education to Greek poets and scholars, as Lorenzo de' Medici did many centuries later.[143]

The families allied to the Medici shared fully in the feeling of well-being, which expressed itself in a new longing for luxury. There was such a flurry of building that architects, labourers and building materials were in short supply. Lorenzo de' Medici had the magnificent villa at Poggio a Caiano built, as well as the convent church of San Gallo— no longer standing—just outside the town gate of the same name. His friends Giuliano Gondi and Filippo Strozzi had monumental palaces built within the city walls, the construction of which was observed with envy and admiration. Filippo Strozzi's palace next to the Palazzo Tornabuoni was so impressive that the chronicler Landucci said he expected it to last "for the better part of eternity".[144]

But other forces, too, were at work in the city. Not everyone could spend money lavishly. The lower classes suffered greatly from increasing inflation and unavoidable tax increases, despite Tribaldo de' Rossi's wishful thinking. The gap between rich and poor was becoming painfully obvious. Grand palaces could not be built without expropriating and demolishing humble dwellings. The clergy were well aware of the growing feelings of unrest. In the spring of 1490, the Dominican friar Girolamo Savonarola, who had held the post of 'lecturer' in the convent church of San Marco in the 1480s, returned to Florence. Preaching in a grave, low-pitched voice, but with burning conviction, the Ferrarese reformer denounced the moral decay he sensed all around him. When San Marco could no longer contain the growing crowds of people, Savonarola began to preach in the Cathedral. More than any other cleric, he was aware of the power of the word. At the age of nearly ninety, Michelangelo could still remember Savonarola's sermons. His apocalyptic message, predicting the imminent punishment of godless, worldly Italy, attracted an especially large following among young Florentines. This spiritual leader and sworn enemy of luxury and corruption was immortalized by Fra Bartolomeo, the painter-monk who had followed in the footsteps of Fra Angelico by entering the Dominican order. The stark portrait, intended as a posthumous tribute to the 'prophet of God', is indeed captivating (fig. 69). As in Ghirlandaio's portrait of Giovanna degli Albizzi, the sitter's silhouette stands out against the dark background. Savonarola's likeness, however, has been stripped of all ornament. His characteristic profile—hooked nose, sunken cheeks, tense mouth—emerges from his black cowl. Fra Bartolomeo modelled the monk's face with so much finesse that the viewer is held in thrall by the unadorned image.[145]

In Florence, one of Savonarola's supporters was Ugolino Verino, a man of letters from the circle of Lorenzo' de Medici. Verino questioned the wisdom of having young people

68. [p. 122] Sandro Botticelli, *Calumny of Apelles*, detail.
Florence, Uffizi.

69. [p. 125] Fra Bartolomeo, *Portrait of Girolamo Savonarola*.
Florence, Museo di San Marco.

70–1. Fifteenth-century artist in the style of Niccolò Fiorentino, portrait medal of Lorenzo Tornabuoni:
Portrait of Lorenzo Tornabuoni (obverse); *Mercury with Sword and Caduceus* (reverse).
Washington, National Gallery of Art, Samuel H. Kress Collection.

educated in the works of Homer and Virgil, and disapproved of the excessive attention paid to ancient rhetoric. In his view, this pedagogical approach stood in the way of genuine moral instruction. "What singular impudence! They prefer Jupiter to Christ, the thyrsus-staff to the cross, Juno and Bacchus to Mary and John", he scoffed. Verino dedicated his *Carmen de Christianae religionis, ac vitae monasticae foelicitate* to Savonarola, who responded with the *Apologeticus de ratione poeticae artis*, in which he lashed out at the classics and light-hearted love poetry, from Dante to Petrarch. Not everyone, therefore, was charmed by the elegance of classical authors and modern sonnet writers. In Savonarola's eyes, poetry was the least important of the humanities.[146]

The world of the relatively young Lorenzo Tornabuoni was that of the splendour-seeking patriciate, bent on attaining *magnificenza*. Lorenzo did not fail to exploit to the full the advantages of his noble birth, immense wealth, excellent education and powerful connections, all of which enabled him to become a person of great authority. As he grew older, his responsibilities increased accordingly. In March 1490, at his father's urging, Lorenzo was appointed director of the Medici bank in Naples. The Naples office was affiliated with the branch in Rome, where Giovanni Tornabuoni and his nephew Onofrio (or Nofri) di Niccolò Tornabuoni held sway. From that same month, Lorenzo also had a vested interest in the Lyons branch, which was given the name 'Heirs of Francesco Sassetti & Giovanni Tornabuoni & Co'. In Lyons, Lorenzo had occasional dealings with Piero di Lorenzo de' Medici, from whom he eventually took over a silk business. Lorenzo thus developed by degrees into a "famous merchant", as he would later be called. This was all to be expected: Mercury, the god of commerce, had for years been his tutelary deity and featured on the reverse of one of his portrait medals (figs. 70–1). Before he turned thirty, Lorenzo would not be qualified to hold public office, but his name was nevertheless drawn from the electoral purses more than once. In April 1490, for example, he was among those selected to serve as Gonfaloniere di Compagnia, without being eligible to hold the office.[147]

In that same year, Giovanni Tornabuoni—by this time sixty-two—granted his son a number of special powers with regard to the furnishing and decoration of the family chapel in Santa Maria Novella. Driven by a mixture of family pride and true piety, Giovanni sought to ensure the continuation of his 'life's work'. The embellishment of the *cappella maggiore* remained one of the most high-profile artistic commissions in Florence. Four years later, the altarpiece was installed in the middle of the chapel (its central panel depicting the *Resurrection of Christ* has already been discussed). The monumental, free-standing structure had the form of a triumphal arch and was painted on all four sides. It was topped by a lunette, inside which was a tabernacle containing the Blessed Sacrament. In both size and splendour, this work of art was practically unparalleled, even in Florence. One of the most striking of the now dispersed side panels was the depiction of *St Lawrence*, Lorenzo Tornabuoni's name saint (fig. 72). Lawrence stood to the left of the central representation of the *Madonna and Child in Glory with St Dominic, St Michael, St John the Baptist and St John the Evangelist*, that is, on Mary's right side. Domenico Ghirlandaio portrayed the martyr in bright colours, with his body turned slightly and his gaze directed heavenwards. In one hand he holds the gridiron on which he was roasted, in the other the palm branch of victory. The inscription PRESSVRAM FLANME [*sic*] NON | TIMVI ET IN MEDIO IGNIS | NON SVM ESTVATVS ('I did not fear torture by fire and in the middle of the fire I did not feel the heat') typifies Lawrence as a paragon of faith, whose firm conviction could not be weakened by

torture. This fine motto could easily be applied to Lorenzo, whose device appears on the saint's robe. To Lorenzo, who was gradually gaining in authority, firmness of heart and mind would prove indispensable in dealing with a wide variety of circumstances.[148]

In 1491 Lorenzo married for the second time, as was only natural for such a young widower (barely twenty when Giovanna died). His new wife, Ginevra di Bongianni Gianfigliazzi, was the daughter of a well-to-do merchant from the Tornabuoni's neighbourhood. Remarkably, Ginevra's father—like Giovanna's father—had been a member of the diplomatic mission sent in 1480 to pay an official visit to Pope Sixtus IV. This confirms the importance of the social network that bound highly placed Florentine families.

The exact date of Lorenzo and Ginevra's marriage is uncertain. It was solemnized, in any case, before 13 October 1491, the day on which Lorenzo took possession of part of the dowry, from which we may assume that the marriage had been consummated. Ginevra presumably moved into the Palazzo Tornabuoni in September 1491. She eventually bore Lorenzo three children: a son named Leonardo and two daughters, Francesca (named after Lorenzo's mother) and Giovanna (after either Lorenzo's first wife or his father). Even though the birth of a second son offered an additional guarantee of the continuation of the male line, much attention in the Tornabuoni family was given to Lorenzo's elder son, Giovannino. As the first-born, he had a suite of his own in the *palazzo*.[149]

A few years after Giovanna's death, therefore, Lorenzo Tornabuoni's private life seemed to have gained some measure of stability. Nevertheless, his situation and that of his closest family and friends changed drastically in the tumultuous years 1492–4.

In the winter of 1491–2, the health of his cousin Lorenzo de' Medici took a turn for the worse. The Magnificent was often bedridden, and when his second son, Giovanni (the future Pope Leo X), became a cardinal in early March 1492, he was unable to attend the investiture. At the beginning of April, Lorenzo's health worsened dramatically. He had himself conveyed to the villa at Careggi in the hope of regaining his strength in the country air, but during the night of 6/7 April, when he felt the end nearing, he summoned Piero, his eldest son, to his bedside, where—according to Politian's records—he gave him some political advice: do not always listen to the counsel of friends or individual citizens, but heed the opinion of the majority of the *civitas*, which is a creature of many heads. And beware of seeking absolute power. It was not the first time that Lorenzo had warned Piero to temper his personal ambitions. As early as 1484, Piero had been urged to act in the presence of his townsmen as their fellow citizen—with style and distinction, but humanely and politely. At Lorenzo's deathbed Piero was joined by physicians, philosophers, scholars and even Savonarola, the prior of San Marco, all of whom came to offer spiritual and moral support. When Lorenzo's last hour had come and "only his soul" still showed signs of life, he took leave of his loved ones. On 8 April Lorenzo de' Medici breathed his last.[150]

The news of the death of the Magnificent provoked mixed reactions in the city of Florence. Many were overcome with a feeling of relief: Lorenzo had not been especially popular among the common folk. Moreover, many families had suffered greatly from the political reforms Lorenzo had adroitly implemented. In April 1480, when the Council of Seventy had been created, many prominent citizens had been barred from the political arena. Those who had been excluded now hoped to manoeuvre themselves back into power. By contrast, the numerous Florentines allied with the Medici understandably felt Lorenzo's loss keenly. They had every reason to wonder what the future held in store. Everyone, how-

PRESSVRAM FLANME NON
TIMVI · ET · INMEDIO IGNIS
NON SVM ESTVATVS ·

72. Domenico Ghirlandaio, *St Lawrence*.
Munich, Alte Pinakothek.

ever, agreed that the death of Lorenzo meant the loss of the most powerful man in Flo-
rence, a man who inspired awe in all Italians. Such were the mythic dimensions of his rep-
utation as a political leader that a direct link was sought between his death and a series of
unusual events: on 5 April 1492, for example, when lightning struck the lantern atop the
dome of the Cathedral, every chronicler recognized it—though only in retrospect—as a
harbinger of Lorenzo's death.[151]

Lorenzo de' Medici had made many enemies during his years of political leadership,
and yet his son Piero (fig. 73) was able to take his place with surprising ease. A majority of
influential citizens soon voted to allow Piero to assume his father's duties and political pow-
ers. In a very short time, young Piero had become a member of the Council of Seventy, an
accoppiatore (electoral official), governor of the Palace and governor of the Wool Guild.
Moreover, Piero could count on the support of the pope, who had only recently made his
brother Giovanni a cardinal. From every corner of the Italian peninsula, envoys were sent
to Florence to offer Piero their condolences. Without exception, they expressed the hope
that Piero would follow in his father's footsteps. Many of their faces would have been fa-
miliar to the new leader from the diplomatic missions his father had sent him on.[152]

In theory, Piero's succession opened up perspectives for Lorenzo Tornabuoni. Piero was,
after all, his first cousin once removed and a close boyhood friend. Lorenzo acted as god-
father to Piero's son Lorenzo, born in September 1492, and also rode alongside him in a
tournament held in 1493. Piero was cut out for such sporting events: the new leader of the
Florentine Republic was of strong build and—through his mother's side of the family, the
pugnacious Orsini—had a penchant for the military.

Both Lorenzo Tornabuoni and Piero de' Medici were as interested in arms as they were
in literary pursuits, so it is not surprising that they were once thought to have been por-
trayed side by side in the Tornabuoni Chapel, namely in the fresco depicting the *Expul-
sion of Joachim from the Temple* (fig. 74): according to this interpretation, Piero had been
given a role in a cycle from which Lorenzo de' Medici was conspicuously absent—perhaps
because Giovanni Tornabuoni feared that a portrait of the Magnificent would attract more
attention than those of his own Tornabuoni-Tornaquinci clan. Just how much the lives of
Lorenzo and Piero were intertwined is apparent from the shrewd analysis of the historian
Francesco Guicciardini:

> For one thing, Piero was his blood cousin, and under his rule he had enjoyed great power.
> For another, he was a very generous man [*magnifico*] and had spent a great deal of money,
> and was also heavily involved in the Medici business, all of which had put his finances in
> such disorder that he would soon have gone bankrupt …[153]

History has yet to pass final judgement on the political role played by Piero de' Medici.
His nickname, *lo Sfortunato* ('the Unfortunate'), speaks volumes. Up to now, few have been
willing or able to write an impartial account of Piero's life. For centuries the comparison
with his successful father has worked to his disadvantage. We could certainly obtain a clear-
er picture of him by returning to the original sources, beginning with the extensive and
largely unstudied correspondence, for even though he was not hugely successful, Piero was
certainly exceptionally well-educated and highly energetic—and, on occasion, capable of
acute perception. And yet it is difficult to avoid the impression that—as critics claim—

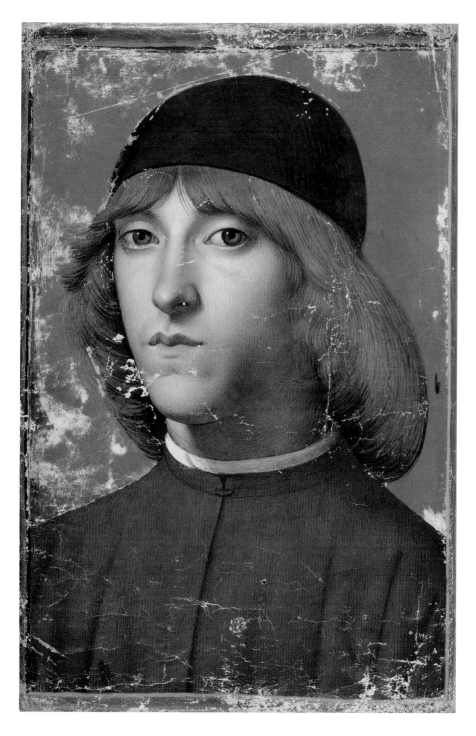

73. Gherardo di Giovanni, *Piero di Lorenzo de' Medici*, in Homer, Ποίησις ἄπασα.
Naples, Biblioteca Nazionale "Vittorio Emanuele III".

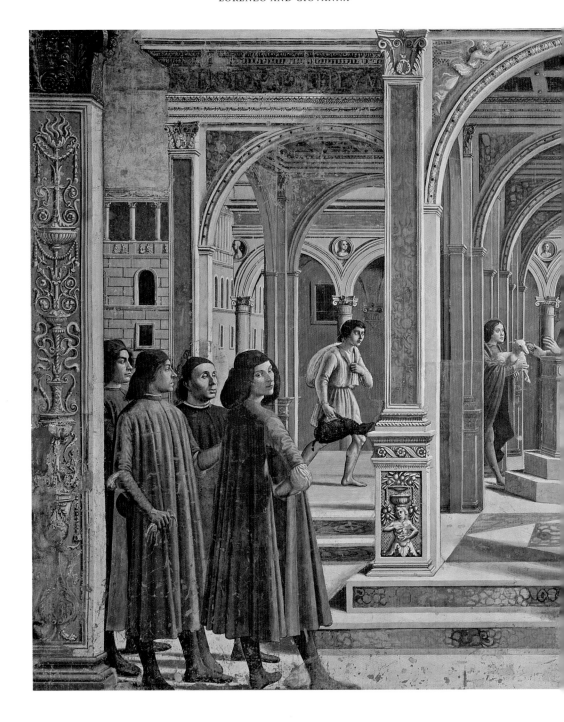

74. Domenico Ghirlandaio and assistants, *Expulsion of Joachim from the Temple*.
Florence, Santa Maria Novella, main chapel.

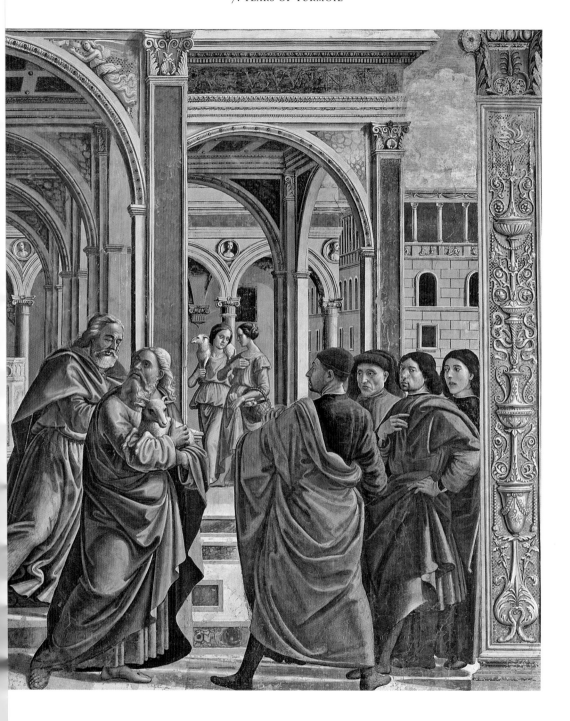

CHAPTER 8
The final act

After Piero de' Medici had been driven out of the city, his friends and allies were no longer safe. On the night of 9 November 1494, Lorenzo Tornabuoni was picked up by a group of armed citizens, who—according to Parenti—had discovered him hiding under the straw in the latrine of a friend's house near the church of Santa Croce. The provisional arrest of Lorenzo and his political sympathizers was a strategic move, aimed at preventing Piero's old friends from taking immediate action. After their release, Lorenzo Tornabuoni, Bernardo del Nero, Niccolò Ridolfi, Messer Agnolo Niccolini and others were forbidden to go about the city armed.[166]

In the meantime, the Signoria had their hands full preparing for the imminent arrival of the French, and until a final agreement had been reached, the city was still threatened with plundering. Charles VIII, who was leading his troops across the Arno valley, was naturally in the strongest bargaining position. Restoring Piero de' Medici to power would theoretically be to his advantage, since Piero had promised his complete cooperation, but the balance of power in Florence had meanwhile shifted drastically. The French king noticed this on 17 November, when he marched into the city and was received with all honours. The entry of Charles VIII and his retinue was documented by Francesco Granacci (fig. 75), a friend of Michelangelo—in fact, the one responsible for introducing him to Ghirlandaio and his workshop. The painting shows throngs of people in Via Larga, watching an impressive cavalry procession. In the midst of it, seated on a black horse, is Charles himself, in battledress but recognizable by his gold crown. He turns towards the Palazzo Medici (front left), where he is about to take up temporary residence. Granacci was not an eyewitness to these events, so his painting is not an entirely reliable account of the proceedings, but even so the atmosphere of tension and expectation is palpable: the soldiers' raised lances fill the length and breadth of Via Larga.[167]

As soon as Charles VIII and his men were settled in their new Florentine accommodations, they were besieged by representatives of every political persuasion attempting to win their favour. The first to pay the king a visit were the Signoria, who went with no few-

er than three hundred men to pay tribute to the 'liberator' of Italy. Luca Corsini acted as spokesman, beginning his address in Latin, the lingua franca of educated Europeans. Lorenzo Tornabuoni, Giannozzo Pucci and Alfonsina Orsini, the wife of Piero de' Medici, also put in an appearance: by showering Charles with costly gifts, they hoped to win him over to their cause. Authorized to act on behalf of the city government, such political heavyweights as Francesco Valori, Braccio Martelli and Piero Capponi were charged with the task of reopening the negotiations and bringing them to a satisfactory conclusion. For several days there was uncertainty as to the outcome of the talks. The Florentines feared the worst, since they expected the French to demand the victor's spoils in their magnificent city. That the uncle of Charles VIII, Philippe de Bresse, was a guest at the Palazzo Tornabuoni also provoked scepticism. Finally, after days of deliberation, the French relinquished control of Pisa and the northern fortresses in exchange for 120,000 ducats (50,000 to be paid within fifteen days, the rest in two later instalments). Thanks in part to the persuasive powers of Savonarola, the French troops left the city peacefully on 28 November.[168]

The French gradually drifted down to Rome and Naples, but in Florence a political revolution ensued. The fate of the Medici regime was sealed on 2 December at a public meeting that dissolved all existing councils and committees. They were replaced by a committee of twenty electoral officials charged with recompiling the electoral purses for a new drawing of lots. All of this took place in the Piazza della Signoria: the citizens of Florence flocked to the piazza until two-thirds of them were present. However, many doubted that these measures would bring about real change, as sourly reported by Piero Parenti: "all good citizens were struck with grief: they complained that they had taken up arms for freedom, whereas in fact, as it turned out, they had done so not for the freedom of the people, but to keep in power the very same citizens who were governing before".

All the same, the people felt a need for retaliation as well as renewal. No one could prevent Antonio di Bernardo Miniati from being hanged from one of the windows of the Bargello. As *provveditore* of the Monte, or head of the municipal savings bank, Miniati had introduced new, onerous taxes and had become a particular object of hatred.[169]

There were many among the vengeful populace who, in the words of Francesco Guicciardini, were ready to "strike out" at Bernardo del Nero, Niccolò Ridolfi, Lorenzo Tornabuoni and other supporters of the Medici regime. They were restrained, however, by Piero Capponi and Francesco Valori. While undoubtedly acting for the public good by seeking to prevent the complete breakdown of the political establishment, they were at the same time safeguarding their own interests. In 1434 the parents of these patricians had seen to it that Cosimo the Elder could return to Florence from his place of exile. In a time of general political instability, their position was not secure either. Thus a compromise was sought, and the fact that it was finally found was, in the opinion of Guicciardini, due mainly to one man: the charismatic Savonarola.[170]

The arrival of Charles VIII had turned Piero de' Medici into an exile and Savonarola into a prophet and saviour, for it was owing to the intervention of this Dominican friar that Florence had not been struck by "the scourge of God". Savonarola emphasized that God had no reason to spare Florence; He had taken pity on it purely out of charity. Savonarola had developed and zealously propagated a new view, in which apocalyptic visions alternated with promises of divine love. The two main elements of his prophetic message can be seen on a bronze medal struck around 1497, which combines the symbols of the Holy

Spirit, the sword and the dove (figs. 76–7): God's punishment hangs above everyone like a sword, but penitence and prayer are the way to salvation. It was in these years that Florence came to be seen as the New Jerusalem, this Christian myth replacing the earlier view of the city as the reincarnation of classical Athens or Rome. Reflections of this can be found in the work of Botticelli, particularly in the *Mystic Crucifixion* (fig. 78), a small but highly dramatic painting in which Mary Magdalene firmly embraces the foot of the cross in a display of extreme compassion. While an angel strikes a lion—the *marzocco* symbol of Florence—with a burning staff, devils hurl devastating flames onto the earth from the dark sky (the evil spirits are barely visible, owing to the work's poor condition). The notion underpinning this complex allegory is the struggle between good and evil. In the left background, the threatening black of the heavens has made way for clear skies. On the horizon lies Florence, bathed in sunlight. It is the city chosen by God, where the simplicity of the Christian life and the ideals of God's kingdom have been reinstated.[171]

Savonarola's intended political role was that of conciliator:

> Our boat remains at sea and sails toward the harbour, that is, toward the peace which Florence must have after her tribulations. Officers old and new, all of you together, see to it that this universal peace is realized; make sure that good laws are passed in order to stabilize and strengthen your government. And let the first be this: that people no longer call themselves *bianchi* ['Whites'] or *bigi* ['Greys'], but that all together be united as one and the same. This partisanship and partiality in the city are not good ... Make true peace, from the heart, and incline always toward mercy more than justice this time, for God has once again employed more mercy than justice toward you. O Florence, you were in need of great mercy, and God has shown it to you; do not be ungrateful.

The *bigi*, to whom the Tornabuoni family belonged, had admittedly been sullied by the old regime, but they were not lost in the preacher's eyes. Savonarola was among those who pressed for the formation of a Great Council patterned after the Venetian model, but he firmly believed that, when this reform had been implemented, a general pardon should be granted to the old guard. Universal peace was the message he preached from the pulpit.

Savonarola's appeal did not fall on deaf ears. On 19 March 1495, a general pardon was issued. The Tornabuoni could once again breathe freely. They were allowed back into the political arena, and reassumed their public role as prominent patricians and civic leaders.[172]

In the years in which Savonarola's power was at its height, Giovanni and Lorenzo Tornabuoni commissioned the monumental, free-standing altarpiece in the chapel in Santa Maria Novella. At some point in the period 1492–6 they reaffirmed their role as outstanding patrons of the arts by having three impressive stained-glass windows installed (fig. 79). These windows, more than ten metres in height, were produced after a design by Domenico Ghirlandaio and exhibited a luxuriant style characteristic of the modern Renaissance manner. The finely wrought detail of the design extended from the scenes of the Virgin and the saints to the decorative borders, in which all the Tornabuoni symbols and devices —the family arms, the diamond, the bundle of flames—are reiterated.

Apart from these commissions, remarkably little occurred in the artistic sphere in Florence in the years 1494–8. Many artists, including Michelangelo, had fled the city. Moreover, as Savonarola's influence grew, there was less and less room for a worldly sense of beau-

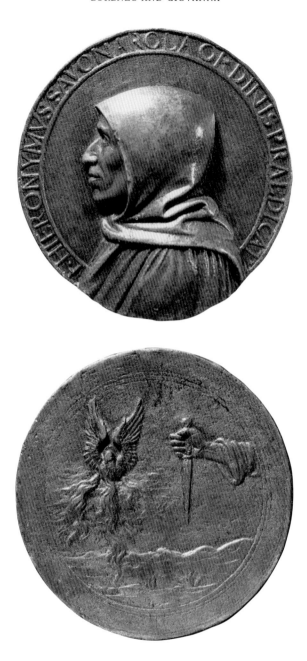

75. [p. 138] Francesco Granacci, *Entry of Charles VIII into Florence*, detail.
Florence, Uffizi (storerooms).

76–7. Francesco della Robbia (attributed), portrait medal of Girolamo Savonarola:
Portrait of Girolamo Savonarola (obverse); *Symbols of the Holy Spirit* (reverse).
Florence, Bargello.

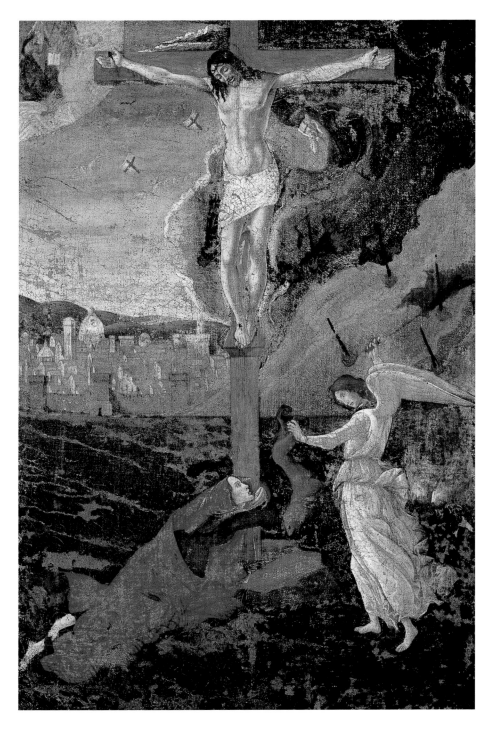

78. Sandro Botticelli, *Mystic Crucifixion*.
Cambridge, Mass., Harvard Art Museums, Fogg Museum.

ty in either monumental painting or daily life. In one of his sermons on the prophet Amos, delivered during Lent in 1496, the friar criticized the habit of young Florentine women of wearing their hair in the style of nymphs. Furthermore, for the carnivals of 1497 and 1498 he held two bonfires of the vanities, in which mounds of objects associated with moral laxity, including many works of art, were destroyed. Savonarola's strict notions of the function of art led to commissions in which aesthetic delight (*delectare*) was made subordinate to moral instruction (*docere*). This is perhaps most evident in a triptych produced by Filippino Lippi, which was commissioned by the family of Francesco Valori, a fervent follower of Savonarola and a fierce opponent of Bernardo del Nero and other Medici sympathizers. The triptych was intended for the Valori family chapel in the church of San Procolo (also popularly called San Brocolo), located in present-day Via de' Giraldi, off Borgo degli Albizzi. The central panel depicting the *Crucified Christ between Mary and St Francis* looked old-fashioned, owing to its uniform gold ground and austere lines: it was nonetheless a striking work, and equally striking were the two oblong panels that functioned as the side wings of the Crucifixion picture. Both of them focus on mortification, but that thematic constraint was splendidly exploited by the versatile painter. In his characteristic style, Filippino typified both John the Baptist and Mary Magdalene as solitary desert saints who abstain from all sensual pleasure to devote themselves to rigorous penance. The central panel was lost during the Second World War, but the side panels can be seen in the Accademia in Florence (figs. 80–1). Viewers cannot fail to be moved by them. The saints' bodies are skeletal, their skin tawny, their faces and poses expressive of spiritual rapture. In the midst of ochre, grey and green, the colourful accent provided by John the Baptist's red cloak is particularly intense.[173]

After the general pardon, the Tornabuoni resumed their business activities. On 4 June 1495, the city authorities charged Giovanni and Lorenzo Tornabuoni with the task of auditing the account books of the Rome branch of the Medici bank. The Florentine government was curious to know whether any money was still to be had, since the Ufficiali sui beni dei ribelli (Syndics of Rebel Properties) could claim anything that had once belonged to the family assets or trading capital of Piero de' Medici. The final balance was disappointing, however, for there appeared to be nearly equal numbers of debtors and creditors. The Tornabuoni then found themselves in the uncomfortable position of managing the bank on their own—and at their own risk. As we shall see, before taking on this responsibility, Giovanni had secured his own capital by having a notary transfer possession of the family property to his two grandsons, thus protecting himself and his son. Moreover, Lorenzo insisted on selling some of the valuables confiscated from the Medici collection in Rome. This provided him with an opportunity to initiate new financial transactions and gave him more room to manoeuvre in the Roman milieu.[174]

At the same time, the Tornabuoni engaged in a number of surreptitious dealings of which the Florentine rulers had no knowledge. At least as interesting as the account books of the Medici bank in Rome is the secret diary (*Libretto segreto*) of Francesco di Agostino Cegia, nicknamed Cegino, which reveals the illegal traffic between Florence and Rome. Born in 1460 to one of the agents of the Medici family, he had strong ties to Lorenzo the Magnificent: he lodged with his patron and managed the household's day-to-day business. Cegia had been arrested immediately following Piero's expulsion from Florence and had spent ten days in prison. The 1495 pardon gave him a chance to wipe the slate clean, at least

in the eyes of the authorities, and he even ended up working for the Syndics of Rebel Properties. In fact, he used his new position to strengthen his ties to Piero de' Medici (who had fled to Rome) and his followers. In August 1496 he was again arrested by the Otto di Guardia—the eight-man policing committee—on suspicion of pro-Medici dealings, and even tortured, but did not break and was eventually released. He was thus able to set up an underground network that mobilized a large number of people with a single goal: to bring together the many treasures, meanwhile dispersed, which the Medici had collected in the course of a century. Two outstanding sculptures by Donatello—the bronze *David* and the equally impressive *Judith and Holofernes* (figs. 82–3)—had been taken from the Palazzo Medici to the Palazzo della Signoria, where Florence's new rulers ordered them to be stripped of their Medicean inscriptions. Other works of art and precious objects had also been confiscated by the authorities: even the family chapel, the famous Cappella dei Magi (fig. 84), had been cleared out. However, some of the most valuable objects—jewels and classical gems—had been brought to safety before Piero de' Medici fled the city. As a precautionary measure, many of these treasures had been hidden in the homes of friends and allies, where they were out of the syndics' sight. Piero's followers now proceeded to gather together and export these valuables and convert them into ready money, which could be used to prepare for Piero's return to Florence. The Augustinian friars of the convent of San Gallo could always be counted on to lend a helping hand; operating from the convent built just outside the city walls with the financial aid of Lorenzo de' Medici, they had for years been the mainstay of the *bigi*.[175]

Lorenzo Tornabuoni was one of the leading players in this illegal network, as well as in the transactions conducted under the supervision of city officials. Together with Cegia, for example, he arranged for the export of the crowning glory of the former Medici collection: the magnificent sardonyx bowl (or cup) known as the Tazza Farnese (fig. 85).[176]

Lorenzo had not given up hope that Piero, who was living in Rome, would one day return to Florence and be restored to power. This hope grew as several of his allies strengthened their hold on Florentine politics. On 1 March 1497, Bernardo del Nero—an *arriviste* who had worked his way up the social ladder—was chosen for the third time as Gonfalonier of Justice. When Piero heard this news, he concluded—all too quickly—that his followers in Florence were in the majority. He brought his men together, began to seek allies, and developed a strategy to regain power. It seems that Bernardo tried to curb Piero's impetuosity by advising him to wait for a more propitious moment, but Piero pressed ahead with his plans. With a retinue of two thousand, most of them mercenaries, he marched from the south to the gates of Florence, calling his troops to a halt on 28 April 1497 at San Gaggio, just outside the Porta a San Pier Gattolini (present-day Porta Romana).[177]

Piero alleged that he had received a letter requesting him to return to his native city, but his opponents, naturally suspicious, had made thorough preparations for his arrival. First of all, more than fifty men thought to be Piero's allies—including Lorenzo Tornabuoni and Luca degli Albizzi, Giovanna's half-brother—were summoned, under the pretext of attending an emergency consultation, to the Palazzo della Signoria, where they were temporarily detained. The presence of an official executioner accompanied by henchmen wielding axes, chains and ropes made it clear that Piero's adversaries were in earnest this time. Meanwhile, reinforcements were sent to strengthen the defence of the Porta Romana. Additional measures included blocking the borders of Florentine territory, increasing the

79. Sandro del Bidello, after cartoons by Domenico Ghirlandaio, stained-glass windows with *Stories of the Virgin*. Florence, Santa Maria Novella, main chapel.

80–1. Filippino Lippi, *St John the Baptist* and *St Mary Magdalene*.
Florence, Accademia.

monetary reward for Piero's capture or elimination, and summoning the help of the *condottiere* Rinuccio da Marciano, who was ordered to surround Piero and his men on the side of San Casciano.[178]

Piero took the precaution of withdrawing temporarily to Tavarnelle, some twenty miles south of Florence. While regrouping, he won over the peasants in the area by promising them money, but torrential downpours prevented him from launching a new offensive. Having realized that his supporters in Florence were incapable of action, Piero decided to return with his men to Siena.

Piero's abortive action was not the only setback Lorenzo was forced to deal with in the spring of 1497. More drastic still was the death of his father at the age of sixty-nine. In accordance with the terms of his will, Giovanni Tornabuoni was buried in Santa Maria Novella. Further details of his death and interment are not known, but his funeral must have been accompanied by elaborate tributes from numerous Florentine patricians. The loss of his father made Lorenzo more vulnerable in public life. For decades Giovanni Tornabuoni had played a commendable role in local politics: as a man of standing, he had had an important voice in society. His son Lorenzo—now twenty-eight years old—was not yet ready to succeed him, however, because he would not be eligible to hold public office until the age of thirty.[179]

By April 1497 all signs of the Medici regime had been removed from public view. The escutcheons that had decorated the Palazzo Medici, the convent church of San Gallo, the parish church of San Lorenzo and other public buildings had been mercilessly obliterated.

But the possible return of Piero was not the Florentines' only worry. For some years they had been trying, with varying success, to suppress the revolt of Pisa, which had risen against Florence following the expulsion of the Medici, and hostilities continually flared up in the area of Vicopisano. The economic malaise had spread, and many people's incomes had been dramatically reduced. The threat of new taxes only increased the social unrest, and food shortages began to take their toll. To make matters worse, there was an outbreak of the plague. In July 1497, the philosopher Marsilio Ficino wrote a letter to his publisher, the famous Aldus Manutius, in which he summed up the seriousness of the situation. The great Plato scholar, who had seen better days under Lorenzo de' Medici—admitted that he no longer felt at ease in Florence: "Neither in the city nor outside can I live safely … For a long time now, three furies have constantly been tormenting wretched Florence: plague, famine and sedition". Just how dramatic the situation was emerges from official documents issued by the highest government bodies. In early July the Signoria had had great difficulty in holding a meeting. Finally, at an assembly convened on 28 July, all the city's problems were discussed: in addition to plague, famine and war, another major threat was "the scant concord and love seen among citizens".[180]

Indeed, it was becoming increasingly unclear who was in charge in these difficult times. People had begun to say that things had not been so bad under the Medici after all. Moreover, the twelve citizens who had been granted special powers in July—namely Messer Domenico Bonsi, Messer Francesco Gualterotti, Bernardo del Nero, Tanai de' Nerli, Antonio Canigiani, Giovan Battista Ridolfi, Paolantonio Soderini, Lorenzo Morelli, Messer Guido Antonio Vespucci, Bernardo Rucellai, Francesco Valori and Pierfilippo Pandolfini—represented divergent political factions. Two of them, Bernardo del Nero and Francesco Valori, were even arch-enemies.[181]

This delicate balance was abruptly disturbed in early August 1497, when a political conspiracy was discovered that was to have far-reaching consequences for Lorenzo Tornabuoni. Parenti reports that at one point the exile and "rebel" Lamberto dell'Antella, who for years had been among Piero de' Medici's most faithful friends, ventured to go to his ancestral estate just outside Florence. There spies of the Signoria were lying in wait for him, for Francesco Valori, among others, was always hungry for information about Piero's activities. Lamberto appeared to be carrying a letter that was intended for his brother-in-law Francesco Gualterotti, one of the twelve men currently in charge of government affairs. In this missive he promised to disclose Piero's secret plans. Lamberto and his brother, though reputed to be rebels, had meanwhile changed their minds about Piero, who had allegedly treated them "worse than dogs". Piero had first begun to doubt the loyalty of the Dell'Antella brothers during his forced stay in Siena, and had ordered Pandolfo Petrucci, who ruled the city at the time, to throw them in the Carnaio, the dreaded prison that no one ever left alive. Petrucci, loath to have such cruel treatment on his conscience, released them on the condition that they remain in the territory of Siena. Disobedience would mean a fine of 2,000 florins, but Lamberto and his brother felt so humiliated by Piero that they hastened towards Florence to seek revenge.[182]

Lamberto, however, fell into the hands of the Florentine authorities, who applied torture to extract from him all the information they needed. His disclosure of every detail of Piero's plans insured Lamberto's pardon. He revealed that preparations were under way to bring Piero into the city on the night of 15 August. A strategy had been devised to bring down the incumbent government. Famished townspeople would be lavishly regaled with grain, bread and money, and then urged to steal even more from the houses of the rich: in the ensuing chaos, Piero hoped to take possession of the Palazzo della Signoria. Clearly, the Florentine Republic was in grave danger. As a precautionary measure, the authorities ordered the city gates to be closed; more importantly, they prevented news of Lamberto's arrest from leaking out. Lamberto had divulged the names of all the prominent citizens involved in Piero's plot. These persons were summoned by the Signoria under false pretences. When the unsuspecting Bernardo del Nero, Niccolò Ridolfi and Lorenzo Tornabuoni presented themselves, they were promptly arrested and interrogated by the Eight. Even so, a number of Piero's allies—including Lorenzo's brother-in-law, Iacopo Gianfigliazzi—did manage to escape.[183]

From this moment on, Lorenzo Tornabuoni's life hung by a thread. An unpublished document contains a record of the confession he made before the Dodici Buonomini (Twelve Good Men), one of the city's most powerful councils. Put under pressure by his interrogators, Lorenzo provided information about the state of affairs earlier that year, when Bernardo del Nero had been elected Gonfalonier of Justice, remarking that, in his opinion, this had given hope to those desiring Piero's return. It emerged that in March and April there had been a flurry of correspondence between Piero de' Medici, Nofri Tornabuoni (Lorenzo's older cousin, who lived in Rome) and Piero's Florentine allies. Lorenzo did not conceal his participation, nor did he hesitate to mention such names as Pandolfo Corbinelli, Gino Capponi and Francesco Martelli. It was to the advantage of Lorenzo and his fellow detainees to lay most of the blame on Fra Mariano da Genazzano, since the friars at the convent of San Gallo often served as go-betweens. Lorenzo's statement remained objective and largely impersonal. Apparently he felt no need to beg for forgiveness.[184]

82. Donatello, *Judith and Holofernes*.
Florence, Palazzo Vecchio.

83. Donatello, *David*.
Florence, Bargello.

84. Benozzo di Lese (Gozzoli), *Procession of the Magi*.
Florence, Palazzo Medici Riccardi, Chapel of the Magi, west wall.

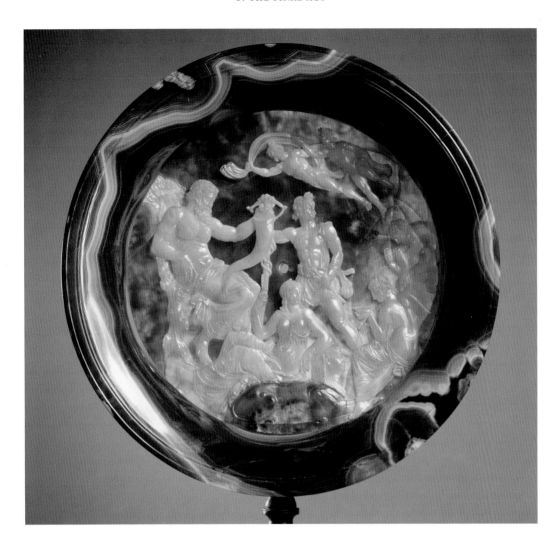

85. Alexandrian art, Tazza Farnese (*Allegory of the Fertility of the Nile*).
Naples, Museo Archeologico Nazionale.

The five detainees included—in addition to Bernardo del Nero, Niccolò Ridolfi and Lorenzo Tornabuoni—Giannozzo Pucci, a friend of Lorenzo, and Giovanni di Bernardo Cambi, a Medici agent in Pisa, who had lost a great deal of money following the revolt of that city and the ensuing hostilities. These men were accused of the worst possible crime: high treason. According to Parenti, not one of them was popular. Bernardo del Nero—over seventy years old at the time and thus the oldest of the five—appeared to many as "extremely cruel and ambitious", Niccolò Ridolfi, the father-in-law of one of Piero de' Medici's sisters, as "a rapacious man, and overly ambitious". Giannozzo Pucci was hated because of his closeness to Piero and his hugely inflated ego, while Giovanni Cambi, though less conspicuously hateful, was guilty of urging Medici supporters to restore Piero to power. Finally, Lorenzo Tornabuoni was deemed "unconscionably proud"; moreover, "as a man of high birth and possessed of money, he never gave in to anyone". Other historians such as Iacopo Nardi and Francesco Guicciardini are less harsh; the latter, in particular, stresses that Francesco Valori would gladly have spared Lorenzo.[185]

The officials hesitated to hand down a guilty verdict, for fear of incurring the wrath of several of the oldest and most prominent families in Florence. The incumbent Gonfalonier of Justice, Messer Domenico di Giovanni Bartoli, who was known as a wise and prudent man, insisted that the case be brought before the Great Council the very same day. Some members of the Signoria, however, opposed this resolution and sought to obtain a deferment. Many in Florence were hoping that the tide would soon turn, perhaps under pressure from outside forces: they knew, after all, that Piero was recruiting troops in Romagna and drumming up supporters everywhere.[186]

A special assembly (*pratica*) was scheduled to meet on 17 August. The meeting was attended by the members of all the city's councils and committees—160 persons altogether. The charges were read, and the verdict was nearly unanimous: the five men should be sentenced to death. While the friends of the conspirators were beginning to regret the decision not to bring the case before the Great Council, the Signoria called upon the Otto di Guardia to hand down the verdict. Two of them were against the death penalty, but six were in favour of it, enough to carry out the sentence. At this critical moment, those supporting the defendants produced their last trump card in the form of Messer Guido Antonio Vespucci, one of the city's foremost legal minds and an old-school Medici supporter.

Vespucci moved against the verdict on solid legal grounds, since the pardon strongly advocated by Savonarola provided for the possibility—in the case of death sentences pronounced by the Signoria, the Otto di Guardia and their appointed jurors—of appealing to the Great Council, in which the old families were amply represented. Vespucci also remarked that, in his opinion, the five condemned men were not all equally responsible.[187]

The decision was again postponed, this time for four days. The populace grew impatient. People took to the streets, volubly demanding justice. The men's fate, however, could only be decided in the assembly room, and indeed it was here, on 21 August 1497, that one of the most heated political debates in Florentine history took place.

This second meeting of the *pratica* was carried out by a more restricted group, consisting of the Signoria, the Dieci di Balìa (Ten of War), the Otto di Guardia and a selection of councillors. The case was to be decided, in the end, by the nine votes of the Signoria itself: the eight Priors and the Gonfalonier of Justice. Everyone present was aware of the gravity of the situation, understanding all too well that there were plans afoot to bring down the

government. From every corner of Italy, Florentine envoys reported that the duke of Milan and the pope were supporting Piero and scheming against the Republic. Acceding to Vespucci's 'legal' appeal would therefore be completely irresponsible from a political point of view. It would be better to make additional resources available for the defence of the city. Francesco Gualterotti, the spokesman for the Dieci di Balìa, declared that nefarious plans were being hatched both inside and outside the city, and that the appeal served no purpose other than to play for time in order to pave the way for Piero's return. Luca Corsini, a politician of great stature and a commanding public speaker, responded thus: "I am dumbfounded to find that the enemies within the city are more numerous and more dangerous than the enemies without". Florence's freedom, "a truly precious jewel", was being jeopardized by individuals to whom the city had shown "great clemency". The representatives of the people were also given a chance to express an opinion. They declared themselves firmly in favour of the death sentence, but hastened to add, as was customary, that they would go along with whatever decision the authorities took.[188]

The Signoria seemed briefly inclined to postpone the decision yet again. Night had fallen and fatigue had set in. This moment of flagging interest and the Signoria's deliberate dithering provoked in Francesco Valori, a fierce opponent of the Medici sympathizer Bernardo del Nero, an irrepressible rage. He stormed up to the Signoria's bench, grabbed the voting urn, slammed it down on the table and cried out to the assembled company: "Let justice be done, or scandal will follow!". The chairman, Luca Martini, could no longer put off the vote. Five black beans were cast in favour of the death sentence, and four white ones against it: one vote too few to condemn the men by the necessary two-thirds majority. The judgement of the Signoria, which clearly differed from the opinion of the greater part of the assembly, was so repugnant to Valori that he went against all the rules and demanded that everyone present cast a vote. He burst into a fiery speech, which is recorded in a sixteenth-century chronicle:

> To what end, then, have your lordships brought together so many citizens, who four days ago, one by one, have so freely and publicly expressed their opinion regarding these conspirators, subverters of the fatherland and destroyers of freedom? What does sparing these traitors mean other than publicly welcoming back the tyrant? The tyrant who is already preparing to return by force. Do you not see the wish of so many good men? Do you not hear the universal outcry, calling for justice and the safeguarding thereof? Do you not perceive the imminent danger of deferring judgement? Remember that the people of Florence have placed you in this highest office to guarantee their safety. They have entrusted you with the public good. And if your lordships should neglect this duty out of respect for such wicked enemies, there is no lack—no lack, you can be certain!—of persons who shall embrace so just and sacred a cause, to the detriment of all who would oppose them.[189]

Feelings were running high, and there were several scuffles: as later recounted by his son Francesco, the prior Piero Guicciardini had trouble fending off Carlo Strozzi. In the end, Luca Martini felt compelled to call a new vote, and this yielded just enough to carry out the death sentence. After the requisite six black beans had been counted, the chairman ordered "that the lives of the five citizens they had just condemned during the assembly be taken" by the Eight without delay, "that very night".[190]

While everything was made ready at the Bargello, the condemned men were put in chains and their shoes removed. As they were led from the Palazzo della Signoria to the nearby palace, their cries for clemency went unheard: any compassion the people felt was far outweighed by their indignation.

At the Bargello the five men were allowed to see a priest and ask forgiveness for their sins. Francesco Valori took the precaution of having soldiers stand guard at the palace, in order to prevent the family and friends of the condemned from attempting to stop the execution.

The darkness lent the inner courtyard—surrounded by tall arcaded walls—an atmosphere as gruesome as it was eerie. Accompanied by a magistrate and a priest, the condemned were led to the place of execution one by one, starting with the youngest. Lorenzo, showing no fear whatsoever, was beheaded at the bottom of the stairs.

The doors of the Bargello, which had remained closed while the executions were being carried out, were opened once the bodies had been thrown onto a pile of hay. The crowd flocked in to view the ghastly scene. A passage in Piero Parenti's *Storia fiorentina* suggests that shortly before Lorenzo's beheading, nine-year-old Giovannino had begged the Signoria to spare his father's life:

> Just before [the execution] the Pucci and Tornabuoni families went in front of the Signoria to plead for their imprisoned relatives: particularly moving was the young son of Lorenzo Tornabuoni who, well instructed, asked that his father be granted grace.[191]

The Signoria immediately sent word to Rome, informing the pope that the executions had taken place, stressing political unity within the city and adding that anyone who attempted to disrupt it could expect the same fate. The bodies were then turned over to their families for burial. Luca Landucci could not hold back his tears when at the Canto de' Tornaquinci, just before dawn, he saw the body of "that youth" Lorenzo Tornabuoni being carried on a bier. Lorenzo's funeral was necessarily deprived of all ceremony. His body was interred in Santa Maria Novella, next to the graves of his father and his first wife.[192]

Lorenzo's death prompted Bernardo Accolti, an old friend and political sympathizer, to write a sonnet in which Lorenzo, when his last hour has struck, thinks to himself:

> I, who was once a jewel of nature,
> Now come with hands tied, barefoot and unarmed,
> To lay my young neck on the hard wood
> And rest on a bed of cheap straw.
> Take example from me, you who rise
> To worldly power, wealth or kingdom,
> For often scorned by heaven and earth
> Is he who underestimates his good fortune.
> And of you who take from me gems and treasures,
> My wife, my children, my sorry life—
> For a Turk or a Moor would show more kindness—
> Of you, obnoxious crowd, I ask only this:
> That you have my severed head presented
> To my beloved on a golden plate.[193]

156

We will never know what thoughts filled Lorenzo's mind in his final moments; but perhaps more typical of his beliefs and actions are the verses that a poet who signed himself "Aurelius Cambinius" dedicated to him when the young scion of the Tornabuoni family was still faring very well indeed. He warned Lorenzo in poetic terms against throwing himself headlong into danger. Jupiter laughs from Olympus if he sees that anybody fears more than he should; fearlessness, however, is the other extreme. The observation that "nothing seems too difficult to mortals in their madness" is followed by this advice: "Live free from care while the fates permit … Life hastens swiftly past, incapable of holding the reins for such a brief moment. But of their own accord men offer themselves to fate and do not fear dire Phlegethon". Cambini went on to say that even the most successful Roman generals were not blessed with lasting fortune.[194]

Interestingly enough, the poet drew Lorenzo Tornabuoni's attention to the dangers of seeking wealth and fame: "Change your plans; do not go to meet swift death". Cambini also gave him a piece of advice: "The greatest good is to be able to live … We must live only with a love for virtue and cast base desires from our hearts". Cambini closed the poem in the spirit of Horace:

> Pale death kicks with impartial foot at royal palaces
> And the dwellings of peasants and humble folk.
> One must fill one's breast with Socratic concerns
> And live one's life in accordance with sound rules.
> Noble virtue never plunges into the Styx nor into darkness;
> Aiming high, it cannot stay in a humble place.
> O lofty spirits, take heart and live courageously,
> So that you will escape the waters of Lethe,
> And when Lucifer will shine in that fateful hour,
> Ever-vigilant glory will open up the way to heaven.[195]

These words sounded like sensible, well-meant advice when they were written, but after the dramatic events of August 1497 they were tinged with melancholy.

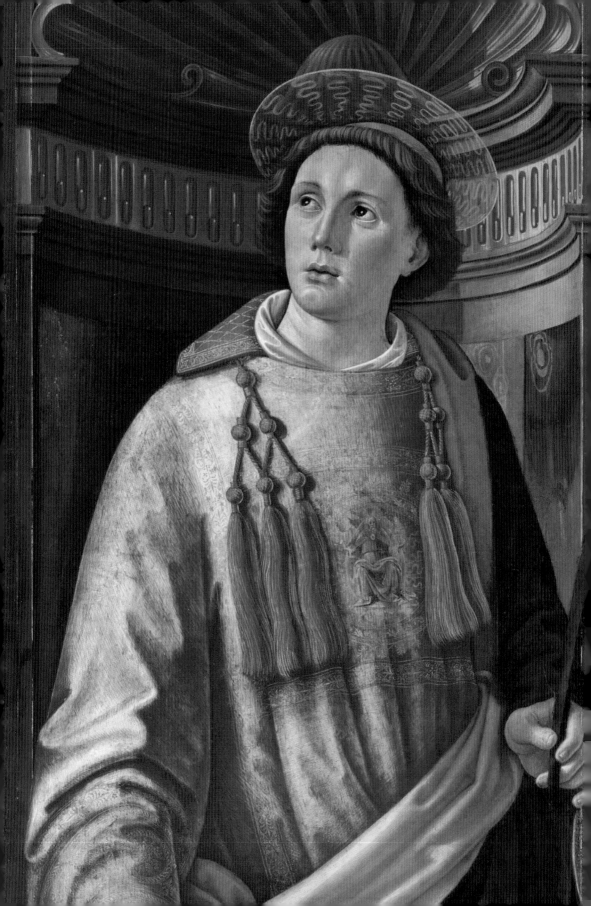

Epilogue

The grief did not end with the execution of Lorenzo: the judgement handed down by the Signoria included the confiscation of his property. The strict laws of the Florentine Republic showed no mercy towards disloyal citizens, and so Lorenzo's next of kin were faced with a long series of difficult financial negotiations with the authorities. His wife Ginevra also had another setback to deal with: in addition to the death of her husband and the seizure of his property, one of her brothers had been banished from the city.[196]

From a legal standpoint alone the situation was extremely complex. Lorenzo was survived by two male heirs, both underage at the time of his death: Giovannino was nine, Leonardo only four. When a well-to-do Florentine citizen died intestate leaving one or more underage children, it was left to the Magistrato dei Pupilli (Court of Wards) to determine how the family estate would be administered until the heirs attained their majority. To this end, an inventory had to be drawn up of the family property. As mentioned earlier, the Tornabuoni were visited in January 1498 by a clerk authorized to take stock of their possessions. He made an exhaustive record of all the movable goods to be found in the *palazzo* in Via dei Belli Sporti and at the country estates at Chiasso Macerelli and Le Brache. A cousin of Lorenzo, Giuliano di Filippo Tornabuoni, saw to it that everything was recorded in good order. Giuliano's willingness to help Ginevra, Giovannino and Leonardo shows that the Tornabuoni stood by one another. At the same time, Giuliano, in helping his cousin's heirs, was returning a favour, for his uncle Giovanni had earlier paid for part of his university education.[197]

The municipal authorities no doubt hoped to lay their hands on a substantial part of the family fortune. When the officials of the Court of Wards completed their investigation, the Syndics of Rebel Properties would be able to take action. But those who assumed that the Tornabuoni fortune would fill the depleted public coffers were sorely mistaken. There was, in fact, a striking discrepancy between the value of the assets administered by Lorenzo since his father's death in April 1497 and those which legally belonged to him. The State Archives in Florence contain a brief summation of Giovanni Tornabuoni's total assets at the time of

his death. In terms of landed property, he owned the Palazzo Tornabuoni in the city and a number of country estates ranging in value from 3,000 to 5,000 florins. The furnishings of these houses—which included beautifully decorated *cassoni*, Ghirlandaio's tondo and his portrait of Giovanna degli Albizzi—were worth altogether about 2,500 florins. The jewels alone—including a precious pendant—were valued at no less than 1,400 florins. His personal property was thus estimated to be worth more than 40,000 florins; the debts, however, amounted to 25,000 florins.[198]

Fortunately, in 1495 old Giovanni Tornabuoni had had the foresight to transfer the ownership of the bulk of his fortune not to his son but to his grandchildren. That decision had been prompted by the fact that he and Lorenzo had taken great financial risks by agreeing, earlier that year, to sort out the affairs of the Medici bank. Thus the administrators of Lorenzo Tornabuoni's property were confronted with unexpectedly complex legal constructions. To complicate matters further, the syndics were immediately besieged by claims from alleged creditors who maintained that Lorenzo owed them money. On 17 February 1498 the Signoria set up a special committee of six citizens and entrusted them with the task of deciding which creditors were acting in good faith. It took until May 1500 (and perhaps even longer) for the authorities to sort out Lorenzo's confiscated possessions. The registers of the Captains of the Guelph Party in Florence's State Archives describe various transactions relating to the collection and payment of debts to the estate.[199]

There are compelling reasons to assume that the syndics, despite their zealousness, ultimately confiscated only a fraction of the vast family fortune. In 1542, when the imposing Palazzo Tornabuoni was sold to the Ridolfi family, the costly works of art—including Ghirlandaio's tondo of the *Adoration of the Magi*—were still in place. Until that time, therefore, Lorenzo's relatives had succeeded in keeping the most precious possessions in the family.[200]

The family's solidarity manifested itself even more clearly in their concern for Lorenzo's spiritual welfare. The first to make a payment for masses for Lorenzo's soul was Messer Luigi di Filippo Tornabuoni. Acting on behalf of the heirs, on 30 August 1497 he donated a sum that covered the cost of eighteen *libbre* (more than six kilograms) of beeswax for torches and candles. One year after the death of her husband, Ginevra gave more than two gold florins to the friars, so that they would not neglect to say the Office of the Dead. Not long afterwards she turned again to the monastic community of Santa Maria Novella, requesting that forty clerics recite the Thirty Masses of St Gregory. The origin of this custom, in which thirty masses are celebrated on thirty consecutive days, can be traced to the sixth century, when Gregory the Great refused burial in consecrated ground to the monk Justus, who had violated his vow of poverty (three gold coins had been found in his possession). Some time later Gregory relented: moved with compassion for the dead monk's soul, he had thirty masses said for him, after which the deceased appeared to one of his brethren to say that he had been saved. Later celebrations of the Thirty Masses of St Gregory were generally undertaken—completely in the spirit of the legend—with the purpose of saving the deceased's soul. By paying for the celebration of the Thirty Masses, Ginevra was doing what she could to ensure that God would be merciful to Lorenzo. When Giovannino was approaching adulthood, he also made several financial donations to the convent: in 1502 and 1504 he paid for torches to be lit on All Souls' Day.[201]

During the last years of his life, Lorenzo Tornabuoni was involved with men who were eager to throw themselves into the fray and therefore did not shrink from danger. None of

them died a natural death. Cegino, the kingpin of the illegal traffic in Medici possessions between Rome and Florence, was arrested as early as August 1497 and detained for several months. When it was realized that no more secrets could be extracted from him, he was condemned to death and beheaded on 16 December in the inner courtyard of the Bargello, the very place of Lorenzo Tornabuoni's execution.[202]

Less predictable was the rapid downfall of Savonarola and his most fervent and outspoken follower, Francesco Valori, the leader of the *piagnoni* ('weepers') or *frateschi* ('the friar's men'). For several years Savonarola and his fierce campaigns for strict moral reform met with much success among the Florentines. People flocked to hear his sermons, which he delivered more and more often in the magnificent Cathedral. Savonarola stood at the head of a relatively independent congregation (he had secured privileges for San Marco from Pope Alexander VI), which gave him great freedom of action. He urged the Florentines to consider Christ their only true leader and himself their spiritual guide on earth. Savonarola also made use of the newly emerging art of book-printing to speed up the dissemination of his radical ideas. Understandably, he encountered much resistance from the Roman Curia. The pope's abolition of the congregation of San Marco in 1496 was followed by the excommunication of Savonarola in 1497. Even so, the sermons of this fanatic preacher-prophet continued unabated. In March 1498 the Signoria asked Savonarola to stop preaching, because the pope was threatening to impose an interdict on Florence if the friar was not silenced. At first Savonarola complied with their request, but then he appealed to the 'defenders of Christianity'—namely the emperor and the monarchs of France, England, Spain and Hungary—to summon a council which would reform the Church and depose the incumbent pope. As a result of this new provocation, Savonarola was challenged by his opponents in Florence to submit to an ordeal by fire. Against Savonarola's wishes, his fellow brother Domenico da Pescia offered to undergo the ordeal on his behalf—in the presence of the city's entire population. Despite the extensive preparations that had been undertaken to turn the Piazza della Signoria into a suitable venue, the trial by fire had to be cancelled owing to protracted, last-minute negotiations on the day itself and to a sudden thunderstorm, with its own threat of pyrotechnics.

In the meantime, the atmosphere in Florence was becoming more menacing by the minute. The day after the foiled ordeal—on 8 April 1498 (Palm Sunday)—the populace stormed the convent of San Marco. The hours-long siege lasted well into the night, until Savonarola gave himself up and was escorted—with physical and verbal abuse raining down on him from the angry mob lining the streets—to the Palazzo della Signoria, where he was accused of heresy, schism and contempt of papal authority, and thrown into the dungeon. A trial held in the presence of two papal nuncios resulted in the death sentence for Savonarola and his two faithful followers, Domenico da Pescia and Silvestro Maruffi. The friar's execution is described in gruesome detail in all the chronicles. To stage this macabre spectacle, the Signoria had ordered the erection of a long wooden platform extending from the Palazzo della Signoria to the middle of the piazza (fig. 87). The three friars were led out to the gallows at the end of the platform and hanged, after which their bodies were consumed by a bonfire lit beneath them. According to Luca Landucci, they "burned at the stake for a few hours, until their charred limbs fell off one by one". Their thoroughly incinerated bodies were then thrown into the river "so that not a single piece of them could be found"; but "there were those who secretly got hold of the floating charcoals".[203]

Landucci's fellow chronicler Piero Parenti gives the most detailed account of the subsequent fate of Francesco Valori, the politician who had passionately argued in front of the Signoria for sentencing to death Bernardo del Nero, Niccolò Ridolfi, Lorenzo Tornabuoni, Giannozzo Pucci and Giovanni Cambi. On 8 April 1498, when a multitude of Savonarola's opponents—the *arrabbiati* ('the enraged' or 'maddened')—stormed the convent of San Marco, Valori happened to be attending Vespers there. At the friars' urging, he set off for his palace, which he hoped to use as a base for recruiting men to make a stand against the *arrabbiati*; on his way home, however, he was beset by an armed mob and realized that he had no choice but to take cover. The hatred of Valori's enemies could not be suppressed: his palace was plundered, his wife killed when she appeared at an upstairs window. Representatives were sent by the Signoria to escort Valori to the seat of government, but as soon as he came out of hiding he was brutally slain. According to Parenti, his murder was the work of "men of the Ridolfi, Pitti and Tornabuoni families", who were bent on avenging the death of their loved ones.[204]

The rapid succession of executions and reprisals illustrates the state of political confusion prevailing in Florence at the end of the fifteenth century. The deep feelings of discontent were expressed in a number of ways. After Savonarola's execution, holy places were repeatedly targeted by troublemakers. In 1498, Christmas Mass in the Cathedral was disrupted when a horse was brought into the building and tortured to death. That same night other incidents followed: bonfires were lit in several churches and goats were let loose in Santa Maria Novella. This was not the first time that the church where the Tornabuoni had their beautifully decorated chapel had been vandalized: according to Landucci, a few years earlier miscreants had desecrated a number of graves in front of it.[205]

As a pre-eminent rebel and political exile, Piero de' Medici witnessed neither the slaying of the *fratteschi* nor the Christmas Day disturbances of 1498. When the confusion was at its height, he repeatedly attempted to return to Florence in the hope of seizing power. His life came to a premature end, however, in 1503. Piero had sided with the French, who were in the area of Gaeta, south of Rome, making a stand against the Spanish troops led by Gonzalo Fernández de Córdoba. When they finally clashed on the banks of the river Garigliano, the French were defeated by the Spanish. During the retreat, Piero drowned while attempting to evacuate artillery in a boat. His inglorious death is one of the reasons for his nickname, 'the Unfortunate'.[206]

Although constantly seeking to distinguish himself through valorous deeds, Piero was not on good terms with Dame Fortune, despite Machiavelli's assertion that human destiny could more readily be shaped by forceful—rather than timorous—leaders, "because fortune is a woman, and if you wish to keep her under it is necessary to beat and ill-use her". In Piero the 'lion' and the 'fox' were not in harmony, and this led to many victims, himself included.[207]

In the years 1502–12 the city of Florence experienced a gradual recovery. The Florentine Republic was headed by Piero Soderini, who was appointed Gonfalonier of Justice for life to ensure political stability. For an entire decade the authorities succeeded in keeping the Medici at bay and partially limiting papal interference. A number of important fiscal and military reforms were implemented. In this period of renewed self-confidence, Leonardo da Vinci, Michelangelo and Raphael were among the city's residents. Michelangelo, who in 1503 had unveiled his marble *David*, a symbol of the freedom of the Florentine state,

86. [p. 158] Domenico Ghirlandaio, *St Lawrence*, detail (→ 72).

87. Florentine artist (Francesco Rosselli?), *Savonarola Burned at the Stake in the Piazza della Signoria*, detail. Florence, Museo di San Marco.

88. [p. 165] Domenico Ghirlandaio, *The Calling of Peter and Andrew*, detail (→ 9).

and Leonardo were commissioned to decorate the Council Hall—the Sala del Gran Consiglio, later called Salone dei Cinquecento, or Hall of the Five Hundred—in the Palazzo della Signoria with portrayals of two landmark victories of the Florentine army. Begun in May 1495 and built in record time, this hall had become necessary since the creation of the Great Council, which had many more members than the previous government bodies. Leonardo's unfinished *Battle of Anghiari* has not survived, and Michelangelo never even began to paint the planned *Battle of Cascina*, meant to celebrate Florence's hard-won victory over Pisa in 1364 (a harbinger of the Florentine triumph of 1509, which finally put an end to the war that had broken out following the expulsion of Piero de' Medici). The famous cartoon he produced for the scene was later destroyed.

But Soderini's position was not unassailable either. For a long time Florence had focused its political attention on France. This policy, strengthened by a trade agreement, proved fatal to the Republic when the French king Louis XII (Charles VIII's successor) clashed with the Holy League, founded at the instigation of Pope Julius II. French and Florentine troops were defeated, and after the sack of Prato, Soderini fled Florence. In the meantime Giovanni de' Medici, Piero's younger brother, had managed to reorganize Medici sympathizers in the city and secure the pope's support. On 16 September 1512, the Medici took over the reins of government. The following year Giovanni was elected pope under the name of Leo X.[208]

Once the Medici had been restored to power, such families as the Tornabuoni no longer needed to keep out of the public eye. And so it happened that Giovannino, the only child of Lorenzo and Giovanna, was able to take a seat in the Signoria as soon as he reached the required age. In October 1519, when he was thirty-two, he assumed the office of Prior, and scarcely three years later was elected *orator* of the Florentine Republic at the papal court. The young scion must have been proud to carry on the family tradition. It is not known how long he stayed in Rome or whether, like his grandparents, he lived in a house in the Ponte district, opposite Castel Sant'Angelo. At some point, however, he must have gone to the Sistine Chapel—whose ceiling had meanwhile been decorated by Michelangelo—to view the life-size portrait of his father painted by Ghirlandaio in 1482 (fig. 88).[209]

No doubt the sight of this portrait opened the floodgates of memory. Giovanni Tornabuoni's image of his father was determined in part by the magnificent works of art commissioned by his family, which gave expression to a complex web of aspirations, both worldly and spiritual. In the space of ten years, his family had employed every means at their disposal to add lustre to their lives. Lorenzo's refined taste had led him since adolescence to seek out the greatest Florentine artists. These were years of glory, during which the Tornabuoni distinguished themselves as prominent citizens of 'the new Athens on the Arno'. But self-glorification and the promotion of familial interests were not the only reasons for commissioning art. In their aesthetic refinement and iconographic richness, the artistic creations of such artists as Botticelli and Ghirlandaio touched an unprecedented range of feelings and ideals. Life and art were closely interwoven in pictures that allowed pagan gods or Christian saints to mingle with fifteenth-century Florentines. Together these images tell a story of prosperity and adversity, of glory, mortality and a longing for the sublime.

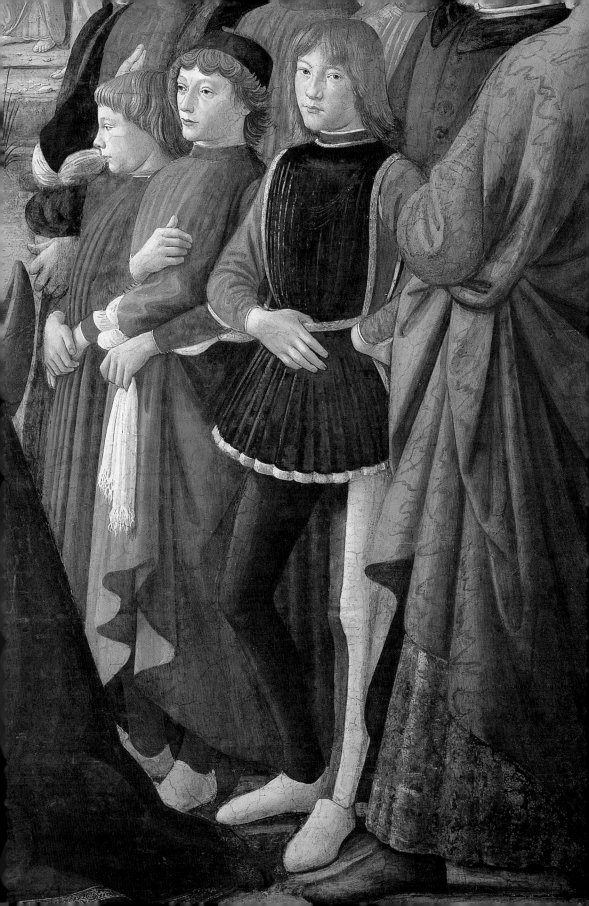

Abbreviations

AOSMF Archivio dell'Opera di Santa Maria del Fiore, Florence

ASFi Archivio di Stato di Firenze, Florence
 CRSPL: Compagnie religiose soppresse da Pietro Leopoldo
 CRSGF: Corporazioni religiose soppresse dal governo francese
 DG: Decima Granducale
 Grascia: Ufficiali poi Magistrato della Grascia
 Pupilli: Magistrato dei Pupilli avanti il Principato
 MaP: Mediceo avanti il Principato
 Monte: Monte comune o delle graticole
 NA: Notarile antecosimiano

ASV Archivio Segreto Vaticano (Vatican Secret Archives), Vatican City

BAV Biblioteca Apostolica Vaticana (Vatican Library), Vatican City

BML Biblioteca Medicea Laurenziana, Florence

BNCF Biblioteca Nazionale Centrale di Firenze, Florence

Notes to the Preface

1 On the intertwining of life and art in the fifteenth century, see Huizinga 1916 and Huizinga 1919, English translation 1996, Chapter 12 ('Art in Life').

2 The fifteenth-century Florentine patron who commissioned more works of art than anyone else was Cosimo de' Medici the Elder (1389–1464); his 'patron's oeuvre' is the subject of Kent 2000. His son Piero (1416–69) and grandson Lorenzo (1449–92) were responsible for fewer commissions. In the last quarter of the fifteenth century the Tornabuoni were among the most important art patrons in Florence.

3 The scholarly treatise on Giovanni Tornabuoni's 'patron's oeuvre' referred to here is the dissertation by Patricia Simons (1985), which contains many references to source material.

Notes to Chapter I

4 For the history of the Tornaquinci and Tornabuoni families, see Plebani 2002.

5 Regarding Francesco Tornabuoni as Gonfalonier of Justice, see ibid., 192. On Lucrezia Tornabuoni, see Patrizia Salvadori's 1993 edition of her letters and Pernis–Adams 2006.

6 Regarding the Rome branch of the Medici bank and Giovanni's position there, see Roover 1963, 194–224. The designation "ministro e chonpagno" appears in the contract signed by Giovanni and Piero de' Medici on 31 October 1465 (Simons 1985, I, 124). In Rome, in addition to his banking activities, Giovanni also engaged in trade. In the 1450s he regularly imported textiles and parchment from Florence. Until about 1465, Florentine merchants were still doing good business in Rome, but then things changed: see Plebani 2002, 241–50, esp. 243. Regarding the conspiracy against Piero de' Medici, see Rubinstein 1966, 154–63 and Rubinstein 1968.

7 Lorenzo Tornabuoni's date of birth is recorded in ASFi, Tratte, 80, Libri di età, fol. 146r. The precise date of birth of his sister Ludovica is not known: in the *catasto* declaration of 1480 a girl by the name of Ludovica is mentioned as being four years old (ASFi, Monte, Copie del Catasto, 73, fol. 431r). Ludovica "Johannis de Tornabuonis filia" was still alive in late 1511, when the four children she had borne to Alessandro di Francesco Nasi (Francesca, Caterina, Francesco and Giovanni) were entrusted to her care after her husband's death: cf. ASFi, NA, 21124, fol. 27r (Burke 2004, 233 note 73). On the relations between the Tornabuoni and the French royal family, see Simons 1985, II, 116 note 182. See ibid., I, 130–1, for information on Antonio, Lorenzo's illegitimate half-brother.

8 A comprehensive list of names of Florentine bankers with business interests in Rome was provided by Benedetto Dei, a friend of Lorenzo Tornabuoni, in his *Memorie*, fol. 52r. Regarding the Tornabuoni's Roman residence, see Plebani 2002, 248 note 179, with reference to ASFi, MaP, filza 28, doc. 339r: "al presente habbiamo mutata casa et habbiamo una bella e piacevole stantia" (letter of 31 July 1472 from Francesca Pitti to Clarice Orsini). For Giovanni Tornabuoni's role in the Confraternity of Santo Spirito in Sassia, see ibid., 249–50, with reference to *Necrologi* 1908–14, II, 108–9. For the relations between the confraternity and Pope Sixtus IV, see also Howe 2005.

9 A facsimile edition of Giuliano da Sangallo's sketchbook (MS Vat. Barb. lat. 4424) was published in 1910 (reprinted in 1984). Regarding Giovanni's mediation in the acquisition of Argyropoulos' books, see Simons 1985, I, 126–7, 132, II, 106 note 121; for Lorenzo's collection of ornamental stones and sculpture, see Fusco Corti 2006, *ad indicem*.

10 See the excellent biography by Ingeborg Walter (2003), with detailed bibliography.

11 Hatfield 2004, 103 note 15: "Consistently 'magnificent' and sometimes also 'generous' persons whom I have encountered in Florentine records from about 1450 on include the members of the *Signoria* and the *Dieci di Balia*; foreign nobles who served as military commanders (who also were 'strenuous'); some knights, including Messer Andrea Pazzi, Messer Luca Pitti and Messer Tommaso Soderini, Cosimo, Piero (both di Cosimo and di Lorenzo), Lorenzo and Giuliano de' Medici; and Giovanni Tornabuoni. Others who usually were *not* described as 'magnificent' or 'generous' were Francesco Sassetti, Antonio Pucci and Filippo Strozzi". For the shift of *magnifico* as an adjec-

tive to *il Magnifico* as an epithet in the case of Lorenzo de' Medici, see Walter 2003, 258–9. For an example of the use of the term *magnifico* with reference to Lorenzo Tornabuoni, see below, note 15.

12 ASFi, MaP, filza 35, doc. 746r: "Carissimo mio Lorenzo. Son tanto oppresso da passione e dolore per l'acerbissimo e inopinato chaso della mia dolcissima sposa, che io medesimo non so dove mi sia. La quale, chome arai inteso ieri, chome piacque a Dio a hore xxii soppra parto passò di questa presente vita, e·lla creatura, sparata lei, gli chava[m]mo di corpo morta, che m'è stato anchora doppio dolore. Son certissimo che per la tua solita pietà avendomi chompassione m'arai per ischusato s'io non ti scrivo a longho …". The missive is dated 24 September 1477.

13 Passavant 1969, 188; Agghàzy 1978; Butterfield 1997, 237–9.

14 See Musacchio 1999, 30–1: "If the child had been baptised while in the womb, a relatively common practice when death was feared, it could have been buried in the sarcophagus with Francesca, thus accounting for the double effigy". The earliest description of the ensemble was given by Giorgio Vasari (1568, ed. Bettarini–Barocchi 1966–87, III, 535, 480–1), according to whom Giovanni Tornabuoni had commissioned Ghirlandaio to fresco the wall behind the funerary monument. See also Kecks 2000, 362–4.

15 Regarding the walnut table, see ASFi, Pupilli, filza 181, fol. 150r: "Nell'antichamera di detta chamera [the 'sala grande'] … 1° tavolino da chontare danari di nocie". For the treatise on arithmetic (*Trattato d'abacho*), see BNCF, Magl. XI.115; the illuminated title page (fol. 1r) bears the following dedication: "Giovanni di Bernardo Banchegli Al magnifico | Lorenzo Thornabuoni". With regard to Lorenzo's early education, see *Lives of the Early Medici* 1910, 218 and Simons 1985, I, 130–1. Clarice Orsini, wife of the Magnificent, criticized Politian for favouring humanistic education over religious instruction in tutoring her sons (cf. Walter 2003, 237, with reference to Picotti 1955); Politian was temporarily dismissed, and Piero, too, was tutored for a time by Martino della Commedia: see Isidoro Del Lungo's edition of Politian's writings (1867, 72–3 note 3).

16 On the impact of the 1439 Council of Florence, see *Firenze e il Concilio* 1994. Lorenzo Tornabuoni's borrowing of the *Iliad* and the *Odyssey* is documented in *Protocolli del carteggio di Lorenzo* 1956, 229 (quoted in Fahy 1984, 233). For Politian's dedication of the *Ambra*, dated "pridie nonas novembres MCCCCLXXXV", see once again the edition by Isidoro Del Lungo (1867, 335).

17 Regarding the decoration of the Sistine Chapel and the role possibly played by Lorenzo de' Medici, see Elam 1988; Cadogan 2000, 221–6; Walter 2003, 195–7. For the portrait of Giovanni Tornabuoni, see Schmid 2002, fig. 52.

18 Verde 1973–94, III/1, 575–7.

19 With regard to Lorenzo's *emancipazione*, see ASFi, NA, 1925, fols. 37v–8r and ins. 2, no. 9 (cf. Simons 1985, II, 113 note 165); see also Sman 2007, 184–5 note 77 and below, Chapter 8.

20 For the masses said in memory of Francesca Pitti, see Simons 1985, I, 137 and II, 115 note 179. Regarding Giovanni's position as manager of the Rome branch of the Medici bank, see Roover 1963, 218–24. Raymond de Roover sketches a rather negative picture of Giovanni Tornabuoni. Regarding Ghirlandaio's donor portrait in the chapel of Santa Maria Novella, he comments: "Giovanni's portrait does not convey the impression of a forceful personality but of a man who conformed to conventions and was a follower rather than a leader. This was the great shortcoming of Giovanni Tornabuoni as a businessman". Melissa Bullard revised this opinion in a recent study, in which she states that Lorenzo the Magnificent had every reason to be grateful to Giovanni Tornabuoni ('Heroes' 1994, 119): "he was Lorenzo's long-time business partner in Rome, who in fact had more of his own money invested in the Rome bank than Lorenzo and to whom Lorenzo owed a great deal personally as well as financially". Guicciardini's praise of Lorenzo Tornabuoni is included in the *Storie fiorentine* (ed. Lugnani Scarano 1970, 167: "al quale, sendo giovane pieno di nobiltà e di gentilezza, non mancava grazia e benivolenzia universale di tutto el popolo, e più che a alcuno della età sua").

21 For the history of the Albizzi family, see Dumon 1977. With regard to the Albizzi's role in establishing an oligarchy, see Rado 1926.

22 Mallett 1967, 195–206. Maso was born in early 1427 (ibid., 199; ASFi, Catasto, 80, fol. 52v) and died on 13 April 1491, while holding the office of *proposto*: see Brown 1992, 109 note 16, 140, with reference to ASFi, Balie, 39, fol. 148v.

23 Pontassieve, Poggio a Remole, Archivio Frescobaldi, 199 [191], Albizi, *Ricordi di Maso di Luca di messer Maso degli Albizi*, hereafter *Ricordi*; 204 [18], Albizi, *Libro debitori e creditori di Maso di Luca di messer Maso degli Albizi di Luca di Maso (1480–1511)*, hereafter *Libro debitori e creditori 1480–1511*; 203 [19], Albizi, *Libro debitori e creditori di Maso di Luca di messer Maso degli Albizi (1458–1479)*.

24 Regarding the birth of Luca di Maso, see *Ricordi*, fols. viii-viiii. For Albiera's premature death and the rare, and thus so interesting, description of the burial rites, see ibid., fol. xiiiir: "Richordo chome og[g]i questto xxv di mag[g]io 1455 a ore 17 ½ chome fu piacere di Dio l'Albiera mia don[n]a et figliuola di messer Orlando de' Medici essendo di partto di dì 25 in Piero mio figliuolo pas[s]ò di questta presentte vitta a la quale Idio eb[b]e fatto verace perdono per sue chrazie di malat[t]ie discese [?] e di chat[t]iva disposizione di corpo. Churol[l]a maestro Pagholo del maestro Domenicho e maestro Giovanni da Luc[c]ha il quale mandò messer Orlando suo padre. L'onoranza la fe [*sic*] fu in questo ef[f]etto sotto ischritto. | A dì 25 detto a ore xxii si sopelì chon una vigilia cho' fratti di Santa Croce e circha pretti 25 e chon buon numero di cit[t]adinanza perché il corpo non era da serbare. | E a dì 28 detto si fé l'asequio e indug[i]os[s]i rispetto a le feste de lo Ispirito Santo. Fuv[v]i i frati di Santa Croce et di San Domenicho et Charmino e Servi e 'l cherichato di Santa Maria del Fiore sanza suono di chanpana e circha pretti 25 forestieri. Lo choro si tran[?]chiuse et in manno libbre 227 di cera. Vesti[i] madon[n]a sua madre di tagli ii di panno monachino [linen], vai, veli e sc[i]ughatoi chome chostume et più vesti[i] la bonde [?] e l'Andromacha sua chognata di tagli uno per c[i]aschuna di panno monachino e veli. | E a dì 29 detto si facerno le messe in San Piero Mag[g]iore in buono numero di pretti e chon quel[l]a quantità di cera si poteva c[i]ascuna volta non uscendo de l'ordine. Di poi la sera uscendo fuori andai a vicitare messer Orlando e madonna chome costume e fu fuori di conventuo le requieschant in pace, il quale asequio mi ven[n]e fiorini centocinquanta d'oro per tutto. | Stette mecho da dì xxi di gennaio 1452 per insino a detto dì xxv di mag[g]io 1455 che furano anni due et iiii mesi e iiii dì di puntto che nel detto tenpo mi fé in mesi xiii due figliuoli maschi, che l'uno a nome Lucha il mag[g]iore e l'altro Piero". Regarding Piero's death, see ibid., fol. xiiir. For Domenico Veneziano's painting, see Wohl 1980, 48, 131–2, fig. 110.

25 *Ricordi*, fol. xviir: "Richordo come og[g]i questto dì xi d'ottobre 1455 chol nome di Dio esendo rimaso vedovo dell'Albiera mia donna a richiestta e volontà di Chosimo de' Medici e di chonsiglio di messer Orlando de' Medici mio primo suocero e di Lucha Pitti e altri nostri parenti e amici in chasa del sopradetto Chosimo chonsenti[i] e presi per donna la Chatterina figliuola di Tomaso di Lorenzo Soderini chon quella dotta e quantità di dota pare a Lucha Pitti e Piero di Chardinale Rucel[l]ai ne quai liberamentte mi rimisi chome in parentti e intimi benivoli a noi di parere e chonsenso di Lucha mio padre. Roghatto ser Pagholo di Lorenzo di Pagholo notaio fiorentino la quale dotta che avevano fus[s]i fiorini mille d'ariento cioè fiorini 1000 chontanti e fiorini 200 di donora. E choxì restai chontentto benché di più m'aves[s]ino datto intendimentto restai paziente al volere loro. | E a dì xxii di gennaio 1455 chol nome di Dio me ne la menai a chasa sanza alchuna dimostrazione chon don[n]a. | E a dì xi di feb[b]raio 1455 chonfessai avere aùta la dotta cioè fiorini milledugentto tra danari e chose et Lucha mio padre la sodò. Roghatto ser Nicholò di Michele di Feo Dini nottaio fiorentino sotto detto dì".

26 Both Litta (1879, plate XX) and Dumon (1977, 184–5) are incorrect and incomplete in their reconstruction of Maso and Caterina's family. Between 15 November 1457 and 5 February 1479, the following girls were born: Albiera (I), Maria, Bartolomea (I), Dianora, Lisabetta (I), Bartolomea (II), Lisabetta (II), Giovanna, Albiera (II), Aurelia, Francesca, Ginevra. When their mother, Caterina, had her will drawn up on 25 April 1497, seven of the twelve daughters were still alive, namely Maria, Dianora, Bartolomea II, Lisabetta II, Albiera II, Aurelia and Francesca; see ASFi, NA, R.301, fol. 132r-v. For their dates of birth, see below, note 29. Bartolomea I was born in August 1460 and died a few

months later (see *Ricordi*, fol. xlr: "monna Chaterina donna d'Antonio d'Agostino da Ugnano a Set-
timo eb[b]e a lat[t]are la Barttolomea mia figliuola a dì ii di aghosto 1460 per lire cinque il mese d'ac-
[c]hordo con la Chaterina mia don[n]a et più eb[b]e con detta fanc[i]ul[l]a le sotto ischritte chose
pel bisogno d'es[s]e … | A dì 3 di dicembre 1460 manchò la fanc[i]ul[l]a sopradetta malatta del qual
male la notte sechuente chome fu piacere di Dio si morì. À esser pagatta per tutto detto dì. | Rende
le sopradette chose avevo notatte di sopra e fe[ci]le dovere del servitto suo"). Her Christian name
was assumed by Bartolomea II, born on 1 December 1463. This practice was repeated in 1467 when
Lisabetta II took the name of a girl born in 1462, who also died in infancy. Ginevra was born in 1479
and died on 30 August 1483; for her death, see *Libro debitori e creditori 1480–1511*, fol. 25.

27 Cf. L. Bellosi, in *Pittura di luce* 1990, 56–7, no. 5.

28 For the amount of the girls' dowries, see ASFi, Catasto, 1022, fol. 33r and the *Libri debitori
e creditori* mentioned above, note 23. For a description of the *desco da parto* now at the Museo Horne,
see De Carli 1997, 164–5 (with an attribution to the 'Master of the Johnson Nativity') and Däubler-
Hauschke 2003, 328–30 (Florentine school).

29 See the registers of the Baptistery (AOSMF, Archivio storico delle fedi di battesimo, available
on the Internet at <http://www.operaduomo.firenze.it/battesimi>) under the following dates: 19
December 1458 (Maria, born on 18 December; see *Ricordi*, fol. xxxvv); 29 July 1461 (Dianora); 12
November 1462 (Lisabetta); 1 December 1463 (Bartolomea II); 8 July 1467 (Lisabetta II); 19 Decem-
ber 1468 (Giovanna Francesca Romola, born on 18 December); 10 June 1474 (Albiera II, born the
same day); 15 July 1476 (Aurelia, born on the same day); 27 July 1477 (Francesca); 6 February 1478
[Florentine style, i.e. 1479] (Ginevra, born on 5 February). Regarding the birth of Albiera, see *Ricor-
di*, fol. xxxiiiv: "Lunedì not[t]e a ore x incircha vegnentte il martedì a dì xv di novembre 1457 trovan-
domi a Nipoz[z]ano per rispetto a la morìa ch'era a Firenze la Chaterina mia don[n]a partorì una
fanc[i]ul[l]a femina la quale ba[t]tez[z]ai a dì 16 detto a le fontti di Ghiacetto, posile nome Albiera
et Lisabetta per la mia prima donna. I chompari furono e sotto ischritti c[i]oè | Ser Dofo di Chur-
[r]ado prette di San Nicholò a Nipoz[z]ano | Charlo di Zanobi Bucoli [?] | Geri di Choc[c]ho del
Chaio di Valdisieve per lui Francesco suo figliuolo | Giovanni di Simone detto Forziere fat[t]ore di
chasa | Monna Apol[l]onia donna di Bindo [?] da Nipoz[z]ano | Monna Ginevra figliuola di Biagi-
no da Ghiacetto di Valdisieve".

30 Giovanna's date of birth is known from the Baptistery registers (see previous note) and ASFi,
Monte, 3743, fol. 8r.

31 Angelo Poliziano, *In Albieram Albitiam*, in id., *Due poemetti latini*, ed. Bausi 2003, ll. 33–6:
"Solverat effusos quoties sine lege capillos, / infesta est trepidis visa Diana feris, / sive iterum ad-
ductos fulvum collegit in aurum, / compta Cytheriaco est pectine visa Venus". For the collection
of writings compiled in memory of Albiera, see Patetta 1917–8. Regarding Albiera's fiancé, Sigi-
smondo di Agnolo della Stufa, see Cecchi 2005, 179 note 127. An illuminated manuscript contain-
ing epigrams by Martial served to mark the engagement of Albiera and Sigismondo (see De la Mare–
Fera 1998).

32 "Namque umeris de more habilem suspenderat arcum / venatrix dederatque comam diffun-
dere ventis, / nuda genu nodoque sinus collecta fluentis"; English quoted from the translation by
H. Rushton Fairclough for the Loeb Classical Library (Virgil, *Eclogues, Georgics, Aeneid I–VI*, Lon-
don–New York, 1916, 263). Giovanna's portrait medal is discussed in Wind 1968, 75.

33 On Annalena Malatesta and the convent (later dedicated to St Vincent Ferrer), see Richa
1754–62, X, 119–78; Zippel 1901; W. Paatz–E. Paatz 1940–54, V, 407–12. On the convent as an edu-
cational institution, see Strocchia 2003, 181. When Sigismondo della Stufa gave the volume of po-
etry (now in Turin, Accademia delle Scienze, MS 0235) to Annalena Malatesta, he wrote: "Ea mit-
to ad te, si eandem vim habere tecum possint. Scio enim te quoque egere consolatoribus, que tua in
Albieram pietas fuit" ('I send you all of these in the hope that they have the same power, since I
know that you, too, need comforters, and I am well aware of the affection you bore for Albiera').

For a codicological description of the manuscript, see Clemente 2005, 62–5, no. 14, figs. 9–12. For the mention of Annalena in connection with Giovanna's *donora*, see below, note 41.

34 The *Ricordi* (fol. xxxiv, 1459) mention "iiii Libri", namely "uno Terenzio", "uno Tul[l]io De ofiti [Cicero's *De officiis*]", "uno di Lasandro [Alessandro] Magnio" and "uno primo Bel[l]o Punicho"; see also ibid., fol. xlvr for a reference to, among others, a book "di filosofia". Regarding Maso's lending of the book on zoology, see a loose note inserted in Maso's *Libro debitori e creditori 1480–1501*: "Maso pregovi in servigio grandissimo che·cci prestiate a suora Maria da san Ghaggio vostra cugina e a me quel vostro libro della natura degli animali che v'è su el palisco [*sic*] e se volete cosa che possiamo avisateci che saremo ap[p]arec[c]hiatissime | Suora Annalena". For Filippo Lippi's Madonna, see *Ricordi*, fol. xxvv: "1º Cholmo di Nostra Don[n]a col fanc[i]ul[l]o in chol[l]o di mano di Fra Filip[p]o".

35 Plebani 2002, 167 note 242.

Notes to Chapter 2

36 See Klapisch-Zuber 1979 and Fabbri 1991, 175–93. Most of these phases are clearly described in Filippo di Cino Rinuccini's *Ricordi storici* (ed. 1840, 253).

37 On the life and works of Naldo Naldi, see Della Torre 1902, 503–6, 628, 668–81; Verde 1973–94, II, 492–9, V/2, 544, 545; Naldi, *Bucolica …*, ed. Grant 1994. For Alessandro di Bartolomeo da Verrazzano, see De la Mare 1985, 472–3, 480–1, 595. Alessandro was of good birth. In 1488 he married a sister of the humanist Giovanni Nesi, who in 1484 had dedicated the dialogue *De moribus* to Piero di Lorenzo de' Medici. Some of Alessandro's manuscripts were intended as gifts for friends. His patrons included Lorenzo di Pierfrancesco de' Medici (1487) and Lorenzo the Magnificent (*c.* 1490). For Giovanni Nesi, see Vasoli 1973.

38 Naldi Naldii *Nuptiae domini Hannibalis Bentivoli* (Florence: Francesco di Dino, after 1 July 1487); cf. Rhodes 1988, 83, no. 464. The beautiful manuscript containing the *Carmen nuptiale ad Laurentium Strotium Philippi fi(lium) iuvenem clarissimum* was last recorded at a Paris sale (*Manuscrits a peintures* 1968, lot no. 10); its present location is unknown. A colour photograph of the magnificent title page is preserved in the Paul Oskar Kristeller Papers, Columbia University, New York.

39 Regarding the Monte delle doti, see Molho 1986 and Molho 1994, 56. Maso di Luca's first deposit for Giovanna is registered in ASFi, Monte, 3743, fol. 8r; see also Cecchi 2005, 281 note 115 with reference to ASFi, Monte, parte II, 1396, fol. 56r. The total cost of the marriage is recorded on a loose note inserted in the *Libro debitori e creditori 1480–1511*. The text reads:

Lorenzo Tornabuoni de' avere	
per la dotta de la Giovan[n]a	fiorini 1250 larghi
Àne aùto d'aprile [14]86 dal Monte	
ghuadagnati	fiorini 141.8.1. larghi
A dì 18 di giugno 1488 dal Monte di	
dotta ghuadagnati	fiorini 652.18.6. larghi
A dì detto per uno chapitale di dota	
de la Ginova [Ginevra] ghuadagnati d'agho	
sto [14]85 peromutai [*sic*] detto dì in Lorenzo	fiorini 149 larghi
Àne aùto per estimo di donora m'imp	
ortò stimate fiorini 350 di suggello in larghi	fiorini 291.13.4 larghi

1234.19.11

Resta a avere fiorini 15 soldi - denari 1 larghi

40 Ibid., fol. cxii: "E a dì xxv detto lire trentadue piccioli paghò per me Filippo Nasi in questo a c. 112 per chosto di 7 sciughatoi per donare, uno boc[c]hale d'ottone, uno forzierino orpellato per la ghuardadon[n]a e altro per tutto — lire 32".

41 Ibid., fol. cxii (24 July): "E a dì xxiiii detto fiorini venti larghi di grossi per me a Lapo Sette [?] sensale per chosto d'uno libricino di Nostra Don[n]a storiatto e lavorato l'as[s]i d'ariento eb[b]i per suo mez[z]o el quale dis[s]e era di Giovanni Chacini in chonto di donora in questo c. 115 — fiorini 20"; fol. 115 (24 July): "E a dì xxiiii detto fiorini venti larghi di grossi paghò Filippo Nasi in questo c. 112 per me per Lapo Sette [?] per chosto d'uno libricino di Nostra Don[n]a storiatto e lavorato l'as[s]e con ariento dis[s]e era di Giovanni Chacini per la detta — fiorini 20"; fol. 119 (31 August): "e a dì detto lire cinquantasei soldi x piccioli paghò Filippo Nasi in questo a c. 118 per me a Francesco di Giovanni di Salvi orafo per motto d'ariento e doratura di tutto uno libricino el quale si iscribe di copertura tut[t]e l'as[s]i. Montò il richrescimento lire 45 soldi 10 e lire 11 per 2 ismalti cho' l'armi pel bacino e boc[c]hale per la detta — lire 56 soldi 10"; fol. cxxviii (31 August): "E a dì detto lire cinquantasei soldi x piccioli per me a Franc[esc]o di Giovanni di Salvi orafo sono per ariento e oro mes[s]o di soprapiù nel libricino che si dorò tutto e maestero [magistero] in tutto lire 45 soldi 10 e lire 11 in 2 smalti d'ariento pel bacino e boc[c]hale per la Giovanna in conto di donora in questo a c. 119 in tutto chome detto — lire 56 soldi 10". Regarding the use of such a basin, generally referred to as a *bacino colla misciroba*, see Klapisch-Zuber 1984, ed. 1988, 204; for the articles customarily included in the *donora*, see ibid., 153–91, 193–211.

42 Burke 2004, 142. Also worthy of mention is the fact that Filippo Nasi and his brother Bernardo acquired the rights to a chapel in the church of Cestello, as did Lorenzo Tornabuoni: see Luchs 1977, 83–5.

43 For the list of retail merchants, see *Libro debitori e creditori 1480–1511*, fols. 115, cxv; for the payments made to Annalena Malatesta, see ibid., fols. 118, 119, cxxi.

44 For these payments, see *Libro debitori e creditori 1480–1511*, fol. cxv: "Den dare a dì primo d'aghosto 1486 lire quat[t]ordici soldi vi piccioli paghò per me Filippo Nasi a Francesco Finighuerra orafo in questo a c. 112 per chosto di maglietti e punte di ariento dorate per fornitura d'una chotta di raso alessandrino per la detta e due anel[l]a da chucire [thimbles] d'ariento in tutto chome detto — lire 14 soldi 6". With regard to Antonio Salvi and Francesco di Giovanni's relief portraying *Herod's Banquet* (c. 1478), see Liscia Bemporad 1980; Butterfield 1997, 218–9; Wright 2005, 288–9. For information on Francesco and Maso Finiguerra, see Carl 1983 and Melli 1995. Regarding Francesco Finiguerra's financial straits, see his *portata al catasto* or property statement of 1480, Quartiere di Santa Maria Novella, Gonfalone dell'Unicorno, in Carl 1983, 531, doc. 13 (ASFi, Catasto, 1009, fol. 430r: "Il detto Francesco fa bottega d'orafo in Vac[c]hereccia … In detta botteglia non à chorpo e lavoro a' banchi e è che gli dà che fare, ch'à faticha di ghuadagnare la pigione").

45 *Libro debitori e creditori 1480–1511*, fol. cxii: "MCCCCLXXXVI Filippo di Lutoz[z]o d'Iachopo Nasi de' avere per conto di spese farò per la Giovanna mia figliuola maritata a Lorenzo Tornabuoni a dì iiii di luglio lire quindici soldi ii piccioli per me a Betto legnaiolo per più opere mi fé con sua chonpagni nel palcho fé pel chorteo de la detta — lire 15 soldi 2 | E a dì detto lire 6 per me a Bac[ci]o legnaiolo per opera mi fe' per lui in detto palcho — lire 6 | E a dì iiii di luglio lire ven[ti]sette soldi x per me Antonio di Tad[d]eo merc[i]aio per paghare più spese per lui fatte e a diverse persone pel dì del chorteo cioe treb[b]iano, pan b[i]ancho, quochi, c[i]aldoni e altre simile ispese — lire 27 soldi 10"; see also ibid., fol. 114: "Bartolomeo di Cristofano legnaiuolo de' dare a dì 8 luglio lire tre per monte di lib[b]re 20 d'achutti [nails] di più rag[i]oni eb[b]e da me per soldi 3 la lib[b]ra d'estratto dal palchetto fatto ne la chorte pel chorteo de la Giovanna — lire 3".

46 For the date of the *ductio ad domum*, see *Nuptiale carmen*, ll. 11–2: "Tertia lux mensis venit septembris et hora / qua medium celi Phoebus adurget iter"; cf. *Libro debitori e creditori 1480–1511*, fol. 120: "Lorenzo di Giovanni Tornabuoni maritto de la Giovanna mia figliuola di conto detto de' dare a dì iii di settenbre 1486 fiorini trecento cinquanta d'oro di sug[g]el[l]o per istima di più donora gli mandai detto dì a chasa detro a la sposa stimate per chome è chostume in conto di donora fat[t]e per la detta in questo a c. 123 vagliono ridot[t]i in fiorini larghi fiorini dugentonovantuno soldi xiii denari iiii a oro larghi per valuta de' detti fiorini 350 di su[g]gel[l]o — fiorini 291". Lorenzo Tor-

nabuoni refers to his marriage in a letter to Benedetto Dei, dated 27 September 1486: "Amatissimo mio Benedetto Dei: ho una vostra elegantissima lettera de' dì xx de settembre alla quale appresso farò risposta. A quanto prima vi rallegrate con esso mecho delle mie nozze fatte. Di questo senza lettera ero certissimo, come richiede la mia innata benevolentia. E che l'uno amico si ralegri di tutte le cose prospere dell'altro nel numero del quale siete voi ..." ('My dearest Benedetto Dei: I have here your most elegant letter of 20 September, to which I shall respond below. You rejoice in my recent wedding, and of this I had no doubt even without the letter, as befits my innately benevolent disposition. It is only natural that one friend should rejoice in the good fortune of the other, and I count you among them ...'; ASFi, CRSGF, 78, Badia di Firenze, 317, no. 219; cf. Sman 2007, 181 note 20). Regarding the Barons' Revolt, see Pastor 1886–1933, II, 223 ff. and Butters 1992. For detailed bibliographical information, see Paolo Viti's notes in Redditi, *Exhortatio*, ed. Viti 1989, 57–9. It is known that the Florentines were not entirely satisfied with the peace treaty concluded on 11 August, not least because the fortress of Sarzana remained in enemy hands. There was widespread anxiety about the final terms of the treaty ("capitoli e conditioni"), as emerges from a letter written by Bartolomeo Scala to Luigi Guicciardini, dated 21 August 1486: Florence, Archivio Guicciardini, Legazioni e commissarie, busta V, fasc. c, no. 259. On Lorenzo's meeting with the duke of Calabria, see Lorenzo de' Medici, *Lettere*, ed. Butters 2002, 429: "Io sono suto a visitare il duca di Calabria" (Lorenzo to Iacopo Guicciardini, 7 September); see ibid. (note 8) for a reference to Stefano Taverna's letter to the duke of Milan (now in that city's Archivio di Stato), which reported that a meeting had taken place on 1 September 1486 between the Magnificent and Alfonso duke of Calabria at a location between Anghiari and Borgo San Sepolcro.

47 Naldi, *Nuptiale carmen*, ll. 17–28: "Post ubi constituit sedes Iovanna paternas / linquere visa satis culta fuisse sibi // candida de thalamo niveaque in veste refulgens / vertice baccatas et religata comas. // Exit ut Etrusco populo daret illa videndam / se qui mane frequens per foribus steterat. // Hanc equus excepit phaleris insignit et auro / qualis amiclei Castoris ante fuit. // Exoritur clamorque virum clangorque tubarum / huius in abscessu limine de patrio. // Quid referam varios comites quos ante puella / se tulit aut lateri quis vir adhesit ovans". Additional information is to be found in Ammirato, *Delle famiglie nobili fiorentine*, ed. 1615, 42: "Ma tra' dì felici di Luca [*sic*] fu, quando egli diede marito a Giovanna sua figliuola donna di singolari bellezze: la qual maritò l'anno 1486 a 15 di giugno [*sic*] a Lorenzo Tornabuoni, del qual matrimonio fu Lorenzo de Medici zio del giovane [*sic*] ordinatore, et mezzano. Fur fatte le nozze belle et magnifiche, così dall'una parte come dall'altra, essendo in guisa di corteo intervenute cento giovani fanciulle nobili, et quindici giovani vestiti a livrea: quando ella fu giunta a Santa Maria del Fiore. Nel dar l'anello fu presente per honorar la pompa del matrimonio il Conte di Tendiglia ambasciadore per lo Re di Spagna al Pontefice, con molti cavalieri così forestieri, come cittadini, tra quali Luigi Guicciardini, et Francesco Castellani accompagnarono la sposa a casa il marito, il padre del quale havendo messo in palco la piazza di S. Michele Albertelli per danzare, et per festeggiare diede gratissimo spettacolo al popolo, sì come fece poi ancor Maso. Il quale richiamata la fanciulla e il genero a casa et quivi data una suntuosissima cena, fece il rimanente della notte armeggiare a lume di doppieri, et ballare, havendo ancor egli posto il terreno in palco, et fatte altre magnificenze, per render la festività di quelle nozze celebre et lieta fuor di misura" ('But among the happiest days of Luca's [*sic*] life was the one on which he gave the hand of his daughter Giovanna, a woman of singular beauty, in marriage: he gave her away in the year 1486 on 15 June [*sic*] to Lorenzo Tornabuoni, the architect and mediator of the wedding being Lorenzo de' Medici, the uncle [*sic*] of the bridegroom. The nuptials were celebrated in beautiful and magnificent fashion by both sides, as a procession of a hundred young women of standing and fifteen young men in livery accompanied the bride to Santa Maria del Fiore. When the rings were exchanged, the count of Tendilla, the king of Spain's ambassador to the pontiff, honoured the wedding with his presence. Many knights—both foreign and Florentine—were also in attendance, and among them were Luigi Guicciardini and Francesco Castellani, who escorted Giovanna to the house

of her husband. Having set up a podium in the Piazza of San Michele Berteldi where people could dance and be merry, Lorenzo's father offered the citizenry a most welcome spectacle, as later did Maso, who, in turn, invited his daughter and son-in-law to his house and had the most sumptuous dinner served. Having set up a podium himself, as well as other lavish structures and decorations, he then had two-branched candlesticks lighted so that jousting and dancing would go on till dawn, and the celebrations of the wedding be famed and joyful beyond measure'). For the identification of the Luigi Guicciardini mentioned here, cf. Simons 1985, II, 102–3 note 96; with regard to his elevation to the knighthood, Goldthwaite 1968, 108, 118–25. Regarding the life and political career of Francesco di Matteo Castellani (1418–94), see the introduction to his *Ricordanze*, ed. Ciappelli 1992–5, 3–32. Remarkably, even Castellani's epitaph (FRANCISCVS CASTELLANVS XII AETATIS ANNI EQVES IACET HIC ET VXOR EIVS VT IPSE VOLVIT HELENA ALEMANNA) mentions that he was knighted at the age of twelve; regarding the family chapel decorated with frescoes by Agnolo Gaddi and Starnina, see Baldini–Nardini 1983, 211–25. The figure of Don Íñigo Lopez de Mendoza is elucidated in Suárez Fernández 1965–72, II, 124–32, 397. The wedding of Clarice Orsini and Lorenzo de' Medici is described by Marco Parenti (*Lettere*, ed. Marrese 1996, 247–50).

48 Naldi, *Nuptiale carmen*, ll. 41–69: "Ipse suis manibus turbas aperire Cupido / censuit et nuptae previus inde fuit. // Hanc Venus e summo venientem mater Olympo / spectans purpureas sparsit in ore rosas. // Iamque propinquabat laribus nova nupta mariti, / iam videt ornatas coniugis illa domos. // Cum viridem Pallas coluit quam semper olivam / pretulit et nuptae est hinc dea facta comes // hanc ut participem faceret bona Pallas honoris. / Urbis ab imposito nomine quem retinet // ex quo Neptuno fuit haec certamen Athenis / nomen uter priscis impositurus erat // Palladis est arbor mediis ubi missa fenestri / civibus ut Tuscis visa iocosa daret. // Ante fores subito socer astitit ipse Johannes / praebeat ut nurui basia casta piae // excipiatque domi venientem letus in ulnas / atque volens tantos donet habere lares // quos simul ac subiit nitidas Hymenaeus eunti / ut decuit nuptae praetulit ipse faces // quin Cytherea libens cestum sua dona puellae / attulit ut castae munera casta daret // adfuerant Charites illi Charitumque Cupido / frater. At huic humeris nulla pharetra fuit: // nam Veneris supere tunc vota pudica secutus / quod decuit castas praestitit ille nurus". For Virgil's well-known metaphor, see *Aen.* 12. 67–9: "Indum sanguineo veluti violaverit ostro / si quis ebur aut mixta rubent ubi lilia multa / alba rosa: talis virgo dabat ore colores"; English quoted from the translation by H. Rushton Fairclough for the Loeb Classical Library (Virgil, *Aeneid VII–XII, The Minor Poems*, London–New York, 1918, 303).

49 The *Wedding Banquet of Nastagio degli Onesti* is one of the four panels inspired by Boccaccio's *novella* (*Decameron* 5. 8) and produced to mark the marriage of Giannozzo di Antonio Pucci and Lucrezia di Piero Bini in 1482 or 1483: cf. Lightbown 1978, II, 48–51, no. B38. Regarding Lorenzo de' Medici's role of *mezzano* ('mediator'), see Guidi Bruscoli 1997: he acted as a mediator, or marriage broker, hundreds of times, which is yet another indication of the extent of his influence. The expression 'new Athens on the Arno' is taken from Hans Baron; cf. Borsook 1966, 19 (for the popularity of this comparison in the fifteenth century, see Baldassarri–Saiber 2000, xxx).

50 Naldi, *Nuptiale carmen*, ll. 85–6, 113–4, 131–4: "Non privata domus sed regia tota videtur; / regales illic esse videntur opes // ... Pinucleata quidem convivas dantur in omnes / auri quae tenuis lamina fulva tegit // ... Atque ait hanc ipsam Laurenti edocte puellam / quam tibi de media nobilitate petis // arbitror aeternam vobis propriamque futuram / et tibi quae prolem sit genitura novam".

51 Ibid., ll. 145–66: "Ante domum sacram spatio patet area quadro / hic ubi Michaeli templa dicata manent // hanc trabibus cingunt tabulata intexta refixis / ut circi speciem sint habitura novam // extendunt pannos celique colore sereni / desuper infectos ne calor una petat. // Vestibus exornant diversa sedilia pictis / quos super ut sedeat quaeque puella toros. // Nec desunt iuvenes de nobilitate suprema / ad numerum docti quisque movere pedes // inter quos Petrus Medices ita fulget ut inter / fulget Apollineum signa minora iubar // Phoebus enim celsa quodcumque in mente volutat / ille deum vates quid meditatur opus // cogitat hoc et Medices ita Petrus et acer / ingenio tentat

quelibet alta gravi // noverit ut veteres quicquid scripsere Latini, / quicquid item Graiis Musa be-
nigna dedit // ut quecumque velit Graeco sermone loquatur / oreque Pindarico cuncta referre queat.
// Incipiat cum tale puer iam scribere carmen / quale senes docti vix cecinisse solent". In the letter
of 21 September 1478, six-year-old Piero refers to the *Grammar* by Theodore Gaza (1415–75), a work
often used as an introduction to the Greek language (see *Lives of the Early Medici* 1910, 212–3; for
the letter of 1479, see ibid., 219–20). For more information on Piero's schooling with Politian, see
the bibliographical references given by Paolo Viti in his edition of Filippo Redditi's *Exhortatio ad
Petrum Medicem* (1989, 82). Piero's importance as a collector of Greek manuscripts is underlined by
Angela Dillon Bussi in *L'uomo del Rinascimento* 2006, 136. It is also known that Piero, like his father,
excelled at *cantar improvviso*: cf. Walter 2003, 242.

52 Naldi, *Nuptiale carmen*, ll. 201–6: "Dum rapit hic chlamydem totam conscindit at ille / que
cecidere humeris pallia tollit humo. // Est quoque manibus spumantia pocula binis / raptans se
plenis proluit in pateris, // clamat hic ille leves saltu se iactat in auras / ut voret iniectos ore paten-
te cibos". Regarding the Cassone Adimari, see S.G. Casu, in *L'uomo del Rinascimento* 2006, 110,
no. 37 and D.L. Krohn, in *Art and Love* 2008, 288–91, no. 134. The theft of the silver is mentioned
in Bocchi 1592, 97.

53 Naldi describes the wedding night as follows: "Qua duce tale fuit Iovanna ingressa cubile /
Persarum nuruum quale fuisse putem // in quo dum mirans oculis et mente morata / conspicit au-
ratis fulchra referta notis. // Virgoque dum timide lectum subit ipsa virilem / dum rubor et niveas
spargit in ore genas // divinas circum nubes Venus aurea fundit / strataque tam miris protegit il-
la modis // cernere ne quis ibi posset nuptamque virumque / dum genio faciunt dulcia sacra deo"
(*Nuptiale carmen*, ll. 221–30). Only in early October 1486 did Lorenzo collect part of Giovanna's
dowry: ASFi, Monte, 3743, fol. 8r; see also Cecchi 2005, 281 note 115, with reference to ASFi, Monte,
parte II, 1396, fol. 56r.

54 Naldi, *Nuptiale carmen*, ll. 273–6: "Huc geminas huc flecte acies quicumque subisti / haec lo-
ca namque pater maximus urbis adest // qui regit Etruscos patriae qui moenia servat / unus et hos-
tiles pellit ab urbe minas". Regarding the friendly relations between Íñigo López de Mendoza, count
of Tendilla, and Lorenzo de' Medici, see Suárez Fernández 1965–72, II, 127.

Notes to Chapter 3

55 Alberti, *De re edificatoria*, ed. Orlandi–Portoghesi 1966, I, 414 ff.

56 For the history of the construction and renovation of the Villa Tornabuoni (now Villa Lem-
mi), see *Villa Tornabuoni Lemmi* 1988. For the play on words Careggi/*Charitum ager*, see Gombrich
1945, ed. 1972, 60.

57 Lillie 2005, 155–253; for the letter from Francesco Sassetti to Giovanni Tornabuoni (26 No-
vember 1488; ASFi, MaP, filza 96, doc. 195r), see ibid., 253: "Ricordasi di me quando siate nella con-
solatione di cotesta bella villa, maxime d'Africo in quel bel boschetto di Francesco Nori dove vi do-
vrebbe essere una fontana".

58 For the conveyance of the villa from the Galliano to the Tornabuoni, see Pedroli Bertoni–
Prestipino Moscatelli 1988, 145 6. Presumably the Tornabuoni already owned property in the area
of Careggi before they purchased this villa. Niccolò di Francesco Tornabuoni, Giovanni's brother,
wrote two letters from Chiasso Macerelli as early as 1449: see ASFi, MaP, filza 17, docs. 69r (10 Au-
gust), 70r (1 September). For Piero de' Medici's mediation, see *Villa Tornabuoni Lemmi* 1988, 147
and Sman 2007, 180 note 7.

59 ASFi, Monte, Copie del Catasto, 73, fol. 430r, where Giovan Battista (i.e. Giovanni) di Fran-
cesco Tornabuoni declares an estate in the parish of Santo Stefano in Pane with the road on one side
and properties of Lorenzo de' Medici and Tommaso Lottieri on the other two ("Uno podere posto
nel popolo e piviere di Santo Stefano in Pane luogho detto Chiasso a Mascierelli con casa da signo-
re e lavoratori confinato da primo via e secondo Lorenzo de' Medici e 3 Tomaso Lottieri"): see Horne

1908, 142, 353, doc. XXVI. For the inventory, see ASFi, Pupilli, filza 181, fols. 141r–4r. Alberti's *De re aedificatoria* remains the most authoritative source concerning the daily use of the villa. See in particular ed. Orlandi–Portoghesi 1966, I, 416–7, with regard to the family and the courtyard as the 'heart' or 'bosom' of the house: "Familiam constituent vir et uxor et liberi et parentes, et qui horum usu una diversentur, curatores ministri servi; tum et hospitem familia non excludet" ('The family consists of the husband, wife, children and grandparents, and their live-in domestics—clerks, attendants and servants; any guest is to be included in the family'); "Omnium pars primaria ea est, quam, seu cavam aedium seu atrium putes dici, nos sinum appellabimus" ('The most important part is that which, though you might refer to it as the courtyard or atrium, we shall call the bosom of the house').

60 ASFi, Pupilli, filza 181, fol. 142r–v: "Nella sala terrena … 2 scha[c]chieri e 1° tavoliere | 1ª viuola da sonare …"; "Nella chamera di detta sala [the "saletta de' famigli"] … 1° chap[p]ello di paglia di Giovannino"; "Nello schrittoio … 30 volumi et libri latini et volchari".

61 For the life and work of Botticelli, see Horne 1908; Lightbown 1978; Cecchi 2005; Zöllner 2005; Körner 2006. The most comprehensive analysis of the *Primavera* is still Dempsey's (1992).

62 For the earliest descriptions of the frescoes, see Conti 1881–2; Ephrussi 1882; Lee 1882.

63 The identification of the portraits has often been the subject of discussion. As early as 1908, the great Botticelli connoisseur Herbert Horne identified those portrayed as Lorenzo Tornabuoni and Giovanna degli Albizzi. However, over the years German, English and American scholars have made other suggestions which continue, even now, to sow confusion. Mesnil (1938) identified the young man as Giovanni Pico della Mirandola and Gombrich (1945, ed. 1972, 76) as Lorenzo di Pierfrancesco de' Medici. The suggestion that the couple portrayed are Nanna di Niccolò Tornabuoni and Matteo degli Albizzi was made by Ettlinger (1976) and seconded by Pons (1989, 72–3), Martin (1996, 119), Röttgen (1997, 176), Acidini Luchinat (2001, 17) and Zöllner (2005, 225–6). Others have suggested that the woman portrayed may be Lorenzo's second wife, Ginevra Gianfigliazzi, based on the supposed resemblance of this figure to the woman Ghirlandaio portrayed behind Giovanna in the *Visitation* scene in Santa Maria Novella: see Simons 1985, I, 172; Kent 2001, 40; L. Syson, in *El retrato del Renacimiento* 2008, 204; Fahy 2008, 25; Musacchio 2008, 30. I have three objections to this theory: first, the likeness is not striking enough, as already emphasized by Schmid (2002, 128); second, it is not certain that Lorenzo and Ginevra were already betrothed by the time the frescoes in Santa Maria Novella were completed; third, the style of the frescoes and the age of Ludovica (fig. 29) seem to preclude a dating to around 1490–1. This chapter will go on to show to what extent the subject matter of Botticelli's frescoes corresponds to that of Naldi's *Nuptiale carmen*. Botticelli's likenesses of Lorenzo and Giovanna are idealized according to the painter's customary stylistic formulas. The degree of stylization is apparent from comparison with Lorenzo's portrait medal (fig. 70): according to Syson (in *Renaissance Faces* 2008, 151), the medal served as Botticelli's model, but the relationship between the medal and the fresco is certainly not exact. The designation found in ASFi, Pupilli, 181, fols. 143v–4r is, in my opinion, decisive: "nella chamera di Lorenzo di sopra". "Di sopra" refers to the location of the rooms *above* the mezzanine, where some of the servants had their quarters; we can thus be certain that Lorenzo's apartment was situated in the place where Botticelli's frescoes were found. For a description of the objects 'in Lorenzo's room upstairs', see ibid.: "1ª Vergine Maria di giesso in 1° tondo di diamante | 1° telaio entrovi la Natività di nostro Signiore | 1ª lettiera choperta di nocie di braccia 5 con trespolo e chanaio e predella intorno | 1° sacchone in dua pezzi | 1ª materassa di bordo e tela rossa di lana | 1ª choltrice con federa per chasa piena di piuma | 2 primacci di detto letto peso in tutto libbre 130 | 1° choltrone a detto letto usato buono | 3 sguanciali da letto con federe | 1° chortinagio a padiglione con pendenti | 1° lettuccio chon corniciome a tarsia di braccia 5 incirca | 1° materassino a bordo nuovo con lana | 1° tappeto di braccia 4 ½ vecchio | 1° paio di sguanciali di choio dipinti e dorati | 1° paio di sguanciali da lettuccio con federe dozinali | 1° desco semplice a 4 piedi | 1° tappeto di braccia 4 usato | 2 chassoni di braccia 4 l'uno …".

64 Several photographs taken in the 1880s record the situation before the removal of the frescoes. They show the Albizzi family arms as well as the architectural frame (Sman 2007, figs. 6, 7). The fresco with the portraits of Giovanni and Ludovica is described by Lightbown (1978, II, 62, no. B45A).

65 Naldi, *Nuptiale carmen*, ll. 73–6: "Coniugis es foelix etiam virtute benigni / ob quam Pieria tendit in astra via. // Nam tenet egregias divinae Palladis artes / quicquid et in Latiis scripta vetusta docent. // Ausus item sic est Graiis haurire liquores / fontibus ut linguas noverit inde duas". Regarding Lorenzo's humanist education, see Chapter 1. It is no coincidence that Giovanni Tornabuoni placed so much importance on his son's knowledge of Greek; he had a kindred spirit in Lorenzo de' Medici, who was no less proud that his son Piero had mastered a language he had never learned. In 1486 the Magnificent appealed to Ercole d'Este, duke of Ferrara, to lend him a manuscript of Cassius Dio Cocceianus, so that Piero, who was "quite well versed in Greek literature", could study it (Walter 2003, 242). That wide reading was considered a virtue in a young Florentine patrician is apparent from a passage in the popular work *De nobilitate* by Buonaccorso da Montemagno (*c.* 1392–1429): Gaius Flaminius and Publius Cornelius compete for the hand of the pretty Lucretia, and the former boasts about his library and knowledge of Greek and Latin authors (Baldassarri 2007, 10–1).

66 For the first editions of the *Quadriregio* (late fourteenth–early fifteenth century) and the *Hypnerotomachia Poliphili*, see Sman 1989 and Calvesi 1983, respectively. For the primacy of Grammar over the other liberal arts, see Horne 1908, 145, with reference to Dante, *Paradiso* 12. 137–8 ("Donato / ch'a la prim'arte degnò porre mano") and a sonnet by Burchiello ("Sette son l'arti liberali e prima / grammatica dell'altre è via e porta": *Sonetti*, ed. Zaccarello 2004, CXLV). For Politian's ideas on the power of language, see Rotondi Secchi Tarugi 1995.

67 For a Florentine manuscript (*c.* 1420) with illuminations by Bartolomeo di Fruosino which include personifications of the arts, see Brieger–Meiss–Singleton 1969, I, 314, II, plate 10. With regard to the prominent role of arithmetic, see Lightbown 1978, I, 96. On the relationship between arithmetic and trade, see also the *Trattato d'abacho* dedicated to Lorenzo (Chapter 1 and fig. 8).

68 *Convivio* 3. xi, 9: "Onde non si dee dicere vero filosofo alcuno che, per alcuno diletto, con la sapienza in alcuna sua parte sia amico; sì come sono molti che si dilettano in intendere canzoni ed istudiare in quelle, e che si dilettano studiare in Rettorica o in Musica, e l'altre scienze fuggono e abbandonano, che sono tutte membra di sapienza" (English quoted from the translation by Richard H. Lansing, 1990, 121). Extremely popular in fifteenth-century Florence, Dante's treatise was copied by such scribes as Antonio Manetti (Florence, Biblioteca Riccardiana, 1044) and Bernardo del Nero (1456; BNCF, II.III.210, fols. 1r–92v); see De Robertis 1974. Regarding the contacts between the Tornabuoni and Bernardo del Nero, see Chapter 8.

69 For the rejection of other identifications (*Phronesis, Saggezza, Caritas, Fortitudo*) and an iconographic analysis with extensive commentary, see Sman 2007.

70 Berlin, Staatsbibliothek zu Berlin–Preussischer Kulturbesitz, MS Lat. fol. 25, fol. 86v. In some fifteenth-century French manuscripts as well, Philosophy no longer resembles the old woman originally described by Boethius: cf. *Renaissance Paintings in Manuscripts* 1983, 158, fig. 20c (Jean Colombe, 1476) and Braun 1994, 212–3. For Dante's description of Philosophy, see *Convivio* 2. xii, 6–9; cf. G. Petrocchi, 'Donna gentile', in *Enciclopedia dantesca* 1984, II, 574–7. Filippino's fresco is reproduced in Geiger 1996, fig. 42 and Sman 2007, fig. 9.

71 Nicholas of Cusa, *De venatione sapientiae*, ed. Klibansky–Senger 1982, 4. Regarding Nicholas of Cusa's influence in Florence, see Tarabochia Canavero 2002 and Vasoli 2002.

72 *Convivio* 4. xxiv, 12: "così l'adolescente, che entra ne la selva erronea di questa vita, non saprebbe tenere lo buono cammino, se da li maggiori non li fosse mostrato" ('so an adolescent who enters into the meandering forest of this life would not know how to keep to the right path unless it were shown to him by his elders'). Giovanni Rucellai, a well-known patrician, expressed his concern in his *Zibaldone* about the tendency of young people to abandon themselves to life's pleasures (ed. Perosa 1960, 14, 'Sull'educazione dei figli').

73 The explanation is in *Convivio* 3. viii, 15–6: "Onde è da sapere che di tutte quelle cose che lo 'ntelletto nostro vincono, sì che non può vedere quello che sono, convenevolissimo trattare è per li loro effetti effetti: onde di Dio, e de le sustanze separate, e de la prima materia, così trattando potemo avere alcuna conoscenza. E però dico che la biltade di quella *piove fiammelle di foco*, cioè ardore d'amore e di caritade; *animate d'un spirito gentile*, cioè informato ardore d'un gentile spirito, cioè diritto appetito, per lo quale e del quale nasce origine di buono pensiero" ('Here we must know that all those things which surpass our intellect, so that it cannot perceive what they are, are most suitably described by means of their effects; and thus by approaching God, the separate substances, and the first matter in this way, we can gain some understanding of them. This is why I say that the beauty of this lady *rains down little flames of fire*, that is, the ardour of love and of charity, *enkindled by a gentle spirit*, that is, an ardour taking the form of a gentle spirit, namely right appetite, by and from which springs the origin of good thoughts'). The bundle of flames is thus symbolic of love or desire as a moving principle of philosophy.

74 For this kind of explicit gesture of welcome, see Baxandall 1972, 68. For a more detailed explanation of the philosophical import of the fresco, see also Sman 2007. In my opinion, the mystical element, that of ascesis in the Platonic sense, plays a less important role in Botticelli's allegory than is sometimes maintained. Even though Botticelli's creations sometimes tend towards Neoplatonism, the borrowings from Dante are more numerous and more concrete.

75 Regarding the motif of the Garden of Love, see Watson 1979, 70–1 and Rohlmann 1996, 116. For the mention of the *gamurre*, see *Libro debitori e creditori 1480–1511*, fol. cxv: "E a dì xvi detto fiorini nove d'oro in oro larghi paghò Filippo Nasi in questo a c. 112 per Tomaso di Pagholo richatiere per chosto d'una pez[z]a di cianbel[l]otto [*cammellotto*, a heavy cloth woven of camel hair or angora] gial-[l]o per una ghamur[r]a per la detta — fiorini 9"; fol. cxvii: "Lionardo di Zanobi Ghuidotti e chonpagni lanaiuoli deono avere a dì viiii d'aghosto fiorini venticinque larghi di grossi sono per chosto di braccia xx di pan[n]o paghonaz[z]o di Giano di san Martino eb[b]i da loro per fiorini vi di sug[g]el-[l]o che n'è in tempo d'un anno per una cap[p]a con choda et una ghamur[r]a per la Giovan[n]a mia figliuola in conto di donora … — fiorini 25"; fol. cxviiii: "E den dare lire cinquantasette soldi x piccioli per chosto di braccia 23 di rasc[i]a [coarse wool cloth] turchina eb[b]i da detti a c. 117 per una gia[c]chetta e ghamurra — fiorini - lire 57 soldi x"; fol. 123: "E den dare per fornimenti di veste di setta e di pan[n]o, cot[t]a e ghamur[r]a aùte d'Antonio di Taddeo merc[i]aio in questo a c. 138 per la detta Giovanna — fiorini - lire 40 soldi - …"; fol. cxxvii: "E deno avere a dì di luglio [*sic*] lire cinquantasette soldi x piccioli per chosto di braccia xxiii di rascia turchina eb[b]i da loro per una giac-[c]hetta e ghamurra per la Giovanna mia figliuola per soldi 50 il braccio a paghare come di sopra in conto di donora in questo a c. 119 — fiorini - lire 57 soldi 10". For the jewels, see Chapters 2 and 5.

76 With regard to the exegesis of the names of the Three Graces, see Gombrich 1945, ed. 1972, 56. Concerning the use of colour, see Alberti, *De pictura*, ed. Grayson 1972, 91.

77 See the characterization of Venus's girdle as a chaste gift in Naldi, *Nuptiale carmen*, ll. 65–6: "Quin Cytherea libens cestum sua dona puellae / attulit ut castae munera casta daret"; for the context, see above, note 48. Lorenzo's epigram, in which he associates the Three Graces with inner beauty, is quoted below, Chapter 5.

78 This portrait medal, too, is discussed in detail by Wind 1968, 73–5; E. Luciano, in *Virtue and Beauty* 2001, 130–1, no. 11; B. Tomasello, in *Pulchritudo, Amor, Voluptas* 2002, 90–1, no. 9. Wind's iconological interpretation is completely convincing, but his assumption of Platonic love between Giovanna and the philosopher Giovanni Pico della Mirandola is unfounded.

79 One of the most lyrical descriptions is to be found in the *Journal* of the painter Maurice Denis (ed. 1957, I, 67), who was enchanted with "le candide élégance d'un dessin serré, l'harmonie sereine d'une composition décorative, et la blancheur d'une coloris pâle, dans une atmosphère lumineuse et douce" ('the simple elegance of a tight drawing, the serene harmony of a decorative composition, and the cleanness of a pale palette, in a soft, luminous atmosphere').

Notes to Chapter 4

80 For the so-called *Pianta della Catena*, see Kreuer 1998; for the story of the construction of the Palazzo Tornabuoni, see Gurrieri 1992 and Galleni 1998, 315–7; cf. Simons 1985, I, 158–60, with reference, among other documents, to ASFi, NA, B.570, fols. 1027r–32v (division among the heirs of Francesco Tornabuoni, 1460); ASFi, Catasto, 922, fol. 150r; ASFi, NA, B.735, fols. 50r–v, 96r (purchase of the houses of Salvestro di Giovanni di Salvestro Popoleschi and Giovanni di Francesco Tornaquinci, 1477).

81 The sober yet imposing façade is described by Giorgio Vasari (ed. Bettarini–Barocchi 1966–87, III, 237), who ascribed it to Michelozzo: "fece al canto de' Tornaquinci la casa di Giovanni Tornabuoni, quasi in tutto simile al palazzo che aveva fatto a Cosimo, eccetto che la facciata non è di bozzi né con cornici sopra, ma ordinaria" ('[Michelozzo] built a house on the Canto dei Tornaquinci for Giovanni Tornabuoni, almost entirely similar to the palace he had made for Cosimo, except that the façade is not rusticated and has no cornices above, but is plain'). Two decorated wooden panels now in the Museo Stefano Bardini, inv. 11507, may have originally been part of the wooden door of the main entrance of the *palazzo* (Martin 1996, 118–9, fig. 1); instead, Scalini (2001, 76–7, no. 2) links the panels to the door of the Palazzo Medici.

82 On the reception of Cardinal Francesco Gonzaga, see the account of Francesco Filarete (ed. Trexler 1978, 95): "fu aspettato dalla nostra magnifica Signoria alla ringhiera. E dopo la visitatione fu acompagnato a' Tornabuoni, cioè in casa di Giovanni Tornabuoni, e fattogli spese del publico" ('He was welcomed by our magnificent Signoria on the raised platform in front of the seat of government. And after the official reception he was taken to the house of Giovanni Tornabuoni, where he stayed at the city's expense'); see also Rinuccini, *Ricordi storici*, ed. Aiazzi 1840, cxxxv. As bankers, the Tornabuoni had regular dealings with Francesco Gonzaga: the cardinal was in debt to the Medici bank to the tune of 3,500 ducats and when he died in 1483, the Tornabuoni acted as mediators between his heirs and the Medici (see Chambers 1992). Regarding Nicola Orsini's visit, see Elam 1989, 185. The eulogy of the Palazzo Tornabuoni comes from Mini 1593, 119: "due fra gl'infiniti [palazzi] che ornano la Città di Firenze, passano i termini della Magnificenza civile; sono eglino, la casa de Tornabuoni, e la casa de Medici, l'una edificata da Cosimo il Vecchio padre della patria, e l'altra edificata da Giovanni capo di quella famiglia". Remarkably, no foreign guests were received at the Palazzo Medici from 1473 to 1492 (Kress 2003, 247); see also Simons 1985, I, 161.

83 Naldi describes the wall paintings as follows: "Illic aspicias tulerit quos terra colores / Attalus et vestes quas tibi Roma dedit. // Nanque erat Attalico paries depictus honore / sic foret Attalicum preter ut inde nihil // mira canam sed vera tamen fuit omnibus una / forma fuit cunctis versicoloris opus // vere novo varios quot habent nova prata colores / sparsa ve quam vario flore nitescit humus // tam variis fuerant aulea coloribus illa / picta quibus paries undique tectus erat" (*Nuptiale carmen*, ll. 89–98); "Cum vero ad solitos rediit lustrata penates / et fuit a multis usque reducta domum, // invenit hic variis aulea expromta figuris / que secus ac fuerant atria tecta tegant // in quibus et pugnas Gallorum vidimus acres / in quibus et Caroli maxima gesta ducis // esset ut amotis ornatibus undique primis / vestibus hinc paries tectus ubique novis" (ibid., ll. 239–46). On the fresco in the oratory of the Buonomini di San Martino, see Bargellini 1972 and Cadogan 2000, 208–13, no. 10. Giuliano di Filippo Tornabuoni held various offices (Salvini, *Catalogo cronologico*, ed. 1782, 54), and found favour with both Pope Sixtus IV and Pope Leo X (Plebani 2002, 253–4). For the portrait of Lucrezia, see ASFi, Pupilli, filza 181, fol. 147v: "Nella chamera terrena in su l'androne | Una Vergine Maria di giesso dorata in 1° tabernacolo | 3 telai con piu fighure fiandresche di tela lino | 1° quadretto d'una testa e busto di Mᵃ Luchrezia de' Medici". A female portrait attributed to Domenico Ghirlandaio, now in the National Gallery of Art in Washington (no. 1952.5.62), is connected by some scholars to this archival record: see E. Luciano, in Boskovits–Brown 2003, 303–7. The portrait resembles one of the three women in the *Visitation* fresco in Santa Maria Novella (Schmid 2001, 128–9): see here fig. 63.

84 ASFi, Pupilli, filza 181, fol. 149r–v: "Nella chamera di Giovan[n]i … | Una Vergine Maria di marmo dipinta in un tabernacolo | 1ª tavoletta quadra e chornicione d'oro dipintovi el Salvatore | 1° quadro chon chornicione dorato in tela dipintovi Santa Maria Mad[d]alena | 1° quadro chon chornicione d'oro dov'è dipinto Santo Francesco | 1° tondo chon chornicione d'oro e dipinto da donne di parto … Nello schrittoio | 1° paio di falchole di cera biancha di libbre 6 | 1ª chassettina d'arcipresso … dentro più medaglie … e 1° tabernacolino dove nostra Donna e Santo Girolamo e San Francesco | 1° sacchetto dov'è 1° libretto e più schritture rinchiuse nella chassetta dello schrittoio … 2 choppe di rame in ariento smaltate". Interestingly, the Palazzo Tornabuoni also had a *salotto* that was used as a chapel. The portable altar consisted of a consecrated stone placed on a wooden trestle table (see Musacchio 2000, 154).

85 ASFi, Pupilli, filza 181, fol. 149r–v: "Nella chamera dove dorme Giovannino | … | 1° vasetto di mistura dorato | 1ª lucierna chon lavori d'ottone …". The gilt cradle was kept in the "maghaz-[z]ino dell'antichamera" ('closet of the antechamber') of Lorenzo's chamber: "1ª chulla di legniame dipinta e oro fu di Giovannino" (ibid., fol. 148v; cf. Kress 2003, 263).

86 See Kress 2003, 269, with reference to, among others, ASFi, Pupilli, filza 181, fol. 148r: "2 forzieri da spose dorati e dipin[t]i chon ispalliere dorate e dipinte | 1° forziere di nocie chon prospettiva e altri lavori di nocie chon dette spalliere choperto di tela az[z]urra"; regarding the use to which such rooms were put, see also Lydecker 1987, 165–75.

87 Giovanna's family was not directly involved—at least not financially—in the furnishing and decoration of Lorenzo's chamber. If Maso di Luca degli Albizzi had contributed money to this project, it would have been recorded in his account books. For the previously mentioned Marco di Parente Parenti (the father of Piero—the author of the *Storia fiorentina*—who in turn wrote a book of *ricordi*) and Bernardo di Stoldo Rinieri, see Lydecker 1987, 88–101.

88 On the 'Otto prints', so called after the eighteenth-century collector Ernst Peter Otto, see Zucker 1993, 127–57 and Dempsey 1992, 111–2.

89 For the ivory boxes with depictions of Jason and Medea, see Schlosser 1899; Fité i Llevot 1993; Tomasi 2003. On Jason's popularity in Burgundy, see, among others, Tanner 1993, 146–61.

90 ASFi, Pupilli, 181, fol. 147r–v: "1° pettorale da chavallo chon 3 sonagli | 26 sonagli da cholmi grossi | 1ª testiera di rame lavorata da chavagli". For Politian's reference to the *equitum certamen*, see Viti 1994, 112–3. Regarding the fifteenth-century fascination for the chivalric ideal, see Huizinga 1919, English translation 1996, 87 ff.

91 For Politian's study of the *Argonautica*, see Kress 2003, 259 and Cesarini Martinelli 1992. For Lascaris' edition, see Fantuzzi 1992, 50–2. In the Biblioteca Nazionale Centrale, Florence, there is a rare copy of this *editio princeps* with miniatures attributed to Attavante Attavanti (Banco Rari 110); cf. C. Filippini, in *In the Light of Apollo* 2003, 296, no. IV.23. In a recent study (2007) Caroline Campbell has suggested that the panels depicting the *Story of Jason and Medea* are not based on ancient sources; instead, their origins can be found in two late-medieval chivalric texts, the *Historia destructionis Troiae* by Guido delle Colonne and the *Histoire de Jason* by Raoul Le Fèvre. I agree with her about the complex interaction and mingling of classicism and chivalry in Florence in the 1470s and 1480s, but see no reason to minimize the importance of the original Greek texts.

92 Susanne Kress (2003, 258) remarks: "Die formale, farbliche und ikonographische Korrespondenz zwischen dem Argonautenzyklus der Spalierbilder und den beiden Trojatafeln der Cassoni läßt vermuten, daß dem Auftraggeber Lorenzo Tornabuoni bei der komplexen Gestaltung seines Hochzeitszimmer ein Berater zur Seite stand, für den eigentlich nur sein humanistischer Lehrer und Freund Angelo Poliziano in Frage kommt" ('The formal, colouristic and iconographic correspondence between the Argonaut cycle of the *spalliere* pictures and the two *cassone* panels of Troy suggests that the patron, Lorenzo Tornabuoni, had someone to advise him on the complex design of his bridal chamber, and the only possibility is in fact his humanist teacher and friend Politian'). Unfortunately, there is no concrete proof of this hypothesis, nor any evidence that Politian gave advice

on other commissions discussed in this book, so that nothing can be said for certain on his role as a humanist adviser. For the sake of completeness it must be mentioned that in Western literature and philosophy, the Jason legend is sometimes interpreted in an esoteric sense or linked to alchemy, though these interpretations were not fashionable until the sixteenth century (see Faivre 1980).

93 Apollonius of Rhodes, *Argonautica* 1 (esp. ll. 221–4 with the mention of Zetes and Calais; English translation 1912, 17).

94 On the life and work of Bartolomeo di Giovanni, see *Bartolomeo di Giovanni* 2004; for the parchment rolls, see Hagopian van Buren 1979.

95 Apollonius of Rhodes, *Argonautica* 3. 967–74 (English translation 1912, 261).

96 Cf. Bartoli 1999, 211–2, no. 73.

97 Hannover, Niedersächsisches Landesmuseum, inv. nos. KM 308/157 and KM 309/158. The first panel shows Aeneas landing on the coast of Carthage and his reception by Dido; the second depicts Dido's banquet and ends with the hunting party and Aeneas and Dido together in the cave, where—in the words of Virgil—Dido first called Aeneas 'my husband': cf. Callmann 1974, 68–9, figs. 165–6, 168–72, 236, 264. In later times there were even more original examples of the adaptation of a mythological story for application to a real-life marriage. In 1600 Ottavio Rinuccini wrote the pastoral *Euridice*, with music by Iacopo Peri, in honour of the marriage of Maria de' Medici and Henry IV of France. The festive performance took place in the splendid Palazzo Pitti on 6 October at dusk. This opera had an appropriately happy ending, since Orpheus succeeded—to everyone's astonishment—in freeing Eurydice from the underworld (see Sternfield 1979). According to Caroline Campbell (2007, 19), "only the use of a framework derived from Guido delle Colonne's *Historia destructionis Troiae*, as well as details from Raoul Lefèvre's *Histoire de Jason* [see above, note 91], could make the story of Jason and Medea into an exemplary painted history with positive messages for both Lorenzo Tornabuoni and his bride". In my opinion, however, the emphasis should be laid on the inventive use of the Greek text, which was so much appreciated by Lorenzo and his contemporaries.

98 Naldi, *Elegum carmen*, a1r–v: "Gloria nulla quod hac maior videatur habenda: / quam peperere simul robur et ingenium". On Heracles as a shining example, see Hessert 1991, 37 ff.

99 On the Heracles myth as applied to Lorenzo de' Medici, see Hessert 1991, 50 and Wright 1994. For the Medici arms on the ship's flag, see Fahy 1984, 244. For the possible reference to the inner courtyard of the Palazzo Medici, see Caglioti 1995, 38 and Bartoli 1999, 175 note 69.

100 *Iliad* 22. 401–4 (English translation by Richmond Lattimore, Chicago, Ill., 1951, 446).

101 Cf. Dacos 1962, fig. 22. Like his colleague and fellow townsman Domenico Ghirlandaio, Biagio d'Antonio took advantage of a stay in Rome to increase his knowledge of classical art. That opportunity arose in 1481–2, when he was asked to contribute to the decoration of the Sistine Chapel.

102 The equation of Troy, Rome and Florence also occurs on the title page of a magnificent Virgil manuscript intended for Francesco Sassetti, presumably produced around 1480 (Florence, Biblioteca Medicea Laurenziana, Plut. 39.6): see A. Garzelli, in *Miniatura fiorentina* 1985, I, 194–5, II, figs. 733–4.

103 Leonardo Bruni, *Laudatio Florentine urbis*, ed. Baldassarri 2000, 4, 15. In his *Cronica* Benedetto Dei called Florence "un'altra Roma novella", 'another new Rome' (ed. Barducci 1985, 84; cf. Pisani 1923, 91 and Kent, *Household* 1977, 101), while Politian attempted to demonstrate that Augustus had played a role in the founding of Florence (see Rubinstein 1957, 101–10). Putting Florence on a par with Rome occurs again in a stained-glass window in the main chapel of Santa Maria Novella, which depicts the *Miracle of Our Lady of the Snow*: medieval legend places the miracle in late antiquity, in fourth-century Rome, but the dome of the building in the right background was inspired by Brunelleschi's Cupola. Giovanni Tornabuoni assigned himself a key role in the stained-glass window in the Tornabuoni Chapel: as the chapel's donor, he was portrayed here as his Roman namesake, the patrician Johannes, who witnessed the miracle of the snow and was a co-founder (with Pope Liberius) of the famous basilica of Santa Maria Maggiore in Rome.

104 On the religious symbolism of the ruins in Adoration scenes, see Hatfield 1976, 56–67. In the fifteenth century, ruins were also associated with the Templum Pacis in Rome, which, according to Jacob of Voragine's *Golden Legend*, collapsed on the night of Christ's birth, an episode also recounted in Rucellai's *Zibaldone quaresimale*. The presence of numerous warriors in armour is one of the most striking characteristics of the *desco da parto* made to mark the birth of Lorenzo the Magnificent (New York, Metropolitan Museum of Art, inv. 1995.7; cf. Däubler-Hauschke 2003, 85–124). A connection between this painting and Ghirlandaio's *Adoration of the Magi* cannot be ruled out. Regarding the portraits that are difficult to identify, cf. Olson 2000, 181.

105 The pose of the old king in Ghirlandaio's tondo is comparable to that of the old king in the *Adoration of the Magi* by Fra Angelico and Benozzo Gozzoli in the convent of San Marco in Florence; this mural decorated the private cell of Cosimo the Elder (see Morachiello 1995, 297–8, 306). For the gatherings of the Compagnia dei Magi, and in particular Giorgio Antonio Vespucci's sermon, see Hatfield 1970, 133, 158. On the relationship between outward ritual and inner experience, see the enlightening comments in Weismann 1990, 262.

106 Cf. Kress 2003, 252–3. An indication of the popularity in Florence of the theme of the Three Kings is to be found in a letter written in 1460 by Alessandra Macinghi Strozzi to her son, in which she describes a painted cloth with the "tre Magi che offersono oro al Nostro Signore" ('Three Wise Men offering gold to Our Lord'; ed. 1987, 141, quoted in Hope 1990, 547). The miniature from the Hours of Philip the Good (The Hague, Royal Library, MS 76 F 2, fol. 143v) is discussed in Van Os 1994, 14–5, fig. 2.

107 Many a humanist thought that Lorenzo de' Medici acted as a catalyst: see Borsook–Offerhaus 1981, 57 note 220. The passage from Landino is quoted ibid., note 219: "non potendo esser religione alcuna più vera che la nostra, havrò adunque ferma speranza che la Republica christiana si ridurrà a ottima vita e governo, in modo che potremo veramente dire: 'Iam redit et Virgo, redeunt Saturnia regna'"; see also Costa 1972, 44.

Notes to Chapter 5

108 ASFi, Tratte, Libri di età, 443bis, fol. 140r and 444 bis, fol. 162r; AOSMF, Archivio storico delle fedi di battesimo (see above, note 29), registro 5, fol. 182: "Giovanni Antonio Gerolamo di Lorenzo di Giovanni Tornabuoni popolo di San Pancrazio nacque adì ii hore 13".

109 Recent studies on the chapel include Kempers 1987, English translation 1988, 206–8; Cadogan 2000, 236–42 (frescoes), 264–8 (altarpiece); Kecks 2000, 277–330; Schmid 2002. Regarding the choir stalls, see Cecchi 1990.

110 Cf. Simons 1987.

111 For the text of the famous contract, see Cadogan 2000, 350–1 (translation in Chambers 1970, 172–5). The following phrase is particularly revealing: "magnificus et generosus vir Iohannes quondam Francisci domini Simonis de Tornabuonis, civis ac mercator florentinus, ad presens, ut asseritur, patronus et iura indubitati patronatus tenens maioris cappelle site in ecclesia Sancte Marie Novelle de Florentia …" ('the magnificent and generous Giovanni, son of the late Francesco of Signor Simone Tornabuoni, citizen and merchant of Florence, currently, as is said, the patron and holder of undisputed rights of patronage to the main chapel of the church of Santa Maria Novella in Florence'). It is apparent from the use of "ut asseritur" that at this stage Giovanni was still fighting to gain exclusive control of the chapel. After this, more than a year passed before the Dominicans of Santa Maria Novella granted Giovanni and his *consorteria* (i.e. the Tornaquinci clan) the legal rights of patronage to the chapel. Giovanni undoubtedly profited from the fact that Francesco Sassetti had meanwhile set his sights on the church of Santa Trinita.

112 On the torches ("torchi alla cortigiana") presented by Giovanni, see ASFi, CRSGF, 102, Santa Maria Novella, Appendice, 16, fol. 39v and Appendice, 84, unnumbered fol. (cf. Simons 1987, 234, note 41). On the ambassador's visit, see Landucci, *Diario*, ed. Del Badia 1883, 52–3 ("una gi-

raffa molto grande e molto bella e piacevole: com'ella fussi fatta se ne può vedere i' molti luoghi in Firenze dipinte. E visse qui più anni. E uno lione grande, e capre e castroni, molto strani"), as well as Rinuccini, *Ricordi*, ed. Aiazzi 1840, CXLIII: "uno lione dimestico, una giraffa, uno cavallo corridore, uno becco e una capra con orecchi grandi cascanti, uno castrone e una pecora con code grosse" ('a tamed lion, a giraffe, a racing horse, a he-goat and she-goat with large floppy ears, a wether and a sheep with bulky tails').

113 For the ongoing dialogue between Giovanni Tornabuoni and the friars of Santa Maria Novella, see Simons 1987 and Hatfield 1996.

114 Part of the accompanying biblical text ("Et postulans pugillarem scripsit dicens: 'Ioannes est nomen eius'. Et mirati sunt universi") is visible in the frieze. This text is lent added value by the text in the fresco depicting the *Annunciation to Zacharias*: "Dominus ab utero vocavit me, de ventre matris meae recordatus est nominis mei" (Isa. 49:1: 'The Lord hath called me from the womb; from the bowels of my mother hath he made mention of my name').

115 Cf. Simons 1985, I, 318–9.

116 Offerhaus (1976, 22), Schmid (2002, 130) and Hatfield (1996, 115) recognize in the young woman wearing the richly ornamented gown and costly jewels a portrait of Giovanna degli Albizzi: this remains hypothetical. The passage from André Jolles's letter is in Bodar 1991, 15. For the *Dovizia* symbolism of the woman with a platter of fruit on her head, see Wilkins 1983.

117 ASFi, Grascia, 190 [5] (1457–1506), fol. 19: "la donna di Lorenzo di Giovanni Tornabuoni riposta in Santa Maria Novella adì 7 octobre 1488". For the funeral and the *messa cantata*, or 'sung mass' (14 October), see ASFi, CRSGF, 102, Santa Maria Novella, Appendice, 84, fol. 40r (Simons 1985, I, 143 and II, 118 note 195).

118 See Isidoro Del Lungo's edition of Politian's writings (1867, 154–5): "Stirpe fui, forma, natoque, opibusque, viroque / felix, ingenio, moribus atque animo. / Sed cum alter partus jam nuptae ageretur et annus, / heu! nondum nata cum sobole interii. / Tristius ut caderem, tantum mihi Parca bonorum / ostendit potius perfida quam tribuit"; cf. Maier 1965, 194 note 2, 244, 292. For the translation of Politian's epitaph, see Cadogan 2000, 277. The original Latin of Lorenzo's epigram is as follows: "Laur. Tor. Epigramma pro | obitu uxoris suae Ioannae. | Cui Charites mentem dederant cui Cypria formam / cui castum pectus Delia sacra dedit / hic Iovanna iacet patriae decus Albiza proles / sed Tornabuono nupta puella viro; / ut quae gerens vitam populo gratissima mansit / sic quoque nunc supero permanet ipsa Deo".

119 On the masses said for Giovanna's soul in Santa Maria Novella, see Simons 1985, I, 143 and II, 118, note 196, with reference to ASFi, CRSGF, 102, Santa Maria Novella, Appendice, 19, fols. 5r ("per la cera s'a[p]ic[c]hò nella cappella per la messa fece cantare per la Giovanna, sua donna") and 18r ("per chalo della cera della cappella"). Regarding the bust of Albiera degli Albizzi, see Patetta 1917–8, 326.

120 The famous portrait, made shortly after the *Visitation* fresco in Santa Maria Novella (Pope-Hennessy 1966, 28), is discussed by, among others, Simons (1988), Cadogan (2000, 278–9, no. 46) and J.M. Riello (in *El retrato del Renacimiento* 2008, 202–3, no. 23). It was first recorded in ASFi, Pupilli, 181, fol. 148r: "Nella chamera del palcho d'oro … 1° quadro chon chornicione messo d'oro chon testa e busto della Giovanna degli Albizi". For the sake of completeness, I consulted two unpublished typescripts at the Museo Thyssen-Bornemisza, Madrid: Henry Willet, 'Portrait of Giovanna degli Albizzi Wife of Lorenzo Tornabuoni Painted by Domenico Ghirlandaio in 1488', undated, and Maurice W. Brockwell, 'Domenico Ghirlandaio. Portrait of Giovanna Tornabuoni', 30 June 1919. Willet, who from 1878 had the portrait in his possession for a time, gives a detailed description of the motifs and symbols woven into the fabric of Giovanna's dress.

121 Martial, *Epigrammata* 10. xxxiii, 5–6 (the reading adopted by Ghirlandaio is also found in a Venetian edition dated 1482 and dedicated to Lorenzo the Magnificent; cf. Shearman 1992, 108–13 and 112 of the 1995 Italian edition). See also Hendy 1964, 43–5 and Pope-Hennessy 1966, 24–8.

122 In his edition of Politian's writings, Del Lungo mentions the dedication that allegedly accompanied Giovanna's epitaph on her tombstone (1867, 155): "Joannae Albierae [*sic*] Uxori incomparabili | Laurentius Tornabonus Pos(uit) B(onae) M(emoriae)". For Giovanni's will, see ASFi, NA, filza 5675, fols. 47r–50r ("Item uno pendente con uno rubino et i° diamante et tre perle, di valuta di fiorini 120 larghi"); for the receipt of Ludovica's dowry, see ASFi, NA, filza 13187, fols. 125r–6r: 125v ("Un altro pendente chon uno rubino chagnuolo, uno punto in mezzo, uno diamante tavola, tre perle fine bianche ben fatte ànno un pocho e lungho e una un pocho rognosa pesano cho' picc[i]uoli d'oro charati diciasette chon uno rovescio, una foglia smaltata d'az[z]urro e bianco comunis extimationis et pretii florenorum centum largorum"); cf. Hatfield 2009, 22, 34 note 145, 25 note 147, where the dates of the betrothal (25 February 1489) and the wedding (27 August 1492) are also given.

123 Cf. Wright 2000, 96.

124 For the references to the *paternostri*, see *Libro debitori e creditori 1480–1511*, fols. cxviii and 119 ("una filza di paternostri di filo dorati e smaltatti di peso d'once ⅔"). The term *paternoster* was used for all kinds of beads of the size of large rosary beads. On the reputed power of coral to avert evil, see the section 'Le virtù delle gemme', edited by Patrizia Castelli, in *L'oreficeria* 1977, 309–29; on Giovanna's portrait, see ibid., 334, no. 211. On the painting by Masaccio, see Musacchio 1999, 133, figs. 126, 128.

Notes to Chapter 6

125 On Domenico Ghirlandaio's assistants, see Kecks 2000, 115–32. On relations between Ghirlandaio and Michelangelo, see Hatfield 2002, 145–51.

126 For the technical aspects of the fresco cycle, see Danti 1990 and Ruffa 1990. On Ghirlandaio's working method and his use of drawings and cartoons, see Cadogan 2000, 103–51 and Kecks 2000, 133–57. In the eyes of his contemporaries, Ghirlandaio was "homo expeditivo, et che conduce assai lavoro" ('an expeditious man and one who gets through much work'): this is how he was described to the duke of Milan by an anonymous agent reporting on the best painters available in Florence at the time (quoted in Baxandall 1972, 26).

127 Cf. Schmid 2002, 78 ff. The identification of those portrayed—more than twenty altogether—is based on an old source, namely a list drawn up in 1561 at the request of Vincenzo Tornaquinci by the eighty-nine-year-old Benedetto Landucci. Benedetto was the son of the well-known (and by now familiar to us) chronicler Luca, who resided and had an apothecary shop in the vicinity of the Palazzo Tornabuoni. Benedetto was eighteen or nineteen when the frescoes were unveiled, so his list can be considered a reliable source. Simons (1987, 237) focuses attention on the similarity to Ghirlandaio's preparatory drawing in Vienna (Albertina, inv. no. 4860; cf. Cadogan 2000, 305–6, no. 112, fig. 135), where the artist wrote the names of four prominently portrayed figures ("Messer Giuliano", "Giovanni Francesco", "Messer Luigi" and one "Lorenzo" or "Leonardo"). Three of these names agree with the identifications provided by Landucci: Giuliano di Filippo Tornabuoni, Giovanni di Francesco Tornaquinci, Luigi Tornabuoni (in the fresco the latter was moved to the left). The fourth figure is most likely Leonardo di Francesco Tornabuoni, Giovanni's elder brother, who is depicted in a similar position in the fresco. In Ghirlandaio's preparatory drawing, several figures are missing, including the patron himself.

128 The Magnificat (Luke 46–55) begins with the lines: "My soul magnifies the Lord, and my spirit rejoices in God my Saviour; because He has regarded the lowliness of His handmaid; for behold, henceforth all generations shall call me blessed".

129 On Ghirlandaio's indebtedness to the Flemish Primitives, see Nuttall 2004, 140.

130 See above, note 119.

131 Regarding the altarpiece, see Cadogan 2000, 264–8, no. 38, figs. 191–2, 247–52 and Kecks 2002, 321–30; cf. also Chapter 8. The theme of 'vanquishing death through death' is aptly expressed in the iconography of the altarpiece, particularly in the *Resurrection* scene. Inscribed on the sarco-

phagus are the letters that recall Christ's crucifixion (INRI, Iesus Nazarenus Rex Iudaeorum); below is a pelican nourishing its offspring with its own blood. The pelican is a symbol of Christ, who spilled His blood on the cross for all mankind. Dante therefore calls Christ "nostro pellicano" (*Paradiso* 25. 113); see also Thomas Aquinas' eucharistic hymns. Aby Warburg was the first to focus attention on the expressive poses of the sentinels, whose origins are to be found in classical art (1914, Italian translation 1966, 302–3).

132 For the symbol of the fig branch, see Levi D'Ancona 1977, 135–42 and Loosen-Loerakker 2008, 166.

133 For Ghirlandaio's *Visitation* with Mary of Cleophas and Mary Salome, see Cadogan 2000, 262–3. Regarding the chapel in Naples, see Michalsky 2005, 82–4, 90 note 29 (with bibliography). Later on, Pontano and his son were also buried in the chapel, as planned.

134 On the history of the church, see Luchs 1977.

135 See ibid., 284–5, 348. The passage relating to the construction and dedication of the chapel is in ASFi, CRSPL, 417, unnumbered folio, no. 62: "A dì otto d'agosto 1490 el nobile Lorenzo di Giovanni Tornabuoni ordinò e chiese che gli fussi murata una chapella nella nostra chiesa di Cestello e a dì primo di marzo 1490 [Florentine style, i.e. 1491] fu finita di tutto circa el murare e spese ducati sessanta quat[t]ro o circa e adì 28 di giugno 1491 fu consecrata detta ara in onore Visitationis sancte Marie Dei genitricis virginis per messer tridetto episcopo Vasonensi e lasciò in detto dì per tutti e tempi correnti dì C [i.e. 100] di perdonantia a chi visitassi detta ara et per tutte le feste a sant. di Nostra Donna dì 40 e chosì tutte le domeniche e le feste degli apostoli et di sancta Maria Magdalena e di sancto Bernardo e di santo Benedetto et tutte e doppi overo di due messe per tutto l'anno". The masses to be said in memory of Giovanna are mentioned in the following passage: "Nell chapitolo fatto a Ferrara nello anno 1492 fu terminato per gli diffinitori della chongregatione di sancto Bernardo che nella sopradetta chapella si dicessi per spatio d'anni cento ogni settimana una volta una messa partichularmente et spetialmente pe·lla anima della donna che fu del sopradetto Lorenzo Tornabuoni cioè pe·lla Giovanna figliuola che fu di Maso degli Albizi la qual messa si chominciò adì 25 di dicembre 1490". According to Alison Luchs, the celebrations of these masses actually began on Christmas 1490, but Patricia Simons (1985, II, 118 note 197) thinks it more likely that the first mass was said on Christmas 1491. From then on, the masses said in memory of Giovanna were moved from Santa Maria Novella to the church of Cestello.

136 Luchs 1977, 284–5: "A dì 21 di luglio del 1491 el sopradetto Lorenzo mandò a Cestello nella sua chappella una bella tavola dipinta cholla Visitatione che fu di pregio di duchati ottanta di mano di Domenicho Grillandaio et detto dì mandò per ornare detta chappella predella d'altare et panche colle spalliere e due chandelliere bianchi grandi e due di ferro per tenere in sull'altare per ap-[p]ic[c]hare [*appicciare*, light)] le candele et etiam detto dì la finestra invetrata con una figura di santo Laurenzio dentrovi fatta da Sandro bidello dello Studio. | E mandò detto dì una pianeta di damaschino bianco fiorito dalmaticha et tonicello e uno paliotto d'altare d'una fatta e uno bellissimo piuviale d'ap[p]icciolato [silk cloth] domaschino. Benedicetur Deus qui retribuat ei sechondum suum laborem".

137 On Sandro Agolanti, see Forlani 1960; Martin 1996; Cadogan 2000, 284. For his work commissioned by Giovanni Tornabuoni for the church of Santa Maria delle Carceri in Prato, see Morselli–Corti 1982, 69–70, figs. 33–6.

138 Regarding the woodcut on the title page of Savonarola's *Tractato del sacramento et de mysterii della messa et regola utile* (Florence: Bartolomeo de' Libri, before September 1495; Rhodes 1988, III, no. 701), see E. Torelli, in *Immagini e azione riformatrice* 1985, 91–3, no. 13. For Lorenzo's part in the dedication of the altar, see Luchs 1977, 67–8. Luchs also underscores the suitability of the theme for the Cistercians, since the Visitation had been an official feast of their order since 1476.

139 Cf. Vincke 1997, 75–7. The shells and pearls on the cornice can be interpreted as symbols of the Immaculate Conception.

140 For a critical comparison of the books of hours belonging to the daughters of Lorenzo de' Medici, see Regnicoli 2005, 202–3. One fifteenth-century book of hours has survived that was made for a member of the Tornabuoni family, possibly Giovanni di Francesco: datable to about 1475, it is preserved in the Biblioteca Nazionale in Florence (Nuovi acquisti 1370); see Ciardi Duprè Dal Poggetto 1977; Di Domenico 1997; *Sette anni di acquisti e doni* 1997, 11–3.

141 Cf. Wieck 1997, 86–7. On the composition of books of hours, see Leroquais 1927. The composition and illumination of fifteenth-century Italian books of hours has yet to be researched.

Notes to Chapter 7

142 Regarding the great contrasts in Florence around 1490, see Walter 2003, 225 ff. ('Schatten über der goldenen Zeit'). On the parade (*mumieria*), see Bessi 1992, 114; Ventrone 1992, 29; Ventrone 1996, 422; Helas 1999, 124–5. To celebrate this triumphal procession, Naldo Naldi wrote an ode titled *Elegia in septem stellas errantes sub humana specie per urbem Florentinam curribus a Laurentio Medice patriae patre duci iussas more triumphantium* (Florence: Francesco di Dino, *c.* 1490–2; for the edition preserved in the Biblioteca Riccardiana (Ed. rare 572), see L. Biagini, in *Le tems revient* 1992, 238, no. 7.7. Naldi's text is primarily a panegyric to Lorenzo de' Medici, who was said to be the first to summon the gods to earth; see Ventrone 1990, 357–60. For the *Canzona de' sette pianeti* and the *Canzona di Bacco*, see Lorenzo de' Medici, *Opere*, ed. Zanato 1992, 366–8, 391–4 ("Quant'è bella giovinezza / Che si fugge tuttavia! / … Donne e giovinetti amanti, / viva Bacco e viva Amore! / Ciascun suoni, balli e canti! / Arda di dolcezza il core! / Non fatica, non dolore! / Ciò c'ha esser, convien sia. / Chi vuol esser lieto, sia: / di doman non c'è certezza").

143 Pinelli 1996, 231. The passage of Tribaldo de' Rossi's *Ricordanze*, published by Ildefonso di San Luigi in 1786, is quoted in Ventrone 2007, 64: Paullus returned "chon tanto tesoro che Roma istette da 40 o 50 anni che 'l popolo non paghò mai graveza niuna tanto tesoro conchuistò".

144 For the 'building craze' that marked this period, see Landucci, *Diario*, ed. Del Badia 1883, 58–9: "E in questi tenpi si faceva tutte queste muraglie: l'Osservanza di Samminiato de' Frati di San Francesco; la sacrestia di Santo Spirito; la casa di Giuliano Gondi, e la Chiesa de' Frati di Santo Agostino fuori della Porta a San Gallo. E Lorenzo de' Medici cominciò un palagio al Poggio a Caiano, al luogo suo, dove à ordinato tante belle cose, le Cascine. Cose da signori! E a Serezzana si murava una fortezza; e molte altre case si murava per Firenze, per quella Via che va a Santa Caterina, e verso la Porta a Pinti, e la Via nuova da' Servi a Cestello, e dalla Porta a Faenza verso San Bernaba, e in verso Sant'Ambrogio, e in molti luoghi per Firenze. Erano gli uomini in questo tenpo atarentati al murare, per modo che c'era carestia di maestri e di materia". For the comment on Filippo Strozzi's new residence, ibid., 62: "Durerà questo palazzo quasi in eterno"; see also Kent, 'Più superba' 1977.

145 On Savonarola, see, among others, Weinstein 1970. For Fra Bartolomeo's portrait of Savonarola, see Ch. Fischer, in *L'officina della maniera* 1996, 74–5, no. 1.

146 Ridolfi 1981, 56, 516 ff.; Walter 2003, 285.

147 Cf. Roover 1963, 260, with reference to ASFi, MaP, filza 89, doc. 189 (letter dated 25 March 1490). Lorenzo is referred to as a 'famous merchant' in the document in which the Rome branch of the Medici bank is said to be entrusted to him (quoted in *Le collezioni medicee* 1999, 42: "famoso mercatori Laurentio Iohannis de Tornabonis civi Florentino"). On Lorenzo's candidature for public office, see *Florentine Renaissance Resources. Online Tratte of Office Holders 1282–1532*, edited by D. Herlihy et al., <http://www.stg.brown.edu/projects/tratte>.

148 Giovanni Tornabuoni's stipulations are recorded in a will dated 26 March 1490; see Ross 1983, 64–8, 221–3 notes 126–36 and Cadogan 2000, 370. Regarding the altarpiece, see Holst 1969, as well as Cadogan 2000, 267. On the placing of the altar, see Hatfield 1996, 114.

149 On Lorenzo's collection of part of the dowry after marrying Ginevra, see Luchs 1977, 160 note 16, with reference to ASFi, NA, G.826, fol. 145r; see also Hatfield 2009, 22, 34 note 142. Regarding the colourful Bongianni Gianfigliazzi, see the concise biography by Vanna Arrighi (2000) and

Preyer 2004, 66. An important source is Bongianni's own diary, the *Libro di Ricordi* (Florence, Archivio della Congregazione dei Buonomini di San Martino, Gianfigliazzi): the handwritten text can be perused on microfilm (ASFi, Archivi esterni, Buonomini di San Martino, bobina 1). Of particular importance are the notes concerning Ginevra—born on 4 April 1473 "a ore 23 ½ in domenicha" and baptized on 5 April (fols. 2, 15)—as well as the mention of Niccolò di Arnolfo Popoleschi in connection with Ginevra's dowry (fol. 15) and of the diplomatic mission to Rome in 1480 (fol. 49). For Leonardo's date of birth (29 September 1492), see Simons 1985, II, 114 note 167, with reference to ASFi, Tratte, 443bis, fol. 146v. When the inventory of the movable goods in the Palazzo Tornabuoni was drawn up in January 1498, Lorenzo and Ginevra's two daughters, Francesca and Giovanna, were three and one, respectively: see Simons 1985, II, 114 note 167, with reference to ASFi, Pupilli, filza 181, fol. 141r. See Chapter 4 with regard to Giovannino's privileged position.

150 Walter 2003, 286–93. On the advice given to Piero, see Fabroni 1784, I, 203; P. Viti, in Redditi, *Exhortatio*, ed. Viti 1989, XXIII.

151 The exclusion of many families as a result of the creation of the Council of Seventy was regretted by Benedetto Dei, among others (see Kent 1994, 54). Regarding the opposition during the last years of Lorenzo de' Medici's leadership, see Brown 1994, 66–80. On the connection between the bolt of lightning that struck the lantern and Lorenzo's death, cf. Walter 2003, 291.

152 Parenti, *Storia fiorentina*, ed. Matucci 1994–2005, I, 26–8; see also Kuehn 1982, 142. Another piece of writing that must be mentioned in this context is the *Exhortatio ad Petrum Medicem* by Filippo Redditi—written between late 1487 and the first months of 1489—in which Piero is urged to follow in his father's footsteps. We also know that Piero was sent on diplomatic missions at a young age. He was present, for example, at the 1489 marriage of Gian Galeazzo Sforza and Isabella of Aragon, the daughter of Duke Alfonso of Calabria: see ASV, Armadio XLV, 36, letters of Iacopo da Volterra, 1487–90, fol. 146r.

153 On Lorenzo Tornabuoni and his new brother-in-law, Iacopo di Bongianni Gianfigliazzi, as the godfathers of Piero's son, see ASFi, NA, B.910, ins. 1, fol. 211r. For the tournament, see Viti 1991, 11–4. Regarding the lack of a portrait of Lorenzo de' Medici in the Tornabuoni Chapel, Ingeborg Walter (2003, 224–5) perceptively observed that the ancient Tornaquinci/Tornabuoni clan felt equal in rank to the Medici. For Guicciardini's observations, see *Storie fiorentine*, ed. Lugnani Scarano 1970, 167: "ma oltre al parentado che aveva con Piero suo carnale cugino, e la potenzia si gli mostrava in quello governo, lo essere uomo magnifico ed aver speso assai, ed avviluppato e' fatti suoi nel sindacato de' Medici, l'aveva messo in tanto disordine che sarebbe di corto fallito".

154 Piero's negative character traits are often blamed on his mother's side of the family. See, for example, Aby Warburg's comments regarding Piero's youthful portrait in the Sassetti Chapel (fig. 22): "Piero, der Älteste ... blickt gleichfalls heraus, aber selbstbewußt mit dem dünkelhaften Gleichmut des künftigen Gewaltherrschers. Das mütterliche stolze, römische Ritterblut der Orsini beginnt bereits im verhängnisvollen Trotz gegen das klüglich ausgleichende florentinische Kaufmannstemperament aufzuwallen" ('Piero, the eldest ... likewise looks out of the picture, but self-consciously, with the arrogant composure of the future tyrant. The maternally proud, knightly Roman blood of the Orsini is already beginning to seethe in fatal pride against the cleverly conciliatory Florentine merchant temperament'; 1902, ed. 1932, 104). Alison Brown, who is preparing a scholarly study of Piero di Lorenzo, recently told me that, in her opinion, the role played by Piero is underestimated (private communication). For the story of the snowman, see Condivi, ed. Nencioni 1998, 14.

155 There were those who expected a political about-face after scarcely two months (June 1492); see Parenti, *Storia fiorentina*, ed. Matucci 1994–2005, I, 32: "el popolo e corpo universale della città stava sospeso, non intendendo a che cammino [o] a che fine le cose s'avessino a riuscire. Desideravano la vera libertà, e aspettavano occasione, e in effetto male erano contenti del presente stato: e ciascuno in aspettazione vivea" ('the people and body politic of the city were as though suspended, not knowing which way things would turn out. They longed for true liberty, and were waiting for

the right chance, and were in effect discontented with the present state: so that everyone lived in expectation'). By April 1493, Piero's leadership had shown all its weaknesses: state affairs were run by a group of ten people, including Agnolo Niccolini, Bernardo del Nero, Francesco Valori and Niccolò Ridolfi. Parenti (ibid., I, 47) writes that "in questi X consisteva tutto il pondo dello stato, benché Piero de Medici da·lloro governare si lasciassi, e essi lui come capo per la loro conservazione usassino. Onde continuamente segrete e palesi ragunate faceano, e secondo el loro arbitrio determinavano" ('in these ten people resided all the weight of the state, although Piero de' Medici let himself be governed by them, and they acknowledged his leadership to remain in power. And they continually met both in secret and in public, and deliberated as they saw fit').

156 Ibid., I, 51–4.

157 Guicciardini (*Storie fiorentine*, ed. Lugnani Scarano 1970, 175) sketches Valori's character as follows: "Fu Francesco uomo molto ambizioso ed altiero, e tanto caldo e vivo nelle opinioni sua, che le favoriva sanza rispeto, urtando e svillaneggiando tutti quegli che si gli opponevano: da altro canto fu uomo savio e tanto netto circa la roba ed usurpare quello di altri, che pochi cittadini di stato sono suti a Firenze simili a lui, vòlto molto e sanza rispeto al pubblico bene" ('Francesco was a very ambitious and haughty man, so vehement and obstinate in his opinions that he pursued them without scruple, attacking and insulting all who opposed him; on the other hand, he was a clever man, and so free of corruption or the taint of taking other men's goods that there have been few citizens in Florentine politics who can compare with him; and he was greatly and uncompromisingly devoted to the public good'); see also ibid., 116, 123. Regarding Valori's opposition, see Parenti, *Storia fiorentina*, ed. Matucci 1994–2005, I, 60–1. Parenti also remarks that Piero was not a worthy successor to this father, who was indeed able 'with a single gesture' to bend the Florentine citizens to his will ("con un solo cenno tutti li altri cittadini alla volontà sua restringeva").

158 See Parenti, *Storia fiorentina*, ed. Matucci 1994–2005, I, 64 ("Cominciarono le cose di Francia forte a riscaldare"), 90 (regarding Charles VIII's attempt to approach the Florentines in August 1494), 101 ff. (visit of the French ambassadors, October 1494). Giovanni and Lorenzo di Pierfrancesco de' Medici had been banished from the city as early as April 1494 (ibid., 67–73). The rivalry between Piero di Lorenzo and Lorenzo di Pierfrancesco, born on 4 August 1463, had been going on for some time. Even before his expulsion, Lorenzo had supposedly planned to oust Piero, a rumour recorded by Paolo Somenzi in a letter to the duke of Milan: "molti dicono che epso cercava de volersi fare grande, cioè capo della Ciptà, come era Piero" ('many say that he was attempting to rise in power, that is, to become head of the city, as Piero was'; quoted in Villari 1859–61, II, XXX). For the events leading up to this, as well as further details, see Guasti 1902, 73; Bertelli 1972, 35–40; Martelli 1978, 190–3; Brown 1994, 71. On Lorenzo Tornabuoni's hatred of Lorenzo and Giovanni, see Guicciardini, *Storie fiorentine*, ed. Lugnani Scarano 1970, 167: "dubitò non diventassino capi della città Lorenzo e Giovanni di Pierfrancesco, a' quali era inimicissimo e gli temeva; e però volle prevenire" ('he thought his arch-enemies Lorenzo and Giovanni di Pierfrancesco, whom he feared deeply, might become leaders of the city, and thus he tried to prevent it'). The *restitutio* or rehabilitation of the latter took place as soon as Piero di Lorenzo had been expelled from the city: see ASFi, Signori e collegi, Deliberazioni in forza di ordinaria autorità, 96, fol. 87r.

159 See, among other sources, Parenti, *Storia fiorentina*, ed. Matucci 1994–2005, I, 100–14 ("'Oportet quod unus moriatur pro populo' … altri dissono che sue parole furono; 'Ciascuno facci per sé'"). A number of factors were responsible for Florence's isolation. The king of Naples had tried to obtain permission for his troops to disembark at Porto Pisano, hoping to send them east to meet the French in Romagna; the Florentines, however, thwarted this action to prevent Tuscany from becoming a battlefield. By July the unrest had already spread to Siena, where the Medici sympathizer Giacoppo Petrucci, brother of Pandolfo, had been removed from office by the people (ibid., I, 85–6). Regarding Piero's behaviour at this juncture, see Rubinstein 1960, 148, with reference to the *Priorista* by Agnolo and Francesco Gaddi (ed. 1853, 43), who noted that Piero acted 'on his own authori-

ty, without any public mandate, to ingratiate himself to the King' ("non havendo alcun mandato o commessione dal publico, di sua propria authorità, per gratificarsi al Re"). In my opinion, the communication between Piero and the Florentine government in the days leading up to the surrender deserves further study.

160 Parenti, *Storia fiorentina*, ed. Matucci 1994–2005, I, 115 ("Offerendo Piero de' Medici molte grandi condizioni al re di Francia, domandato fu che autorità avessi. Il perché lui subito mandò qui Lorenzo Tornabuoni, il quale ordinassi che per sindaco Piero fatto fussi con tutta l'autorità del popolo: il che, tentatosi, non riuscì"); Landucci, *Diario*, ed. Del Badia 1883, 71; see also ibid., 70–1: "E a dì 26 d'ottobre 1494, si partì di qui Piero de' Medici e andò per la via di Pisa incontro al Re di Francia; e come giunse al Re, gli fece dare le chiavi di Serezzano e di Pietrasanta e anche gli promise denari. El Re volendo intendere el vero se gli aveva questa comessione, e' venne qui Lorenzo di Giovanni Tornabuoni, ch'era andato col detto Piero de' Medici, e andò alla Signoria, che gli fusse dato questa comessione; e nollo vollono fare. E Lorenzo un poco isbigottito non tornò in là: onde Piero fu un poco biasimato. E' fece come giovanetto, e forse a buon fine, poiché si restò amico del Re, a lalde di Dio" ('And on 26 October 1494 Piero de' Medici left the city and took the road to Pisa to meet with the king of France; and when he reached the king, he had the keys to Serezzano and Pietrasanta presented to him, and promised him money as well. The king wanted to make sure that Piero had the mandate to do all this, so Lorenzo di Giovanni Tornabuoni, who had accompanied Piero, returned to Florence and went to the Signoria, so that they might give him this mandate, but they refused. Lorenzo was dumbfounded, and did not go back, and Piero was criticized by some. He acted like a youth, but perhaps it was all for the best, for he remained friends with the king, God be praised').

161 Parenti, *Storia fiorentina*, ed. Matucci 1994–2005, I, 116–7. Machiavelli's passage reads as follows: "a Carlo re di Francia fu licito pigliare la Italia col gesso" (*Il Principe*, ed. Vivanti 1997, 151).

162 Parenti, *Storia fiorentina*, ed. Matucci 1994–2005, I, 117–8 ("vedutisi in isterminio condotti, a volgere mantello cominciorono").

163 See Landucci, *Diario*, ed. Del Badia 1883, 73: "E a dì 8 di novembre 1494, tornò qui in Firenze Piero de' Medici, che veniva dal Re di Francia da Pisa; e quando giunse in casa, gittò fuori confetti e dètte vino assai al popolo, per recarsi benivolo al popolo; mostrandosi avere buono accordo col Re; e mostrossi molto lieto"; Parenti, *Storia fiorentina*, ed. Matucci 1994–2005, I, 121.

164 Parenti, *Storia fiorentina*, ed. Matucci 1994–2005, I, 121–4.

165 Landucci, *Diario*, ed. Del Badia 1883, 74–5; Parenti, *Storia fiorentina*, ed. Matucci 1994–2005, I, 124–5 (125: "in tale modo, per la sua temerità, Piero de' Medici lo stato, anni 60 durato fino dal suo bisavolo, perdé, e libera la città rimase più per opera di Iddio che delli uomini, la città la quale con tanto animo l'arme per la libertà sua poi prese, quanto mai popolo alcuno si vedessi").

Notes to Chapter 8

166 Parenti, *Storia fiorentina*, ed. Matucci 1994–2005, I, 126: "Lorenzo in casa Antonio in Santa Croce, tra 'l fieno de' cessi, ser Giovanni in San Marco, dove la ipocrisia essercitava, occultati s'erano"; 130: "si levò l'arme a Bernardo del Nero, Niccolò Ridolfi, Lorenzo Tornabuoni, messer Agnolo Niccolini e altri: così cominciorono e' Grandi a essere notati". Landucci gives the following account of Lorenzo's arrest (*Diario*, ed. Del Badia 1883, 76–7): "E a dì 10 detto, lunedì, ritornorono e cittadini in piazza armati, e tuttavolta mandavano a pigliare giente. Fu preso Antonio di Bernardo, ser Giovanni di ser Bartolomeo, ser Simone da Staggia, ser Ceccone di ser Barone, ser Lorenzo che stava in Dogana, Lorenzo di Giovanni Tornabuoni, Piero Tornabuoni, cavati di casa. La Signoria mandò un bando, a pena delle forche, chi avessi o sapessi chi avessi beni di Piero de' Medici e del Cardinale suo fratello, e così di ser Giovanni e di ser Simone e di ser Piero che stava in casa e' Medici e d'Antonio di Bernardo e di ser Lorenzo di Dogana" ('And on the 10th of said month, Monday, the citizens again took to the streets in arms, and had a number of people arrested, including Anto-

nio di Bernardo, ser Giovanni di ser Bartolomeo, ser Simone da Staggia, ser Ceccone di ser Barone, ser Lorenzo who worked at Customs, Lorenzo di Giovanni Tornabuoni, Piero Tornabuoni, who were taken out of their own homes. Anyone who had—or knew someone who had—property belonging to Piero de' Medici or his brother the cardinal, as well as to ser Giovanni, ser Simone, ser Piero who stayed at the Medici house, Antonio di Bernardo and ser Lorenzo of Customs, was ordered by the Signoria to come forward under pain of hanging').

167 Antonio Natali pointed out (in *Sandro Botticelli* 2000, I, 136–7, no. 4.2) that the procession probably moved from the Cathedral towards the Palazzo Medici and San Marco, and not vice versa as depicted by Granacci, since the French troops entered the city from the south. We know that Via Larga was draped with blue cloth decorated with countless fleurs-de-lis. A triumphal arch designed by Perugino adorned the main entrance to the Palazzo Medici, meanwhile occupied by the Florentine authorities. For the iconography of Charles VIII in Italy, see Scheller 1981–2.

168 Parenti, *Storia fiorentina*, ed. Matucci 1994–2005, I, 133–44; Guicciardini, *Storie fiorentine*, ed. Lugnani Scarano 1970, 129. The legendary boldness displayed by Piero di Gino Capponi during the negotiations with Charles VIII is the subject of a fresco by Bernardino Poccetti in the great hall of the Palazzo Capponi on the Lungarno Guicciardini in Florence. The fresco, painted in 1583–5, bears the inscription: "Piero di Gino Capponi, con atto generoso induce Carlo VIII re di Francia a più honesti patti col popol fiorentino nel 1494" (Vasetti 2001, 88, fig. 60).

169 Landucci, *Diario*, ed. Del Badia 1883, 89: "E a dì 2 di dicenbre 1494, martedì, si fece Parlamento in Piazza de' Signori, circa a ore 22, e venne in piazza tutti e gonfaloni, che ogniuno aveva dietro tutti e sua cittadini sanza arme. Solo fu ordinato armati assai alle bocche di piazza; e lessesi molte cose e statuti che furono parecchi fogli scritti. E prima fu dimandato al popolo se in piazza era e due terzi de' cittadini. Fu risposto da' circunstanti che sì. Alora si cominciò a leggere: e dissono ne' detti capitoli, ch' annullavano tutte le leggi dal trentaquattro in qua e annullavano e Settanta e' Dieci e Otto di Balìa …". For Antonio di Bernardo's hanging see ibid., 91: "fu inpiccato Antonio di Bernardo di Miniato, la mattina inanzi dì, alle finestre del Capitano; e stettevi inpiccato insino alle 24 ore". See also Parenti, *Storia fiorentina*, ed. Matucci 1994–2005, I, 150: "tutti e' buoni cittadini adolororono. Lamentavansi d'avere prese per la libertà l'arme, con ciò fussi che non per la libertà del popolo, ma per la conservazione dello stato de' medesimi che prima governavano prese le avevano".

170 Guicciardini, *Storie fiorentine*, ed. Lugnani Scarano 1970, 132–3: "Erano nella città molti che arebbono voluto percuotere Bernardo del Nero, Niccolò Ridolfi, Pierfilippo, messer Agnolo, Lorenzo Tornabuoni, Iacopo Salviati e gli altri cittadini dello stato vecchio; alla quale cosa si opponevano molti uomini da bene, massime Piero Capponi e Francesco Valori, parte mossi dal bene publico perché in verità si sarebbe guasta la città, parte dal privato loro. Perché sendo loro naturalmente e e' maggiori loro amici della casa de' Medici, e che nel 34 avevano rimesso Cosimo, dubitavano che spacciati gli altri dello stato vecchio, e' quali vulgarmente si chiamavano bigi, loro non restassino a discrezione degli offesi nel 34, che naturalmente erano anche inimici loro". See also Rubinstein 1960, 163.

171 For the Savonarola medal, see F. Nicosia, in *Sandro Botticelli* 2000, I, 152–3, no. 4.11; for Botticelli's *Mystic Crucifixion*, N. Pons, ibid., I, 162–3, no. 4.16.

172 Savonarola, *Prediche sopra Aggeo*, XXIII, ed. Firpo 1965, 427–8: "Ora la nostra nave, come v'ho detto, resta in mare e va verso el porto, cioè verso la quiete, che ha avere Firenze dopo le sue tribolazioni. Signori vecchi e nuovi, tutti insieme procurate che questa pace universale si faccia, e fate fare buone leggi per stabilire e fermare bene el vostro governo. E la prima sia questa: che nessuno si chiami più 'bianchi' o 'bigi', ma tutti insieme uniti siano una medesima cosa; queste parte e parzialità nelle città non stanno bene … Fa pace vera e di cuore, e declina sempre più a misericordia che a iustizia questa volta, perché Dio ha usato ancora questa volta verso di te più misericordia che giustizia. O Firenze, tu avevi bisogno di gran misericordia, e Dio te l'ha fatta; però non esser ingrata"; English translation 2006, 174–5. For the term *bigi*, see also Parenti, *Storia fiorentina*, ed.

Matucci 1994–2005, I, 190 ("male vissuti ne' tempi passati cittadini, e' quali per comune vocabolo Bigi si chiamavano"). On the general pardon, see Rubinstein 1960, 164.

173 See Hall 1990 with regard to Florentine artistic production in the years 1494–7 and Savonarola's influence on it. Marcia Hall (ibid., 499–500) assumes that Savonarola disapproved of the combination of religious scenes and worldly portraits in the main chapel of Santa Maria Novella, but Savonarola's criticism was aimed primarily at the overly lifelike and bodily portrayal of the saints: it is uncertain whether he objected to the life-size portraits in the Tornabuoni Chapel, though it is a distinct possibility. On the criticism of feminine ostentation, see Warburg 1895, ed. 1932, 290, with reference to Savonarola's *Prediche quadragesimale* (ed. 1539, fol. 175): "Guarda che usanze ha Firenze; come le donne fiorentine hanno maritate le loro fanciulle: le menano a mostra: e acconciatele che paiono nymphe". On Filippino Lippi's triptych, see Zambrano–Nelson 2004, 494–502.

174 On the covenant between the Tornabuoni and the 'Sindichi et Uficiali' dating from 4 June 1495, see Roover 1963, 224, 452 note 115, with reference to ASFi, MaP, filza 82, doc. 145 (fols. 447 ff.). Regarding the final balance, see Sapori 1973 and Bullard, 'Fortuna' 1994. Of all the debtors, Virginio Orsini owed the largest amount, 39,204 ducats: Piero de' Medici had lent him money to buy Anguillara and Cerveteri (Shaw 1988, 29 and 42 note 36). On the transference of the *sustanze* to the grandchildren, see ASFi, NA, 1924, ins. 1, fols. 281r–7v and 1925, fols. 37v–8r (Simons 1985, II, 113 note 165); see also the Epilogue. On the part played by Lorenzo Tornabuoni in the agreement with the syndics, see Fusco–Corti 2006, 165–70.

175 On Cegia and his secret diary (ASFi, Carte strozziane, Seconda serie, reg. 25), see Pampaloni 1957. Biographical information on Cegia can be found in Ristori 1979, as well as in *Le collezioni medicee* 1999, XII–XIII. Regarding the confiscation of Donatello's statues, see Caglioti 2000, 291 ff. In the autumn of 1495, the bronze *David* was moved from the inner courtyard of the Palazzo Medici to that of the Palazzo della Signoria, while the sculpture of *Judith and Holofernes* was placed at the entrance to the government building. Gentile de' Becchi (one of the four literati and philosophers portrayed in the Tornabuoni Chapel: fig. 62) provided Latin inscriptions, now lost, for the bases of both statues. Around 1464 Piero the Gouty had had the following passage inscribed on the base of the *Judith*: "Salus publica | Petrus Medices Cos(mi) fi(lius) libertati simul et fortitudini | hanc mulieris statuam, quo cives invicto | constantique animo ad rem publicam tuendam redderentur, dedicavit" ('The salvation of the state. Piero de' Medici son of Cosimo dedicated this statue of a woman both to liberty and to fortitude, so that the citizens might devote themselves with unvanquished and constant heart to defending the republic'). In 1495 this inscription was replaced by EXEMPLVM· SAL(utis)·PVB(licae)·CIVES·POS(uerunt)·MCCCCXCV. On the construction of the convent of San Gallo, see G.C. Romby, in *L'architettura di Lorenzo il Magnifico* 1992, 164–6. The most important contact at this convent was Fra Mariano da Genazzano, a protégé of Lorenzo de' Medici (see Niccolò Valori, *Vita del Magnifico*, ed. Dillon Bussi–Fantoni 1992, 82 ff.). Like Lorenzo Tornabuoni, Fra Mariano was present at the baptism of Piero de' Medici's son (Parenti, *Storia fiorentina*, ed. Matucci 1994–2005, I, 36).

176 On the Tazza Farnese, see Fusco–Corti 2006, 169.

177 For a concise biography of Bernardo del Nero (born in Florence on 23 June 1426), see Arrighi 1990. Bernardo's political career began in 1460. His shop ("bottegha") is mentioned in passing in the diary of Maso degli Albizzi (*Ricordi*, fol. xxxviir, April 1459).

178 Parenti, *Storia fiorentina*, ed. Matucci 1994–2005, II, 96–9.

179 Archival research undertaken by Rab Hatfield has shed light on Giovanni's date of death: see ASFi, CRSGF, 102, Santa Maria Novella, Appendice, 86, *ad datam*. Giovanni's *mortorio* (funeral) is dated 7 April 1497, and his *onoranza* (public tribute) 19 April; cf. Simons 1985, II, 112 note 159 and 176 note 126.

180 On the removal of the Medici arms, see Parenti, *Storia fiorentina*, ed. Matucci 1994–2005, II, 106. For Ficino's letter to Manutius, see BAV, Reg. lat. 2023, fol. 173r, quoted by Stefano Pagliaroli,

in *Sandro Botticelli* 2000, I, 146–7, no. 4.8 ("nec in urbe nec in suburbiis habitare tuto possum … Tres enim furie Florentiam iamdiu miseram assidue vexant, morbus pestilens et fames atque seditio"). Regarding the Florentine government's cries of distress, see ASFi, Consulte e pratiche, registro 63, fols. 52r: "per cagione della peste potersi con grandissima difficultà havere el Consiglio Maggiore" ('there being the greatest difficulty in having the Great Council meet owing to the plague'; 4 July); 69r: "Considerato e' nostri Magnifici et Excelsi Signori in quanti affanni et manifesti pericoli si truova la cictà vostra et le cose del vostro dominio, et potere ogni dì venire in maggiori non faccendo e' rimedii convenienti per la peste, fame, guerra et pocha concordia et amore si vede tra cictadini, che ognuna di queste è per sé potente a dare tribulatione grande alla Republica nostra …" ('Our magnificent and exalted Lords having considered the troubles and patent dangers besetting your city and everything in your dominion, and the continuous risk of worse if appropriate measures are not taken against the plague, famine, war and the scant harmony and love that can be seen among the citizens, each of which is, by itself, capable of causing much harm to our Republic …'; 28 July); cf. *Consulte e pratiche* 2002, 491, 500.

181 Parenti, *Storia fiorentina*, ed. Matucci 1994–2005, II, 117–8.

182 Ibid., 119. On the discovery of the conspiracy and its consequences, see especially Villari 1859–61, II, 39–55, CLXIX–CLXXI and Martines 2006, 175–200.

183 Parenti, *Storia fiorentina*, ed. Matucci 1994–2005, II, 121.

184 ASFi, Carte strozziane, Prima serie, 360, fols. 10r–8v, Terza serie, 41, no. XIII, fols. 1r–3r. For the activities of Nofri Tornabuoni, see Bullard 2008.

185 Parenti, *Storia fiorentina*, ed. Matucci 1994–2005, II, 122–3, esp. 122: "Lorenzo Tornabuoni superbissimo si giudicava, e sendo di danari e parentado caldo, cedere ad alcuno non volea". Guicciardini, *Storie fiorentine*, ed. Lugnani Scarano 1970, 165: "Da altro canto, tutti quegli che si erano pe' tempi passati scoperti inimici de' Medici, eccetti e' Nerli, avendo paura grande della ritornata loro, tutti quegli a chi piaceva el vivere populare e el presente governo, uniti in grandissimo numero volevano tôrre loro la vita. Di questi era fatto capo Francesco Valori el quale, o perché si vedessi battezzato inimico a' Medici, o perché volessi mantenere el consiglio nel quale gli pareva essere capo della città, o come fu poi publica voce, per levarsi dinanzi Bernardo del Nero, uomo che solo era atto a essergli riscontro e a impedire la sua grandezza, vivamente gli perseguitava. E benché avessi dolore della morte di Lorenzo Tornabuoni e volentieri l'avessi voluto salvare, nondimeno considerando che Lorenzo aveva errato quasi più che niuno altro, e che salvando lui, bisognava salvare gli altri, poté tanto più in lui questa passione, che si era risoluto al tutto vederne la fine" ('On the other side, all those who in the past had come out openly as enemies of the Medici—except the Nerli—and greatly feared their return, together with all those who liked the popular government and present way of life, were united in great numbers in wishing to see them executed. Francesco Valori was made the leader of this group, and—either because he was a notorious enemy of the Medici or because he wished to preserve the council in which he thought he ruled the city or, as rumour later had it, because he wanted to get rid of Bernardo del Nero, the only man capable of opposing him and hindering his rise to power—he spoke vigorously against the prisoners. Although he grieved at the death of Lorenzo Tornabuoni and would have been glad to spare him, he nevertheless considered that Lorenzo was more culpable than almost any of the others and that, if he were spared, all the others would have to be spared as well, so his determination was such that he had quite made up his mind to see them dead'). See also Chapter 1.

186 For the characterization of Messer Domenico Bartoli as a 'calm and peaceable man' ("homo pacifico e quieto"), see Parenti, *Storia fiorentina*, ed. Matucci 1994–2005, II, 115.

187 On the legal implications of the trial, see Martines 1968, 442 ff.

188 ASFi, Consulte e pratiche, registro 63, fols. 83r–7v: 84v–5r (21 August); cf. *Consulte e pratiche* 2002, 509–14, esp. 511–2 ("sto tucto stupefacto che sono assai maggior et più pericolosi nimici quelli che sono dentro che quegli di fuori").

189 Pitti, *Istoria fiorentina*, ed. Mauriello 2005, 64–5: "A che effetto, dunche, hanno le Signorie Vostre richiamato qui questi tanti cittadini, questi che, quattro dì sono, tanto liberamente, ad uno ad uno, fecero in publica forma rogare la mente loro, contro di quei macchinatori di novità, suversori della patria, distruttori della libertà? E che altro importa non li levare subitamente dal mondo che richiamare di nuovo publicamente il tiranno? Il quale di già è preparato per ritornare con la forza. Non veggono elleno la disposizione di tanti uomini buoni? Non odono elleno il grido universale, geloso della giustizia e della sua salute? Non scorgono elleno il soprastante pericolo nel differire? Ricordinsi che il popolo di Firenze in questo seggio supremo le ha collocate per guardia e sicurtà sua: in loro ha confidato il gran publico bene; lo quale se le Signorie Vostre, per rispetto di sì perfidi nemici, trascureranno, non manca, non manca, sienne pur certe, chi abbracci prontamente causa tanto giusta, tanto santa, con danno di chiunque ne contrasti!".

190 Guicciardini, *Storie fiorentine*, ed. Lugnani Scarano 1970, 166: "molti, inanimiti, cominciorono a svillaneggiare e minacciare la signoria; fra' quali Carlo Strozzi prese pella veste Piero Guicciardini e minacciollo di gittare a terra dalle finestre" ('many were emboldened to insult and threaten the Signoria; Carlo Strozzi seized Piero Guicciardini by his gown and threatened to throw him out of the window'); Pitti, *Istoria fiorentina*, ed. Mauriello 2005, 65.

191 Parenti, *Storia fiorentina*, ed. Matucci 1994–2005, II, 124: "Solo prima la famiglia de' Pucci e Tornabuoni in favore de' loro prigioni la Signoria a pregare andorono: moveva compassione uno figliolo tenero d'età di Lorenzo Tornabuoni, il quale, bene amaestrato, grazia li conciliava".

192 See Landucci, *Diario*, ed. Del Badia 1883, 157 ("E feciogli morire la notte medesima, che non fu sanza lacrime di me, quando vidi passare a' Tornaquinci, in una bara, quel giovanetto Lorenzo, inanzi dì poco"); see also Parenti's *Storia fiorentina* (ed. Matucci 1994–2005, II, 124) and the *Istorie* by the chronicler Giovanni Cambi, contemporary and namesake of the Cambi involved in the conspiracy (ed. 1785–6, II [XXI], 109: "furono dicapitati l'ottava di S. Maria mez[z]aghosto drento alla porta del Capitano, colla porta ser[r]ata, circha a ore 7. di notte, addì 22 d'aghosto 1497"). On Lorenzo's funeral, see ASFi, Grascia, 190 [5] (1457–1506), fol. 286r (cf. Luchs 1977, 160 note 16).

193 BML, Plut. 41.33, fol. 80v (formerly 75v): "Dello Accolti per la morte di Lorenzo | Tornabuoni | Io che già fu' thesor della natura / con man legate scinto et scalzo vegnio / ad porre el g[i]ovin collo al duro legnio / et ricever vil pagha [paglia] in sepultura. / Pigli exemplo da me chi s'assicura / in potentia mortal, fortuna o regnio, / ché spesso viene al mondo, al cielo ad sdegnio / chi la felicità sua non misura. / Et tu che levi ad me gemme et thesauro, / la consorte, e figl[i]uoli, la vita mesta, / ché più pio troverrei un turco, un mauro, / fammi una gratia almen turba molesta: / ad colei cui tanto amo in piacto d'auro / fa' presentare la mie tagliata testa". The text is included in a codex containing mainly profane poems by Lorenzo the Magnificent and supplied with extremely elegant pen-and-ink drawings in the style of Botticelli (Botticelli himself could not have made the drawings, however, since according to scholars the manuscript was not produced until after 1514: see I.G. Rao, in *Sandro Botticelli* 2000, I, 118–9, no. 3.3). On Bernardo Accolti, see Mantovani 1960; Verde 1973–94, III/1, 180; Ianuale 1993; Mussini Sacchi 1995–6, 232 ff. It is known that he gave Piero de' Medici 200 florins to support his attempts to regain power in Florence.

194 Cambini, ed. Richards 1965, 103–5: "Iuppiter omnipotens ex alto ridet Olympo, / si plus quam satis est quem trepidare videt"; "Difficile insanis nihil est mortalibus usquam / … Vivite securi, dum pia fata sinunt. // Immanes peragunt subito data pensa sorores / et coeptum nulli Parca revolvit opus. // Festinat cursu rapidissima vita citato, / nescia momento frena tenere brevi. // Obvia sed rapidis mortales pectora fatis / sponte ferunt, dirum nec Phlegethonta timent". The manuscript of Cambini's work is preserved in Perugia (Biblioteca Augusta, I 69).

195 Ibid.: "Vertite propositum, rapidae ne occurrite morti"; "magnum est / vita decus, summum vivere posse bonum // … Vivendum recte solo virtutis amore / turpibus eiectis corde cupidinibus"; "Pallida mors aequo passim pede regia pulsat / atria, plebeias ruricolasque domos. // Socraticis debent ornari pectora curis / et sana vitam ducere lege decet. // Ad Styga vel tenebras numquam ruit

inclyta virtus; / alta petens, humili nescia stare loco. // Magnanimi, revocate animos et vivite fortes; / sic vos Lethaeas effugietis aquas // et cum fatalis fulgebit Lucifer horae, / pervigil ad superos gloria pandet iter". The lines are a variation on Horace, *Carmina* 1. 4, 13–4: "Pallida mors aequo pulsat pede pauperum tabernas, / regumque turris …" ('Pale death kicks with impartial foot at the hovels of the poor / and the towers of kings').

Notes to the Epilogue

196 On the banishment of Iacopo Gianfigliazzi, see Landucci, *Diario*, ed. Del Badia 1883, 157.

197 On the Florentine laws regarding underage children, see *Statuta Populi et Communis Florentiae*, ed. 1777–83, I, 206 and Morandini 1955–7. For the inventories of the furnishings, as previously mentioned, see ASFi, Pupilli, filza 181, fols. 141r ff. On Giuliano di Filippo Tornabuoni and his relationship to Giovanni di Francesco, see Simons 1985, I, 137 and Verde 1973–94, III/1, 554–5, 575–7.

198 ASFi, Carte strozziane, Seconda serie, 124, fols. 76v–7v (cf. Simons 1985, I, 135, II, 112 note 163 and Plebani 2002, 231 note 117): "Sunto dello stato della [e]redità di Lorenzo di Giovanni Tornabuoni … | Una gioia impendente 400 | L'offizio del Vescovo di Volterra 1500 | La chasa di Firenze 5000 | La chasa di Neri e di Giovanni suo fratello | e la drieto colla stalla: in tutto chase 3 | 1000 | El Chiasso [Macerelli] co' 3 poderi 4000 | E beni dell'Antella sanza l'obrigho 3000 | Più masserizie 2500 | Gioie e altre frasche 1000 | El Tanino 3000 | Le Brache 3000 | Ragionasi al suo conto la ragione di Lorenzo 4000 | Somma tutto il dare 40.242 …".

199 On the *emancipazione* of Lorenzo's sons, see ASFi, NA, 1924, ins. 1, fols. 280v–7r and 1925, fols. 37v–8r. On the difficult settlement of Lorenzo's confiscated property, see ASFi, Carte strozziane, Prima serie, 360, fols. 10r–8v (resolution of 17 August 1497) and Terza serie, 41, no. XIII, fols. 1r–3r (vernacular copy of a resolution of the Signoria concerning Lorenzo Tornabuoni's creditors, 17 February 1498), 7r–9v (documentation on the creditors) and ASFi, Capitani di Parte Guelfa, Numeri rossi, 79, fols. 95, LXV (1500).

200 Regarding the conveyance effected in November 1542, see ASFi, NA, 16323, fols. 220r ff. The complete furnishings were sold with the house: "Tutte le panche, tavole … chassoni, forzieri di ogni sorte, banche, cornici, cornicioni, un tondo di Nostra Donna nella chamera principale …" (fol. 222r); the last-mentioned work is almost certainly Ghirlandaio's *Adoration of the Magi*. The new owner of the Palazzo Tornabuoni, Lorenzo Ridolfi, was the son of Piero Ridolfi and Contessina de' Medici, the daughter of Lorenzo the Magnificent (cf. Spallanzani 1978). In 1534 the *palazzo* was still in the possession of Leonardo di Lorenzo Tornabuoni: see ASFi, Decima Granducale, 3623, fols. 365v–7v. His son Leonetto ("nobilis vir Leonettus quondam domini Leonardi quondam Laurentii Johannis de Tornabonis civis florentinus") was responsible for selling it. The deed of sale states that in 1542 Ginevra still lived in the house: "In qua ad presens habitat domina Ginevra relicta quondam dicti Laurentii de Tornabonis …".

201 ASFi, CRSGF, 102, Santa Maria Novella, Appendice, 21, fols. 5v (Messer Luigi di Filippo di Filippo pays for "torchi, falchole e candele per lle messe di detto Lorenzo e pel mortorio"—'torches and candles for the masses said for Lorenzo'—on behalf of Lorenzo's heirs on 30 August 1497), 13r and 105v. Cf. Simons 1985, II, 113 note 166, although she mistakenly includes "le messe di sancto Gregorio per Lorenzo Tornabuoni" among the sung masses. For the donations made by Giovannino, see ibid., II, 120 note 206.

202 Landucci, *Diario*, ed. Del Badia 1883, 160–1.

203 Ibid., 178: "e in poche ore furono arsi, in modo che cascava loro le gambe e braccia a poco a poco … e attizzando sopra detti corpi, feciono consumare ogni cosa e ogni reliquia: dipoi feciono venire carrette e portare ad Arno ogni minima polvere, acciò non fussi trovato di loro niente … E non di meno fu chi riprese di quei carboni ch'andavano a galla, tanta fede era in alcuni buone genti; ma molto segretamente e anche con paura …". On the fortunes of Savonarola, see also Martines 2006, 201 ff.

204 Parenti, *Storia fiorentina*, ed. Matucci 1994–2005, II, 163–5.

205 Landucci, *Diario*, ed. Del Badia 1883, 190.

206 Ibid., 265.

207 Machiavelli, *Il Principe*, Chapter XXV ('Quantum fortuna in rebus humanis possit, et quomodo illi sit occurrendum'), ed. Vivanti 1997, 189: "meglio essere impetuoso che respettivo: perché la fortuna è donna ed è necessario, volendola tenere sotto, batterla e urtarla". See also Chapter XVIII ('Quomodo fides a principibus sit servanda'), ibid., 165: "Sendo dunque necessitato uno principe sapere bene usare la bestia, debbe di quelle pigliare la golpe ed il lione: perché el lione non si difende da' lacci, la golpe non si difende da' lupi; bisogna adunque essere golpe a conoscere e' lacci, e lione a sbigottire e' lupi" ('Thus, since a prince is compelled of necessity to know well how to use the beast, he should pick the fox and the lion; because the lion does not defend itself from snares and the fox does not defend itself from wolves; so one needs to be a fox to recognize snares, and a lion to frighten the wolves'). When still a child, in 1479 (see above, note 51), Piero had written to his father: "Strong and brave men are not good at subterfuges but shine in open warfare. Thus we confide in you, as we well know that besides your goodness and valour you bear in mind the heritage left to us by our ancestors, and the injury and outrages we have endured" (*Lives of the Early Medici* 1910, 220).

208 On the consequences of the election of Pope Leo X for the production of art in Florence, see *L'officina della maniera* 1996, 191–236; with regard to the preceding period, see ibid., 71–165. On the construction of the Sala del Gran Consiglio in the Palazzo della Signoria, see Rubinstein 1995, 40–1.

209 On Giovanni's election as Prior (29 October 1519), as one of the Dodici Buonomini (12 December 1520) and again as Prior (29 October 1525), see <http://www.stg.brown.edu/projects/tratte> (see above, note 147). Regarding Giovanni as a diplomat at the papal court, see ASV, A.A. Armadio I, xviii, 2574. Giovanni di Lorenzo Tornabuoni died on 25 March 1532 and his body was interred in Santa Maria Novella: see ASFi, Grascia, 191 [6] (1506–60), fol. 447: "Giovanni Tornabuoni riposto in Santa Maria Novel[l]a morì 25 detto".

Acknowledgements

For their suggestions and help, I am grateful to Stefano U. Baldassarri, Susanna de Beer, Xavier van Binnebeke, Anton Boschloo, Attilio Bottegal, Alison Brown, Wolfger Bulst, Isabelle Chabot, Laura De Angelis, Marieke van den Doel, Tonny Dronkers, Lorenzo Fabbri, Dino Frescobaldi, Edward Grasman, Piero Guicciardini, Wouter Haanegraaff, Rab Hatfield, Jan de Jong, Joost Keizer, Bram Kempers, Michael Kwakkelstein, Janis Chan Marche, Bert Meijer, Paul Nieuwenhuizen, Ludwin Paardekoper, Claudio Paolini, Brenda Preyer, Michael Rocke, Ludovica Sebregondi, Patricia Simons, Jan van der Sman and Linda van der Sman-van Oosten, Guillermo Solana, Marco Spallanzani, Claudia Tripodi.

Bibliographical references

Acidini Luchinat 2001 = Cristina Acidini Luchinat, *Botticelli. Allegorie mitologiche*, Milan, 2001.

Agghàzy 1978 = Maria G. Agghàzy, 'Problemi nuovi relativi a un monumento sepolcrale del Verrocchio', *Acta historiae artium Academiae Scientiarum Hungaricae*, 24 (1978), 159–66.

Alberti, *De pictura*, ed. Grayson 1972 = Leon Battista Alberti [1404–72], *De pictura*, in id., *On Painting and On Sculpture. The Latin Texts of "De pictura" and "De statua"*, edited with translations, introduction and notes by Cecil Grayson, London, 1972; Latin and vernacular texts in id., *Opere volgari. III*, edited by Cecil Grayson, Bari, 1973.

Alberti, *De re aedificatoria*, ed. Orlandi–Portoghesi 1966 = Leon Battista Alberti, *L'architettura (De re aedificatoria)*, Latin text edited and translated into Italian by Giovanni Orlandi, introduction and notes by Paolo Portoghesi, 2 vols., Milan, 1966.

Alighieri, *Convivio*, ed. Busnelli–Vandelli 1954 = Dante Alighieri, *Il Convivio*, edited by Giovanni Busnelli and Giovanni Vandelli, with an introduction by Michele Barbi, 2nd edition, 2 vols., Florence, 1954 (1st edition Florence, 1934); English translation by Richard H. Lansing, New York, 1990.

Ammirato, *Delle famiglie nobili fiorentine*, ed. 1615 = Scipione Ammirato [1531–1601], *Delle famiglie nobili fiorentine*, part I [published posthumously by Scipione Ammirato the Younger], Florence, 1615.

Apollonius of Rhodes, *Argonautica* = Apollonius of Rhodes [3rd century BC], *Argonautica*, critical edition by Hermann Fränkel, Oxford, 1961; English translation by Robert C. Seaton, London–New York, 1912.

L'architettura di Lorenzo 1992 = *L'architettura di Lorenzo il Magnifico*, exhibition catalogue (Florence, Spedale degli Innocenti, 1992), edited by Gabriele Morolli, Cristina Acidini Luchinat, Luciano Marchetti, Cinisello Balsamo, 1992.

Arrighi 1990 = Vanna Arrighi, 'Del Nero, Bernardo', in *Dizionario Biografico degli Italiani*, XXVIII, Rome, 1990, 170–3.

Arrighi 2000 = Vanna Arrighi, 'Gianfigliazzi, Bongianni', in *Dizionario Biografico degli Italiani*, LIV, Rome, 2000, 344–7.

Art and Love 2008 = *Art and Love in Renaissance Italy*, exhibition catalogue (New York, Metropolitan Museum of Art, 2008–9; Fort Worth, Tex., Kimbell Art Museum, 2009), edited by Andrea Bayer, New York, 2008.

Baldassarri 2007 = Stefano U. Baldassarri, 'Amplificazioni retoriche nelle versioni di un best-seller umanistico: il *De nobilitate* di Buonaccorso da Montemagno', *Journal of Italian Translation*, 2/2 (2007), 9–35.

Baldassarri–Saiber 2000 = Stefano U. Baldassarri, Arielle Saiber, 'Introduction', in *Images of Quattrocento Florence. Selected Writings in Literature, History and Art*, edited by Stefano U. Baldassarri and Arielle Saiber, New Haven, Conn., 2000, XVII–XL.

Bargellini 1972 = Piero Bargellini, *I Buonomini di San Martino*, Florence, 1972.

Bartoli 1999 = Roberta Bartoli, *Biagio d'Antonio*, Milan, 1999.

Bartolomeo di Giovanni 2004 = *Bartolomeo di Giovanni, collaboratore di Ghirlandaio e Botticelli/Bartolomeo di Giovanni, Associate of Ghirlandaio and Botticelli*, exhibition catalogue (Florence, Museo di San Marco, 2004), edited by Nicoletta Pons, [Italian/English], Florence, 2004.

Baxandall 1972 = Michael Baxandall, *Painting and Experience in Fifteenth-Century Italy. A Primer in the Social History of Pictorial Style*, Oxford, 1972.

Bertelli 1972 = Sergio Bertelli, 'Machiavelli e la politica estera fiorentina', in *Studies on Machiavelli*, [papers presented at a seminar held at Villa I Tatti in Florence, September 1969)], edited by Myron P. Gilmore, Florence, 1972, 29–72.

Bessi 1992 = Rossella Bessi, 'Lo spettacolo e la scrittura', in *Le Tems revient* 1992, 103–17.

Bocchi 1592 = Francesco Bocchi, *Opera … sopra l'imagine miracolosa della Santissima Nunziata di Fiorenza*, Florence, [Michelangelo Sermartelli], 1592.

Bodar 1991 = Antoine Bodar, 'Aby Warburg en André Jolles, een Florentijnse vriendschap', *Nexus*, 1 (1991), 5–18.

Borsook–Offerhaus 1981 = Eve Borsook, Johannes Offerhaus, *Francesco Sassetti and Ghirlandaio at Santa Trinita, Florence. History and Legend in a Renaissance Chapel*, Doornspijk, 1981.

Boskovits–Brown 2003 = Miklós Boskovits, David Alan Brown, *National Gallery of Art, Washington. Italian Paintings of the Fifteenth Century*, with Robert Echols et al., Washington, 2003.

Brieger–Meiss–Singleton 1969 = Peter H. Brieger, Millard Meiss, Charles S. Singleton, *Illuminated Manuscripts of the Divine Comedy*, 2 vols., Princeton, N.J., 1969.

Brown 1992 = Alison Brown, 'Public and Private Interest: Lorenzo, the Monte and the Seventeen Reformers', in *Lorenzo de' Medici* 1992, 103–65.

Brown 1994 = Alison Brown, 'Lorenzo and Public Opinion in Florence. The Problem of Opposition', in *Lorenzo il Magnifico* 1994, 61–85.

Brown 2002 = Alison Brown, 'Lorenzo de' Medici's New Men and Their Mores. The Changing Lifestyle of Quattrocento Florence', *Renaissance Studies*, 16/2 (2002), 113–42.

Bruni, *Laudatio Florentine urbis* = Leonardo Bruni [1370–1444], *Laudatio Florentine urbis*, vernacular translation by Lazaro da Padova with the title *Panegirico della città di Firenze*, Florence, 1974; critical edition by Stefano U. Baldassarri, Florence, 2000.

Bullard, 'Fortuna' 1994 = Melissa M. Bullard, 'Fortuna della banca medicea a Roma nel tardo Quattrocento', in *Roma capitale (1447-1527)*, proceedings of the IV symposium of the Centro Studi sulla Civiltà del Tardo Medioevo (San Miniato, 27–31 October 1992), edited by Sergio Gensini, Pisa, 1994, 235–51.

Bullard, 'Heroes' 1994 = Melissa M. Bullard, 'Heroes and Their Workshops. Medici Patronage and the Problem of Shared Agency', *The Journal of Medieval and Renaissance Studies*, 24 (1994), 179–98.

Bullard 2008 = Melissa M. Bullard, '"Hammering away at the Pope": Nofri Tornabuoni, Lorenzo de' Medici's Agent and Collaborator in Rome', in *Florence and Beyond. Culture, Society and Politics in Renaissance Italy. Essays in Honour of John M. Najemy*, edited by David S. Peterson, with Daniel E. Bornstein, Toronto, 2008, 383–98.

Burchiello, *Sonetti*, ed. Zaccarello 2004 = Burchiello [Domenico di Giovanni; 1404–49], *I sonetti*, edited by Michelangelo Zaccarello, Turin, 2004.

Burke 2004 = Jill Burke, *Changing Patrons. Social Identity and the Visual Arts in Renaissance Florence*, University Park, Pa., 2004.

Buser 1979 = Benjamin Buser, *Die Beziehungen der Mediceer zu Frankreich während der Jahre 1434-1494 in ihrem Zusammenhang mit den allgemeinen Verhältnissen Italiens*, Leipzig, 1879.

Butterfield 1997 = Andrew Butterfield, *The Sculptures of Andrea del Verrocchio*, New Haven, Conn.–London, 1997.

Butters 1992 = Humfrey Butters, 'Florence, Milan and the Barons' War (1485–1486)', in *Lorenzo de' Medici 1992*, 281–308.

Cadogan 2000 = Jeanne K. Cadogan, *Domenico Ghirlandaio, Artist and Artisan*, New Haven, Conn.–London, 2000.

Caglioti 1995 = Francesco Caglioti, 'Donatello, i Medici e Gentile de' Becchi: un po' d'ordine intorno alla *Giuditta* (e al *David*) di Via Larga. III', *Prospettiva*, no. 80 (1995), 15–58.

Caglioti 2000 = Francesco Caglioti, *Donatello e i Medici. Storia del "David" e della "Giuditta"*, 2 vols., Florence, 2000.

Callmann 1974 = Ellen Callmann, *Apollonio di Giovanni*, Oxford, 1974.

Calvesi 1980 = Maurizio Calvesi, *Il sogno di Polifilo prenestino*, Rome, 1980.

Cambi, *Istorie*, ed. 1785–6 = Giovanni Cambi [1458–1535], *Istorie*, edited and supplemented with ancient documents by Ildefonso di San Luigi, 4 vols., Florence, 1785–6 (*Delizie degli eruditi toscani*, XX–XXIII).

Cambini, ed. Richards 1965 = C. Aurelius Cambinius [? Cambini; 15th century], *Opusculum elegiarum*, in J.F.C. Richards, 'The Poems of C. Aurelius Cambinius', *Studies in the Renaissance*, 12 (1965), 73–109.

Campbell 2007 = Caroline Campbell, 'Lorenzo Tornabuoni's History of Jason and Medea Series. Chivalry and Classicism in 1480s Florence', *Renaissance Studies*, 21 (2007), 1–19.

Capponi 1842 = Gino Capponi, 'Nota al Documento III (Convenzione della Repubblica Fiorentina con Carlo VIII, 25 Novembre 1494', *Archivio storico italiano*, 1 (1842), 348–61 [for the *Capitoli fatti dalla città di Firenze col re Carlo VIII, a dì 25 di Novembre del 1494*, see ibid., 362–75].

Carl 1983 = Doris Carl, 'Documenti inediti su Maso Finiguerra e la sua famiglia', *Annali della Scuola Normale Superiore di Pisa. Classe di Lettere e Filosofia*, 3rd series, 13 (1983), 507–44.

Castellani, *Ricordanze*, ed. Ciappelli 1992–5 = Francesco Castellani [1418–94], *Ricordanze*, edited by Giovanni Ciappelli, 2 vols., Florence, 1992–5.

Cecchi 1990 = Alessandro Cecchi, 'Percorso di Baccio d'Agnolo legnaiuolo e architetto fiorentino. 1. Dagli esordi al Palazzo Borgherini', *Antichità viva*, 29/1 (1990), 31–46.

Cecchi 2005 = Alessandro Cecchi, *Botticelli*, Milan, 2005.

Cesarini Martinelli 1992 = Lucia Cesarini Martinelli, 'Grammatiche greche e bizantine nello scrittoio del Poliziano', in *Dotti bizantini 1992*, 257–90.

Cesarini Martinelli 1996 = Lucia Cesarini Martinelli, 'Poliziano professore allo Studio fiorentino', in *La Toscana 1996*, II, 463–81.

Chambers 1992 = David S. Chambers, *A Renaissance Cardinal and His Wordly Goods. The Will and Inventory of Francesco Gonzaga (1444–1483)*, London, 1992.

Chastel 1959 = André Chastel, *Art et humanisme à Florence au temps de Laurent le Magnifique. Études sur la Renaissance et l'humanisme platonicien*, Paris, 1959.

Christianity and the Renaissance 1990 = *Christianity and the Renaissance. Image and Religious Imagination in the Quattrocento*, edited by Timothy Verdon and John Henderson, Syracuse, N.Y., 1990.

Ciappelli 1995 = Giovanni Ciappelli, *Una famiglia e le sue ricordanze. I Castellani di Firenze nel Tre-Quattrocento*, Florence, [1995].

Ciardi Duprè Dal Poggetto 1977 = Maria Grazia Ciardi Duprè Dal Poggetto, 'Considerazioni su Antonio di Niccolò e su di un offiziolo fiorentino', in *Per Maria Cionini Visani. Scritti di amici*, Turin, 1977, 33–7.

Le collezioni medicee 1999 = *Le collezioni medicee nel 1495. Deliberazioni degli Ufficiali dei ribelli*, edited by Outi Merisalo, Florence, 1999.

Condivi 1553 = Ascanio Condivi, *Vita di Michelagnolo Buonarroti*, Rome, Antonio Blado, 1553; edited by Giovanni Nencioni, with essays by Michael Hirst and Caroline Elam, Florence, 1998.

Consorterie politiche 1992 = *Consorterie politiche e mutamenti istituzionali in età laurenziana*, exhibition catalogue (Florence, Archivio di Stato, 1992), edited by Maria Augusta Morelli Timpanaro, Rosalia Manno Tolu, Paolo Viti, Cinisello Balsamo, 1992.

Consulte e pratiche 2002 = *Consulte e pratiche della Repubblica fiorentina, 1495-1497*, edited by Denis Fachard, Geneva, 2002.

Conti 1882 = Cosimo Conti, 'Découverte de deux fresques de Sandro Botticelli', *L'Art*, 27 (1881), 86–7; 28 (1882), 59–60.

Costa 1972 = Gustavo Costa, *La leggenda dei secoli d'oro nella letteratura italiana*, Bari, 1972.

Dacos 1962 = Nicole Dacos, 'Ghirlandaio et l'antique', *Bulletin de l'Institut Historique Belge de Rome*, 34 (1962), 419–55.

Danti 1990 = Cristina Danti, 'Osservazioni sugli affreschi di Domenico Ghirlandaio nella chiesa di Santa Maria Novella in Firenze. I. Tecnica esecutiva e organizzazione del lavoro', in *Le pitture murali* 1990, 39–52.

Däubler-Hauschke 2003 = Claudia Däubler-Hauschke, *Geburt und Memoria. Zum italienischen Bildtyp der "deschi da parto"*, Munich, 2003.

De Carli 1997 = Cecilia De Carli, *I deschi da parto e la pittura del primo Rinascimento toscano*, Turin, 1997.

De la Mare 1985 = Albinia de la Mare, 'New Research on Humanistic Scribes in Florence', in *Miniatura fiorentina* 1985, I, 393–600.

De la Mare–Fera 1998 = Albinia de la Mare, Vincenzo Fera, 'Un Marziale corretto dal Poliziano', in *Agnolo Poliziano poeta, scrittore, filologo*, proceedings of the international symposium (Montepulciano, 3–6 November 1994), edited by Vincenzo Fera and Mario Martelli, Florence, 1998, 295–321.

De Robertis 1974 = Domenico De Robertis, 'Antonio Manetti copista', in *Tra latino e volgare. Per Carlo Dionisotti*, edited by Gabriella Bernardoni Trezzini et al., 2 vols., Padua, 1974, II, 367–409.

Dei, *Cronica*, ed. Barducci 1985 = Benedetto Dei [1418–92], *La cronica dall'anno 1400 all'anno 1500*, edited by Roberto Barducci, preface by Anthony Molho, Florence, 1985.

Dei, *Memorie* = Benedetto Dei, *Memorie*, MS, Florence, Biblioteca Riccardiana, 1853.

Della Torre 1902 = Arnaldo Della Torre, *Storia dell'Accademia Platonica di Firenze*, Florence, 1902.

Dempsey 1992 = Charles Dempsey, *The Portrayal of Love. Botticelli's "Primavera" and Humanist Culture at the Time of Lorenzo the Magnificent*, Princeton, N.J., 1992.

Denis, *Journal*, ed. 1957 = Maurice Denis [1870–1943], *Journal. I. 1884-1904*, Paris, 1957.

Di Domenico 1997 = Adriana Di Domenico, 'L'offiziolo riconsiderato: Antonio di Niccolò allievo di Bartolomeo Varnucci?', *Rara volumina*, 4/2 (1997), 19–28.

Domenico Ghirlandaio 1996 = *Domenico Ghirlandaio, 1449-1494*, proceedings of the international symposium (Florence, 16–8 October 1994), edited by Wolfram Prinz and Max Seidel, Florence, 1996.

Dotti bizantini 1992 = *Dotti bizantini e libri greci nell'Italia del secolo XV*, proceedings of the international symposium (Trent, 22–3 October 1990), edited by Mariarosa Cortesi and Enrico V. Maltese, Naples, 1992.

Duits 2008 = Rembrandt Duits, *Gold Brocade and Renaissance Painting. A Study in Material Culture*, London, 2008.

Dumon 1977 = Georges Dumon, *Les Albizzi. Histoire et généalogie d'une famille à Florence et en Provence du onzième siècle à nos jours*, [Cassis], 1977.

Elam 1988 = Caroline Elam, 'Art and Diplomacy in Renaissance Florence', *RSA Journal*, 136 (1988), 813–25.

Elam 1989 = Caroline Elam, 'Palazzo Strozzi nel contesto urbano', in *Palazzo Strozzi, metà millennio: 1489-1989*, proceedings of the symposium (Florence, 3–6 July 1989), edited by Daniela Lamberini, Rome, 1989, 183–94.

Enciclopedia dantesca 1984 = *Enciclopedia dantesca*, 2nd revised edition, 6 vols., Rome, 1984.

Ephrussi 1882 = Charles Ephrussi, 'Les deux fresques du Musée du Louvre attribuées à Sandro Botticelli', *Gazette des Beaux-Arts*, 25 (1882), 475–83.

Ettlinger 1965 = Leopold D. Ettlinger, *The Sistine Chapel before Michelangelo: Religious Imagery and Papal Primacy*, Oxford, 1965.

Ettlinger 1976 = Helen S. Ettlinger, 'The Portraits in Botticelli's Villa Lemmi Frescoes', *Mitteilungen des Kunsthistorischen Institutes in Florenz*, 20 (1976), 404–7.

Fabbri 1991 = Lorenzo Fabbri, *Alleanza matrimoniale e patriziato nella Firenze del '400. Studio sulla famiglia Strozzi*, Florence, 1991.

Fabroni 1784 = Angelo Fabroni, *Laurentii Medicis Magnifici vita*, 2 vols., Pisa, 1784.

Fahy 1984 = Everett Fahy, 'The Tornabuoni–Albizzi Panels', in *Scritti di storia dell'arte in onore di Federico Zeri*, edited by Mauro Natale, 2 vols., Milan, 1984, I, 233–47.

Fahy 2008 = Everett Fahy, 'The Marriage Portrait in the Renaissance, or Some Women Named Ginevra', in *Art and Love* 2008, 17–28.

Faivre 1990 = Antoine Faivre, *Toison d'or et alchimie*, Milan, 1990.

Fantuzzi 1992 = Marco Fantuzzi, 'La coscienza del *medium* tipografico negli editori greci di classici dagli esordi della stampa alla morte di Kallierges', in *Dotti bizantini* 1992, 37–60.

The Fifteenth-Century Frescoes 2003 = *The Fifteenth-Century Frescoes in the Sistine Chapel*, texts by Jorge María Mejía et al., edited by Francesco Buranelli and Allen Duston, Vatican City, 2003.

Filarete–Manfidi, ed. Trexler 1978 = Francesco Filarete, Angelo Manfidi, *Ceremonie notate in tempi di F. Filarethe heraldo*, MS, ASFi, Carte di corredo, 10; edited by Richard C. Trexler in *The Libro Cerimoniale of the Florentine Republic*, Geneva, 1978.

Firenze e il Concilio 1994 = *Firenze e il Concilio del 1439*, [proceedings of the symposium (Florence, 29 November–2 December 1989)], edited by Paolo Viti, 2 vols., Florence, 1994.

Fité i Llevot 1993 = Francesc Fité i Llevot, 'Jàson i Medea, un cicle iconogràfic de la llegenda troiana a l'arqueta de Sant Sever de la Catedral de Barcelona', *D'Art*, no. 19 (1993), 169–86.

Flaten 2003 = Arne Robert Flaten, 'Portrait Medals and Assembly-Line Art in Late Quattrocento Florence', in *The Art Market in Italy, 15th–17th Centuries*, edited by Marcello Fantoni, Louisa C. Matthew, Sara F. Matthews-Grieco, Modena, 2003, 127–39.

Forlani 1960 = Anna Forlani, 'Agolanti, Alessandro (Sandro)', in *Dizionario Biografico degli Italiani*, I, Rome, 1960, 452–3.

Fusco–Corti 2006 = Laurie S. Fusco, Gino Corti, *Lorenzo de' Medici, Collector and Antiquarian*, Cambridge, 2006.

A. Gaddi–F. Gaddi, *Priorista*, ed. 1853 = *Sulla cacciata di Piero de' Medici, e la venuta di Carlo VIII in Firenze*, excerpt from the *Priorista* by Agnolo Gaddi and Francesco Gaddi, *Archivio storico italiano*, 4 (1853) [*Vite di illustri italiani inedite o rare*, II], 41–9.

Galleni 1998 = Rodolfo Galleni, 'Riflessi dell'opera di Michelozzo nell'architettura civile fiorentina della seconda metà del Cinquecento', in *Michelozzo scultore e architetto (1369-1472)*, proceedings of the symposium (Florence, 2–5 October 1996), edited by Gabriele Morolli, Florence, 1998, 315–23.

Geiger 1996 = Gail L. Geiger, *Filippino Lippi's Carafa Chapel. Renaissance Art in Rome*, Kirksville, Mo., 1996.

Gilbert 1957 = Felix Gilbert, 'Florentine Political Assumptions in the Period of Savonarola and Soderini', *Journal of the Warburg and Courtauld Institutes*, 20 (1957), 187–214.

Gilbert 1965 = Felix Gilbert, *Machiavelli and Guicciardini. Politics and History in Early Sixteenth-Century Florence*, Princeton, N.J., 1965.

Gilbert 1977 = Creighton E. Gilbert, 'Peintres et menuisiers au début de la Renaissance en Italie', *Revue de l'art*, 37 (1977), 9–28.

Gilbert 1994 = Creighton E. Gilbert, 'A New Sight in 1500: The Colossal', in *Art and Pageantry in the Renaissance and Baroque*, edited by Barbara Wisch and Susan Scott Munshower, 2 vols., University Park, Pa., 1990, II, *Theatrical Spectacle and Spectacular Theatre*, 396–415; repr. in id., *Michelangelo: On and Off the Sistine Ceiling*, New York, 1994, 227–51.

Goldthwaite 1968 = Richard A. Goldthwaite, *Private Wealth in Renaissance Florence. A Study of Four Families*, Princeton, N.J., 1968.

Gombrich 1945 = Ernst H. Gombrich, 'Botticelli's Mythologies. A Study in the Neoplatonic Symbolism of His Circle', *Journal of the Warburg and Courtauld Institutes*, 8 (1945), 7–60; repr. in id., *Symbolic Images. Studies in the Art of the Renaissance*, London, 1972, 31–78.

Grendler 1989 = Paul F. Grendler, *Schooling in Renaissance Italy. Literacy and Learning, 1300–1600*, Baltimore, Md.–London, 1989.

Grote 1975 = Andreas Grote, 'La formazione e le vicende del tesoro mediceo nel Quattrocento', in *Il tesoro di Lorenzo il Magnifico, II. I vasi*, edited by Detlef Heikamp, essays and documents edited by Andreas Grote, Florence, 1975, 1–22.

Guasti 1902 = Gaetano Guasti, *Di Cafaggiolo e d'altre fabbriche di ceramiche in Toscana*, based on studies and documents partly collected by Gaetano Milanesi, Florence, 1902.

Guicciardini, *Storie fiorentine*, ed. Lugnani Scarano 1970 = Francesco Guicciardini [1483–1540], *Opere. I. Storie fiorentine*; *Dialogo del reggimento di Firenze*; *Ricordi e altri scritti*, edited by Emanuella Lugnani Scarano, Turin, 1970; English translation by John Rigby Hale in id., *History of Italy and History of Florence*, New York, 1965.

Guidi Bruscoli 1997 = Francesco Guidi Bruscoli, 'Politica matrimoniale e matrimoni politici nella Firenze di Lorenzo de' Medici. Uno studio del ms. Notarile Antecosimiano 14099', *Archivio storico italiano*, 155 (1997), 347–98.

Gurrieri 1992 = Francesco Gurrieri, *Il Palazzo Tornabuoni Corsi, sede a Firenze della Banca Commerciale Italiana*, Florence, 1992.

Hagopian van Buren 1979 = Anne Hagopian van Buren, 'The Model Roll of the Golden Fleece', *The Art Bulletin*, 61 (1979), 359–76.

Hall 1990 = Marcia B. Hall, 'Savonarola's Preaching and the Patronage of Art', in *Christianity and the Renaissance* 1990, 493–522.

Hallock 1972 = Ann H. Hallock, 'Dante's *Selva Oscura* and Other Obscure "Selvas"', *Forum Italicum*, 4 (1972), 57–78.

Hatfield 1970 = Rab Hatfield, 'The "Compagnia dei Magi"', *Journal of the Warburg and Courtauld Institutes*, 33 (1970), 107–61.

Hatfield 1976 = Rab Hatfield, *Botticelli's Uffizi "Adoration". A Study in Pictorial Content*, Princeton, N.J., 1976.

Hatfield 1996 = Rab Hatfield, 'Giovanni Tornabuoni, i fratelli Ghirlandaio e la cappella maggiore di Santa Maria Novella', in *Domenico Ghirlandaio* 1996, 112–7.

Hatfield 2002 = Rab Hatfield, *The Wealth of Michelangelo*, Rome, 2002.

Hatfield 2004 = Rab Hatfield, 'The Funding of the Façade of Santa Maria Novella', *Journal of the Warburg and Courtauld Institutes*, 67 (2004), 81–127.

Hatfield 2009 = Rab Hatfield, 'Some Misidentifications in and of Works by Botticelli', in *Sandro Botticelli and Herbert Horne. New Research*, [papers presented at a conference held in Florence in 2008], edited by Rab Hatfield, Florence, 2009, 7–61.

Helas 1999 = Philine Helas, *Lebende Bilder in der italienischen Festkultur des 15. Jahrhunderts*, Berlin, 1999.

Hendy 1964 = Philip Hendy, *Some Italian Renaissance Pictures in the Thyssen-Bornemisza Collection*, [German/English], Lugano–Castagnola, 1964.

Herlihy–Klapisch-Zuber 1978 = David Herlihy, Christiane Klapisch-Zuber, *Les Toscans et leurs familles. Une étude du catasto florentin de 1427*, Paris, 1978; abridged English translation, New Haven, Conn., 1985.

Hessert 1991 = Marlis von Hessert, *Zum Bedeutungswandel der Herkules-Figur in Florenz von den Anfängen der Republik bis zum Prinzipat Cosimos I.*, Köln, 1991.

Hicks 1996 = David L. Hicks, 'The Sienese Oligarchy and the Rise of Pandolfo Petrucci, 1487–97', in *La Toscana* 1996, III, 1051–72.

Hill 1930 = George Francis Hill, *A Corpus of Italian Medals of the Renaissance before Cellini*, 2 vols., London, 1930.

Holst 1969 = Christian von Holst, 'Domenico Ghirlandaio: l'altare maggiore di Santa Maria Novella a Firenze ricostruito', *Antichità viva*, 8/3 (1969), 36–41.

Hope 1990 = Charles Hope, 'Altarpieces and the Requirements of Patrons', in *Christianity and the Renaissance* 1990, 535–71.

Horne 1908 = Herbert P. Horne, *Alessandro Filipepi, Commonly Called Sandro Botticelli, Painter of Florence*, London, 1908.

Howe 2005 = Eunice D. Howe, *Art and Culture at the Sistine Court. Platina's "Life of Sixtus IV" and the Frescoes of the Hospital of Santo Spirito*, Vatican City, 2005.

Huizinga 1916 = Johan Huizinga, *De kunst der Van Eyck's in het leven van hun tijd* [1916], in id., *Verzamelde werken*, 9 vols., Haarlem, 1948–54, III, *Cultuurgeschiedenis I*, 436–82.

Huizinga 1919 = Johan Huizinga, *Herfsttij der Middeleeuwen. Studie over levens- en gedachtenvormen der veertiende en vijftiende eeuw in Frankrijk en de Nederlanden*, Haarlem, 1919; English translation by Rodney J. Payton and Ulrich Mammitzsch with the title *The Autumn of the Middle Ages*, Chicago, Ill., 1996.

Ianuale 1993 = Raffaella Ianuale, 'Per l'edizione delle *Rime* di Bernardo Accolti detto l'Unico aretino', *Filologia e critica*, 18 (1993), 153–74.

Immagini e azione riformatrice 1985 = *Immagini e azione riformatrice. Le xilografie degli incunaboli savonaroliani nella Biblioteca Nazionale di Firenze*, exhibition catalogue (Florence, Biblioteca Nazionale Centrale di Firenze, 1985), edited by Elisabetta Turelli, essays by Timothy Verdon, Maria Grazia Ciardi Duprè Dal Poggetto and Piero Scapecchi, Florence, 1985.

In the Light of Apollo 2003 = *In the Light of Apollo. Italian Renaissance and Greece*, exhibition catalogue (Athens, National Gallery–Alexandros Soutzos Museum, 2003–4), edited by Mina Gregori, 2 vols., Cinisello Balsamo, 2003.

Kecks 2000 = Ronald G. Kecks, *Domenico Ghirlandaio und die Malerei der Florentiner Renaissance*, Munich–Berlin, 2000.

Kempers 1987 = Bram Kempers, *Kunst, macht en mecenaat. Het beroep van schilder in sociale verhoudingen, 1250-1600*, Amsterdam, 1987; English translation by Beverley Jackson with the title *Painting, Power and Patronage. The Rise of the Professional Artist in the Italian Renaissance*, Harmondsworth, 1988.

Kent, *Household* 1977 = Francis W. Kent, *Household and Lineage in Renaissance Florence. The Family Life of the Capponi, Ginori, and Rucellai*, Princeton, N.J., 1977.

Kent, 'Più superba' 1977 = Francis W. Kent, '"Più superba de quella de Lorenzo": Courtly and Family Interest in the Building of Filippo Strozzi's Palace', *Renaissance Quarterly*, 30 (1977), 311–23.

Kent 1978 = Dale V. Kent, *The Rise of the Medici: Faction in Florence, 1426–1434*, Oxford–New York, 1978.

Kent 1994 = Francis W. Kent, '"Lorenzo ..., amico degli uomini da bene". Lorenzo de' Medici and Oligarchy', in *Lorenzo il Magnifico* 1994, 43–60.

Kent 2000 = Dale V. Kent, *Cosimo de' Medici and the Florentine Renaissance: The Patron's Oeuvre*, New Haven, Conn.–London, 2000.

Kent 2001 = Dale V. Kent, 'Women in Renaissance Florence', in *Virtue and Beauty* 2001, 25–48.

Kirshner–Molho 1978 = Julie Kirshner, Anthony Molho, 'The Dowry Fund and the Marriage Market in Early Quattrocento Florence', *Journal of Modern History*, 50 (1978), 403–38.

Klapisch-Zuber 1979 = Christiane Klapisch-Zuber, 'Zacharie, ou le père évincé. Les rites nuptiaux toscans entre Giotto et le concile de Trente', *Annales. Économies, Sociétés, Civilisations*, 34 (1979), 1216–43; English translation in Klapisch-Zuber 1985, 178–212.

Klapisch-Zuber 1982 = Christiane Klapisch-Zuber, 'Le complexe de Griselda. Dot et dons de mariage au Quattrocento', *Mélanges de l'École française de Rome. Moyen Âge-Temps Modernes*, 96 (1982), 7–43; repr. in id., *La maison et le nom. Stratégies et rituels dans l'Italie de la Renaissance*, Paris, 1990, 185–213; English translation in Klapisch-Zuber 1985, 213–46.

Klapisch-Zuber 1984 = Christiane Klapisch-Zuber, 'Le "zane" della sposa. La donna fiorentina e il suo corredo nel Rinascimento', *Memoria. Rivista di storia delle donne*, nos. 10–1 (1984), 12–23; repr. in id., *La famiglia e le donne nel Rinascimento a Firenze*, Italian translation by Ezio Pellizer, Rome–Bari, 1988.

Klapisch-Zuber 1985 = Christiane Klapisch-Zuber, *Women, Family, and Ritual in Renaissance Italy*, Chicago, Ill., 1985.

Körner 2006 = Hans Körner, *Botticelli*, Köln, 2006.

Kress 2003 = Susanne Kress, 'Die "camera di Lorenzo, bella" im Palazzo Tornabuoni. Rekonstruktion und Künstlerische Ausstattung eines Florentiner Hochzeitszimmers des späten Quattrocento', in *Domenico Ghirlandaio. Künstlerische Konstruktion von Identität im Florenz der Renaissance*, edited by Michael Rohlmann, Weimar, 2003, 245–85.

Kreuer 1998 = Werner Kreuer, *Veduta della Catena. Fiorenza/Die Grosse Ansicht von Florenz: Essener Bearbeitung der Grossen Ansicht von Florenz des Berliner Kupferstichkabinetts "Der Kettenplan"*, with an essay by Hein-Th. Schulze Altcappenberg, [German/Italian], Italian translation by Maurizio Costanzo, Berlin, 1998.

Kuehn 1982 = Thomas Kuehn, *Emancipation in Late Medieval Florence*, New Brunswick, N.J., 1982.

Landino 1481 = Cristoforo Landino, *Comento sopra la Comedia di Danthe Alighieri poeta fiorentino*, Florence, Niccolò di Lorenzo della Magna, 1481.

Landucci, *Diario*, ed. Del Badia 1883 = Luca Landucci, *Diario fiorentino dal 1450 al 1516 …, continuato da un anonimo fino al 1542*, edited by Iodoco del Badia based on the MSS at Siena's Biblioteca Comunale and Florence's Biblioteca Marucelliana, Florence, 1883.

Lapini, *Diario*, ed. Corazzini 1900 = Agostino Lapini, *Diario fiorentino dal 252 al 1596*, edited by Giuseppe Odoardo Corazzini, Florence, 1900.

Lavin 1970 = Irving Lavin, 'On the Sources and Meaning of the Renaissance Portrait Bust', *Art Quarterly*, 33 (1970), 207–26.

Lee 1887 = Vernon Lee [Violet Paget], 'Botticelli at the Villa Lemmi', *The Cornhill Magazine*, 46 (1882), 159–73; repr. in id., *Juvenilia*, being a second series of essays on sundry æsthetical questions, 2 vols., London, 1887, I, 77–129.

Leroquais 1927 = Victor Leroquais, *Les Livres d'heures manuscrits de la Bibliothèque nationale*, 3 vols., Paris, 1927.

Levi D'Ancona 1977 = Mirella Levi D'Ancona, *The Garden of the Renaissance. Botanical Symbolism in Italian Painting*, Florence, 1977.

Lewine 1993 = Carol F. Lewine, *The Sistine Chapel Walls and the Roman Liturgy*, University Park, Pa., 1993.

Il libro di Giuliano da Sangallo, ed. 1910 = *Il libro di Giuliano da Sangallo. Codice Vaticano Barberiniano Latino 4424*, with an introduction and notes by Christian Hülsen, 2 vols., Leipzig [then Turin] 1910; facs. reprint Vatican City, 1984.

Lightbown 1978 = Ronald W. Lightbown, *Sandro Botticelli*, 2 vols., London, 1978.

Lillie 2005 = Amanda Lillie, *Florentine Villas in the Fifteenth Century. An Architectural and Social History*, Cambridge, 2005.

Lindow 2007 = James R. Lindow, *The Renaissance Palace in Florence. Magnificence and Splendour in Fifteenth-Century Italy*, Aldershot–Burlington, Vt., 2007.

Liscia Bemporad 1980 = Dora Liscia Bemporad, 'Appunti sulla bottega orafa di Antonio del Pollaiolo e di alcuni suoi allievi', *Antichità viva*, 19/3 (1980), 47–53.

Liscia Bemporad 1992–3 = *Argenti fiorentini dal XV al XIX secolo. Tipologie e marchi*, edited by Dora Liscia Bemporad, 3 vols., Florence, 1992–3.

Litta 1879 = Pompeo Litta, *Famiglie celebri in Italia*, issue 180, Milan, 1879.

Lives of the Early Medici 1910 = *Lives of the Early Medici as Told in Their Correspondence*, translated and edited by Janet Ross, London, 1910.

Loosen-Loerakker 2008 = Anna Maria van Loosen-Loerakker, *De Koorkapel in de Santa Maria Novella te Florence*, n.p., 2008.

Lorenzo de' Medici, *Lettere*, ed. Butters 2002 = Lorenzo de' Medici [1449–92], *Lettere. IX. 1485-1486*, edited by Humfrey Butters, Florence, 2002.

Lorenzo de' Medici, *Opere*, ed. Zanato 1992 = Lorenzo de' Medici, *Opere*, edited by Tiziano Zanato, Turin, 1992.

Lorenzo de' Medici 1992 = *Lorenzo de' Medici. Studi*, edited by Gian Carlo Garfagnini, Florence, 1992.

Lorenzo il Magnifico 1994 = *Lorenzo il Magnifico e il suo mondo*, proceedings of the international symposium (Florence, 9–13 June 1992), edited by Gian Carlo Garfagnini, Florence, 1994.

Luchs 1977 = Alison Luchs, *Cestello. A Cistercian Church of the Florentine Renaissance*, New York–London, 1977.

Lydecker 1987 = John Kent Lydecker, *The Domestic Setting of the Arts in Renaissance Florence*, Ph.D. Diss., Baltimore, Md., Johns Hopkins University, 1987.

Machiavelli, *Il principe*, ed. Vivanti 1997 = Niccolò Machiavelli [1469–1527], *Il principe*, in id., *Opere*, edited by Corrado Vivanti, 3 vols., Turin 1997, I, 115–92; English translation by Peter Bondanella, with an introduction by Maurizio Viroli, Oxford–New York, 2005.

Macinghi Strozzi, *Lettere*, ed. 1987 = Alessandra Macinghi Strozzi [1407–71], *Tempo di affetti e di mercanti. Lettere ai figli esuli*, Milan, 1987.

Maier 1965 = Ida Maier, *Les manuscrits d'Ange Politien. Catalogue descriptif*, Geneva, 1965.

Mallett 1967 = Michael E. Mallett, *The Florentine Galleys in the Fifteenth Century*, with the *Diary of Luca di Maso degli Albizzi, Captain of the Galleys, 1429–1430*, Oxford, 1967.

I manoscritti miniati 2005 = *Accademia delle Scienze di Torino. I manoscritti miniati*, catalogue edited by Chiara Clemente, Florence, 2005.

Mantovani 1960 = Lilia Mantovani, 'Accolti, Bernardo, detto l'Unico Aretino', in *Dizionario Biografico degli Italiani*, I, Rome, 1960, 103–4.

Manuscrits à peintures 1968 = *Manuscrits à peintures, XIII*, *XIV*, *XV*, *XVI*, *siècles*, auction catalogue (Paris, Palais Galliera, 24 June 1968), Paris, 1968.

Martelli 1978 = Mario Martelli, 'Il *Libro delle Epistole* di Angelo Poliziano', *Interpres*, 1 (1978), 184–255.

Martin 1996 = Frank Martin, 'Domenico del Ghirlandaio *delineavit*? Osservazioni sulle vetrate della Cappella Tornabuoni', in *Domenico Ghirlandaio* 1996, 118–40.

Martines 1968 = Lauro Martines, *Lawyers and Statecraft in Renaissance Florence*, Princeton, N.J., 1968.

Martines 2003 = Lauro Martines, *April Blood. Florence and the Plot against the Medici*, London–New York, 2003.

Martines 2006 = Lauro Martines, *Fire in the City. Savonarola and the Struggle for the Soul of Renaissance Florence*, Oxford–New York, 2006.

Melli 1995 = Lorenza Melli, *Maso Finiguerra. I disegni*, Florence, 1995.

Mesnil 1938 = Jacques Mesnil, *Botticelli*, Paris, 1938.

Michalsky 2005 = Tanja Michalsky, 'CONIVGES IN VITA CONCORDISSIMOS NE MORS QVIDEM IPSA DIS-IVNXIT. Zur Rolle der Frau im genealogischen System neapolitanischer Sepulkralplastik', *Marburger Jahrbuch für Kunstwissenschaft*, 32 (2005), 73–91.

Mini 1593 = Paolo Mini, *Discorso della nobiltà di Firenze, e de' fiorentini*, Florence, Domenico Manzani, 1593.

Miniatura fiorentina 1985 = *Miniatura fiorentina del Rinascimento, 1440-1525. Un primo censimento*, edited by Annarosa Garzelli, 2 vols., Florence, 1985.

Mirimonde 1984 = Albert P. de Mirimonde, *Le Langage secret de certains tableaux du Musée du Louvre*, Paris, 1984.

Molho 1986 = Anthony Molho, 'Investimenti nel Monte delle doti di Firenze. Un'analisi sociale e geografica', *Quaderni storici*, 21 (1986), 147–70.

Molho 1994 = Anthony Molho, *Marriage Alliance in Late Medieval Florence*, Cambridge, Mass., 1994.

Morachiello 1995 = Paolo Morachiello, *Beato Angelico. Gli affreschi di San Marco*, Milan, 1995.

Morandini 1957 = Francesca Morandini, 'Statuti e Ordinamenti dell'Ufficio dei Pupilli et Adulti nel periodo della Repubblica Fiorentina (1388-1534)', *Archivio storico italiano*, 113 (1955), 522–51; 114 (1956), 92–117; 115 (1957), 87–104.

Morselli–Corti 1982 = Piero Morselli, Gino Corti, *La chiesa di Santa Maria delle Carceri di Prato. Contributo di Lorenzo de' Medici e Giuliano da Sangallo alla progettazione*, Prato–Florence, 1982.

Musacchio 1999 = Jacqueline Marie Musacchio, *The Art and Ritual of Childbirth in Renaissance Italy*, New Haven, Conn.–London, 1999.

Musacchio 2000 = Jacqueline Marie Musacchio, 'The Madonna and Child, a Host of Saints, and Domestic Devotion in Renaissance Florence', in *Revaluing Renaissance Art*, edited by Gabriele Neher and Rupert Shepherd, Aldershot–Brookfield, Vt., 2000, 147–64.

Musacchio 2008 = Jacqueline Marie Musacchio, *Art, Marriage, and Family in the Florentine Renaissance Palace*, New Haven, Conn.–London, 2008.

Mussini Sacchi 1995–6 = Maria Pia Mussini Sacchi, 'Le ottave epigrammatiche di Bernardo Accolti nel ms. Rossiano 680. Per la storia dell'epigramma in volgare tra Quattro e Cinquecento', *Interpres*, 15 (1995–6), 219–301.

Naldi, *Bucolica* …, ed. Grant 1994 = Naldo Naldi [1436–1513], *Bucolica, Volaterrais, Hastiludium, Carmina varia*, edited by W. Leonard Grant, Florence, 1994.

Naldi, *Elegum carmen* = Naldo Naldi, *Elegum carmen ad eruditissimum Petrum Medicem Laurentii filium*, n.p., n.d. [1487?].

Naldi 1487 = Naldo Naldi, *Nuptiae domini Hannibalis Bentivoli*, Florence, Francesco di Dino, after 1 July 1487.

Necrologi 1908–14 = *Necrologi e libri affini della Provincia romana*, edited by Paolo Egidi, 3 vols., Rome, 1908–14.

Nicholas of Cusa, *De venatione sapientiae*, ed. Klibansky–Senger 1982 = Nicolai de Cusa *De venatione sapientiae* …, in id., *Opera omnia. XII*, edited by Raymond Klibansky and Hans Gerhard Senger, Hamburg, 1982.

Nicolaus Cusanus 2002 = *Nicolaus Cusanus zwischen Deutschland und Italien. Beiträge eines deutsch-italienischen Symposiums in der Villa Vigoni*, proceedings of the symposium (Loveno di Menaggio, 28 March–1 April 2001), edited by Martin Thurner, Berlin, 2002.

Nuttall 2004 = Paula Nuttall, *From Flanders to Florence. The Impact of Netherlandish Painting, 1400–1500*, New Haven, Conn.–London, 2004.

Olsen 1992 = Christina Olsen, 'Gross Expenditure: Botticelli's Nastagio degli Onesti Panels', *Art History*, 15/2 (1992), 146–70.

Olson 2000 = Roberta J.M. Olson, *The Florentine Tondo*, Oxford, 2000.

L'oreficeria 1977 = *L'oreficeria nella Firenze del Quattrocento*, exhibition catalogue (Florence, Santa Maria Novella, 1977), Florence, 1977.

Orsi Landini–Westerman Bulgarella 2001 = Roberta Orsi Landini, Mary Westerman Bulgarella, 'Costume in Fifteenth-Century Florentine Portraits of Women', in *Virtue and Beauty* 2001, 89–98.

Os 1994 = Henk van Os, *Gebed in schoonheid. Schatten van privé-devotie in Europa, 1300-1500*, exhibition catalogue (Amsterdam, Rijksmuseum, 1994–5), in collaboration with Eugène Honée, Hans Nieuwdorp, Bernhard Ridderbos, Amsterdam–London, 1994.

W. Paatz–E. Paatz 1940–54 = Walter Paatz, Elisabeth Paatz, *Die Kirchen von Florenz. Ein kunstgeschichtliches Handbuch*, 6 vols., Frankfurt am Main, 1940–54.

Il Palazzo Medici Riccardi 1990 = *Il Palazzo Medici Riccardi di Firenze*, a cura di Giovanni Cherubini e Giovanni Fanelli, Florence, 1990.

Pampaloni 1957 = Guido Pampaloni, 'I ricordi segreti del mediceo Francesco di Agostino Cegia (1495-1497)', *Archivio storico italiano*, 115 (1957), 188–234.

Pampaloni 1968 = Guido Pampaloni, 'I Tornaquinci, poi Tornabuoni, fino ai primi del Cinquecento', *Archivio storico italiano*, 126 (1968), 331–62.

Panofsky 1939 = Erwin Panofsky, *Studies in Iconology. Humanistic Themes in the Art of the Renaissance*, New York, 1939.

Parenti, *Lettere*, ed. Marrese 1996 = Marco Parenti [1421–97], *Lettere*, edited by Maria Marrese, Florence 1996.

Parenti, *Storia fiorentina*, ed. Matucci 1994–2005 = Piero Parenti [1450–1519], *Storia fiorentina*, edited by Andrea Matucci, 2 vols., Florence, 1994–2005.

Passavant 1969 = Günter Passavant, *Verrocchio. Skulpturen, Gemälde und Zeichnungen*, London, 1969; English translation by Katherine Watson, London, 1969.

Pastor 1886–1933 = Ludwig von Pastor, *Geschichte der Päpste seit dem Ausgang des Mittelalters*, 16 vols. in 21, Freiburg im Breisgau 1886–1933; English translation, 40 vols., London, 1938–68.

Patetta 1917–8 = Federico Patetta, 'Una raccolta manoscritta di versi e prose in morte d'Albiera degli Albizzi', *Atti della R. Accademia delle Scienze di Torino*, 53 (1917–8), 290–4, 310–8.

Patrons and Artists 1970 = *Patrons and Artists in the Italian Renaissance*, [edited by] David S. Chambers, London, 1970.

Pernis–Adams 2006 = Maria Grazia Pernis, Laurie Schneider Adams, *Lucrezia Tornabuoni de' Medici and the Medici Family in the Fifteenth Century*, New York, 2006.

Picotti 1955 = Giovanni Battista Picotti, *Ricerche umanistiche*, Florence, 1955.

Pinelli 1996 = Antonio Pinelli, 'Gli apparati festivi di Lorenzo il Magnifico', in *La Toscana* 1996, I, 219–34.

Pisani 1923 = Maria Pisani, *Un avventuriero del Quattrocento. La vita e le opere di Benedetto Dei*, Genoa, 1923.

Pitti, *Istoria fiorentina*, ed. Mauriello 2005 = Iacopo Pitti [1519–89], *Istoria fiorentina*, [MS, Florence, BNCF, Magl. XXV.349], edited by Adriana Mauriello, Naples, 2005.

Pittura di luce 1990 = *Pittura di luce. Giovanni di Francesco e l'arte fiorentina di metà Quattrocento*, exhibition catalogue (Florence, Casa Buonarroti, 1990), edited by Luciano Bellosi, Milan, 1990.

Le pitture murali 1990 = *Le pitture murali. Tecniche, problemi, conservazione*, a cura di Cristina Danti, Mauro Matteini, Arcangelo Moles, Florence, 1990.

Plebani 2002 = Eleonora Plebani, *I Tornabuoni. Una famiglia fiorentina alla fine del Medioevo*, Milan, 2002.

Politian, ed. Bausi 2003 = Politian [Angelo Poliziano; 1454–94], *Due poemetti latini. Elegia a Bartolomeo Fonzio. Epicedio di Albiera degli Albizi*, edited by Francesco Bausi, Rome, 2003.

Politian, ed. Del Lungo 1867 = Politian, *Prose volgari inedite e poesie latine e greche edite ed inedite*, edited by Isidoro Del Lungo, Florence, 1867.

Pons 1989 = Nicoletta Pons, *Botticelli. Catalogo completo*, Milan, 1989.

Pope-Hennessy 1966 = John Pope-Hennessy, *The Portrait in the Renaissance*, London, 1966.

Preyer 2004 = Brenda Preyer, 'Around and in the Gianfigliazzi Palace in Florence: Developments on Lungarno Corsini in the 15th and 16th Centuries', *Mitteilungen des Kunsthistorischen Institutes in Florenz*, 48 (2004), 55–104.

Preyer 2006 = Brenda Preyer, 'The Florentine *Casa*', in *At Home in Renaissance Italy*, exhibition catalogue (London, Victoria and Albert Museum, 2006–7), edited by Marta Ajmar-Wollheim and Flora Dennis, London, 2006, 34–49.

Protocolli del carteggio di Lorenzo 1956 = *Protocolli del carteggio di Lorenzo il Magnifico per gli anni 1473-74, 1477-92*, edited by Marcello Del Piazzo, Florence, 1956.

Pulchritudo, Amor, Voluptas 2001 = *Pulchritudo, Amor, Voluptas. Pico della Mirandola alla corte del Magnifico*, exhibition catalogue (Mirandola, Centro culturale polivalente, 2001–2), edited by Mario Scalini, Florence, 2001.

Rado 1926 = Antonio Rado, *Dalla Repubblica fiorentina alla Signoria medicea. Maso degli Albizi e il partito oligarchico in Firenze dal 1382 al 1393*, Florence, 1926.

Redditi, *Exhortatio*, ed. Viti 1989 = Filippo Redditi, *Exhortatio ad Petrum Medicem*, with an appendix of letters, introduction, critical edition and commentary by Paolo Viti, Florence, 1989.

Regnicoli 2005 = Laura Regnicoli, 'Tre *Libri d'ore* a confronto', in *Il Libro d'ore di Lorenzo de' Medici*, companion volume to the facs. reproduction of the MS, edited by Franca Arduini, Modena, 2005, 183–223.

Renaissance Faces 2008 = Lorne Campbell et al., *Renaissance Faces. Van Eyck to Titian*, exhibition catalogue (London, National Gallery, 2008–9), with contributions by Philip Atwood et al., London, 2008.

Renaissance Painting in Manuscripts 1983 = *Renaissance Painting in Manuscripts. Treasures from the British Library*, edited by Thomas Kren, catalogue and essays by Janet Backhouse et al., with an introduction by Derek H. Turner, New York, 1983.

El retrato del Renacimiento 2008 = *El retrato del Renacimiento*, exhibition catalogue (Madrid, Museo Nacional del Prado, 2008; London, National Gallery, 2008–9 [see also *Renaissance Faces* 2008]), edited by Miguel Falomir, Madrid, 2008.

Rhodes 1988 = Dennis E. Rhodes, *Gli annali tipografici fiorentini del XV secolo*, Florence, 1988.

Richa 1754–62 = Giuseppe Richa, *Notizie istoriche delle chiese fiorentine, divise ne' suoi quartieri*, 10 vols., Florence, 1754–62.

Ridolfi 1981 = Roberto Ridolfi, *Vita di Girolamo Savonarola*, 6th revised edition, Florence, 1981 (1st edition in 2 vols., Rome, 1952; abridged English translation [documents are omitted] by Cecil Grayson, New York, 1959).

Rinuccini, *Ricordi storici*, ed. Aiazzi 1840 = Filippo Rinuccini [1392–1462], *Ricordi storici ... dal 1282 al 1460 colla continuazione di Alamanno e Neri suoi figli fino al 1506*, followed by other unpublished historical chronicles transcribed from the original codices and preceded by a genealogical history of their family and a description of the family chapel in Santa Croce, with documents and illustrations, edited by Giuseppe Aiazzi, Florence, 1840.

Ristori 1979 = Renzo Ristori, 'Cegia (Del Cegia, Cegi, il Cegino), Francesco', in *Dizionario Biografico degli Italiani*, XXIII, Rome, 1979, 324–7.

Rohlmann 1996 = Michael Rohlmann, 'Botticellis *Primavera*. Zu Anlaß, Adressat und Funktion von mythologischen Gemälden im Florentiner Quattrocento', *Artibus et Historiae*, no. 33, 17 (1996), 97–132.

Roover 1970 = Raymond de Roover, *The Rise and Decline of the Medici Bank, 1397–1494*, Cambridge, Mass., 1963.

Ross 1983 = Sheila McClure Ross, *The Redecoration of Santa Maria Novella's Cappella Maggiore*, Ph.D. Diss., Berkeley, Calif., University of California, 1983.

Rossi, *Ricordanze*, ed. 1786 = Tribaldo de' Rossi [15th century], *Ricordanze*, in Cambi, *Istorie*, ed. 1785–6, IV (1786) [*Delizie degli eruditi toscani*, XXIII], 236–303.

Rotondi Secchi Tarugi 1995 = Luisa Rotondi Secchi Tarugi, 'Polizianos Wirken als Humanist am Hofe Lorenzo il Magnificos', in *Lorenzo der Prächtige und die Kultur im Florenz des 15. Jahrhunderts*, edited by Horst Heintze, Giuliano Staccioli, Babette Hesse, Berlin, 1995, 101–18.

Röttgen 1997 = Steffi Röttgen, *Wandmalerei der Frührenaissance in Italien. II. Die Blütezeit, 1470-1510*, Munich, 1997.

Rubinstein 1957 = Nicolai Rubinstein, 'Il Poliziano e la questione delle origini di Firenze', in *Il Poliziano e il suo tempo*, proceedings of the international symposium (Florence, 23–6 September 1954), Florence, 1957, 101–10.

Rubinstein 1960 = Nicolai Rubinstein, 'Politics and Constitution in Florence at the End of the Fifteenth Century', in *Italian Renaissance Studies. A Tribute to the Late Cecilia M. Ady*, edited by Ernest Fraser Jacob, London, 1960, 148–83.

Rubinstein 1966 = Nicolai Rubinstein, *The Government of Florence under the Medici (1434 to 1494)*, Oxford, 1966 (2nd edition Oxford, 1997).

Rubinstein 1968 = Nicolai Rubinstein, 'La confessione di Francesco Neroni e la congiura antimedicea del 1466', *Archivio storico italiano*, 126 (1968), 373–87.

Rubinstein 1995 = Nicolai Rubinstein, *The Palazzo Vecchio, 1298–1532. Government, Architecture, and Imagery in the Civic Palace of the Florentine Republic*, Oxford, 1995.

Rucellai, *Zibaldone*, ed. Perosa 1960 = Giovanni Rucellai [1475–1525], *Giovanni Rucellai ed il suo Zibaldone. I. "Il Zibaldone Quaresimale"*, selection edited by Alessandro Perosa, London, 1960.

Ruffa 1990 = Giuseppe Ruffa, 'Osservazioni sugli affreschi di Domenico Ghirlandaio nella chiesa di Santa Maria Novella in Firenze. II. Censimento delle tecniche di tracciamento del disegno', in *Le pitture murali* 1990, 53–8.

Salvini, *Catalogo cronologico*, ed. 1782 = Salvino Salvini [1667–1751], *Catalogo cronologico de' canonici della chiesa metropolitana fiorentina*, compiled in the year 1751, Florence, 1782.

Sandro Botticelli 2000 = *Sandro Botticelli pittore della Divina Commedia*, exhibition catalogue (Rome, Scuderie Papali al Quirinale, 2000), 2 vols. [vol. I edited by Sebastiano Gentile, vol. II by Hein-Th. Schulze Altcappenberg], Milan, 2000.

Sapori 1973 = Armando Sapori, 'Il *Bilancio* della filiale di Roma del Banco Mediceo del 1495', *Archivio storico italiano*, 131 (1973), 163–224.

Savonarola, *Prediche quadragesimale*, ed. 1539 = Girolamo Savonarola [1452–98], *Prediche quadragesimale … sopra Amos propheta, sopra Zacharia propheta …*, new edition, Venice, Ottaviano Scoto, 1539; edited by Paolo Ghiglieri, 3 vols., Rome, 1971–2.

Savonarola, *Prediche sopra Aggeo*, ed. Firpo 1965 = Girolamo Savonarola, *Prediche sopra Aggeo*, with the *Trattato circa il reggimento e governo della città di Firenze*, edited by Luigi Firpo, Rome, 1965; English translation by Anne Borelli and Maria Pastore Passaro in *Selected Writings of Girolamo Savonarola: Religion and Politics, 1490–98*, New Haven, Conn., 2006.

Scheller 1981–2 = Robert W. Scheller, 'Imperial Themes in Art and Literature of the Early French Renaissance: The Period of Charles VIII', *Simiolus*, 12 (1981–2), 5–69.

Schlosser 1899 = Julius von Schlosser, 'Die Werkstatt der Embriachi in Venedig', *Jahrbuch der Kunsthistorischen Sammlungen des Allerhöchsten Kaiserhauses*, 20 (1899), 220–82.

Schmid 2002 = Joseph Schmid, *"Et pro remedio animae et pro memoria". Bürgerliche 'repraesentatio' in der Cappella Tornabuoni in S. Maria Novella*, Munich–Berlin, 2002.

Sette anni di acquisti e doni 1997 = *Sette anni di acquisti e doni, 1990-1996*, exhibition catalogue (Florence, Biblioteca Nazionale Centrale di Firenze, Tribuna Dantesca, 1997), Livorno, 1997.

Shaw 1988 = Christine Shaw, 'Lorenzo de' Medici and Virginio Orsini', in *Florence and Italy. Renaissance Studies in Honour of Nicolai Rubinstein*, edited by Peter Denley and Caroline Elam, London, 1988, 33–42.

Shearman 1992 = John Shearman, *Only Connect... Art and the Spectator in the Italian Renaissance*, Princeton, N.J., 1992; Italian edition with the title *Arte e spettatore nel Rinascimento italiano. Only connect...*, translation by Barbara Agosti, Milan, 1995.

Silvestri 1953 = Alfonso Silvestri, 'Sull'attività bancaria napoletana durante il periodo aragonese', *Bollettino dell'Archivio Storico del Banco di Napoli*, no. 6 (1953), 80–120.

Simons 1985 = Patricia Simons, *Portraiture and Patronage in Quattrocento Florence, with Special Reference to the Tornaquinci and Their Chapel in S. Maria Novella*, 2 vols., Ph.D. Diss., Melbourne, University of Melbourne, 1985.

Simons 1987 = Patricia Simons, 'Patronage in the Tornaquinci Chapel, Santa Maria Novella, Florence', in *Patronage, Art, and Society in Renaissance Italy*, edited by Francis W. Kent and Patricia Simons, with John Ch. Eade, Canberra–Oxford, 1987, 221–50.

Simons 1988 = Patricia Simons, 'Women in Frames: The Gaze, the Eye, the Profile in Renaissance Portraiture', *History Workshop: A Journal of Socialist and Feminist Historians*, 25 (1988), 4–30.

Sman 1989 = Gert Jan van der Sman, 'Il "Quatriregio": mitologia e allegoria nel libro illustrato a Firenze intorno al 1500', *La Bibliofilía*, 91 (1989), 237–65.

Sman 2007 = Gert Jan van der Sman, 'Sandro Botticelli at Villa Tornabuoni and a Nuptial Poem by Naldo Naldi', *Mitteilungen des Kunsthistorischen Institutes in Florenz*, 51 (2007), 159–86.

Spallanzani 1978 = Marco Spallanzani, 'The Courtyard of the Palazzo Tornabuoni–Ridolfi and Zanobi Lastricati's Bronze Mercury', *The Journal of the Walters Art Gallery*, 37 (1978), 7–21.

Statuta Populi et Communis Florentiae, ed. 1777–83 = *Statuta Populi et Communis Florentiae, publica auctoritate collecta, castigata et praeposita Anno Salutis MCCCCXV*, 3 vols., Freiburg [Florence], n.d. [1777–83].

Sternfield 1979 = Frederick W. Sternfield, 'The Birth of Opera: Ovid, Poliziano, and the *Lieto Fine*', *Analecta musicologica*, 19 (1979), 30–51.

Strocchia 2003 = Sharon T. Strocchia, 'Taken into Custody. Girls and Convent Guardianship in Renaissance Florence', *Renaissance Studies*, 17 (2003), 177–200.

Suárez Fernández 1965–72 = Luis Suárez Fernández, *Política internacional de Isabel la Católica. Estudio y documentos*, 5 vols., Valladolid, 1965–72.

Tanner 1993 = Marie Tanner, *The Last Descendant of Aeneas. The Hapsburgs and the Mythic Image of the Emperor*, New Haven, Conn.–London, 1993.

Tarabochia Canavero 2002 = Alessandra Tarabochia Canavero, 'Nicola Cusano e Marsilio Ficino a caccia della sapienza', in *Nicolaus Cusanus* 2002, 481–509.

Le Tems revient 1992 = *Le Tems revient, 'l Tempo si rinuova. Feste e spettacoli nella Firenze di Lorenzo il Magnifico*, exhibition catalogue (Florence, Palazzo Medici Riccardi, 1992), edited by Paola Ventrone, Cinisello Balsamo, 1992.

Tezmen-Siegel 1985 = Jutta Tezmen-Siegel, *Die Darstellungen der Septem Artes Liberales in der bildenden Kunst als Rezeption der Lehrplangeschichte*, Munich, 1985.

Thieme 1897–8 = Ulrich Thieme, 'Ein Porträt der Giovanna Tornabuoni von Domenico Ghirlandaio', *Zeitschrift für bildende Kunst*, new series, 9 (1897–8), 192–200.

Tinagli 1997 = Paola Tinagli, *Women in Italian Renaissance Art. Gender, Representation, Identity*, Manchester–New York, 1997.

Tomasi 2003 = Michele Tomasi, 'Miti antichi e riti nuziali: sull'iconografia e la funzione dei cofanetti degli Embriachi', *Iconographica*, 2 (2003), 126–45.

Tornabuoni, *Lettere*, ed. Salvadori 1993 = Lucrezia Tornabuoni [1427–82], *Lettere*, edited by Patrizia Salvadori, Florence, 1993.

La Toscana 1996 = *La Toscana al tempo di Lorenzo il Magnifico. Politica, economia, cultura, arte*, proceedings of the symposium organized by the Universities of Florence, Pisa and Siena (5–8 November 1992), 3 vols., Pisa, 1996.

L'uomo del Rinascimento 2006 = *L'uomo del Rinascimento: Leon Battista Alberti e le arti a Firenze tra ragione e bellezza*, exhibition catalogue (Florence, Palazzo Strozzi, 2006), edited by Cristina Acidini and Gabriele Morolli, Florence, 2006.

Valori, *Vita del Magnifico*, ed. Dillon Bussi–Fantoni 1992 = Niccolò Valori [1464–1528], *Vita del Magnifico Lorenzo de' Medici il vecchio*, [vernacular translation by Filippo Valori of the *Vita Laurentii Medicei senioris*, MS, after 1492, Florence, Biblioteca Medicea Laurenziana, Plut. 61.3], in Biagio Buonaccorsi, *Diario de' successi più importanti seguiti in Italia, e particolarmente in Fiorenza dall'anno 1498 in sino all'anno 1512*, Florence, Giunti, 1568; published with the title *Vita di Lorenzo il Magnifico*, introduction by Angela Dillon Bussi, notes by Anna Rita Fantoni, Palermo, 1992.

Vasari 1568 = Giorgio Vasari, *Le Vite de' più eccellenti pittori, scultori, et architettori*, revised and enlarged, 3 vols., Florence, Giunti, 1568; in id., *Le Vite ... nelle redazioni del 1550 e 1568*, edited by Rosanna Bettarini, commentary by Paola Barocchi, 6 vols., Florence, 1966–87; English translation [selection] by George Bull, 2 vols., London, 1987 (1st edition 1965).

Vasetti 2001 = Stefania Vasetti, *Palazzo Capponi on Lungarno Guicciardini and Bernardino Poccetti's Restored Frescoes*, edited by Litta Maria Medri, English translation by Ursula Creagh, Florence, 2001.

Vasoli 1973 = Cesare Vasoli, 'Giovanni Nesi tra Donato Acciaiuoli e Girolamo Savonarola: testi editi e inediti', *Memorie domenicane*, new series, no. 4 (1973) [*Umanesimo e teologia tra '400 e '500*], 103–79.

Vasoli 2002 = Cesare Vasoli, 'Niccolò Cusano e la cultura umanistica fiorentina', in *Nicolaus Cusanus* 2002, 75–90.

Ventrone 1990 = Paola Ventrone, 'Note sul carnevale fiorentino di età laurenziana', in *Il Carnevale: dalla tradizione arcaica alla traduzione colta del Rinascimento*, proceedings of the symposium (Rome, 31 May–4 June 1989), edited by Maria Chiabo and Federico Doglio, Viterbo, 1990, 321–66.

Ventrone 1992 = Paola Ventrone, 'Feste e spettacoli nella Firenze di Lorenzo il Magnifico', in *Le Tems revient* 1992, 21–53.

Ventrone 1996 = Paola Ventrone, 'Il carnevale laurenziano', in *La Toscana* 1996, II, 413–35.

Ventrone 2007 = Paola Ventrone, 'La festa di San Giovanni: costruzione di un'identità civica fra rituale e spettacolo (secoli XIV-XVI)', *Annali di storia di Firenze*, 2 (2007), 49–76; <http://www.dssg.unifi.it/SDF/annali/2007/Ventrone.htm>.

Verde 1973–94 = Armando F. Verde, *Lo Studio fiorentino, 1473-1503. Ricerche e documenti*, 5 vols., Florence, 1973–94.

Villari 1859–61 = Pasquale Villari, *La storia di Girolamo Savonarola e de' suoi tempi*, with new documents, 2 vols., Florence, 1859–61.

Vincke 1997 = Kristin Vincke, *Die Heimsuchung. Marienikonographie in der italienischen Kunst bis 1600*, Köln–Weimar–Vienna, 1997.

Virtue and Beauty 2001 = David Alan Brown et al., *Virtue and Beauty. Leonardo's "Ginevra de' Benci" and Renaissance Portraits of Women*, exhibition catalogue (Washington, D.C., National Gallery of Art, 2001-2), Washington, 2001.

Viti 1994 = Paolo Viti, 'Pico e Poliziano', in *Pico, Poliziano e l'Umanesimo di fine Quattrocento*, exhibition catalogue (Florence, Biblioteca Medicea Laurenziana, 1994), edited by Paolo Viti, Florence, 1994, 103–25.

Walter 2003 = Ingeborg Walter, *Der Prächtige. Lorenzo de' Medici und seine Zeit*, Munich 2003.

Warburg 1895 = Aby Warburg, 'I costumi teatrali per gli intermezzi del 1589. I disegni di Bernardo Buontalenti e il *Libro di conti* di Emilio de' Cavalieri' [1895, original text in Italian], in Warburg 1932, I, 259–300 (English translation 1999, 349–401, 'The Theatrical Costumes for the Intermedi of 1589').

Warburg 1902 = Aby Warburg, 'Bildniskunst und florentinisches Bürgertum. I. Domenico Ghirlandaio in Santa Trinita: die Bildnisse des Lorenzo de' Medici und seiner Angehörigen' [1902], in Warburg 1932, I, 89–126 (English translation 1999, 185–222, 'The Art of Portraiture and the Florentine Bourgeoisie').

Warburg 1914 = Aby Warburg, 'Der Eintritt des antikisierenden Idealstils in die Malerei der Frührenaissance' [1914], in Warburg 1932, I, 173–6 [abstract] (English translation 1999, 271–3, 'The Emergence of the Antique as a Stylistic Ideal in Early Renaissance Painting'); for the complete text, see Warburg 1932, Italian translation 1966, 283–307.

Warburg 1932 = Aby Warburg, *Die Erneuerung der heidnischen Antike. Kulturwissenschaftliche Beiträge zur Geschichte der europäischen Renaissance*, edited by Gertrud Bing, 2 vols., Leipzig, 1932 (*Gesammelte Schriften*, 1–2); Italian translation by Emma Cantimori with the title *La rinascita del paganesimo antico. Contributi alla storia della cultura*, Florence, 1966; English translation by David Britt with the title *The Renewal of Pagan Antiquity. Contributions to the Cultural History of the European Renaissance*, introduction by Kurt W. Forster, Los Angeles, Calif. 1999.

Watson 1979 = Paul F. Watson, *The Garden of Love in Tuscan Art of the Early Renaissance*, Philadelphia, Pa., 1979.

Weinstein 1970 = Donald Weinstein, *Savonarola and Florence. Prophecy and Patriotism in the Renaissance*, Princeton, N.J., 1970.

Weissman 1990 = Ronald F.E. Weissman, 'Sacred Eloquence. Humanist Preaching and Lay Piety in Renaissance Florence', in *Christianity and the Renaissance* 1990, 250–71.

Wieck 1997 = Roger S. Wieck, *Painted Prayers. The Book of Hours in Medieval and Renaissance Art*, New York, 1997.

Wilkins 1983 = David G. Wilkins, 'Donatello's Lost *Dovizia* for the Mercato Vecchio: Wealth and Charity as Florentine Civic Virtues', *The Art Bulletin*, 65/3 (1983), 401–23.

Wind 1968 = Edgar Wind, *Pagan Mysteries in the Renaissance*, 2nd revised and enlarged edition, Harmondsworth, 1968 (1st edition London, 1958).

Witthoft 1982 = Brucia Witthoft, 'Marriage Rituals and Marriage Chests in Quattrocento Florence', *Artibus et Historiae*, no. 5, 3 (1982), 43–59.

Wohl 1980 = Hellmut Wohl, *The Paintings of Domenico Veneziano, ca. 1410–1461. A Study in Florentine Art of the Early Renaissance*, London, 1980.

Woods-Marsden 2001 = Joanna Woods-Marsden, 'Portrait of the Lady, 1430–1520', in *Virtue and Beauty* 2001, 63–87.

Wright 1994 = Alison Wright, 'The Myth of Hercules', in *Lorenzo il Magnifico* 1994, 323–39.

Wright 2000 = Alison Wright, 'The Memory of Faces. Representational Choices in Fifteenth-Century Florentine Portraiture', in *Art, Memory, and Family in Renaissance Florence*, edited by Giovanni Ciappelli and Patricia Lee Rubin, Cambridge, 2000, 87–113.

Wright 2005 = Alison Wright, *The Pollaiuolo Brothers. The Arts of Florence and Rome*, New Haven, Conn.–London, 2005.

Wright–Marchand 1998 = Alison Wright, Eckart Marchand, 'The Patron in the Picture', in *With and Without the Medici. Studies in Tuscan Art and Patronage, 1434–1520*, edited by Eckart Marchand and Alison Wright, Aldershot–Brookfield, Vt., 1998, 1–18.

Zambrano–Nelson 2004 = Patrizia Zambrano, Jonathan K. Nelson, *Filippino Lippi*, Milan, 2004.

Zippel 1901 = Giuseppe Zippel, 'Le monache di Annalena e il Savonarola', *Rivista d'Italia*, 4 (1901), 231–49; repr. in id., *Storia e cultura del Rinascimento italiano*, edited by Gianni Zippel, Padua, 1979, 254–79.

Zöllner 1998 = Frank Zöllner, *Botticelli. Toskanischer Frühling*, Munich–New York, 1998.

Zöllner 2005 = Frank Zöllner, *Sandro Botticelli*, Munich–New York, 2005.

Zucker 1993 = Mark J. Zucker, *The Illustrated Bartsch. 24. Early Italian Masters. Commentary, Part 1*, New York, 1993.

List of illustrations

NOTE. The measurements of paintings and detached frescoes are expressed in centimetres, those of drawings, engravings and medals in millimetres.

with *Stories of St Nicholas of Bari*, 1450s, painting on panel, 23 × 158.
Florence, Casa Buonarroti, inv. 68.

12–3. Florentine school, *desco da parto*, c. 1465, painting on panel, ø 63:
Last Judgement (obverse); *Putto Playing the Bagpipes* (reverse).
Florence, Museo Horne, Inv. 1890, no. 481.[2]**

14–5. Niccolò Fiorentino (Niccolò di Forzore Spinelli; Florence, 1430–1514), attributed,
portrait medal of Giovanna degli Albizzi, 1486 (?), bronze, ø 78:
Portrait of Giovanna degli Albizzi (obverse); *Venus with Bow and Arrows* (reverse).
Florence, Museo Nazionale del Bargello, Inv. Medaglie, no. 6007.[2]

16. → 20

17. Naldo Naldi, *Nuptiale carmen*, MS, Florence, 1486, opening folio. Private collection.

18. Maso di Luca degli Albizzi, *Libro debitori e creditori*, 1480–1511, loose note.
Pontassieve, Poggio a Remole, Archivio Frescobaldi, 204 [18], Albizi.

19. Florentine production, casket with the arms of the Tornabuoni and Albizzi families,
15th century, gilt and painted gesso (pastiglia) on wood, 14.5 × 33.5 (ø).
Private collection.**

20. Sandro Botticelli (Alessandro Filipepi; Florence, 1444/5–1510) and workshop,
Story of Nastagio degli Onesti. IV. The Wedding Banquet, 1483, painting on panel, 84 × 142.
Private collection.[2]

21–2. Domenico Ghirlandaio, *Confirmation of the Rule of St Francis*, 1485, fresco.
Florence, Santa Trinita, Sassetti Chapel.[2]**

23–4. Scheggia (Giovanni di ser Giovanni di Mone; Castel San Giovanni, now San Giovanni
Valdarno, 1406–Florence, 1486), *Wedding Procession* (Cassone Adimari),
1440s, painting on panel, 63 × 280, details.
Florence, Galleria dell'Accademia, Inv. 1890, no. 8457.[2]**

25. → 30

26. → 3

27. Florence, Villa Tornabuoni Lemmi.

28. Ex libris of Francesco Sassetti, in Aristotle, *Nicomachean Ethics*, Latin translation
by John Argyropoulos, MS, Florence, third quarter of the 15th century.
Florence, Biblioteca Medicea Laurenziana, Plut. 79.1, front parchment flyleaf (verso).

29. Sandro Botticelli, attributed, *Giovanni and Ludovica Tornabuoni*, 1486–7, fresco.
Florence, Villa Tornabuoni Lemmi.

30–1. Sandro Botticelli, *Grammar Introduces Lorenzo Tornabuoni to Philosophy
and the Liberal Arts*, 1486–7, detached fresco transferred to canvas, 237 × 269.
Paris, Musée du Louvre, Département des Peintures, RF 322.
© RMN / Daniel Arnaudet.

32. 15th-century Flemish illuminator, *Philosophy Appears to Boethius*;
Philosophy Addresses the Arts, in Boethius, *De consolatione philosophiae*, MS, 1483–5.
Berlin, Staatsbibliothek, Preußischer Kulturbesitz, MS lat. fol. 25, fol. 86v.
© Photo Scala, Florence / BPK, Bildagentur für Kunst, Kultur und Geschichte, Berlin.

33. Sandro Botticelli, *Venus and the Three Graces Offer Flowers to Giovanna degli Albizzi*,
1486–7, detached fresco transferred to canvas, 211 × 283.
Paris, Musée du Louvre, Département des Peintures, RF 321.
© RMN / Daniel Arnaudet.

57. Domenico Ghirlandaio and assistants, *The Naming of the Baptist, c.* 1489, fresco.
 Florence, Santa Maria Novella, main chapel.[1]*

58. Masaccio (Tommaso di ser Giovanni di Mone; Castel San Giovanni, now San Giovanni
 Valdarno, 1401–Rome, 1428), *Birth Scene, c.* 1427, painting on panel, ø 65.
 Berlin, Staatliche Museen, Gemäldegalerie, inv. no. 58C.
 Photo Jörg P. Anders / Artothek.

59. Domenico Ghirlandaio and assistants, *Nativity of St John the Baptist, c.* 1489, fresco.
 Florence, Santa Maria Novella, main chapel.[1]*

60. Domenico Ghirlandaio, *Portrait of Giovanna degli Albizzi,*
 1489–90, painting on panel, 77 × 49.
 Madrid, Museo Thyssen-Bornemisza, inv. 158 (1935.6).
 © Museo Thyssen-Bornemisza, Madrid.

61. → 63

62. Domenico Ghirlandaio and assistants, *Annunciation to Zacharias,* 1490, fresco.
 Florence, Santa Maria Novella, main chapel.[1]*

63. Domenico Ghirlandaio and assistants, *Visitation,* 1489–90, fresco.
 Florence, Santa Maria Novella, main chapel.[1]*

64. Domenico Ghirlandaio and assistants, *Resurrection of Christ,*
 1494, painting on panel, 221 × 199.
 Berlin, Staatliche Museen, Gemäldegalerie, inv. no. 75.
 Photo Scala, Florence / BPK, Bildagentur für Kunst, Kultur und Geschichte, Berlin,
 Photo Volker–H. Schneider © 2009.

65. Florence, Santa Maria Maddalena de' Pazzi (formerly Cestello), Tornabuoni Chapel.*

66. Domenico Ghirlandaio, *Visitation with Mary of Cleophas and Mary Salome,*
 1491, painting on panel, 172 × 167.
 Paris, Musée du Louvre, Département des Peintures, INV 297.
 © RMN / Jean-Gilles Berizzi.

67. Girolamo Savonarola, *Tractato del sacramento et de mysterii della messa et regola utile,*
 [Florence, Bartolomeo de' Libri], before September 1495 [IGI 8796], title page.

68. Sandro Botticelli, *Calumny of Apelles, c.* 1495, painting on panel, 62 × 91, detail.
 Florence, Galleria degli Uffizi, Inv. 1890, no. 1496.[2]**

69. Fra Bartolomeo (Bartolomeo di Paolo del Fattorino called Baccio della Porta;
 Sofignano di Vaiano, Prato, 1472–Pian di Mugnone, Fiesole, 1517),
 Portrait of Girolamo Savonarola, c. 1499–1500, painting on panel, 46.5 × 32.5.
 Florence, Museo di San Marco, Inv. 1890, no. 8550.[2]**

70–1. 15th-century artist in the style of Niccolò Fiorentino, portrait medal
 of Lorenzo Tornabuoni, *c.* 1485, bronze, ø 78: *Portrait of Lorenzo Tornabuoni* (obverse);
 Mercury with Sword and Caduceus (reverse).
 Washington, National Gallery of Art, Samuel H. Kress Collection, 1957.14.890.a–b.

72. Domenico Ghirlandaio, *St Lawrence,* 1494, left panel of the polyptych
 with the *Madonna and Child in Glory with Saints,* painting on panel, 210.5 × 57.5.
 Munich, Alte Pinakothek, inv. no. 1076.

73. Gherardo di Giovanni (Florence, 1445/6–97), *Piero di Lorenzo de' Medici,*
 in Homer, Ποίησις ἅπασα, Florence, Bernardo de' Nerli, 1488–9 [IGI 4795].
 Naples, Biblioteca Nazionale "Vittorio Emanuele III", inc. S.Q. XXIII K 22, fol. iiv.***

74. Domenico Ghirlandaio and assistants,
Expulsion of Joachim from the Temple, c. 1487–8, fresco.
Florence, Santa Maria Novella, main chapel.[1]*

75. Francesco Granacci (Villamagna, Bagno a Ripoli, 1469–Florence, 1543),
Entry of Charles VIII into Florence, 1515–20, painting on panel, 76 × 122.
Florence, Depositi della Galleria degli Uffizi, Inv. 1890, no. 3908.[2]**

76–7. Francesco della Robbia (Fra Ambrogio; Florence, 1477–1527), attributed,
portrait medal of Girolamo Savonarola, after 1497, bronze, ø 91:
Portrait of Girolamo Savonarola (obverse); *Symbols of the Holy Spirit* (reverse).
Florence, Museo Nazionale del Bargello, Inv. Medaglie, no. 6022.[2]

78. Sandro Botticelli, *Mystic Crucifixion*, c. 1500,
painting on panel transferred to canvas, 72.4 × 51.4.
Cambridge, Mass., Harvard Art Museums, Fogg Museum,
Friends of the Fogg Art Museum Fund, 1924-7.

79. Sandro del Bidello (Sandro di Giovanni Agolanti; Florence, 1443–1516),
after cartoons by Domenico Ghirlandaio,
stained-glass windows with *Stories of the Virgin*, before 1497.
Florence, Santa Maria Novella, main chapel.[1]*

80–1. Filippino Lippi (Prato, 1457?–Florence, 1504), *St John the Baptist* and *St Mary Magdalene*,
1496, paintings on panel, 136 × 56 each.
Florence, Galleria dell'Accademia, Inv. 1890, nos. 8653, 8651.[2]**

82. Donatello (Donato di Niccolò Bardi; Florence, c. 1386–1466),
Judith and Holofernes, 1457–64, bronze, h. c. 236.
Florence, Musei Civici Fiorentini, Palazzo Vecchio.[1]

83. Donatello, *David*, second half of the 1430s?, bronze, h. 158.
Florence, Museo Nazionale del Bargello, Inv. Bronzi, no. 95.[2]*

84. Benozzo di Lese (Gozzoli; Florence, c. 1421–Pistoia, 1497),
Procession of the Magi, 1459–61?, fresco.
Florence, Palazzo Medici Riccardi, Chapel of the Magi, west wall.

85. Alexandrian art, Tazza Farnese (*Allegory of the Fertility of the Nile*),
2nd century BC, sardonyx, ø 20.
Naples, Museo Archeologico Nazionale, inv. 27611.***

86. → 72

87. Florentine artist (Francesco Rosselli?), *Savonarola Burned at the Stake
in the Piazza della Signoria*, 1498, painting on panel, 101 × 117.
Florence, Museo di San Marco, Inv. 1915, no. 477.[2]

88. → 9

1 By permission of the Servizio Musei Comunali.
2 By permission of the Ministero per i Beni e le Attività Culturali.
* Photo Antonio Quattrone.
** Photo Rabatti & Domingie Photography, Florence.
*** Photo Luciano Pedicini / Archivio dell'arte.
Unauthorized reproduction is strictly prohibited.

TORNABUONI

SIMONE DI TIERI TORNAQUINCI (then TORNABUONI) (d. 1393)

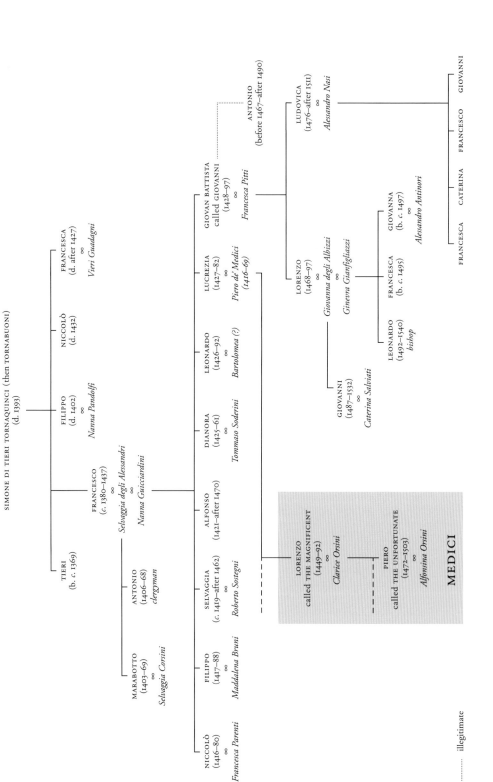

TIERI (b. c. 1369)

FILIPPO (d. 1402) ∞ Nanna Pandolfi

NICCOLÒ (d. 1432)

FRANCESCA (d. after 1427) ∞ Vieri Guadagni

FRANCESCO (c. 1380–1437) ∞ Selvaggia degli Alessandri ∞ Nanna Guicciardini

ANTONIO (1406–68) clergyman

MARABOTTO (1403–69) ∞ Selvaggia Corsini

DIANORA (1425–61) ∞ Tommaso Soderini

LEONARDO (1426–92) ∞ Bartolomea (?)

LUCREZIA (1427–82) ∞ Piero de' Medici (1416–69)

GIOVAN BATTISTA called GIOVANNI (1428–97) ∞ Francesca Pitti

ALFONSO (1421–after 1470)

SELVAGGIA (c. 1419–after 1462) ∞ Roberto Sostegni

FILIPPO (1447–88) ∞ Maddalena Bruni

NICCOLÒ (1416–80) ∞ Francesca Parenti

GIOVANNI (1487–1532) ∞ Caterina Salviati

LEONARDO (1492–1540) bishop

LORENZO (1468–97) ∞ Giovanna degli Albizzi ∞ Ginevra Gianfigliazzi

FRANCESCA (b. c. 1495)

GIOVANNA (b. c. 1497) ∞ Alessandro Antinori

ANTONIO (before 1467–after 1490)

LUDOVICA (1476–after 1511) ∞ Alessandro Nasi

FRANCESCA CATERINA FRANCESCO GIOVANNI

MEDICI

LORENZO called THE MAGNIFICENT (1449–92) ∞ Clarice Orsini

PIERO called THE UNFORTUNATE (1472–1503) ∞ Alfonsina Orsini

......... illegitimate

ALBIZZI

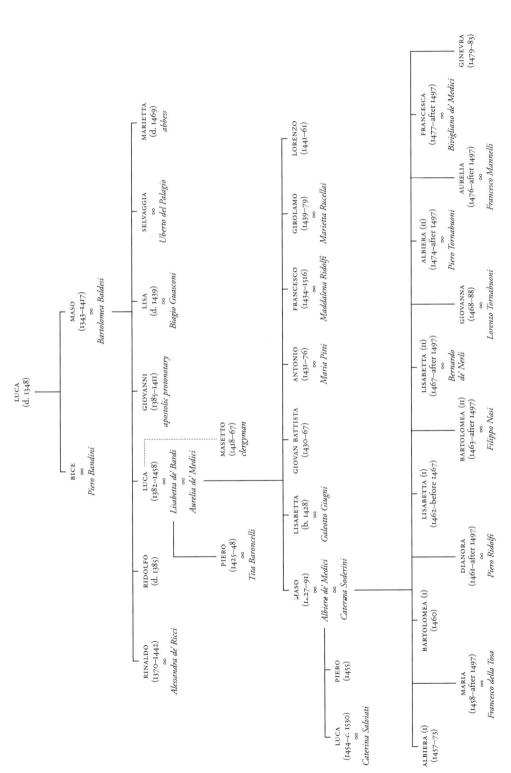

Contents

Printed in Italy
(October 2010).